THE FIRST
CENTURY

BOOKS BY WILLIAM K. KLINGAMAN

THE FIRST CENTURY

EMPERORS, GODS, AND EVERYMAN

WILLIAM K. KLINGAMAN

HarperPerennial
A Division of HarperCollins*Publishers*

For Lyle B. Buck

Photo of Pompeii from *Pompeii: Exploring a Roman Ghost Town*, by Ron and Nancy Goor. Copyright © 1986 by Ron and Nancy Goor. Reprinted by permission of HarperCollins Publishers.

Map of China from *A Traveler's Guide to Chinese History*, by Madge Huntington, © 1986 by Madge Huntington. Reprinted by permission of Henry Holt and Company, Inc.

A hardcover edition of this book was published in 1990 by HarperCollins Publishers.

First HarperPerennial edition published 1991.

Designed by Alma Orenstein

The Library of Congress has catalogued the hardcover edition as follows:

Klingaman, William K.
 The first century : emperors, gods, and everyman / William K. Klingaman.—1st ed.
 p. cm.
 Includes bibliographical references and index.
 ISBN 0-06-016447-6
 1. First century, A.D. I. Title.
D62.K55 1990 89-46540
930'.5—dc20

ISBN 0-06-092127-7 (pbk.)
 92 93 94 95 CW 10 9 8 7 6 5 4 3 2

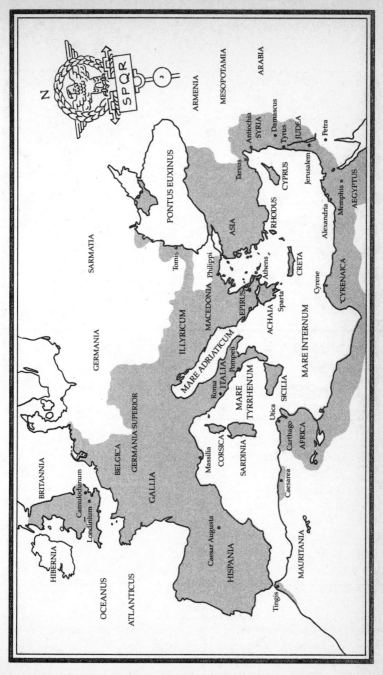

Roman Empire

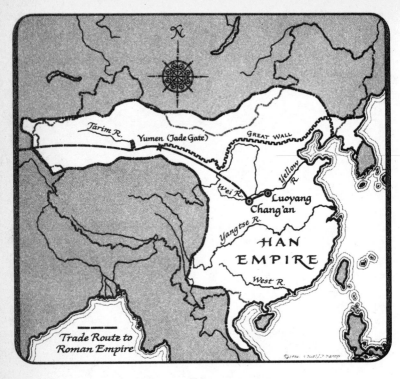

China

Contents

PART THREE: REBELLION

PART FOUR: THE AFTERMATH

Preface and Acknowledgments

From the southern boundaries of the sprawling Chinese empire to the northern reaches of the semicivilized island of Britain, the first century of our age—the years from 1 to 100 C.E. (Common Era)—was a time of extraordinary political and religious ferment. During this tumultuous period, the Roman Empire reached the zenith of its glory and prestige under the leadership of such formidable if somewhat eccentric personalities as Augustus Caesar, Caligula, Claudius, Nero, and Domitian. This was also, of course, the era in which Jesus of Nazareth lived and died and, according to the testimony of certain witnesses, rose from the dead, leading his followers to found an aggressively evangelistic Christian movement marked (in the absence of orthodoxy) by a fascinating diversity of beliefs that would again never be duplicated.

Fewer than forty years after the crucifixion of Jesus outside the walls of Jerusalem, the last remnants of Jewish political independence were brutally extinguished when a revolt launched by Jewish nationalists against their Roman overlords collapsed; in an attempt to ensure the future loyalty of Judea, the imperial legions demolished the holy city, reducing the magnificent Temple of Herod the Great to a pile of smoldering rubble—a tragedy of immense proportions for the Jewish

people, who would not recover their homeland or their sovereignty for nearly nineteen hundred years. Meanwhile, thousands of miles to the east, the rulers of the Later Han dynasty were fashioning the political and ideological models that would guide subsequent autocratic Chinese regimes into modern times, while the exotic foreign religion of Buddhism made its first appearance in the records of the imperial court in the latter half of the century.

The notion that these years constituted "the first century" is, of course, a peculiarly Christian conceit, based on the reckoning of time from the birthdate of Jesus of Nazareth as determined by a sixth-century Scythian monk, who unfortunately miscalculated by about four or five years in counting backward from his own era. If the Jews had divided time into one-hundred-year segments, the period of our study might be known as the twentieth century or even later, depending upon the dates one accepts for the lives of the patriarchal figures of Abraham and Jacob. On the other hand, time within the Roman Empire was officially reckoned either by the legendary founding of the capital by Romulus and Remus about 750 years before the birth of Jesus or, more commonly, by the administrations of consuls or emperors; thus 20 C.E. typically would have been referred to as the sixth year of the reign of Tiberius. During the reigns of the Hans, imperial China employed a similar system, though the Chinese sometimes chose to confuse matters by dating years from the occurrence of an especially significant event, so that a Chinese historian might have spoken of 6 C.E. as the third year since the taming of the Yellow River. Nevertheless, the notion of dating our years from the birth of Jesus has been an accepted convention in most of the Western world since medieval times; and since the events of the period in question were so pivotal in the formation of our modern consciousness, I trust no one will quibble seriously with my choice of title.

Instead of describing the events of the first century through a series of analytical chapters, I have chosen to employ a narrative format, following the fortunes of approximately twenty central characters, including Roman and Chinese emperors, Jewish princes, imperial generals and provincial rebels, Stoic philosophers, men of letters, visionaries, and prophets. By examining the affairs of this period in this fashion, and in a variety of geographical settings, I hope that certain intriguing parallels and comparisons between the Far East and the Mediterranean world in political, military, and spiritual matters

will become clear to the perceptive reader without any excessive prompting from me.

As far as possible, I have attempted to recreate the atmosphere of the first century—to capture for the reader the sights and sounds of that turbulent era from the viewpoint of both aristocrat and commoner—largely by relying on contemporary literary sources and the excellent archaeological work that has been done in recent decades. This approach requires an important caveat, however. There are only a limited number of sources that survive from antiquity; the fire that destroyed so many ancient manuscripts at the famous library in Alexandria, Egypt, proved an incalculable loss to mankind. The principal surviving sources for the Roman Empire are the historical writings of Tacitus (though the books for several critical periods of the first century are missing), Suetonius, Dio Cassius, and Velleius Paterculus, along with the essays and observations of others such as the satirist Juvenal, Pliny, and the geographer Strabo.

Each writer, of course, had his own personal bias and was heavily influenced by the events of the period in which he lived. Tacitus' unflattering portrait of Tiberius, for instance, was largely the product of his own distaste for the late first-century emperor Domitian, who had adopted Tiberius as one of his role models; and the Chinese historian Pan Ku, whose livelihood depended upon the favor of the Later Han emperors, naturally denigrated the virtues of the usurper Wang Mang, who had overthrown the last of the rulers of the Former Han dynasty. Moreover, virtually all the Roman and Chinese sources concentrate on chronicling events in their respective capitals and particularly on military and political matters (often to an excruciatingly detailed degree) as they affected the ruling elite. Provincial affairs typically received short shrift, and what information was presented was often inaccurate or badly distorted (witness Tacitus' description of Judaism circa the year 68). For that matter, few of the ancient historians judged their evidence by the rigorous standards of objectivity employed by most twentieth-century historians, preferring instead to include details of dubious veracity if they added color or spice to their narratives; Suetonius, one of the worst offenders, occasionally descends to the level of fatuous gossip in his biographies of the Caesars. In the case of the gospels of the New Testament, this problem becomes especially acute, because the authors (whoever they were) of those four books were *not* endeavoring to present a factual narrative

of Jesus' life but to paint a portrait that would reveal the glory of his divine mission.

Yet the unmistakable traces of bias in the selection and presentation of material in these ancient texts hardly renders them worthless as historical sources. Rather, they must be approached with caution and a healthy dose of skepticism, and be carefully cross-checked against one another and the available archaeological evidence; fortunately, their authors were usually so open about their prejudices that the task of sifting truth from fiction becomes much easier than it might otherwise have been. The most difficult case remains the New Testament, yet even here there seems no compelling reason to reject as wholly fictitious those considerable portions of the gospels that were actually written during the first century and were almost certainly based upon solid oral tradition and eyewitness testimony—though one must always remember that the gospels were written in a different language (Greek) than the Hebrew and Aramaic that Jesus used and were intended for a far different audience (primarily Gentiles) than the Jewish common people to whom Jesus preached. In the end, I strove to subject the gospels to the same rigorous scrutiny as the rest of my material, and if some fundamentalist Christians object to my failure to mention certain miracles mentioned in the New Testament, doubtless other critics will complain that I leaned too far in the other direction.

Unfortunately, there is simply not enough data about first-century life in Africa or the Americas to include those continents in this survey. Most of Africa, save the strip of Greek, Roman, and Egyptian settlements across the northern coast and through the Nile Valley, had only recently entered the Iron Age when the Han and Roman empires stood at their zenith, though by the end of the first century the tribes that had settled in West Africa—particularly in the area of modern Nigeria—had developed a relatively complex, sedentary agricultural economy and, armed with their superior iron implements, had begun to expand across the central and southern sectors of the continent.

Across the Atlantic, the most sophisticated societies of the Americas during this period appear to have been located in the Andes mountains, along the coast of what is now Peru, and in the valley of Mexico. Around the start of the first century, the population of the latter region suddenly exploded, largely because of enhanced agricultural production, until the capital city of Teotihuacan numbered ap-

proximately eighty thousand residents in an area of roughly twenty square miles. The product of formal urban planning (unlike Rome before the Great Fire of 68 C.E.), Teotihuacan was easily the most impressive city in the Western Hemisphere during the classical period, with straight, broad avenues laid out at right angles, an efficient drainage system that carried rainwater through subterranean conduits, and a special district for religious worship, where the famous Pyramid of the Sun—made of adobe bricks and mortar, sixty-five meters high—dominated the horizon. In the absence of any literary sources, alas, there is simply not enough information available to fashion even the most cursory narrative of events in the Americas during the first century.

Two final notes: Although the title *emperor* was not widely accepted in Rome at the start of the first century (Augustus, for example, insisted on using the designation of *princeps,* the first citizen among many), I have employed it throughout the book to avoid confusion. By the same token, the emperor Gaius, who succeeded Tiberius, is generally referred to by his nickname, Caligula, so the nonspecialist will know to whom I am referring.

More than anyone else, my agent and adviser, Don Cutler, deserves my heartfelt thanks for offering the insights and encouragement that brought this book to completion. My long-time editor and friend, Daniel Bial, kept up my spirits during the writing process and claims never to have doubted that a completed manuscript would finally appear on his desk. I also thank Dr. Billy Wilkinson, Sally Hearn, and Pat Garnett of the Albin O. Kuhn Library and Gallery at the University of Maryland, Baltimore County, and the staff of the Morris Library at the University of Delaware for their kind assistance. Rabbi Morrison Bial kindly reviewed the manuscript and provided numerous insights on Jewish culture in the first century, Dr. David Hatch contributed expertise and valuable suggestions on Chinese affairs, and Lyle B. Buck, Ben McLaughlin, Susan Holderness, and Kim Skilling provided inspiration on the New Testament sections of the narrative. But none of this would have been worthwhile without Janet, Nick, and Marianne.

AUTHOR'S NOTE

Because the designation *C.E.* ("of the common era") has now replaced the older notation *A.D.* (*anno Domini,* "in the year of the Lord") in studies of the first century, I have adopted the newer style throughout this book.

The King of the Jews

Winter–Spring, 4 B.C.E.

O n an early March morning in the thirty-third year of the
reign of King Herod, the narrow streets and alleys sur-
rounding the Temple in Jerusalem were already alive and in their
usual uproar, jammed with a jostling throng of wide-eyed sightseers,
peddlers hawking their wares for God and a good profit, and bare-
footed pilgrims hurrying on their way to worship. Sometimes it
seemed as though the entire Jewish population of Judea—along with
a handful of foreign Jews from Egypt or Babylon who lent an extra
splash of color to the scene—had descended upon the northeastern
corner of the city. To anyone approaching the Temple for the first
time, the whole frenetic spectacle must have been overwhelming.
There was a constant background roar from the shuffling of thousands
of feet across the vast stone courtyards; the air was thick with the
cloying smell of incense and burning meat; voices called in a dozen
different dialects of Greek and Aramaic, offering prayers, counting
out coins, or begging alms; and above all the tumult rose the plaintive
ritual Hebrew chants of the priests in the sanctuary, blending with the
even more doleful cries of the fattened sacrificial lambs and cattle
being led to slaughter.

The Temple itself was a majestic vision. From a distance, it ap-
peared to visitors as a mountain covered with snow, so brilliant was
the whiteness of its stone, and at the hour of sunrise the entire eastern
hill of the city appeared to be engulfed in flame as the first rays of
dawn struck the burnished gold plate atop the sanctuary columns. As

1

one drew nearer, the Temple complex—which encompassed a full twenty-five acres—resolved itself into a series of vast enclosed court-yards of varying size and shape and grandeur; as one ascended the irregular sequence of stairs toward the center, the enclosures grew smaller and more elegant, and admittance more restricted. The outer yard, known as the Court of the Gentiles, was the largest, the lowest, and of course the most easily accessible section, being open to anyone except lepers, victims of veneral disease, and women temporarily excluded by their menstrual period. It was here among the colon-nades, in the shadow of massive stone pillars twenty-seven feet high, that vendors offered doves or pigeons for sale to worshippers, all of whom were obliged to present a live sacrifice to the Lord every time they prayed at the Temple. Those who lacked the proper currency could always obtain assistance from the moneychangers stationed conveniently nearby.

One of the courtyard walls bore inscriptions in Greek explicitly warning non-Jews not to proceed any farther upon pain of death, although any Jew could pass freely through the eastern gate and climb the fourteen semicircular steps that led to the Court of Women, where Jewish parents came to present their first-born children to Yahweh, and mothers received the traditional rites of purification after the ordeal of childbirth. Not even the most devout female, however, could set foot in the next enclosure: the Court of Israel, also known as the Court of Men. There, among the fifty-foot-high Corinthian columns crowned with thick plates of gold and silver, adult male Jews could stand and watch through yet another eastern gate (which al-ways stood open to represent the universal visibility of heaven) as the Temple functionaries performed their duties in the Court of Priests.

In the center of this innermost yard, surrounded by the flames of scores of oil lamps and the scented smoke of burning incense, stood a single altar of unhewn stone. Upon this rock—the very spot where, according to legend, Abraham prepared to slay his son Isaac as an offering to God—the Levites (Temple priests) slaughtered and ex-pertly butchered their sacrificial lambs twice daily. The animals' blood drained through the hollow floor beneath the altar into a huge cistern; an aqueduct and a special system of hidden pipes and sluices carried a constant stream of fresh water onto the platform to wash away the bloody stains. Behind the altar rose the Sanctuary itself, a formidable structure of white marble and gold, with massive cypress doors en-crusted with precious stones and adorned with an elegant Babylonian

tapestry made of blue, scarlet, purple, and flaxen cloth (to represent the elements of air, fire, water, and earth), embroidered with a map of the heavens. Over the doors appeared a stylized sculpture of a golden vine, symbolic of the nation of Israel, so large that each cluster of grapes was as tall as a man.

Within the Sanctuary there was an outer chamber, known as the Holy Place, which housed the sacred furniture: another altar, a table with twelve loaves of shewbread (one for each tribe of Israel), and the menorah, the seven-branched golden candelabrum, which stood for the seven known planets. And above and behind this room, protected by double doors and an impenetrable veil, was the Holy of Holies, the chosen place of the Lord. This site was so sacred that it was forbidden ground to every living being except the High Priest, and even he was permitted to enter only once a year, on the Day of Atonement, Yom Kippur. Seventy years later, when the Romans stormed Jerusalem and razed the Temple, they discovered that this inner chamber was quite empty; apparently there was no earthly thing there at all.

This, then, was the central shrine of Judaism, the sole place of worship ordained by tradition and the Torah. No matter where they lived—and two-thirds of the nearly eight million Jews in the ancient world resided outside the boundaries of Herod's kingdom of Judea— all members of the faith were called upon to journey to Jerusalem to pray and sacrifice at the Temple three times a year, during the holy festivals of Passover, Sukkot, and Shavuot. Of course this was not the original Temple, which had been built during the reign of King Solomon nearly a thousand years earlier and leveled by marauding Babylonians in 587 B.C.E. Shortly thereafter, a Second Temple had been erected by a remnant of Israelites upon their return from exile in Persia, but that modest structure never approached the glory of Solomon's vision. It was left to King Herod to order (and pay for) the construction of a Third Temple, which, though it was designed to be a faithful reproduction of the original, actually surpassed it in breathtaking splendor: "He who has never seen the Temple of Herod," claimed the contemporary wisdom, "has never seen anything beautiful." Construction of the sanctuary itself, which began in 22 B.C.E., was carried out in just eighteen months under the supervision of a small army of priests specially trained as carpenters and stonemasons to ensure compliance with the available scriptural blueprints. Work on the outer courtyards continued at a more leisurely pace for another ten years, concluding finally in 8 B.C.E.

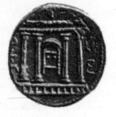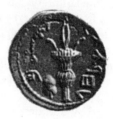

A shekel from the second year of the Jewish Revolt, showing the
columned façade of the Sanctuary of the Temple

For Herod, the successful completion of this monumental endeavor represented a personal triumph of no mean proportions. As a native of Idumea, the rugged Arab desert land on the southern edge of Judea, he had always been distrusted and regarded as an outsider by the orthodox Jewish community of Jerusalem. And with considerable justification; after all, Herod's ancestors had been converted to Judaism (and forcibly, at that) only two generations earlier, and he had never made any secret of his desire to drag his Jewish subjects—albeit kicking and screaming—into the modern era, integrating their traditional, rigidly exclusive culture into the cosmopolitan Mediterranean world. By restoring the Temple to its original awe-inspiring majesty, Herod hoped to placate his fundamentalist critics and provide tangible proof, once and for all, of his devotion to the God of the Jews. At the same time, by subtly enhancing the Temple's beauty with a combination of pagan artistic influences around the edges, he offered an impressive architectural demonstration of the superficial compatibility of Judaism and Hellenism—that attractive cultural blend of Greek rationalism and oriental mysticism which prevailed throughout most of the Roman Empire.

The Temple was Herod's most spectacular (and spectacularly expensive) construction project, but it was certainly not his only one. Like many monarchs in the ancient Mediterranean world, Herod had funded a wide range of elaborate public works as personal monuments to his glory, to enhance his prestige at home and abroad while providing work for his subjects in times of famine and economic distress. For years he had been engaged in an almost obsessive building campaign throughout his kingdom, erecting luxurious royal palaces in Jerusalem and Jericho (his summer capital) and building an imposing phalanx of fortresses—which often doubled as dungeons for political prisoners—at strategic points in the Judean wasteland. Recently Herod had even built an entire city from scratch: the Mediterranean port of Caesarea Maritima, named in honor of the king's Roman patron, Augustus Caesar. And there Herod had raised another temple, dedicated not to Yahweh but to Rome and the divine spirit of the emperor Augustus.

For Herod could never afford to forget that he was not only king of the Jews, but ruler of a substantial Gentile population, too, which was located mostly in the northern half of his kingdom. In truth, his realm was less of a cohesive state than a motley, querulous, patchwork federation of provinces where Jews and Greeks and sundry Near

Eastern nationalities coexisted in a constant and barely suppressed state of antagonism, and only a master politician such as Herod could have successfully balanced their conflicting demands for so long. Nor could Herod ignore the vital strategic interest of Rome in the region, because Judea was the strongest military power between Egypt and the Roman province of Syria. Moreover, it was a valuable buffer between the empire and Parthia, the Mesopotamian warrior kingdom that represented the only viable threat to Roman hegemony in the eastern Mediterranean. For more than a century, Rome had relied upon defensive alliances and treaties of amity to keep Judea on its side, but the mask of friendship had been torn off in 63 B.C.E. when the Roman general Pompey stormed and captured Jerusalem, thrusting Judea firmly into the Roman sphere of influence.

Herod himself owed a considerable debt to Rome, for without extensive military assistance from Marc Antony and Augustus Caesar he could never have enforced his claim to the throne of Judea by defeating the last feeble representative of the decrepit native Hasmonean dynasty. Although Augustus Caesar generally allowed Herod to conduct his internal affairs as he wished, the emperor never let Herod forget who was the senior partner in the relationship. As a political realist, Herod accepted his subservient position and collaborated willingly with Rome; besides, Herod had a real, deep-seated affinity for the sumptuous pleasures of the empire's Hellenistic culture. For the most part, the wily Herod managed to express his pro-Roman sympathies subtly, without alienating his Jewish subjects, many of whom considered the empire to be the latest earthly incarnation of the scourge of God. But occasionally he stepped over the line.

At some point, probably soon after the completion of the Temple, Herod authorized the placement of a statue, a huge gilded eagle with outstretched wings, over the great gate of the Court of the Gentiles. Although the eagle was a familiar motif in Hebrew art and theology, this particular figure atop the Temple gate offended the sensibilities of conservative Jews because it seemed to violate the Second Commandment, which, according to their interpretation, forbade the worship of graven images of any living creature. Moreover, the eagle was widely perceived as a symbol of the armed might of imperial Rome, which doubtless rendered its appearance in the immediate vicinity of the Temple even more blasphemous.

For a time the eagle reposed unmolested atop the gate. Then, on a morning early in March in the year we know as 4 B.C.E., two of the

teachers most Jews ever knew, they gained widespread popular recognition as the nation's foremost scriptural authorities.

Third, and most important, the Pharisees advanced the doctrine of the resurrection of the individual human soul and/or body, accompanied by the prospect of everlasting reward or punishment. This notion of eternal life, deriving primarily from Egyptian and oriental influences, was a relatively recent and potentially explosive innovation in Jewish theology, with a tremendous appeal to the downtrodden peasants and workers of Judea, because it opened the door of salvation to every righteous Jew regardless of economic and social status. Conversely, the concept got a far chillier reception among the Sadducees and the circles of the social and economic elite, who were already perfectly satisfied with their station in this life.

For Judah and Mattathias, however, the promise of the resurrection was a very real element in their plans on that fateful March morning. At their school near the Temple they had gathered a large number of disciples, young men fired with religious zeal and a conviction that King Herod had embarked upon an insidious campaign to appease his Roman masters by subverting the foundations of Judaism. (Because they insisted upon such a rigorous interpretation of the Law, the Pharisees—who preferred to call themselves *haverim*, which translates roughly as "friends"—and their followers were far less willing than the Sadducees to embrace Herod's brand of Judaism, and in recent years the more radical wing of the Pharisaical movement had forsaken their traditional aloofness from political affairs to condemn the king as a dangerous obstacle to their reformist goals.) As the number of students under the Pharisees' guidance multiplied, so did their temerity. Emboldened by a rumor that Herod was gravely ill (which he was) or already dead (which, to their subsequent misfortune, he was not), Mattathias and Judah delivered a lesson one morning on the abominable wages of sin—to wit, the loathsome illness God had visited upon Herod—and then launched into an impassioned oration extolling the alleged virtues of martyrdom. To the Pharisees, martyrdom for the preservation of the faith in times of crisis was an absolute duty; therefore, Judah and Mattithias exhorted their charges to risk their lives by destroying the offending eagle. If any danger should arise, the students were reminded that "it was a glorious thing to die for the laws of their fathers; because the soul was immortal, and that an eternal enjoyment of happiness did await such as died on that account."

most highly respected teachers of Jewish law in Jerusalem decided to take matters into their own hands. These men, named Mattathias ben Margalit and Judah ben Zippori, were both Pharisees, members of that loosely organized group of religious scholars who sought to reform Judaism through a strict and thorough observance of the laws of purity as expounded in the Torah and the oral interpretations and extrapolations that had grown up around the scriptures. Instead of focusing solely upon the written Law and the formal Temple ceremonies, as did the High Priests and their assistants (who were known collectively as Sadducees, since they claimed descent from Solomon's High Priest, Zadok), the Pharisees—from the Greek *pharisaioi*, or "separatists" (*perushim* in Hebrew)—strove to revitalize Judaism by persuading the people that the whole world was God's temple, wherein all men were priests responsible for their own salvation. They turned their faith into a dynamic, living force by demonstrating how its fundamental tenets could (indeed, must) be applied to everyday contemporary existence. And though they did not attempt to usurp the temporal power of the Sadducees, the Pharisees made no secret of their disdain for the Temple priests, alleging that they substituted an arrogant devotion to arid, archaic rituals for proper ethical behavior. "We cry out against you, O Sadducees," ran one typical comment, "for you declare pure a channel of water which flows from a burial ground."

Since the start of their movement about a hundred and fifty years earlier, the Pharisees had been winning converts rapidly, particularly among the common people of Judea and Galilee. They enjoyed three significant advantages in their proselytizing efforts. First, the Pharisees came primarily from middle-class stock and adopted a simple, unassuming lifestyle, living and mixing freely with the masses instead of hiding away in the Temple or the mansions of the wealthy in Jerusalem. Second, the Pharisees placed a great emphasis upon learning and scriptural instruction as an essential step upon the road to salvation. Those who knew the Law were required to teach others the way, for the Pharisees believed that only when the nation as a whole returned to the Lord would Israel be redeemed from bondage. Sometimes these scholars expounded upon the Law in the house of a student, in the early synagogue, or sometimes on a hillside or by the shore of a lake; the more prestigious scholars, including the revered Hillel and Shammai, taught in the academies at Jerusalem or even on the steps leading to the Temple. And since the Pharisees were the onl

Despite their fine words and naive enthusiasm, it seems unlikely that the protesters would have raised their hand against Herod had they not been convinced of the king's imminent demise; no one had dared dislodge the eagle before. Nevertheless, off they went through the teeming city streets in reckless disregard of the consequences, armed with axes, brusquely pushing their way through the midday crowds in the Temple district. As the astonished bystanders gaped in disbelief, several students scrambled to the top of the gate, lowered themselves down by ropes to the level of the blasphemous eagle, and hacked it down. Then their colleagues on the ground smashed the golden bird into bits. So intent were they upon their destructive task that they failed to notice the approach of the Temple guards until it was too late. Although many on the edges of the mob managed to flee, the teachers and forty of their students stood their ground and were duly arrested and taken before the king.

Now it was true that Herod had ignored more serious challenges to his authority before, and the students might have thought that he would do so again, but at that particular moment the king was in no mood to tolerate dissent. Beset by constant, excruciating pain from the final stages of a cancerous illness that burned and gnawed at his bowels and made each breath an agony, Herod was nearing the edge of madness as he watched his regime and his life's work disintegrate before his eyes. A wave of nationalistic opposition to Roman influence and the cultural incursions of Hellenism was sweeping across Judea, encouraged by the radical Pharisees and their political allies, and accompanied (and made much more dangerous) by an almost obsessive, apocalyptic conviction that a Messiah would soon arrive—a charismatic liberator capable of restoring Jewish independence and resurrecting the glory and unity Israel had known in the time of King David. Such messianic expectations had first arisen more than five hundred years earlier, during the bitter period of exile following the devastation of Jerusalem and the collapse of the original covenant between God and Israel. Now the hopes spread like wildfire, in a pervasive popular longing for repentance and resistance and redemption, and the more Herod tried to stamp them out, the more they rose in the hearts of his people.

Paranoia set in; Herod imagined he saw rebellion and plots everywhere. To make matters worse, his private life was a bloody mess. As might be expected of a dying monarch with ten wives and at least sixteen sons, squalid family intrigues were tearing apart his carefully

laid plans for the succession. In 7 B.C.E., Herod had executed two of his sons—he had long ago slain their mother, the doomed, high-born Mariamme—for plotting to seize the throne. (Not for nothing did Augustus say that it was better to be Herod's pig than Herod's son.) In an age when the line between the natural and the supernatural was often blurred, when God, the angels, and assorted demons were accorded the power to actively interfere and guide the course of human affairs, it is not surprising that one of the most damning pieces of evidence in Herod's mind was a recurring dream, or hallucination, in which he saw one of the accused boys standing over his prone body, brandishing a drawn sword. Finally, shortly before the incident of the eagle in the Temple, Herod had been staggered by reports, backed by convincing evidence, that his eldest son, Antipater, was actively conspiring to poison him. In the midst of such turmoil, an uprising of nationalist students was not apt to allay the king's mounting anxieties.

When the two Pharisees and their students were led into Herod's presence, he demanded to know if they were the vandals who had assaulted his eagle. They confessed that they were, and then proceeded to chastise the king for desecrating the Temple with the bird's image in the first place, informing Herod to his face that the laws of God and Moses were far "more worthy of observation than your commands." This, of course, was nothing less than treason. Moreover, the prisoners confessed in an ill-advised burst of candor, they were prepared and even eager to "undergo death, and all sorts of punishment which you might inflict upon us, with pleasure," in the belief that they would "enjoy greater happiness after they were dead."

Livid with fury, Herod pronounced them guilty; but fearing a popular uprising on their behalf, he bound them in chains and smuggled them out of Jerusalem as quickly and silently as possible. Under heavy military guard, the prisoners proceeded northeast toward Jericho: for twenty-three miles they walked, down the steep, rocky, ancient road that descended nearly four thousand feet along its route, falling from the hills surrounding the holy city, traversing the desolate Judean wasteland . . . through the darkness of the Valley of the Shadow of Death, where the towering, barren stone cliffs blotted out the sun . . . past the brooding fortress of Cypros that guarded the entrance to the lush Jericho plain, arriving at last at the town the Jews called "the deepest hole in the world." There Herod interned the captives in an amphitheater and promptly convened an assembly of

the leading citizens from the surrounding area to confirm his verdict (and share the responsibility for the inevitable executions).

Far too weak to stand by this time, the king was carried to Jericho and into the theater on a litter to present the case for the prosecution. Summoning what little strength he had left, Herod raised himself up and spat out a rambling, bitter tirade of recrimination, accusing his Jewish subjects of the basest sort of ingratitude. Had he not brought Judea three decades of peace and prosperity? (He had.) Had he not provided the kingdom with a wide variety of magnificent physical and cultural improvements—culminating, of course, in the Temple, an undertaking so daunting that none of his more orthodox predecessors had even attempted to undertake it? And how had the people repaid his generosity? By insolently trampling upon his goodwill and abusing his handiwork in broad daylight, and for that he demanded the prisoners be executed as blasphemers. They pretended, indeed, that they had destroyed the eagle to affront him, charged Herod, when actually they were nothing less than Temple-robbers who were guilty of sacrilege against God.

More than anything else, the assembled delegates feared that Herod—in his present highly unstable emotional condition—might use this incident as an excuse to launch a wholesale purge of potentially seditious elements among the Jewish population, an exercise that might very well begin with them. So they obediently approved his decision to punish the students and the Pharisees, but begged him not to kill anyone except the conspirators themselves. Reluctantly Herod agreed.

On the thirteenth day of March, Judah and Mattithias and the students who had actually pulled down the eagle were burned alive. The other prisoners were handed over to the proper authorities for execution.

That same evening there was a total eclipse of the moon, a phenomenon so ominous and awe-inspiring that wise men throughout the Near East deemed it a divinely inspired portent of miraculous events to come.

Now Herod had less than a month to live. In a desperate effort to assuage the fever and calm the horrible convulsions that wracked his massive body, the king was taken for treatment to the warm sulphur baths at Callirhoe, on the other side of the Jordan River by the northeastern edge of the Dead Sea; but he found no relief there. As a last resort, his doctors immersed him in a tub of hot oil, where-

upon Herod promptly fainted dead away. When he revived, they brought him back once again to Jericho, where the pain and the madness grew steadily worse. Perhaps Herod was already insane when he issued yet another summons to members of every prominent family of his kingdom to assemble in Jericho. Anyone who resisted his command was to be killed on the spot. This time he imprisoned his guests in the hippodrome. Probably they were only hostages to ensure a peaceful and orderly transition of power to his sons when he died. But there was a persistent rumor that Herod had ordered his troops (to whom he had just awarded a timely bonus) to massacre all the prisoners after he was dead. "I know the Jews will greet my death with wild rejoicings," Herod allegedly told his sister, Salome. "But I can be mourned on other people's account and make sure of a magnificent funeral. . . . These men under guard—as soon as I die, kill them all—let loose the soldiers amongst them; and then all Judea, and every family will weep for me—they can't help it." Given the morbidly diseased state of Herod's mind, the story may not be dismissed as pure fabrication.

Only one more task remained. Antipater, Herod's eldest son, had been convicted on a charge of attempted parricide. According to the accusation, Antipater and Herod's estranged brother, Pheroras, had formed a conspiracy to poison Herod. But Pheroras died (in 5 B.C.E.) before the plan could be carried out, and his servants broke down under torture and revealed incriminating details of their late master's plot to Herod's inquisitors. Antipater, of course, steadfastly denied the charges, and at his trial he called upon God to provide a sign that might prove his innocence. God, however, apparently remained unmoved, and the prosecution subsequently presented tangible and conclusive evidence of Antipater's guilt: namely, the vial of poison that had been specially prepared for Herod. When the potion was administered to a condemned criminal as a test, the poor man promptly keeled over stone dead.

Since Herod preferred not to dispose of Antipater without the formal approval of his patron, Augustus Caesar, he dispatched an envoy to Rome. In the meantime, the king retreated to the fortress of Hyrcania, in the desert wilderness between Bethlehem and the Dead Sea, and lodged his son in the dungeon there. But before the emperor had time to reply (the journey to Rome took two to three months under favorable conditions), Herod sank into an acute state of depression, which quickly deteriorated into suicidal despair. One day he

casually asked a servant for an apple and a paring knife. As he grasped the knife in his right hand, Herod suddenly turned the blade toward his chest and seemed poised to thrust it downward. A cousin who chanced to be standing nearby realized what was happening and grabbed Herod's arm before the knife reached its target, but the incident provoked such a wail of shock and horror from the king's attendants that Antipater, locked in his cell on a lower level, heard the uproar and assumed that his father was finally dead. Without waiting for confirmation, Antipater foolishly attempted to bribe the jailer into releasing him immediately, weaving grandiose visions of what he would do now that the kingdom was his at last. When the jailer reported the conversation to Herod, the king raised himself up on one arm, gave a terrifying cry of wounded love and fury, and ordered the guards to murder his son at once and bury the corpse deep within the darkness of Hyrcania, with no blessings for the dead.

Five days later King Herod died. His ravaged body was laid upon a golden bier and covered with a purple cloak embroidered with precious stones, and a crown of gold was placed upon his head. A procession of nobles accompanied him on the last journey to his tomb at Herodium, twenty-four miles away.

And a first-born infant who had been born without ceremony in Herod's kingdom, possibly at Bethlehem but more likely at Nazareth in Galilee, was taken to Jerusalem by his parents to be presented at the Temple to God.

PART ONE

The Empires

The Colossus

Rome and Rhodes, 1–4 C.E.

If I have pleased you, kindly signify
Appreciation with a warm goodbye.

—Last words of Augustus Caesar

A lone in a sparsely furnished bedroom on the ground floor of a modest stone villa halfway up the Palatine Hill, nestled among the ornate and ostentatious mansions of the ancient Roman aristocracy, the most powerful man on earth awoke to greet the dawn of a new century. Augustus had not slept well; but then he seldom did. At the age of sixty-three, the ruler of the Roman empire seemed to live his nights and days in a constant state of nervous tension, suffering from recurrent bouts of wakefulness, kidney stones, and a sort of chronic asthma that struck him every spring. He was almost blind in his left eye and had lost nearly all of his teeth, and those that remained were yellow and rotting. But Augustus was still alive and the Republic and his enemies were dead; his health was a small price to pay for that.

It was cold. Augustus hated cold weather. So he rose reluctantly from the same low bed in which he had slept for the past forty years, cursed the winter chill that made his dry skin itch and his fingers stiff and numb, and quickly wrapped himself in several layers of heavy woolen undergarments and four purple-striped tunics, all of which had been handwoven and sewn by his wife or granddaughters. Then

Augustus slipped on the thick-soled sandals specially designed to make him look several inches taller, for he was very sensitive about his height (though at five feet four inches he was not much shorter than the average Roman), and he was most careful to put the right foot in the right shoe, for he had once nearly been killed on a day when he got them mixed up, and Augustus—a devout believer in the power of dreams, portents, and oracles—was no less superstitious than most of his contemporaries.

Already the city was awake. Augustus hated rising early almost as much as he hated the cold, so he seldom arose before the second or third hour of the Roman day, which formally began at dawn and was divided into twelve hours of daylight and twelve hours of darkness. (Given the varying amount of sunlight in the changing seasons, this meant that an hour during the day could be as long as seventy-five minutes in midsummer or as short as forty-five minutes in the dead of winter. The resulting confusion seemed to bother no one at all.) As he chewed a crust of coarse bread and a chunk of fresh hand-pressed cheese, which served as his usual light breakfast, Augustus could hear the raucous cacophony of street sounds from the city below: shopkeepers touting their wares at the top of their lungs, soldiers brusquely ordering unwary civilians out of the way, slaves calling out the hour, and a thousand conversations and curses in a dozen different tongues.

Although Augustus once boasted that "I found Rome built of brick; I leave it clothed in marble," the twenty-eight years of his reign had really changed the outward appearance of the city only slightly. It was true that he had authorized the construction of several spectacularly impressive public buildings, including the massive Augustan Forum, the Temple of Mars the Avenger, and the Theater of Marcellus, and he had managed to coax his late son-in-law and deputy, Marcus Agrippa, into paying for the magnificent temple known as the Pantheon. But Rome remained very much a city of concrete and wood, plagued with graffiti-smeared walls—"Please come back to me, Lucius," and underneath, "Lucius is an ass," or worse—and disgraceful districts of horrifyingly dark, foul-smelling, and filthy slums. "Rome is supported on pipestems, matchsticks," complained the acerbic poet Juvenal. "It's cheaper, so, for the landlord to shore up his ruins, patch up the old cracked walls, and notify the tenants they can sleep secure, though the beams are in ruins above them." The city was also appallingly overcrowded: approximately seven hundred and fifty

Caesar Augustus

thousand people were squeezed into an area of six square miles, a population roughly equivalent to that of the District of Columbia in the late twentieth century, in one-tenth the area. Slumlords routinely ignored the laws that required a space of two and a half feet between buildings; as ramshackle wooden tenements rose one on top of another, five or six stories high, apartment dwellers lived in constant peril of a fiery holocaust.

Augustus had, however, brought peace and prosperity (along with an efficient firefighting brigade) to Rome, and for that his countrymen were eternally grateful. Half a century earlier, when he was an unknown boy named Gaius Octavius whose mother happened to be the niece of Julius Caesar, the dying Roman Republic had been torn apart by a seemingly interminable series of fratricidal civil conflicts waged by rival warlords and ruthless demagogues such as Pompey, Catiline, Crassus, and of course Caesar himself, all of whom treated the increasingly feeble and fractious Senate—ostensibly the supreme authority in the land—with the disdain it deserved. In the year which we know as 49 B.C.E., Caesar had emerged triumphant, parlaying his command of the western legions into a civil dictatorship. Unfortunately, the noble Julius combined incomparable political and military abilities with an appalling lack of tact and an undisguised contempt for the time-honored forms of republican rule. Hence his assassination in 44 B.C.E. by a clique of aristocratic reactionaries who feared that Caesar, after being named perpetual dictator by the Senate, would seek to establish an absolute monarchy in the manner of an oriental potentate.

To the surprise of nearly everyone in Rome, the nineteen-year-old Octavius, who had been serving as a staff officer at the right hand of Caesar, was named sole heir in the great man's will. Those who scoffed at the sudden elevation of an untried boy to such an exalted position discovered to their peril that Octavius was an exceptionally hard, cunning, coldly ambitious young man, with a generous measure of cruelty in his character. Swearing vengeance to Mars on his great-uncle's murderers, he fulfilled his vow in an extravagantly bloody and merciless manner with the aid of Caesar's foremost lieutenant, Marc Antony. Then he turned on Antony, and after winning the crucial naval battle of Actium in the year 31 B.C.E., Octavius emerged as the sole ruler of the Roman world. The old Republic was dead, with all of its internal chaos and constant bickering and private warfare among the rich and powerful oligarchs, and many Romans mourned

its passing not at all. The provinces, which had often served as the battlegrounds of the civil wars, were equally relieved that the agony was over. "There is nothing that was decaying and declining to unfortunate state that he did not restore," proclaimed the provincial assembly of Asia in celebration of Octavius' triumph, "and he gave a fresh appearance to the whole universe, which would have been content to accept its own ruin," if Octavius had not appeared on the scene. In gratitude for the peace he had restored to the weary, devastated land, the Senate in Rome heaped honors and power upon Octavius, and voted him the title of Augustus—a rather vague designation calling up connotations of preeminent personal prestige, reverential authority, and unassailable dignity.

Then Augustus began accumulating every scrap of power he could lay his hands on, but he cloaked his ambition so deftly that he actually appeared to be shrinking from the authority thrust upon him by the Senate. As he extended and consolidated his grasp upon the levers of influence, subtly fashioning an entirely novel autocratic system of government, Augustus innocently protested that all he really wanted to do was to restore the Republic; in fact, he claimed that the Republic already *had* been restored, for he was careful to refuse any position that was not sanctioned by custom or ancestral law. Specifically, Augustus was elected consul for ten consecutive years, and later the Senate awarded him proconsular powers for the rest of his life. As *imperator* (another imprecise term meaning roughly "the general" or "the governor"), he ruled single-handedly the strategically vital provinces of Gaul, Egypt, Syria, and Spain, commanding all the legions within those regions (i.e., most of the Roman army), and appointing and dismissing provincial officials at will. As time went by, Augustus was also granted the powers of a tribune of the people for life; a compliant Senate gave him permanent command of all of the armed forces and named him to the venerable ceremonial post of *pontifex maximus,* chief priest of the ancient civic religion, with divine authority over the laws and morals of the nation. In deference to republican sensibilities, Augustus rejected out of hand the title of *dictator,* which had created so much ill-will toward his great-uncle Julius, and adopted instead the role of *princeps*—"the first citizen" of Rome. And when the Roman people displayed an irresistible inclination to worship him as the savior of the city (or, more precisely, to worship the spiritual virtue or immortal *genius* that made the emperor unique), Augustus—who was genuinely uncomfortable with this sort

of adoration—adamantly insisted that any prayers to him be joined
with tributes to the traditional gods of ancient Rome, and he reacted
with undisguised horror when anyone addressed him as "lord."

At the dawn of the first century, the empire over which Augustus
ruled—with the aid of only a rudimentary civil service—encompassed
nearly eighty million people and ranged across ten thousand miles of
frontier which, for reasons of military convenience, generally fol-
lowed clear-cut natural boundaries, stretching from the English
Channel through France, Belgium, and western Germany to the
Rhine, thence across southern Europe through most of the Balkans,
Greece, and the western portions of Asia Minor to the Euphrates and
the Syrian desert; on the southern edge of the Mediterranean, Rome
also controlled the fabulously wealthy land of Egypt and a thin strip
of North African coastline, bounded on the south by the Sahara
Desert, extending to the battered remnants of Carthage near modern-
day Tunis. To many contemporary observers, this represented virtu-
ally the entire civilized world: "Your possession is equal to what the
sun can pass," ran one slightly overwrought tribute to the emperor,
"nor do you reign within fixed boundaries, nor does another dictate
to what point your control reaches; but the sea like a girdle lies
extended, at once in the middle of the civilized world and of your
hegemony."

Much of this vast dominion had been conquered over the past
fifty years solely for strategic (and definitely not economic) reasons,
as a buffer to protect the security of the Italian peninsula and the vital
Mediterranean provinces against the depredations of barbarians. Ever
since a band of Celtic marauders had invaded the peninsula and
wantonly sacked Rome in 387 B.C.E., the city had been understandably
jittery about such matters. It was Rome's misfortune right from the
start, however, that there were so many obstreperous barbarians con-
stantly pressing against the empire's boundaries, who so seldom real-
ized when they had been defeated by the superior force of Roman
arms.

Now, as the new year began, Augustus retreated to the solitude
of his study on the top floor of his house to pore over the latest reports
from his provincial governors. He noted with dismay that the eastern
frontier in Germany seemed to have turned into a potentially disas-
trous quagmire where barbarian forces were launching lightning gue-
rilla attacks upon his legions and then withdrawing into the deep
forests. There were troublesome signs of discontent in the Balkans,

too, among a civilian population hard-pressed by the burdens of Roman taxation. In Britain, Rome's native allies were being threatened by increasingly aggressive neighboring tribes. And the incorrigibly contentious Jews in Judea, freed only four years ago from the iron-fisted rule of the late King Herod, had broken into open rebellion against Herod's son and successor, Archelaus, partly in reaction to the execution of the Pharisees in Jericho. Publius Quinctilius Varus, the Roman governor of Syria, had been forced to send imperial troops to Judea to suppress the disorders; by the time it was all over, the authorities had crucified two thousand insurgents and carried off three thousand more as slaves.

But the most pressing and perplexing dilemma remained the one that had bedeviled Augustus all along: who would inherit his authority and influence when he followed his fathers into eternity? Unlike Herod, who had far too many offspring for comfort, Augustus had no sons; nor was there any crown to inherit, nor one single office of paramount importance.

His first choice as successor had been his nephew Marcellus, whom he had married to his only daughter, Julia, but Marcellus had died suddenly and unexpectedly at the age of nineteen in 23 B.C.E. Augustus then handed over Julia to his long-time friend and deputy, Marcus Agrippa, and though Agrippa was more than twenty years her senior—leading the high-strung Julia to embark on an increasingly frantic quest for sexual excitement in other men's beds—the uneasy union produced three healthy sons and one daughter. Augustus adopted the two eldest boys, Gaius and Lucius Caesar, while they were still toddlers and raised them as his own, teaching them to read and write (he insisted that they mimic his own style of handwriting) and, as they grew older, confiding to them the hard-won secrets of imperial statecraft. To him, they were "the light of my eyes," though this was as close as the hard-bitten emperor ever came to an open expression of sentimentality. As the grandsons of the divine Augustus, the boys enjoyed a tremendous measure of popular goodwill, probably more than their own limited talents and obnoxious personalities warranted. Augustus clearly meant to play on that popularity, keeping Gaius and Lucius in the public eye as much as possible and heaping them with honors and promotions as a tangible demonstration of his confidence in them. Hence the Senate obsequiously raised both boys to the magistracy while they were still in their teens, and in 2 B.C.E. Augustus named Gaius commander of the Danube legions

to celebrate his eighteenth birthday. (At the time, the Danube provinces were unusually quiet; Augustus deemed it prudent to let Gaius learn the practical details of command under a minimum of pressure.)

The following year, the emperor dispatched Gaius on his first major diplomatic mission, to negotiate a settlement of the disputed and impossibly complicated Armenian succession with the Parthians, who also possessed a strategic interest in that troubled border state. The groundwork had already been laid by more experienced hands, and so Gaius could hardly fail to return a conquering hero—providing he returned alive.

Tiberius Claudius Nero wanted to go home.

For the past six years, the man who was the most famous soldier in the Roman Empire and the son-in-law of Augustus had been living in self-imposed exile on the island of Rhodes, in the far eastern reaches of the Aegean Sea. At first his sojourn there had seemed pleasant enough. One of the most agreeable and picturesque isles in the Mediterranean, Rhodes was still a flourishing center of Greek culture, with an excellent university (more precisely, a *gymnasium*) where Tiberius would arrive every morning, his tall, barrel-chested figure dressed casually in a Greek-style cloak and slippers, to indulge his intellectual passion for discussions of philosophy and lectures in rhetoric. Despite the irritation of occasional visits from passing dignitaries who stopped discreetly at his country villa to pay their respects to the son-in-law of Augustus Caesar (Tiberius really would have preferred that they leave him alone), for the most part he had enjoyed his leisurely, uncomplicated existence as a private citizen in retirement, far from the stifling pressures of life in the capital.

Until recently, in fact, Tiberius had given observers the distinct impression that he never wanted to see Rome again. He had departed the city in a fit of pique in 6 B.C.E., much against the wishes of Augustus, who gave him permission to leave only after Tiberius staged a four-day hunger strike to force the emperor's hand. Long after Tiberius had sailed for Rhodes, Augustus continued to berate the Exile (as Tiberius soon became known in Rome) with long-distance accusations of betrayal and desertion.

Only Tiberius knew precisely why he had retired abruptly after reaching the apparent height of his fame and influence, but the general reasons for his discontent were not difficult to trace. As the elder son of aristocratic parents who happened to choose the wrong side

(several times, in fact) during the chaotic years of the civil war, Tiberius had spent his early childhood in constant flight from his father's enemies, settling down to a relatively normal existence only when his mother, the opportunistic and exceptionally capable Livia Drusilla, consented to become Augustus' second wife. Like most young men of noble birth, Tiberius had entered military service as soon as he put on the ceremonial toga of manhood (a rite usually celebrated at a boy's fifteenth birthday). He soon revealed an exceptional flair for command, building a distinguished reputation as a relentless adversary, a sound if not terribly innovative tactician, and a firm but fair disciplinarian whose men loved him for his heartfelt devotion to their welfare. By the age of thirty-one (11 B.C.E.), Tiberius had already led successful campaigns against Rome's enemies in Asia Minor, the Balkans, and Germany, and he and his brother Drusus stood unchallenged at the top of the imperial military hierarchy. Then his world collapsed.

After the death of Marcus Agrippa, Augustus asked (ordered, really) Tiberius to marry the widowed Julia, which meant that Tiberius first had to obtain a divorce from his own wife, Vipsania (who was, coincidentally, the late Agrippa's daughter). This sort of businesslike transaction had long been a common marital practice among the Roman nobility—witness Augustus' callous abandonment of his own first wife ("I could not bear the way she nagged at me," he complained) to marry Livia—and would not have mattered greatly had not Tiberius, who was emotionally awkward and far more vulnerable than he seemed, truly loved Vipsania. Although he eventually gave Augustus what he wanted, the divorce scarred Tiberius for life. Nor did he make any attempt to disguise his feelings. Once when he recognized Vipsania from a distance, he followed her through the city streets with tears running down his cheeks and misery written all over his face, until the emperor at last took measures to prevent Tiberius from ever seeing her again. His misery intensified when Julia resumed her scandalous sexual behavior soon after they were married. Partly as a protest against the stifling patriarchal control under which she, and all Roman wives, suffered, Julia reportedly engaged in drunken nocturnal orgies in the Forum, even copulating upon the speakers' platforms known as the Rostra; in the words of one disgusted contemporary writer, the wayward but apparently highly imaginative Julia "left untried no disgraceful deed untainted with either extravagance

or lust of which a woman could be guilty, either as the doer or as the object."

Tiberius might have been willing to bear his pain and humiliation in silence if Augustus had given some sign that he appreciated just how much his new son-in-law had sacrificed for the good of the state. Instead, Tiberius—with all his hard-won military honors—was bypassed for the succession and relegated to the thankless role of guardian for Gaius and Lucius until the boys were old enough to exercise power on their own. (At some point in the future, of course, the two princes might well decide that the much-decorated Tiberius represented an intolerable danger to their own security, and then his life would not be worth one of the little green figs Augustus often devoured for lunch.) In 9 B.C.E., fate dealt Tiberius another cruel blow when his brother, Drusus, died in a riding accident during a military campaign in Germany, thereby depriving Tiberius of the one man to whom he could confide his innermost thoughts. The last straw came in 6 B.C.E., when a spineless Senate majority nominated Gaius to be consul at the ridiculous age of thirteen. Displaced, embittered, and loveless, Tiberius relinquished his civic responsibilities and sailed away from Rome with barely a word to anyone. He decided to settle in Rhodes, where the ruins of the fabled Colossus served as a grim symbolic reminder of his own shattered career. Augustus commanded him to return. Tiberius obstinately refused—until he realized he had made a grave and dangerous mistake.

Because as time went by, Augustus discovered that he could do very well without Tiberius. And so, it seemed, could Gaius, who no longer needed the protection of an older man after he reached his eighteenth year. In fact, the constant stream of distinguished visitors to Rhodes—many of them highly placed army officers who were old friends of Tiberius—looked rather suspicious to Gaius and Augustus, who wondered whether the Exile was plotting a coup from his island hideaway. Tiberius strenuously denied the rumors, and offered to return to Rome so Augustus could keep an eye on him, but now the emperor petulantly refused to let him come back. Tiberius could only return, Augustus decided, when Gaius said so, and since Gaius at that time was under the influence of a military adviser named Marcus Lollius, who bore an old grudge against Tiberius, the Exile was forced to remain firmly ensconced on Rhodes. Then, in 2 B.C.E., Tiberius lost the protection of his personal ties to the emperor when Augustus finally learned the extent of Julia's widespread indiscretions. (Up to

that point, no one had dared tell him precisely how far his daughter had gone.) Humiliated and furious, Augustus briefly considered executing Julia, then banished her instead to a prison island, forbidding her wine and male companionship for the rest of her life.

At the dawn of the new century, therefore, Tiberius had good reason to fear that his own days of freedom were numbered, especially after he learned that Gaius—who was passing through the Aegean en route to his diplomatic conference with the Parthians—wanted to meet him face-to-face on the island of Samos. Swallowing his pride (which was considerable), Tiberius obediently appeared and humbly prostrated himself before the young prince, assuring him of his loyalty. The performance seems to have worked. When the meeting was over and Tiberius had sailed away, a member of Gaius' entourage offered (not entirely in jest) to follow the ship to Rhodes and "fetch back the Exile's head," but Gaius said no—or at least, not yet.

Then an extraordinary sequence of events knocked all the emperor's carefully laid plans into a cocked hat and thrust Tiberius directly into the line of succession once again.

By the time Gaius finally reached Armenia, the lengthy journey had worn everyone down, particularly Gaius himself, who had apparently inherited Augustus' fragile physical constitution. Even though the grandson of the emperor naturally was invited to stay at the most luxurious private villas along the route, shunning the common variety of smoky taverns and disreputable inns where guests were frequently robbed during the night (often by the innkeeper himself), he was not entirely insulated from the vicissitudes of travel in the Mediterranean world. In some towns the drinking water was disgustingly foul; it was far better to go thirsty than to risk dysentery. Outside Italy, the roads were annoyingly bumpy and, in the rainy season, slippery with mud. In the summer, disease-carrying mosquitoes were a constant problem in low-lying areas such as the Danube marshes, and sickness was rampant; in winter, the damp, biting cold seemed to penetrate everywhere.

Luckily for Gaius, the course of negotiations with Parthia required little effort on his part. Preoccupied with the threat of revolt from his own nobles, the Parthian king caved in completely and acceded to virtually all of Rome's demands, including the right to select the next ruler of Armenia. But that was the last thing that ever went right for Gaius. Shortly before the agreement was to be signed,

Gaius discovered that his trusted adviser, Marcus Lollius, had accepted a bribe from the Parthians to ease the path of the talks. Embarrassed by the revelation, Lollius reportedly committed suicide, though there is a slim chance that an angry Gaius had him murdered. Then, shortly after Gaius departed for a ceremonial tour of Syria, Egypt, and Judea (where he refused to dignify the Jews' eccentric and—to the Roman mind—incomprehensible monotheistic religion by worshipping at the Temple), the Parthian agreement was shattered by a rebellion of the Armenian nobility against the new Roman-appointed monarch. Cutting short his tour, Gaius hurriedly returned north to take command of military operations against the rebels.

Back in Rome, meanwhile, Augustus had celebrated Lucius' eighteenth birthday by giving the young man command of the imperial legions in Spain. Eschewing the traditional overland route through the western Alps, Lucius opted to travel to his new post by sea, despite the well-known dangers of sailing the Mediterranean in the treacherous winter season (particularly for Romans, who were never much known for their navigational skills). Tragically, Lucius drowned when his ship foundered in a storm off the coast of southern Gaul near Massilia, the site of modern Marseilles, in the early months of the second year of the new century.

Although Augustus bore his loss with the sort of stoic resignation expected of a Roman aristocrat, the death of one of his two designated heirs persuaded the emperor to reconsider his refusal to permit Tiberius to return to Rome. Freed from the baleful influence of Marcus Lollius, Gaius, too, relented, though only on condition that the Exile agree to abstain from politics entirely.

When the ship bearing the emperor's long-awaited summons approached Rhodes, Tiberius reportedly was walking along a cliff in the company of his astrologer, a famous Alexandrian savant named Thrasyllus; since his luck had not been running particularly well lately, Tiberius was seriously pondering the advisability of pushing the poor man over the sea wall and hiring himself a new seer. Suddenly Thrasyllus, in a last-ditch attempt to save his reputation and probably his skin, pointed excitedly to the incoming vessel and informed Tiberius that it brought a message of great importance and exceedingly good news. The incident confirmed Tiberius in his lifelong belief in the power of soothsayers and divination—astrology was fast becoming the rage among the Roman aristocracy—and convinced him that he was finally in a position to fulfill the glorious prophecies

the sages allegedly had made to his parents when he was a child.

Unfortunately, there is no written record of the Exile's first meeting with Augustus upon his return to Rome after an absence of seven years. But Tiberius clearly meant to keep a low profile until he saw which way the wind was blowing; besides, he intended to scupulously honor the commitment he had made to Gaius to remain aloof from political affairs. So he moved out of his elegant mansion and took up residence in a suitably discreet dwelling on the Esquiline Hill on the eastern edge of the city, far removed from the Capitol and the emperor's villa. And there, in the year after Lucius' death, he heard the startling news from the East: on the ninth day of September, Gaius had been critically wounded during the siege of the rebel-held town of Artagira. According to the official report, the commander of the local enemy forces had pretended that he wished to surrender and summoned Gaius to a parley to divulge secret intelligence of great strategic value. When the prince carelessly came within range of the city walls, a well-aimed rebel arrow pierced his leather tunic.

He never recovered. Already exhausted from the tour and the ensuing military campaign, Gaius fell into a peculiar sort of lethargy. His mental condition deteriorated rapidly. Spurning the increasingly frantic entreaties of Augustus, he flatly refused to return to Rome. In a rather grotesque imitation of his rival Tiberius, Gaius resigned all his duties and informed his grandfather that he, too, wanted to retire from public life, and requested permission to settle in Syria. Just before the end, he took passage on a cargo ship bound for Lycia on the southern coast of Anatolia, not far from the island of Rhodes. There he died on February 21 in the fourth year of the new century.

Now Augustus had no choice. Longing for peace at the age of sixty-six, and virtually bereft of natural heirs (save for Postumus Agrippa, the brutish and unreliable younger brother of Gaius and Lucius), the emperor officially adopted Tiberius as his son on June 26, less than ninety days after he received the news of Gaius' death. In these circumstances, the adoption procedure was a formality designed to indicate the emperor's choice of a successor; Augustus told the Senate that he was taking this step "for the sake of the state," which meant that he thought the empire would be perfectly safe in Tiberius' capable hands (even if Augustus himself still was not terribly fond of his adoptive offspring). Certainly the people of Rome greeted the news of the adoption warmly, with enthusiastic demonstrations in the city streets, since it guaranteed that the state would not be

plunged, leaderless, into another abyss of anarchy once Augustus was dead. Yet even now Tiberius did not enjoy a clear-cut path to the succession, because one of the emperor's conditions for the adoption was that Tiberius first had to adopt his (that is, Tiberius') nephew Germanicus, the eighteen-year-old son of the late Drusus. In what was rapidly becoming a tangled skein of imperial family relations, Germanicus had recently been betrothed to Agrippina, the grand-daughter of Augustus and the sister of Gaius and Lucius.

Plainly Augustus was trying to keep all his options open for as long as possible, as was his wont. In the meantime, the adoption procedure prevented Tiberius from kicking up any difficulties for the regime, for he was now bound by the full weight of aristocratic tradition, which allowed the patriarch of each Roman clan—in this case, Augustus—to exercise virtually dictatorial control over the lives and property of his relatives. (According to ancient Roman law, a father actually had the right to murder his sons if he wished, though social convention in the time of Augustus frowned upon such excesses.) Secure in the knowledge that the notoriously conservative Tiberius held this sort of filial obligation to be sacred and inviolable, Augustus decided to entrust his newly acquired son with an army once again. Specifically, he dispatched Tiberius to Germany, where Roman forces were massing for an offensive across the Rhine.

The General

Germany and Illyricum, 4–9 C.E.

> Fortune sometimes breaks off completely, sometimes
> merely delays, the execution of men's plans.
>
> —Velleius Paterculus

Velleius Paterculus, the newly appointed prefect of cavalry, had never witnessed anything like the rejoicing that greeted Tiberius upon his return to the legion encampments in Germany. Even from a distance, the troops could recognize the distinctive, hulking figure they had known and loved so well: the long hair curling down the nape of the neck, the slightly protruding goggly eyes, and the peculiar, off-balance way Tiberius had of walking, with his heavy shoulders thrust forward. Battle-hardened veterans wept when he came near; some stood in silent salute, while others rushed forward to touch his uniform. "Is it really you that we see, Commander?" they called out. "Have we received you safely back among us?" "I served with you, General, in Armenia!" "And I received my decoration from you in Vindelicia!"

In an era when the average Roman soldier enlisted for a term of sixteen to twenty years and served under a succession of different commanders whose abilities were likely to vary widely—the ancient Romans liked to pretend that any man of noble birth was inherently qualified to exercise both civil and military authority with only minimal training—the reappearance of Tiberius must indeed have been

cause for celebration. No general took better care of his men. For the twenty-four-year-old Velleius, who had just returned to the West after accompanying Gaius on his ill-fated mission to Armenia, the opportunity to serve on Tiberius' staff in Germany provided an invaluable lesson in the qualities that endeared a Roman commander to his troops. As Velleius recalled years later, "There was not one of us who fell ill without having his health and welfare looked after by Caesar [i.e., Tiberius] with as much solicitude indeed as though this were the chief occupation of his mind, preoccupied though he was by his heavy responsibilities." Indeed, Tiberius seemed relieved to be back in the field amid the commonplace hardships and camaraderie of army life, sharing his bathtub, his physician, and his kitchen staff with his fellow officers, dining with them in spartan simplicity, and traveling by their side on horseback rather than in a more comfortable private carriage. Though he measured his own conduct by a rigorous, self-imposed yardstick of martial discipline, and tolerated no outspoken dissent from his troops (Roman legionaries were famous for their verbal abuse of commanders they disliked), Tiberius was prepared to overlook minor infractions of military regulations so long as no real harm was done. "He often admonished, sometimes gave verbal reproof, but rarely punishment," observed Velleius, "and pursued the moderate course of pretending in most cases not to see things and of administering only occasionally a reprimand."

Life as a Roman soldier was certainly hard enough without a martinet in command. "Truly the army is a harsh, unrewarding profession," lamented one dissatisfied recruit quoted by Tacitus. "Heaven knows, lashes and wounds are always with us! So are hard winters and hardworking summers, grim war and unprofitable peace." Unlike the halcyon days of the Republic, when service in the legions was considered a privilege and duty of citizenship, most of the recruits in the first century Roman army seem to have joined up because they needed a steady job or a safe haven from the law. Ever since the property qualification for becoming a legionary had been dropped in 107 B.C.E., an increasing number of the rank and file had come from the Italian peasantry or the lower urban classes. Indeed, the onerous terms of service for a common soldier positively discouraged prospective recruits from the middle and upper classes; one of Augustus' advisers reportedly recommended in 29 B.C.E. that anyone who had served below the rank of centurion should be permanently barred from membership in the Senate. Nevertheless, all le-

gionaries were still required by law to be Roman citizens.

Enlisted men on active duty were forbidden to marry; those who did so anyway saw their children stigmatized as bastards. Pay was adequate (about two and half sesterces a day) but hardly generous, since the cost of the common soldier's food and equipment—nearly seven hundred sesterces per annum—came out of his own pocket. Because discipline had grown lax during the chaotic years of civil war, Augustus found it necessary to revive some of the more brutal traditional penalties for cowardice or disobedience: anyone caught absent from his post was summarily executed, and if the ranks of a company broke before an enemy onslaught, the survivors were literally decimated—they drew lots and every tenth man was beheaded. Less severe infractions resulted in flogging with a stout cudgel of hard, gnarled vine-wood, loss of pay and/or rations, or the degrading ordeal of standing at attention all day in front of general headquarters holding a sod of turf instead of a sword.

On an ordinary day's march, a legionary might cover fifteen or twenty miles, with a break in the summertime for a brief nap during the seventh hour. Generally the troops skipped breakfast entirely and, like most Romans, ate a light midday meal, though in their case it was as much from necessity as choice, for the common foot soldier had to grind his own wheat and bake his own bread and biscuits, or boil his own vegetable soup and porridge. Occasionally some salted pork was available but not necessarily welcomed by the men; instead, they preferred to catch and cook whatever wildfowl existed in the region. All in all, as one writer noted, "soldiers ate what they could when they could," washing it all down with wine, whenever possible, or a lukewarm mixture of vinegar and water.

Each man carried on his back his own portable kitchen (including a hand-mill, kettle, and bronze food tin) along with rations for three or four days. Since he would almost inevitably be required to help construct roads or fortifications along the line of march, a legionary was also burdened with an ingenious variety of engineering tools—an axe, a coiled length of rope, stakes, and a toolbag filled with chain, hook, and saw—and several articles of earth-moving equipment— usually a spade and a big wicker basket—so he could dig a seven-foot-deep defense ditch all around the perimeter of his encampment every evening. Besides this cumbersome baggage, most legionaries wore a heavy uniform consisting primarily of a leather corselet, sometimes reinforced with metal breastplates to make the wearer appear

more muscular, and a bronze helmet. They also carried a shield made of wood and metal, and the foot soldier's three primary weapons: a seven-foot-long javelin with a barbed, razor-sharp iron head, a nasty-looking dagger hidden in a sheath on the forearm, and a double-edged, two-foot short sword carried in a scabbard high on the right side of the body. Total weight of uniform, weapons, and kit: nearly sixty pounds.

At the dawn of the first century, there were far fewer Romans under arms than there had been during the civil war years. Following the elimination of his last rival, Marc Antony, at Actium in 31 B.C.E., Augustus had slashed the size of the Roman army in an attempt to reduce government expenditures while (not coincidentally) diminishing the chance that any future rival might be tempted to follow his own path to power by staging a military coup. The number of legions was cut to twenty-eight, with each legion bearing a nominal strength of five thousand four hundred men, though in reality few legions ever attained full strength. At least eight imperial legions were stationed in Germany when Tiberius assumed command. Adding the dozen or more units of auxiliary forces—noncitizen soldiers recruited from the provinces—who were garrisoned more or less permanently on the Rhine, Tiberius probably controlled at least a hundred thousand veteran troops in the year 4 C.E. This represented by far the largest concentration of armed men within the empire and slightly more than a third of Rome's entire military strength, which makes it perfectly clear why Augustus sought to assure himself of Tiberius' loyalty before entrusting him with the vital German command. In fact, the appointment of Tiberius provides a perfect illustration of one of the emperor's fundamental rules of self-preservation: staff the highest levels of the military leadership with members of one's own family, including relations by marriage—a policy made all the more necessary by the fact that Augustus had never been a particularly successful field general himself. (He tended to break down with various psychosomatic illnesses whenever he came near a battlefield.) To provide additional protection for his regime, Augustus kept a close eye upon the ranks of junior officers, selecting for promotion those promising young men, like Velleius (whose father had also served the emperor as a cavalry officer in Germany), who lacked aristocratic connections and hence depended entirely upon the emperor's patronage and goodwill for their advancement.

Though it was already midsummer by the time Tiberius and

Velleius arrived in Germany in the year 4, the general refused to delay
the scheduled invasion of the interior. As far as Augustus and his
contemporaries were concerned, the Roman conquest of the vast,
uncharted German homeland seemed to be inevitable; they saw no
sound strategic reason why the blessings of Roman civilization should
be confined by the line of the Rhine, or even the Elbe, though it was
not at all certain that Rome possessed either the will or the resources
to permanently occupy all of Germany. To the enlightened Roman
mind, there was something both fascinating and terrifying about the
forbidding landscapes of this wild and savage land, "a country,"
wrote Tacitus, "that is thankless to till and dismal to behold for
anyone who was not born and bred there." Behind the obvious dread
there was, perhaps, an unspoken recognition that Germany—with its
deep black forests that knew no cities, the woodland gods who bore
no names, the mist-covered swamps, and the abiding presence of
mysteries and magic and human sacrifice—served as the mirror image
of Rome, the primitive antithesis of the empire's humanistic, urban
culture, and a grim reminder of what Italy had been like not so many
centuries before.

Recently some of the more aggressive Germanic tribes had begun
to press against the eastern boundaries of Gaul, raiding the border
settlements in that more civilized province. So Tiberius set out to
teach them a lesson. He intended to spend the first two campaigning
seasons reasserting Roman sovereignty over the northern and western
reaches of Germania, from the North Sea to the Elbe and southward
toward the Danube. Then, in the year 6, he planned to turn and
confront his ultimate objective: Maroboduus, formidable chieftain of
the Marcomanni tribe, the Roman-educated barbarian king who had
fashioned a sophisticated, autocratic German state deep within the
mountains and forests of Bohemia, in the vicinity of the modern city
of Prague.

To Rome, the power of Maroboduus represented an intolerable
threat, despite the chieftain's repeated and evidently sincere assur-
ances that he had no intention of invading Roman territory unless
provoked; in fact, Maroboduus had deliberately led his people far into
the interior, away from their homeland on the Main River, to avoid
friction with any outposts of the empire. Yet Augustus refused to
trust the German king. For one thing, Maroboduus had given aid and
comfort to Rome's enemies by permitting refugees from rebellious
German tribes to settle in his domain, a policy that automatically

made him suspect in the eyes of the emperor. Even more worrisome, however, was the evidence that Maroboduus had constructed a military machine of ominous proportions: Roman intelligence reports indicated that his army consisted of seventy thousand infantry and four thousand mounted troops, strategically positioned to descend at a moment's notice upon either Germany or the Balkans, or even—and this was Augustus' worst nightmare—upon Rome itself, for the southern frontier of the Marcomanni state rested only two hundred miles from the vulnerable Alpine mountain passes.

Hence Tiberius wasted no time in launching the first stage of his offensive in the summer of the year 4. Implementing tactical plans that must have been completed in detail before his arrival on the scene—because Tiberus was a notoriously methodical, almost plodding general who would never have exposed his troops to danger unnecessarily—he divided his forces into two main bodies, commanding one himself and entrusting the other to a veteran officer named Sentius Saturninus who, like Tiberius, already had extensive experience in action on the German front. By December they had crossed the Weser, more than halfway between the Rhine and the Elbe, and subdued the four major tribes within that region.

With the early spring thaw, Tiberius resumed the campaign. As the legions moved relentlessly forward, carrying their sacred chicken coop ahead of them (an army priest periodically examined and interpreted the chicken droppings for auguries of good or ill fortune), the barbarian forces simply melted away into the dark, thick forests. Aside from one minor skirmish, the only excitement that year was provided by a complex amphibious operation in which a Roman naval detachment, laden with supplies, crossed the North Sea around Jutland and sailed upstream along the Elbe to effect a perfectly timed rendezvous with the army.

Tiberius appeared to be unstoppable. "Ye Heavens," exulted Velleius, "how large a volume could be filled with the tale of our achievements. . . . All Germany was traversed by our armies, races were conquered hitherto almost unknown, even by name. . . . All the flower of their youth, infinite in number though they were, huge of stature and protected by the ground they held, surrendered their arms, and, flanked by a gleaming line of our soldiers, fell with their generals upon their knees before the tribunal of the commander." Once more the victorious hero, Tiberius rushed back to Rome for the winter, to report his progress personally to Augustus. So far everything had

gone precisely as planned. To consolidate the conquest of Germany, the imperial armies needed only to trap Maroboduus in a pincer movement. Tiberius himself devised the strategy: a three-pronged, simultaneous advance from the west (the legions commanded by Saturninus), the south, and the southeast, whence Tiberius would bring troops borrowed from the Balkan province of Illyricum. The operation commenced the following spring, and Tiberius and Saturninus had nearly effected a junction just five days' march from Maroboduus' advanced outposts when the entire enterprise came to an abrupt halt.

Sometimes it seemed to Augustus as if everything had gone wrong in Rome since Gaius died. In the past two years, the city had been visited by a disheartening succession of natural and man-made catastrophes. It all began in the month of March in the year 5, when a partial eclipse of the sun (always a sign of impending disaster) caused a tremor of apprehension to run through Rome. Later that spring, earthquakes shook the metropolis. Then the Tiber River, swollen by the melting snows from the Apennine Mountains, overflowed its banks on the western edge of the city, sending torrents of yellow, turbid water cascading over the dykes, sweeping away bridges and crashing through the low-lying sections of Rome where the poor dwelt, destroying scores of flimsy wooden buildings and leaving thousands homeless. For seven days the streets were under so much water that boats could sail easily from one end of the city to the other.

Flood was followed by famine. Ordinarily, Rome imported vast quantities of agricultural produce from the Italian countryside and the provinces; an observer once described the city as a single gigantic mouth, and it was unquestionably the largest center of food consumption in the Mediterranean world. Unfortunately, not everyone in Rome could afford to sample the fabled bounty of the empire's farms. Even at the best of times, more than a third of Rome's population lived on the edge of hunger, saved only by the generous grain dole (about ten gallons of wheat, either uncooked or baked into loaves of bread) provided by the government every month. This long-standing program of public charity was a legacy of the shameless political bribery rampant during the later years of the Republic, and because of that it was strictly limited to Roman citizens, who were, in effect, being rewarded for the civic contributions of their grandfathers. For the rest of the city's impoverished poor—the resident freedmen and

slaves, and the foreigners who had drifted into Rome like so much human flotsam ("Sooner or later," complained one disgruntled contemporary critic, "everything disgusting turns up in Rome")—there was only the hope of private benificence.

When bad weather ruined the crops in North Africa, or political strife disrupted the provincial economies; when storms sabotaged the fragile maritime transportation system, or pirates roamed the Mediterranean (which they were doing with increasing frequency after a brief period of repression by Augustus), the capital inevitably suffered acute distress. Since the causes of the grain shortages often were hidden from the common people, there was a widespread popular assumption that famine reflected a sickness somewhere in the body politic; those who still believed in the ancient religion thought that someone at the top had foolishly antagonized the gods. And so the people searched for a scapegoat. In the marketplace, one heard open criticism of the domestic policies of the regime, probably directed more toward Tiberius than the still-revered Augustus. Explicitly subversive broadsides were posted on the city walls under cover of darkness. At least one genuine conspiracy was uncovered, and rumors of revolution were rife. Political intrigue swirled through the capital as a weary Augustus began to loosen his grip. Disputes over the succession loomed ever larger and more troublesome as adherents of the brutish Postumus Agrippa maneuvered to advance their candidate at the expense of Tiberius. There were even mass demonstrations in the streets demanding the return of Augustus' wayward daughter Julia to Rome. This the beleaguered emperor steadfastly refused to permit, though he did consent to move Julia from her barren island to more comfortable surroundings on the mainland. ("And if you ever bring up this matter again," Augustus shouted at a particularly persistent delegation, "may the gods curse you with daughters and wives like mine!")

Not even the emperor's army was immune from the rapidly spreading disorders. For decades Augustus had placated the legions with bonuses at the end of campaigns and generous settlements for those veterans who managed to reach retirement age (which about three out of five did); when paid in cash, rather than as grants of land in the provinces, a legionary's pension generally equaled about thirteen years' full pay. Most of this money had come out of the emperor's own pocket for the past thirty-five years, but the cost at last had become intolerable, and the public treasury, too, was running dry.

Angry at the meager bonuses they had received lately, and apprehensive lest they be cheated of the expected rewards at the end of their service, thousands of troops refused en masse to volunteer for additional duty. Augustus evidently feared that there was a very real chance of more serious trouble in the near future, because he sent an urgent plea to the Senate to find new, reliable sources of revenue to fund both the empire's regular military expenditures and periodic bonuses. When the Senate failed to devise any workable scheme, Augustus himself imposed a five-percent inheritance tax on the Roman citizenry and appointed a special board of ex-consuls to oversee military spending.

Naturally the new tax caused considerable grumbling among the civilian population, especially since the famine intensified during the spring of the year 6, forcing Augustus to enact a stringent austerity program to conserve the city's dwindling grain supplies. Bread was rationed, public banquets within the city limits were banned, government offices were closed, courts went into recess, senators were invited to leave the city to stay at their country estates for the duration of the crisis, and unemployed gladiators and slaves were removed from Rome to a less hard-pressed district one hundred miles away.

Then fire raged through the troubled capital.

As if these domestic troubles were not sufficient, Augustus had to quash numerous minor rebellions in cities across the eastern provinces and a particularly vicious outbreak of banditry in the mountains of Asia Minor. And Judea was once more in turmoil. Before he died, King Herod had made four separate wills, each of which apportioned his realm in a different way among his favorite sons. Since no one was really sure who ruled what, the whole tangled mess was dumped squarely in the lap of Augustus, who, as Herod's nominal overlord, had to ratify the final arrangements anyway. After hearing exhaustive arguments from all the interested parties, the emperor awarded the southern two-thirds of Herod's kingdom—Idumea, Judea proper, and Samaria—to Herod's eighteen-year-old son, Archelaus; Galilee (the northern part of Herod's kingdom) and a pocket of land east of the Jordan, known as Perea, went to Archelaus' younger brother Antipas; and the recently conquered area in the far northeast, just below Damascus, was given to their half-brother Philip.

Archelaus lasted less than ten years. Completely overmatched by his new responsibilities, he attempted to rule as a tyrant and ended by careening from one violent crisis and popular uprising to another,

alienating virtually every segment of popular opinion. Even the Judeans and Samaritans, who normally despised each other, found common cause in petitioning the emperor for his ouster. In the face of such gross incompetence, Augustus banished Archelaus to Gaul for life. But instead of handing Judea over to Antipas or Philip, Augustus decided to assume control of the strategically placed state himself, transforming it into a Roman province. Henceforth it would be governed by a semiautonomous prefect, appointed by the emperor and directly responsible to him, though the governor of Syria, who was a higher-ranking official than the prefect, could intervene in Judean affairs in an emergency. In Jerusalem, the immediate effect of Augustus' fateful decision was to make many Jews long for what now appeared to be the good old days of King Herod, when they had at least been ruled by a Jew, if not a particularly agreeable one.

For the time being, however, Roman rule in Judea remained only slightly more obtrusive than it was in most of the other imperial provinces. With very few exceptions, Rome carefully refrained from disturbing—any more than was absolutely necessary—the local customs and beliefs of the peoples it conquered. Of course Roman troops were stationed at potential trouble spots to cow the populace into submission, and a thin layer of imperial administration was imposed atop the native political structure: most of the strategically vital provinces were governed by legates appointed personally by Augustus, and the rest by senatorial nominees; below these were quaestors (military officials) and financial administrators known as procurators, who generally came from the equestrian class (i.e., the lesser nobility) of Italy. But as long as taxes were paid and the provinces remained loyal, the vast majority of the inhabitants of the empire lived their lives much as they had done before the Roman conquest, eking out a barely adequate subsistence from the soil.

With one significant difference. When Rome assumed control of an underdeveloped, barbarian (in Roman eyes) territory, a gradual process of cultural subversion occurred as the material benefits of Hellenic civilization—what puritanical critics called the "allurements of vice"—inexorably seduced the local inhabitants and broke down the traditional tribal society. The empire built roads to facilitate trade, communication, and the movement of troops; inevitably the isolation of the hinterland vanished as the new province was drawn into the complex, constantly expanding Mediterranean system of commerce. Prominent provincial aristocrats were granted the privileges of Roman

citizenship, a ploy much favored by Augustus, thereby giving them a vested interest in the imperial regime. Recruits from the countryside joined the auxiliary units of the Roman army and served their time in exotic locales throughout the empire; when they returned home, they brought with them a vastly more sophisticated, worldly outlook. Colonies of retired legionaries who received, willingly or not, land grants instead of cash pensions were planted in certain territories to speed the process of romanization and provide a ready reserve of reliable troops in case of an emergency. And, most importantly, Augustus and his civil and military representatives made a concerted effort to foster the growth of cities—the vital, indispensable centers of Roman culture, around which the entire structure of imperial society and government was organized. In some regions, particularly in the eastern provinces, the task was facilitated by the existence of an already thriving infrastructure of city-states founded by the Greeks; in fact, many of these cities had such a long and proud history that they considered the Romans to be vulgar upstarts. In the west, the process of urbanization often proceeded entirely from scratch.

Not surprisingly, many contemporaries viewed the seemingly irresistible advance of Roman arms and Roman civilization as evidence of the inherent moral superiority of the Italian race. "You alone are rulers, so to speak, according to nature," proclaimed one highly impressed Greek observer. "You have measured and recorded the land of the entire civilized world; you have spanned the rivers with all kinds of bridges and hewn highways through the mountains and filled the barren stretches with posting stations; you have accustomed all areas to a settled and orderly way of life."

Others viewed the ballyhooed splendor of empire with considerably less reverence. "Through war to wealth we hacked our way," wrote the acerbic Latin poet Petronius. "Boredom and greed. Old pleasures palled, decayed. Attrition of dirty hands, pawing, soiling. And the savor eroded, the bloom of goodness rubbed away. Vulgarity by plenty spawned." So self-confident was Rome, however, that all such vitriolic criticisms were widely ignored or lightly dismissed as unpatriotic nitpicking—until the first major rebellion in the provinces shook the foundations of empire.

As Tiberius assembled the massive invasion force which he planned to lead against Maroboduus in the spring of the year 6, he decided that he could safely borrow most of the veteran legions then stationed in the Balkan province of Illyricum, which stretched all the

way from the Danube to Macedonia. Meanwhile, the Roman gover-
nor of Illyricum, Valerius Messalla Messallinus, raised a levy of auxil-
iary troops and supplies from the local populace to provide reinforce-
ments for Tiberius. This proved to be a fatal miscalculation. The entire
Adriatic coast, which had been under Roman control for less than a
full generation, was already chafing under the burdens of imperial
taxation. Although the procurators appointed by Augustus were, on
the whole and throughout the empire, less venal and rapacious than
their republican predecessors, a dangerous measure of resentment still
lingered in many territories toward the oppressive tribute demanded
by Rome. As a Dalmatian chieftain named Bato angrily complained
to Tiberius, "We are your flocks, yet you do not send dogs or shep-
herds to guard us, but wolves."

Bato was, in fact, mad as hell about the way his people were
being treated. The demand for a Dalmatian contingent as part of the
Illyrian levy to assist Tiberius was the last straw. Instead of marching
toward Bohemia, the native troops drafted by Messalinus—led by
Bato and junior officers who had learned much about Roman disci-
pline and tactics from their previous service as auxiliaries—turned
and struck at their Roman masters. Simultaneously, in the northern
sector of Illyricum known as Pannonia, a military commander of the
Breuci tribe who also happened to be named Bato—the better to
confuse subsequent generations—took advantage of the depleted
Roman garrisons in his region to launch a successful uprising, besieg-
ing the central Roman outpost of Sirmium (between present-day
Belgrade and Sarajevo) and inflicting heavy casualties before the de-
fenders finally beat him off. The momentum of rebellion soon proved
irresistible to neighboring tribes, who decided to throw off their
shackles, too, and join the insurgents. Up and down the Adriatic coast
the rebels raged, ravaging the countryside, massacring every Roman
civilian or soldier who stood in their path. "A considerable detach-
ment of veterans, stationed in the region which was most remote from
the commander, was exterminated to a man," reported a stunned
Velleius from Rome. "Macedonia was seized by armed forces, every-
where was wholesale devastation by fire and sword."

Augustus panicked. According to one eyewitness, the emperor
was so shaken by fear that he frantically informed the Senate that
"unless precautions were taken, the enemy might appear in sight of
Rome within ten days." More than anyone else in the capital, Augus-
tus knew precisely how vulnerable Rome was. Decades earlier, the

emperor had elected to keep nearly all the imperial legions stationed along the provincial frontiers. Undoubtedly this plan stemmed from Augustus' nagging fear that if he left any substantial concentration of troops on the Italian peninsula, an unscrupulous politician might be tempted to essay a military coup; besides, the army had to remain discreetly out of sight of the Roman citizenry, to allow the emperor to maintain the fiction of ruling by the consent of the people and the Senate, and not simply by the weight of arms. By spreading his forces so thinly along the borders, however, Augustus was obviously taking a calculated gamble, for it left him with no central reserve of seasoned troops readily available to throw into the breach in an emergency.

Hysterical at the thought of more than two hundred thousand barbarian troops, including nine thousand cavalry, on the warpath, Augustus rounded up practically every warm body in Rome he could find: Senators, equestrians, retired veterans, actors (whom Augustus had never liked anyway, considering them social parasites and moral degenerates), and freedmen, who were allowed for the first time to join the imperial legions, though Augustus kept them carefully segregated from the rest of the ranks and refused to let them carry the regular array of weapons. Then he conscripted slaves from the households of the Roman aristocracy and forced their owners to free them so he could draft them, too, into the army. Bundling this motley aggregation together, Augustus put Velleius in command as his personal legate and told him to hurry northward to rendezvous with Tiberius, who was on his way back from Germany.

Unlike his stepfather, Tiberius had kept his head. First he arranged an armistice with Maroboduus, who, in a stroke of good fortune for Rome, tactfully refrained from joining the insurrection in the south; had he thrown his weight on the side of the rebels, the subsequent course of southern European history might have been far different. With his posterior safely protected, Tiberius sent Messalinus ahead to confront the insurgents and then rushed southward himself with the main body of his army to blockade the mountain passes into Italy. He arrived just in time, for Messalinus and his exhausted troops had already lost one battle and barely managed to withstand a second determined assault by Bato the Dalmatian.

Unable to break through Tiberius' makeshift defenses in the Julian Alps, a frustrated Bato turned northward to join his Breucian counterpart. Together they wreaked havoc throughout the interior by launching guerilla raids upon one Roman settlement after another.

"They were thoroughly familiar with the region and lightly equipped," noted the Greek historian Dio Cassius, "and so could easily move wherever they chose. When winter set in, they caused still greater havoc, for they even invaded Macedonia again."

Even with the reinforcements Augustus had dispatched from Rome and Thrace, Tiberius understood that he was facing a long, brutal conflict; Suetonius later termed it "the most bitterly fought of all foreign wars since Rome had defeated Carthage" two hundred years earlier. Tiberius quickly managed to lock the enemy into a region bounded by Italy on the west and Thrace on the east, but within that territory the Batos possessed the advantage of excellent defensive terrain—the formidable mountain passes of Illyricum—and well-entrenched defensive positions based on a series of stone fortresses built upon hillsides and often bounded by deep, swiftly flowing rivers on at least one side. Moreover, the rebels made a determined effort to avoid any confrontation with Tiberius himself, opting instead to retreat into the mountains whenever he appeared. So Tiberius wisely abandoned all thoughts of a quick knockout blow and settled in for a lengthy war of attrition. In the spring of the year 7, he commenced a savage scorched-earth invasion designed to starve the rebels into submission, devastating fields and burning native settlements as he advanced slowly into the interior.

He was hampered in this task by a chronic shortage of supplies from Rome and constant sniping from Augustus who, by this time, had recovered his nerve. Though he was not a reckless man by nature, Augustus could never be patient when someone else was in command of events; hence he constantly bombarded Tiberius with messages urging greater haste—"Well done is quickly done," and the like—and more decisive victories over the elusive foe. From his vantage point in the capital, Augustus could see very clearly the political dangers of a long drawn-out war. Already the home front was growing restless as the famine continued. There was a great need for news of decisive victories on the battlefield. Also the stepped-up wartime defense expenditures were threatening to empty an already depleted imperial treasury, though as time went by Augustus realized that he could use the crisis to push through more of his own controversial budget-balancing programs, such as a two-percent tax on the sale of slaves and a temporary ban on public funding of gladiatorial games. (As a man who loved athletic contests, and especially a good heavyweight

boxing match, Augustus imposed the latter measure only with great reluctance.)

By summer of the year 7, Tiberius possessed ten legions (over fifty thousand regulars) and ten thousand veterans, and more than seventy thousand auxiliary troops—the largest force assembled in one place since the end of the civil wars. Surely, thought Augustus, any competent general should be able to crush the enemy swiftly with such overwhelming numerical superiority. So why did Tiberius move so slowly? Was it possible that he was deliberately marking time, delaying the ultimate resolution so he could win even more prestige before the war ended? Ill, weary, and unable to quell his suspicions, the emperor finally dispatched young Germanicus, Tiberius' nephew, to Dalmatia at the head of a separate expeditionary force, to help shorten the war and share the glory. Actually, Postumus Agrippa, as the emperor's only surviving grandson, might have been expected to lead the force instead of Germanicus, had he not managed to disgrace himself by wasting his time fishing and consorting with a clique of suspected revolutionaries in the capital. Disgusted by Postumus' crude and boorish behavior, Augustus banished his obstreperous offspring to the island of Planasia, in the general vicinity of Corsica. (In an unguarded moment, the emperor was heard to mutter under his breath, "Ah, never to have married, and childless to have died!")

By the time Germanicus arrived at the front, nearly all of the northern territories had been pacified; much of the fertile Pannonian plain, normally thick with wheat in the autumn, had been reduced to smoldering rubble. The superior organization of the Roman legions—which was particularly noticeable since the rebels were unable to act in unison for any length of time—and the relentless tactics of Tiberius were slowly wearing down the rebels' will to fight. Recognizing that further resistance would only prolong the inevitable, Bato the Breucian surrendered to Tiberius, who decided that he could trust him sufficiently to release him and make him king of his tribe. Shortly thereafter, however, this Bato was captured in an ambush laid by Bato the Dalmatian, who was not yet ready to capitulate, and who therefore executed his former ally on the spot. The surviving Bato was able to rally the resistance in Pannonia for a few brief months, but by the end of the year 8 Tiberius had managed to confine the insurrection to Dalmatia itself.

Fearing that his own troops would mutiny if the brutal campaign dragged on much longer, Tiberius resolved to capture the remaining

rebel strongholds the following year. For a while Bato led him on a merry chase across Dalmatia, always staying one jump ahead, until Tiberius finally caught up with him at a town called Andetrium, which, like most Dalmatian settlements, was built upon a rocky hillside. As he sat within the fortress and pondered his unenviable predicament, Bato finally decided to throw in the towel. His army had been virtually exterminated, and his people were exhausted, ravaged by plague, and famished—they had long ago been reduced to eating whatever roots they could find in the forests. The rest of the garrison, however, stubbornly refused to surrender, fearing that the Romans would show them no mercy, and so Bato slipped away quietly from Andetrium and left the inhabitants to face the inevitable consequences of their obstinance.

When a passive siege showed no signs of reducing the recalcitrant town, Tiberius ordered his troops to launch a frontal attack. The first legion units marched up the steep slope at a walk, in close ranks, in the classical Roman square formation, but soon found themselves falling into disarray as they stumbled over the rough terrain covered with rocks and cut by ravines. Emerging from behind their walls, the rebels—who wore armor and helmets stolen from captured or slain Roman troops—rolled huge stones and wagons filled with debris down the hill. "All these objects hurtling down simultaneously at great speed found their targets on a wide front with the impetus of a slingshot," wrote Dio. "They reinforced the effect of the ground in separating the Romans from one another, and crushed their bodies." Only the vaunted discipline of the veteran legions, and the constant physical pressure of reinforcements which Tiberius kept sending to the front, prevented the attack from disintegrating in complete confusion. Meanwhile, Tiberius ordered one of his reserve detachments to make a wide flanking maneuver around the hillside, out of the defenders' line of sight. As the rebels continued to rain rocks and curses down upon the enemy in front, the Romans fell upon them suddenly from behind, scattering their ranks, chasing them into the woods, and slaughtering every man they caught. ("Like wild beasts," remarked one observer.)

The capture of Andetrium broke the back of the rebellion. Tiberius returned to Rome and allowed Germanicus to take charge of the mopping-up operations against the few pockets of resistance that remained. Still some preferred suicide to surrender. At the town of Arduba, the women inhabitants refused to follow their menfolk into

submission and slavery; instead, they grabbed their children and leaped to their death into the river below or perished in the flames that raged through the burning fortress. Bato met with a far more pleasant fate. He threw himself upon the mercy of Tiberius, fully expecting to be executed, but the Romans spared his life. In fact, Tiberius—who seemed disposed to sympathize with Bato's complaints of ill-treatment by oppressive Roman administrators—even permitted his erstwhile enemy to retire to relatively comfortable internment in Ravenna. The victorious imperial legions fared less well. Because of the extremely destructive nature of the campaign and the impoverished state of the countryside, there had been very little plunder or booty, and the public treasury in Rome was still short of funds for the customary bonus at the end of a war.

Nevertheless, there were great celebrations in the capital when the rebellion was over at last. Tiberius and Germanicus shared an array of triumphal honors, and monuments were voted to Augustus and Tiberius in Pannonia. But the rejoicing was short-lived. Five days later, Rome received eyewitness reports of the worst military disaster in the history of the empire.

The Student in the Temple

Jerusalem, 9 C.E.

> This man was a teacher of a peculiar sect of his own,
> and was not at all like the rest of their leaders.
>
> —JOSEPHUS, *Wars of the Jews*

I n the spring of the year 9, twelve years after the death of King
Herod, Jews from all over the Mediterranean world made their
way to Jerusalem and the Temple for the week-long celebration of
Passover: the feast of unleavened bread. The Roman prefect of Judea,
a knight named Coponius, also rode down from the new provincial
capital of Caesara Maritima for the holiday and shut himself inside
Herod's former palace on the western edge of Jerusalem. With him
came hundreds of additional troops to guard against renewed out-
breaks of violence in the city.

The first three years of Roman administration in Judea had not
been particularly peaceful. Clashes occurred nearly as soon as Arche-
laus was gone. To maximize tax revenues from the new province, the
governor of Syria, P. Sulpicius Quirinius, a politician of considerable
stature who had already served as senator and consul in Rome, had
ordered a census of all the private property in Judea. Now, censuses
were never popular in the ancient world, for the understandable rea-
son that they were designed to discover taxable property that might
otherwise have remained undeclared. But they were viewed with

special distrust among Jews, because they appeared to flout the Torah's admonition that the earth and everything in it belonged to God; the scriptures bore vivid testimony to the disastrous plague that had descended upon the land when King David had attempted to conduct a census of his own a thousand years earlier.

What with the onerous ordeal of the census, the mounting tax bills required to pay for the Roman occupation, the steady economic decline from the general prosperity of Herod's reign as the late king's ambitious public works program wound down, and the sheer humiliation of being turned into a Roman province, Judea resembled a powder keg just waiting for a spark. In the hills, a variety of resistance movements—most of them still underground—gathered strength. Some were led by militant nationalists who thought they were preparing the way for the long-expected Messiah; others were nothing more than a cover for marauding bands of murderers, bandits, and thugs posing as freedom fighters. To the Roman authorities, however, they were all made up of traitors and subversives, and it made little difference whether they called themselves Sicarii (the name came from the short dagger, the *sicarus,* employed by professional assassins) or Zealots.

The most formidable band of insurgents that appeared at this time was led by a man from Galilee called Judah. With its rough-and-tumble mix of fishermen and farmers, Galilee had long been notorious for producing troublemakers and rebels, though the land itself had been relatively calm since the previous governor, Quinctilius Varus, had burned the capital, Sepphoris, to the ground during the riots that followed the death of King Herod. Most of the credit for the restoration of peace to the principality was due to Antipas, the son to whom Herod had entrusted Galilee and Perea. Like his elder brother, Archelaus, Antipas had been called to Rome in the year 6 to account for the administration of his territories since the death of his father. Unlike Archelaus, however, Antipas had settled into his princely responsibilities with a minimum of disorder. During his visit to Rome, Antipas managed to convince Augustus that he possessed both the will and the ability to maintain order and serve Roman interests as tetrarch (a sort of client prince) of the northern lands he had inherited; clearly the young man—he was then about twenty-six—already was learning, like a fox, the art of survival in a treacherous world. By the year 9 he had added his father's name to his own, being known henceforth as Herod Antipas, in an attempt to align himself with the growing Herodian party in the cities of Galilee, where the late king's progres-

sive and secularizing policies had always received their most enthusi-
astic support.

Although all Jews were supposed to go to Jerusalem three times
a year for the great festivals of Passover, Sukkot, and Shavuot, many
Galileeans were able to make the long, arduous journey only for the
Passover celebrations. Often they traveled together in large parties of
family and friends, for both company and protection. They walked
or rode their donkeys down from the rolling hills around Nazareth in
Lower Galilee, bearing well to the southeast to skirt the edge of the
Samarian heights—better to go miles out of one's way than sully
oneself by setting foot in Samaria—and crossed the normally placid
(at that point, anyway) Jordan River into Perea. Then they headed
back across the Jordan into the lush and fertile valley surrounding
Jericho, where Herod's stately palace had recently been sacked and
burned by a rebel force led by one of the late king's former slaves.
Finally, leaving the river valley and the Dead Sea at their backs, they
climbed up the heights once more to where Jerusalem lay nestled
among the Judean hills.

When the party from Nazareth finally reached the Temple, they
must have been appalled by the blasphemous sight of Roman troops
in full battle dress stationed around the Courtyard of the Gentiles to
discourage the vast holiday throng from stirring up trouble. The Sad-
ducees were apparently resigned to the soldiers' presence and went
about their duties as if nothing were amiss; indeed, the Temple priests
had already become one of the main pillars of the new imperial order,
collaborating with the Roman prefect in exchange for his recognition
of their privileged position atop the Jewish religious hierarchy
(though they did rather wish the Romans would return the sacred
robes of the High Priest, which remained—except during holidays—
in the prefect's impious possession in the fortress of Antonia just
outside the Temple gates). For their part, the Roman administrators,
who never did understand the peculiarities of the Jewish spirit, found
it convenient to use the Sadducees as intermediaries, deliberately
reviving their Council of Elders, which had fallen into disuse during
Herod's reign, as a functioning administrative and judicial organ,
because it allowed the priests to take responsibility for exerting disci-
pline over the populace except in times of exceptional disturbance. Of
course, this policy worked only so long as the people respected the
Sadducees as guardians of the traditions of the Temple worship—
which, at least for the moment, they still did.

For a full seven days the pilgrims worshipped and sacrificed at the Temple and recited the ancient and comforting story of the exodus from Egypt and the drowning of the Pharaoh's mighty army in the Red Sea: "The Lord opened the way in the sea, and a path through mighty waters, And drew on chariot and horse to their destruction, a whole army, men of valour; there they lay, never to rise again; they were crushed, snuffed out like a wick." Some prayed for a new Moses to rise up and deliver the people from the tyranny of Rome. Others took advantage of the once-a-year opportunity to study the lessons of scripture at the feet of the city's most learned teachers.

At the end of the week the visitors, presumably enlightened and spiritually refreshed, went back to their homes. But on the second day of the trip back to Galilee, when they had nearly reached Jericho, a family from Nazareth suddenly realized that their eldest son was missing; presumably they were part of such a large traveling party that no one had noticed his absence before. Back they went, scrambling frantically up the steep slopes once again to the holy city, where they found the twelve-year-old boy sitting respectfully in the Temple, listening to the teachers and asking them searching questions that revealed an unusually deep and thorough knowledge of the Law. When his mother had recovered from her anger and anxiety at his absence she asked the boy why he had stayed behind. "How is it that you sought me?" Jesus replied. "Did you not know that I must be in my Father's house?"

And he departed from the Temple, and they all went home to Nazareth together.

The Son of Heaven

China, 1–9 C.E.

> When a man whose reputation has no substance achieves
> advancement, then there are heard sounds without
> bodily form, and their origin cannot be comprehended.
>
> —LI HSUN, QUOTING THE *Hung-fan*

In China, an emperor was dead. The sickly and ill-starred Aidi had ruled for only six years, from 7 B.C.E. until the last year of the old century; when he died he was just twenty-four years old. In his final days on earth, Aidi had used every weapon at his command to persuade the deities to let him live: he provided gifts of liquor and oxen to the peasant villages for the annual sacrifices to the gods of the soil, issued general amnesties throughout the empire as proof of his generosity, and optimistically renamed the new year *T'ai-ch'u yuan-chiang,* "The Initiation of the Grand Beginning." When the sickness persisted, Aidi ordered the faces of all the water clocks in China to be divided into one hundred twenty parts instead of the traditional one hundred parts for every twelve hours because his court numerologists had informed him that six was a more auspicious number for his regime than five. But nothing worked. Desperate, Aidi even offered to abdicate the throne in favor of his male lover, a dissolute young adventurer named Dong Xian; the emperor's inner circle of advisers preferred to treat this suggestion as a bad joke. When the end finally came, on the morning of August 15, 1 B.C.E., Aidi left behind no son to carry on the line of the Han dynasty, which had ruled the

Chinese Empire for the past two centuries. His attendants placed his body in a shroud of jade tablets sewn together with gold wire, and put pieces of jade in his mouth and eye sockets to prevent his lesser soul from escaping and haunting those who survived him.

Later that afternoon, Wang Mang, former Minister of War and scion of the most politically powerful clan in China, received a tersely worded message from his aunt, the Grand Empress Dowager, informing him of the untimely demise of the Son of Heaven. Since neither Aidi's mother nor his grandmother was still alive, the Grand Empress Dowager—the widow of one emperor (Yuandi, 49–33 B.C.E.) and mother of another (Chengdi, 33–7 B.C.E.)—was accorded by tradition the undisputed right to select the next ruler. She wasted no time. Already she had ridden in her carriage to the Weiyang Palace, in the southern district of the capital city of Chang'an (the modern city of Xi'an in Shaanxi province), to seize the royal seals of office. Then she dispatched a messenger to summon Wang Mang to her side.

Her nephew arrived before midnight. Even in the darkness, the palace was a magnificent and imposing sight, with its columns of jade and scented wood ornamented by semiprecious stones, its walls covered with delicate paintings or hung with the finest silk, and its towers that reached toward the sky and the gateways of the Immortals. The palace had been designed as a sanctuary to isolate and elevate the emperor above ordinary human society; only his favorite courtiers, a few trusted advisers, and the relatives of the present empress were permitted to enter his august presence. Undefiled by contact with the mass of his subjects, the sovereign was thereby able to fulfill his role as the sole intermediary between mortals and the three primary deities in the traditional imperial pantheon—Taiyi (the Supreme Unity and ruler of the universe), Tianyi (Heaven), and Diyi (Earth). A vital cog in a cosmological system that assumed the realms of humans and gods were intimately interrelated, the emperor alone was permitted to communicate with and make sacrifices to the Supreme Trinity; Heaven, in turn, made its will known through the emperor and by means of supernatural portents. And as the human representative of Taiyi, the emperor had—theoretically—received a mandate from Heaven to rule over the Chinese people, and was personally responsible for their well-being.

The notion doubtless had occurred to Wang Mang and the Empress Dowager, however, that the degenerate Aidi had long ago forfeited any right to govern in the name of Heaven. Although there

existed a well-established tradition of bisexuality among the Han emperors, Aidi had foolishly permitted his infatuation with his catamite to affect the quality and vigor of his administration, as witnessed by his replacement of Wang Mang with the inexperienced and most unworthy Dong Xian as Minister of War just a year earlier. In fact, thoughtful observers such as Wang Mang wondered whether the increasingly troubled Han dynasty itself had not outrun its allotted lifespan. They could cite as evidence the sickly nature of Aidi and the failure of the three previous emperors—all weak rulers, uninterested in affairs of state—to leave a son as heir; or they could point to the growing discontent among the impoverished peasantry in the countryside; or they could quote the renowned court astrologer who had recently prophesied that the Han dynasty would end after a reign of thrice seventy years, which placed its demise just four short years in the future.

Unlike the Chinese scholars of antiquity, who had conceived of the world in much more fixed, rigid terms, most educated Chinese at the beginning of the first century believed that human history, like nature, followed certain immutable cyclical patterns of growth and destruction, and was also subject to the pull of the antithetical cosmic forces generally known by the names of *yin* (symbolizing response, darkness, and the female principle) and *yang* (movement, light, and maleness). The most widely held philosophical conceit of that era was that of *wuxing,* the Five Phases—earth, wood, metal, fire, and water—which inevitably succeeded one another in an unchanging and infinite cycle. Each phase was represented by its own color (yellow for earth, black for water, etc.), one of the four seasons (spring for wood, summer for fire), and its own direction, planet, type of music, number, and household gods; and each imperial dynasty was governed by one of these phases with all its attendant characteristics. And since no earthly thing, including—or perhaps especially—the ruling family, could reign supreme forever, it seemed clear to Wang Mang, among others, that the corruption of Aidi's court and the growing weakness at the center of the government were sure signs that the vital energy of the Han dynasty was nearly exhausted.

Yet not even the Grand Empress Dowager could peremptorily dismiss the claims to the throne of the many branches of the imperial family without first carefully clearing a path for her nephew. So her first official act upon the death of Aidi was to issue an edict investing Wang Mang with personal control of the palace guards and the Grand

Secretariat. From that moment on, no petitions could be presented to the throne without the approval of Wang Mang.

The next order of business was to dispose of the former favorite, Dong Xian. On the day after the emperor's death, Wang Mang curtly announced to the court that Dong Xian "was young and not in harmony with [the] popular mind." The Empress Dowager told the poor boy to his face that the empire could no longer tolerate the consequences of his incompetence, and stripped him of his office. Disgraced, Dong Xian and his wife committed suicide less than twelve hours later. The Dowager named Wang Mang as his replacement as Commander in Chief, and concurrently raised her nephew to the nobility as Duke Protector of Han.

Then the purge continued. Over the next several weeks, Wang Mang brought charges against every surviving relative of Dong Xian who still held imperial office, and every prominent member of the families of Aidi's widow (the Empress Fu) and his favorite concubine (Ting) at court; all were dispossessed or exiled. The Empress Fu herself was degraded to the status of a commoner for reportedly "plotting to interfere with the Imperial succession, endangering the Dynastic Ancestral Temples, obstructing the Will of Heaven and violating the previous rulers [of the Han dynasty]." "She has not the righteousness of the Imperial mother," declared Wang Mang. The Empress Fu subsequently disappeared into the gardens of her estate and killed herself.

Naturally the Dowager and Wang Mang avoided all close relatives of the Fu clan in choosing a new emperor. Searching for someone with impeccable royal credentials whom they could easily control, they selected an eight-year-old prince named Liu Chi-tzu, nephew of the late emperor Cheng and hence a grand-nephew of the Dowager Wang. The boy duly ascended to the throne under the name of Pingdi on October 15, but the Empress Dowager made it clear that she and, increasingly, Wang Mang would continue to exercise power as Regent. "As the Emperor is a youth," the Dowager proclaimed in an imperial edict celebrating the new regime, "We are temporarily managing the affairs of government until he shall don Imperial robes [i.e., until he reached adulthood]. At the present time affairs have become multifarious and troublesome. Our age is increasing"—the Dowager was then seventy years old—"and Our spirit is inadequate. . . . I have, therefore, selected trustworthy and upright ministers and have newly set up the Privy Council [which was dominated, of course, by Wang

Mang]. With the diligent assumption of responsibilities by all," she concluded, "we should experience long tranquility."

At the dawn of the first century, the Chinese Empire over which Pingdi reigned (in a very nominal way) stretched from northern Korea and the southern edge of Manchuria all the way down to Hanoi in Vietnam and westward into Burma. It was largely an inland empire; most of the coast was populated by disparate ethnic groups that had managed to preserve their independence. Except in the north, where the Great Wall served as a tangible physical line of demarcation, there were no precise boundaries to the empire. Effective control of the border areas fluctuated with pressures from the outside world and changing circumstances in Chang'an, but since provincial government was heavily decentralized anyway in the farthest reaches of the empire, the constant ebb and flow of imperial authority really had very little significance in practical terms.

For administrative convenience, the empire was divided into eighty-three districts known as commanderies, governed by Grand Administrators appointed by the central government; each commanderie was further subdivided into a dozen or more prefectures (about the size of an English county), districts, and wards. With few exceptions, the Han emperors and their bureaucrats chose to maintain the existing local government structure, dating from pre-imperial China, preferring to extend and reinforce their control over the population by working through the traditional political and social elite in the villages. Unlike their Roman counterparts, Han officials distrusted large aggregations of citizens in urban areas. In fact, they sought to break down the population into the smallest family units possible to reduce the threat of conflicting allegiances (i.e., to regional cults or feudal overlords), and occasionally resorted to the forced migration of influential clans to break up dangerous concentrations of potentially seditious elements. There were also about twenty semiautonomous "kingdoms" scattered throughout the empire; more accurately described as fiefdoms, these territories had been awarded to the relatives or cronies of the emperor for their personal enrichment, though by the time of Aidi these areas, too, had come under the close supervision of the central government.

A census of 1–2 C.E.—which was, incidentally, one of the most accurate surveys in Chinese history—revealed a population of fifty-nine million, five hundred ninety-four thousand, nine hundred seventy-eight men, women, and children, living in slightly more than

twelve million households within the empire. The vast majority of the population were illiterate peasant farmers who resided in huts that were often nothing more than miserable hovels. Year after year they raised their traditional crops of barley, wheat, and millet, consumed a monotonous diet of rough food (often husks and beans), wore clothing made of animal skins or coarse fibers—"they wore the coverings of oxen and horses," lamented one contemporary observer, "and ate the food of dogs and pigs"—and lived always at the mercy of nature, the nobility, and the imperial tax collectors.

Whether they owned a small plot of land or leased their holding at high rents from one of the wealthy landowners in the region, a typical family of five found it nearly impossible to make ends meet even with a good harvest, and with each bad year they sank further into debt. Their distress was compounded by the government's demands: all Chinese subjects, including children, were liable for an annual personal tax, payable in cash; there were also land taxes and property taxes on wagons, boats, and domestic animals; and adult citizens might also be drafted to perform forced labor on public works projects such as bridges, roads, or canals. Theoretically, every male citizen was supposed to serve in the military for one year at the age of thirty, though by Wang Mang's day conscription had given way almost entirely to the use of veteran professional soldiers and barbarian auxiliaries. On the other hand, there were very few slaves in Han China, at least in comparison to Rome, partly because there were so many impoverished free people forced to work for cheap wages. Probably less than one percent of the total population was technically unfree, and though slaves were shunned and clearly differentiated from the rest of society by special dress and decorations, they all possessed certain legal rights, whether they were owned by the state—and perhaps half of the slaves in first-century China were—or by private individuals. Unlike their Roman counterparts, the Han emperors appear not to have made a general practice of enslaving enemy troops who surrendered or were captured in combat.

The Chinese empire itself was less than two hundred and fifty years old when Aidi died. Before the late third century B.C.E., the lands of northern China—the so-called Middle Kingdom of antiquity, centered on the plain of the Yellow River—had lain splintered into seven mutually antagonistic major states and dozens of smaller ones, all of which were dominated in varying degrees by an entrenched aristocracy. Beginning in 479 B.C.E., the year Confucius died, these kingdoms

entered upon a time of wrenching crisis known as the Age of Warring
States. For more than two hundred years they battled one another to
the point of utter exhaustion, until at last the ancient social order,
with its archaic system of purely hereditary distinctions, broke down
competely.

From the ashes there emerged a centralized, autocratic state under
the direction of Prince Zheng of the half-barbarous northern kingdom
of Qin. In a series of swift and decisive military campaigns between
230 and 221 B.C.E., Zheng triumphed over all of his rivals, who re-
mained hopelessly disunited to the end; then, assuming the name of
Qin Shi Huangdi ("August Sovereign of the Qin"), he ruthlessly
welded the conquered kingdoms into the first unified Chinese empire
in history. Over the next decade, the despotic Shi Huangdi and his
advisers introduced a host of reforms designed to root out the rem-
nants of feudalism and consolidate their new empire by dividing it
into commanderies, destroying the old defensive walls between
states, confiscating weapons from the vast armies of mercenaries who
had fought in the civil wars (the melted metal was cast into twelve
huge statues), burning every volume of history and philosophy and
eventually every book in the empire except treatises on agriculture,
medicine, and divination, and introducing a single standard of cur-
rency—a round copper coin with a square hole in the middle—and a
uniform set of characters for the written Chinese language. "I brought
order to the mass of beings and put to the test deeds and realities,"
boasted the First Emperor of his prodigious accomplishment. "Each
thing has the name that fits it." Indeed, it was by the name of his own
native kingdom—*Ch'in* in the former mode of romanization—that the
entire empire soon came to be known.

To encourage communication and trade within the empire and
break down the legacy of hostility between the old kingdoms, the
imperial government embarked upon an ambitious program of public
works, constructing an impressive network of roads, fortresses, and
canals, most of which were built by conscripted labor drawn from the
ranks of the peasant farmers, who now found their lives more tightly
regimented than ever before. And along the northern frontier, a Great
(Long) Wall of stone and tamped earth was erected to protect the
empire from the depredations of the Xiongnu, the nomadic herdsmen
("men with hearts of beasts," the Chinese thought) who traversed the
Central Asian steppes and, like the Huns of a later age, had a nasty
habit of erupting into civilized society from time to time in their

never-ending quest for plunder. Yet in the end, the Wall may have cost more lives than it saved; it was rumored that a million men perished under the merciless discipline of the imperial taskmasters: one human life for every stone.

All these measures went far toward reducing the power of the ancient nobility and binding the peasantry directly to the central government. But the headlong pace of drastic change could not be sustained indefinitely, and a storm of reaction—from both the aristocracy and the masses—broke out almost immediately following the death of the First Emperor in 210 B.C.E. After four years of civil war, an exceptionally able rebel military commander named Liu Bang, a commoner whose services had earned him the title of Prince of Han (the kingdom immediately to the southeast of Qin), succeeded in trapping and crushing the imperial armies in the valley of the Wei. Soon thereafter Liu Bang eliminated his erstwhile allies and proclaimed himself emperor, formally establishing the Han dynasty with its capital at the brand-new city of Chang'an. The capital grew with astonishing speed; by the beginning of the first century, Chang'an housed a quarter of a million people, though it was still only a third as large as Rome.

The Han emperors made no wholesale break with the administrative innovations established by the short-lived Qin dynasty, but they did gradually soften its harshest, most repressive features. It was the good fortune of the Hans to preside over a period of tremendous economic expansion fueled by technological advances in agricultural production, irrigation, and the manufacture of steel and iron. In the short run, this buoyant growth swelled the imperial coffers, permitting the emperors to fund a massive program of internal improvements and continue pushing the empire's boundaries far to the south and west. The expansive tendencies of the Han empire reached their climax during the reign of Wudi (141 B.C.E.–87 C.E.), the most famous of all the Han rulers, when the imperial armies threw back the Xiongnu in the western deserts and swept triumphantly through southeastern China, into northern Vietnam, across the southern Manchurian plains, and down the west coast of the Korean peninsula.

The Han emperors, however, did not rely solely upon military conquests to advance Chinese interests and imperial influence in the frontier regions. They also pursued a systematic policy of diplomatic bribery upon a mammoth scale, bestowing extraordinarily lavish gifts of silk and, to a lesser extent, ornately decorated pottery upon their

barbarian enemies in an enormously expensve attempt to win their friendship, or at least seduce and corrupt them with luxury. It has been estimated that nearly one-third of the annual imperial revenues at the time of Aidi—excepting the emperor's private income—was spent on these subsidies. In the year of 1 B.C.E. alone, the empire gave away thirty thousand pounds of floss-silk and an additional thirty thousand rolls of silk to foreign princes and chieftains whom the Chinese considered their vassals, and who were expected, in return, to keep the peace in their own territories and supply the empire with auxiliary troops in the event of an emergency. This policy of calculated generosity, accompanied by the establishment of permanent military colonies at certain strategic points along the frontier, and firm control by Chinese outposts of the overland trade routes (the "Silk Roads") into central and southern Asia, enabled the Hans to extend their economic influence into areas as far west as India, Parthia, and even, indirectly, into the mysterious land known as Da Qin—the eastern provinces of the Roman Empire. During the reign of Augustus, large quantities of Chinese silk reached the city of Rome itself for the first time.

But the strain of Wudi's relentless expansion at last proved too much even for the thriving economy of Han China. After the emperor's death, a number of distressing cracks began to appear in the foundations of the state, and with the accession of every incompetent, weak-willed successor they seemed to grow wider. Imperial society was splitting apart at the seams: The rapid pace of economic growth had enriched a narrow circle of government officials and prominent provincial families who often possessed both extensive agricultural holdings (in an overpopulated country, land was still the most secure form of wealth) and manufacturing or mining enterprises. These were the families who were best placed to profit from the great leap forward in commercial activity. Simultaneously, the rural peasants from whom the empire had originally drawn its strength found themselves unable to keep pace. When the harvests failed in times of drought or flood, these peasant farmers were forced to borrow money from the local gentry at exorbitant rates of interest to survive; then, when they defaulted on their debts in subsequent lean years, they forfeited control of their property and were forced to pay rent for the privilege of farming the land they once had owned.

In the midfirst century B.C.E., several emperors made a series of half-hearted efforts to rein in the excesses of capitalistic enterprise,

but since the bureaucrats who were supposed to enforce these decrees were themselves the objects of the regulations, none of the measures succeeded in reversing the trend toward the creation of a new oligarchy of wealthy civil servants and merchant millionaires. To make matters worse, the indolent and insolent arriviste upper classes began to flaunt their wealth. On their estates they had planted spectacular gardens which were maintained by servants who could never find enough food to provide for their own families. The aristocracy spent their days hunting, racing horses, or playing ball, and engaged in frivolous competitions to outdo one another by hosting sumptuous banquets that featured roast quail, minced young fish, dog cutlets, or spiced kid with oranges and wine, all served in bowls and cups adorned with intricately worked gold or silver; obviously the ancient Chinese moral prohibition against the unnecessary slaughter of animals had long since gone by the board. The best banquets also featured an evening's exotic entertainment: wild animal fights (often tigers or roosters), sword duels or other athletic contests, music by the host's private chorus and orchestra (zither, bell, woodwinds, and drums), or a lineup of prostitutes imported from Central Asia.

Nor did the nobility spare any expense in its choice of clothing. Brightly colored silk garments were *de rigueur,* accompanied by jade earrings and brooches, red badger or fox furs, wild duck feathers, and leather or silk slippers. Their carriages were extravagantly trimmed in gold and silver and precious jewels, as were their cherished horses; one observer noted pointedly that it took as much grain to keep one horse alive as a family of six.

While class tensions and economic discontent rose across the countryside, the imperial court at Chang'an was preoccupied with a rash of conspiracies, intrigues, and palace revolutions fomented by the relatives of the emperors' wives and concubines. Wudi's aggressive centralizing policies had destroyed what was left of the old aristocracy and hastened the trend toward an absolutist monarchy, but his successors were so ineffective and uninterested in the conduct of state affairs that a vacuum was created at the center of the government; in each ensuing reign, a vicious backstairs scramble for power among the court eunuchs and the relatives of the emperors' wives and favorite concubines followed. Fabulous riches were at stake: lucrative government offices, vast land grants, and titles of nobility that carried profitable privileges and prerogatives. The one-sided duel for supremacy between the Empress Dowager Wang, the Empress Fu, and the

concubine Ting upon the death of Aidi was only the latest skirmish in this debilitating conflict that threatened to paralyze the empire at its very heart.

Of course the emperor himself remained aloof from these sordid squabbles. As the Son of Heaven, his role was not to intervene in trivial political affairs, but to serve as a paragon of virtue, the source and guarantor of peace, morality, and harmony on earth. If the emperor exhibited sufficient virtue, his people prospered; conversely, a life of vice would bring down the wrath of Heaven upon his land. As the philosopher Shih Tan explained during the troubled reign of Aidi:

> The institutions of our holy kings took their models from Heaven and Earth; as a result the prescribed distinctions of status were clear and the ethical relationships of man were set straight. In this way the polar opposites of the cosmos attained their correct stations, the powers of *yin* and *yang* followed their regular alternations, and the ruler of mankind and his myriad subjects together were blessed with good fortune. The distinctions of status provide a means of regulating the respective situations of Heaven and Earth, and will not brook disruption.

And Han society was nothing if not well regulated. There were twenty-four distinct and precise gradations of rank, and each citizen within the empire was assigned a place within that hierarchy corresponding to his value to the state. "There is no good word which is not recognized," affirmed the ancient *Book of Poetry*; "there is no virtue which is not rewarded." Farmers, for instance, were ranked higher (and therefore were supposedly entitled to greater rewards) than merchants or artisans, because the production of food contributed more to the health of the empire than did commercial activities, at least according to the orthodox Han theory that "the world is based on agriculture." Those who performed exceptional services for the state were elevated to loftier ranks by a grateful emperor; those found guilty of crimes—and Chinese law was a highly sophisticated mechanism designed to dispense rigidly prescribed punishments for specific transgressions—were degraded and sometimes demoted all the way into slavery.

In real life, of course, virtue was not always rewarded, but when it was combined with exceptional ability and ruthless ambition, as in the case of Wang Mang, the system worked as it was intended. Forty-five years old in the first year of the new century, Wang Mang had

surmounted the disadvantages of a relatively impoverished youth to rise to the top of the imperial bureaucracy through rigid self-discipline and selfless service to the state. He was the heir of the least prosperous branch of the Wang family; his father, who died before Wang Mang reached manhood, was the only one of the Empress Wang's brothers who failed to receive a noble title. Unhindered by the distractions of extravagance and luxury enjoyed by his more fortunate cousins at the imperial palaces, Wang Mang had devoted himself to his studies in his youth. Soon he acquired a reputation for learning and wisdom, displaying a special expertise in the works of the classical philosophers, who were then enjoying a widespread revival in scholarly circles as part of a reaction against both the dissipation and moral corruption of the recent Han emperors and courtiers, and the economic dislocations that were destroying the cherished equilibrium of Chinese society. Given his personal inclination toward a life of humility and spartan simplicity, it is not surprising that the Confucian ideal of government by capable and disinterested public servants captured Wang Mang's imagination so completely.

At the age of twenty-four, Wang Mang received his first government appointment, to the ceremonial office of Gentleman of the Yellow Gate. As he advanced through the ranks of the imperial administration, serving as Commander of the Imperial Archers, Commandant of Cavalry, Chief of Interviews, Imperial Gentleman, and finally Minister of War, Wang Mang grew increasingly distressed by the incompetence and licentiousness he witnessed at court.

Like Augustus Caesar, Wang Mang envisioned himself as the savior of a battered and debauched civilization that desperately needed to recover the idealism and spiritual purity of ages long past. And like Augustus, Wang Mang had the knack of acquiring political power by having it thrust upon him, ostensibly against his will. "When there was something which he wished to do," recalled the first-century historian Pan Ku, who admittedly was no partisan of Wang Mang, "he let it appear slightly as a hint; those of his clique, understanding his intentions, clearly memorialized them to the throne; then Wang Mang would bow his head and weep, firmly declining all honors." Repeatedly he rejected aristocratic titles and gifts of land as compensation for his services, pleading that he was unworthy ("stupid" was the word he used most often to describe himself at these moments) to accept such rewards. He relented only when the Empress Dowager insisted that his stubborn refusal was

jeopardizing the proper order of things—"The court should act according to definite patterns and at the proper time bestow awards," she reminded him—but even then he gave away most of the cash and territory he received.

Nevertheless, Wang Mang was named *An Han kung* (Duke Giving Tranquility to the Han), and on June 1 of the year 4 he was blessed with the title of Superior Duke. A year later he was granted the Nine Awards of Imperial Favor, a prestigious assortment of ceremonial robes, sceptres, weapons, and privileges reserved exclusively for those who stood in the most intimate relationship with the Son of Heaven. By that time, Wang Mang was also the emperor's father-in-law, having married his daughter to Pingdi after an imperial fact-finding commission determined that the girl was suitably "saturated with virtue" and had "the appearance of composure and refinement." All the while, Wang Mang maintained a modest standard of living in stark contrast to the extravagance surrounding him at court. "He wears poor clothing and eats common food," noted one admiring observer. "His carriage is an old crate and his horse an old nag." The welfare of the common people always appeared to be his paramount concern. When a drought and plague of locusts (bad omens for a new regime) struck the province of Qi (modern Shandong) in the summer of the second year of the new century, Wang Mang denied himself all meat and adopted a vegetarian diet to demonstrate his sympathy for the stricken farmers. He also donated the revenues from one hundred and forty acres of his own land—an example that was dutifully, and probably reluctantly, followed by other high-ranking imperial officials—to help alleviate suffering during the famine that followed. Nor was that all. "Day and night," he declared, "I have thought and dreamed that there should be an abundant harvest of the five grains," and eventually, of course, the rains returned.

As Wang Mang's authority grew, the pace of reform quickened. Government spending on frivolous items was slashed. The Superior Duke (i.e., Wang Mang) recalled every top-level provincial civil servant to Chang'an and personally interrogated them to determine whether they were qualified to remain at their posts; those who failed to meet his rigorous standards were summarily dismissed. In a bold experiment to curb grain speculation and stabilize food prices, the government built huge warehouses known as Ever-Normal Granaries, where surplus grain was purchased and stored or sold as circumstances demanded. To prevent a new round of the factional infighting

of the emperor's relatives that had long plagued the imperial court, Wang Mang forbade the family of Pingdi from setting foot in the capital. When they attempted to circumvent his edict, he executed hundreds of the clan and imprisoned or exiled the rest. Wang Mang's own eldest son, who had sympathized with the young emperor's family, was thrown into jail and committed suicide; his wife, who was pregnant at the time, was slain by government assassins after delivering her child.

To educate the citizenry and prepare public opinion for a Confucian renaissance, Wang Mang ordered the construction of new schools and libraries and bestowed government subsidies upon thousands of Confucian scholars to permit them to pursue their studies; in the autumn of the year 4 Wang Mang summoned the leading intellectuals of the empire to Chang'an for a twenty-day symposium on the proper interpretation of the classics. And because Confucius had placed such emphasis upon public performances of morally uplifting (i.e., soporific) songs as a means of controlling the behavior of the masses, Wang Mang personally redefined the standard of acceptable music to accord with the traditions of antiquity.

For the first five years of the Wang ascendancy, everything seemed to go smoothly. On June 22 of the fifth year of the new century, the Empress Dowager summoned Wang Mang to the palace and congratulated him on restoring peace and righteousness to the empire. "Seeking ancient institutions and basing your attitudes on the proper Way, following in accord with the disciplines, and reverencing antiquity, with every movement you have produced results, and all things have attained their right place," she told him. "Your extreme virtue and your possession of doctrines of the essential Way have become known to the divine spirits. . . . Ah! Is this not gloriously beautiful!"

But Wang Mang was no longer the self-effacing statesman who had deplored vanity and ostentatious displays of wealth and rank. Now he possessed an imposing entourage of secretaries, scribes, chamberlains, bodyguards, a High Priest, and his own personal Diviner and Astrologer. His mansion in Chang'an was guarded day and night by a hand-picked unit of elite troops, and no one could enter without a passport. Wherever he went he carried the tasseled staff of Imperial authority, and when he traveled he was accompanied by a military escort; ten magnificent carriages rode in front of him, and ten more behind.

Later that winter, the young emperor fell ill. Dark whispers that he had been poisoned by Wang Mang swirled through the capital. Though the rumors were probably not true, the fact that they were given wide credence reflected the suspicion with which Wang Mang was regarded in court circles. When the planet Mars disappeared behind the moon in the month of January, the sages feared for the boy emperor's life. On February 3 of the year 6, Pingdi died of unexplained causes at the age of fourteen.

This time Wang Mang alone selected the new emperor. He chose a two-year-old infant named Liu Ying, the great-great-grandson of Emperor Xuan, and assumed power himself as sole Regent.

Such presumption was too much for the Han imperial family. Almost at once, a succession of minor insurrections broke out against Wang Mang. First, in May or June, the Marquis of An-chung gathered a small force and raised the standard of rebellion, openly accusing Wang Mang of seeking to usurp the throne. But the rising lacked popular support; the government put it down with ease and treated the rebels with contempt. The Marquis's elderly mother and his infant son were beheaded and the grisly trophies displayed at the top of a pole with earrings and silver jewelry still intact. The Marquis himself was stabbed, his joints broken, and his body sliced into tiny pieces; then his palace was demolished, burned, and replaced with a cesspool into which heaps of unspeakable filth were dumped. Wang Mang smiled when he heard the news.

Shortly thereafter Wang Mang assumed the title of Acting Emperor, on the grounds that the late rebellion had occurred only because his authority as Regent was insufficient. But the troubles did not cease. In the western mountains, near the modern provinces of Sichuan and Gansu, Tibetan tribesmen launched a revolt against the central government's seizure of their land, which had been turned into a penal colony for the growing number of citizens who had violated Wang Mang's edicts. It took nearly half a year to pacify the barbarians. Then in October of the year 7, a much more dangerous internal uprising occurred, led by a local government official named Chai I. "Wang Mang poisoned and murdered Emperor P'ing and acts as regent in the place of the Son of Heaven," Chai I charged. "He desires to bring an end to the House of Han. Let us now unitedly administer Heaven's punishment and execute Wang Mang."

This time Wang Mang took the rebellion very seriously indeed, particularly after he learned that the insurgents had raised nearly a

hundred thousand troops and set up a rival government. Moreover, a secondary uprising had broken out in a district immediately to the east of the capital. Day and night the Acting Emperor walked through the Weiyang palace, holding the infant emperor in his arms, imploring Heaven and his own ancestors for aid. At one point he even published a manifesto promising to turn control of the government over to the tiny child at some unspecified date in the future. Reinforcements were placed along the mountain passes leading to Chang'an, special patrols were established to make the rounds of the palace every hour, and eight generals—armed with the sacred battle-axe from the Ancestral Hall—were dispatched to find and destroy Chai I.

In January of the year 8, the revolution was crushed. Sycophantic courtiers fell over one another in their haste to praise the magnificent leadership of Wang Mang. "Your Sacred Thoughts had just been expressed," sang one official, "and the rebels were completely defeated." The flattery found its mark; at last Wang Mang admitted that his virtue was increasing daily, and that he "had captured the aid of Heaven and of man." From every corner of the empire came reports of strange omens, unmistakable signs from the gods indicating their favor toward Wang Mang. Local government officials reported nocturnal visits from an envoy of Heaven, recommending that Wang Mang be named emperor; similar messages were miraculously inscribed in stone; dragons and phoenixes were sighted; new wells suddenly appeared in the dry ground. And a windstorm deposited a silk chart outside the Weiyang Palace. "This is a symbol of Heaven's announcement to the regent to become Emperor," it said. "This will be in accord with the Mandate of Heaven and is a request of the spirits."

On January 10 of the year 9, the day of the winter solstice, Wang Mang put on a yellow gown (the color of the phase earth, which succeeded the Han dynasty's phase of fire) and walked to the temple of the legendary Emperor Gao. There he received the Royal Crown and the golden casket, which contained the divine commission. Returning to the Weiyang Palace, he issued a fateful proclamation, which read:

> I, unvirtuous one, as a descendant of my original Imperial ancestor, the Yellow Emperor, as a branch descendant of my Imperial ancestor, Emperor Yu, and as the last relative of the Grand Empress Dowager, have been abundantly protected by Imperial Heaven and the *Shang-ti* which

have given the Mandate for the continuation of the succession. The omens and symbols of authority, the chart and inscriptions, the golden casket and the documents indicate the clear commands of the Spirits, entrusting to me the people of the empire. The Red Divine Protector of the Han Imperial family, the spirit of Emperor Gao, received the Mandate of Heaven and has transmitted the dynasty to me. The writing in the golden record book, I greatly respect and fear. Can I dare not reverently to accept?

Thus did Wang Mang proclaim the birth of the Xin (New) dynasty.

The Poet

Rome and Tomis, 8–9 C.E.

> Three in a corner dark their heads hang low,
> For teaching love, which no one does not know.
>
> —Ovid

L ate on his last evening in Rome, after all the weeping was done and his friends had gone away, Publius Ovidius Naso dampened the fires in the hearth and walked out into the night to bid a silent farewell to his beloved city. Looking up at the hill of the Capitol, he could see its cold white marble temples silhouetted in the autumn moonlight. Alone in the darkness, the poet offered a final prayer and valediction to the august Jupiter and his divine companions: "Gods of Quirinius' city reared of yore, hail and farewell for ever, ever more. . . ."

As the stars faded into dawn, Ovid left the city. His wife begged to go with him—"I will be but a small additional burden to the ship of exile," she pleaded—but the poet said no. He sailed from Brindisi, on the southeastern tip of Italy, in November of the year 8. Almost at once the ship was caught in a storm; after it had passed through the Straits of Oranto into the Ionian Sea, a cruel wind blew it back within sight of the Italian peninsula before the sailors regained control. Ovid never again saw his homeland. To Greece they sailed, and up to Corinth, changing ships at Cenchreae and island-hopping across the Aegean via the Cyclades, arriving at last at the Hellespont. Then

the poet traveled overland across the bandit-infested kingdom of Thrace and boarded another ship for a brief journey up the Black Sea to the semicivilized town of Tomis (Constanta in modern Romania), where, by decree of Caesar Augustus, he would spent the rest of his life.

When he departed Rome at the age of fifty, Ovid was probably the most popular and famous poet in the empire. He had never wanted to be anything else. Born in 43 B.C.E.—a year after the assassination of Julius Caesar—in Sulmo, a district in central Italy, in the shadow of the Apennines, filled with hills and streams and olive groves and corn fields, Ovid came from a prosperous if not wealthy equestrian family; somewhere in the past, one of his ancestors had been awarded the cognomen (surname) Naso, apparently in recognition of an unusually prominent nose. Like most members of the knightly class, Ovid's parents provided their sons with the elementary skills of reading, writing, and arithmetic before the boys left home, and then sent them to Rome around the age of twelve to acquire a classical education in the traditional Greek pattern in preparation for an honorable and financially rewarding career in public service. First Ovid studied grammar and literature in both Greek and Latin, and then he moved on to advanced courses in rhetoric, which he was fortunate enough to take with the virtuoso orator Arellius Fuscus, whose emotional, imaginative style made a lasting impression on the exuberant young poet. By this time, however, Ovid (much to the dismay of his straitlaced father) had fallen in with a circle of artists under the patronage of the aristocratic consul M. Valerius Messalla Corvinus, the commander of Augustus' fleet at the battle of Actium; in those first flush days of peace, Messalla was happy to play a major part in the emperor's plan to encourage a new outburst of artistic creativity. One of the youngest recipients of Messalla's generosity, Ovid soon came to know Propertius well, saw Virgil on one of the reclusive poet's infrequent visits to Rome, and heard the famous Horace recite selections from his Odes at least once.

Once his schooling had ended, Ovid dutifully donned the broad-striped tunic of a politician to please his parents, married a girl hand-picked by his father, and actually won election to a few minor judicial offices before throwing over both his political career and his wife (whom he divorced) and abandoning himself to the pleasures of a carefree life in verse. He had already recited several of his poems in public before he turned eighteen—Latin poetry in that age was meant

to be declaimed to an audience, not read alone in silence—and some-
time around the year 22 B.C.E. he published his first major work, the
Amores. This five-volume collection of brief love poems revealed Ovid
as an iconoclast of considerable seductive wit, though perhaps a trifle
heavy-handed at times. (Horace, for one, complained that Ovid "can-
not leave well alone," overwhelming his audience with a dozen exam-
ples where one or two would suffice.) But it was not until the *Ars
Amatoria*—the *Art of Love*— appeared more than a decade later that
Ovid sealed his reputation as the poetic spokesman of the brash and
rebellious young "smart set" of Rome at the dawn of the new century.

Written in the deadpan style of the "how-to" manuals then
popular in polite Roman society, as if the narrator were instructing the
reader in the proper procedures for something as prosaic and passion-
less as building a house or buying a farm, the *Ars* opened with advice
on the best places in the city to pick up eager, unmarried women, of
whom there was presumably a surplus after two generations of civil
war. The list of recommended hunting grounds included the temples
of various oriental or libertine dieties such as Venus Genetrix; the
shadowed porticoes and marble colonnades of the Augustan Forum—
this was a sly dig at the emperor's own highly questionable personal
morality—with their suggestive frescoes and unclad statues; the Cir-
cus Maximus (at least before Augustus forbade women to watch
athletic contests involving naked men); and, most profitably of all, the
theater, where flocks of women regularly came to see and be seen.
Sometimes a special event, such as the spectacular pageant accompa-
nying Gaius' departure for the East in 2 B.C.E., provided a rich array
of prospective lovers, too. But here the author interjected a note of
caution: wherever a gentlemen found a girl, he should take care to see
her in the daylight before committing himself; after all, no prudent
man would buy an emerald or a cow in the dim light of evening.

Ovid then launched into a detailed discussion of "How to Win
Her," based upon the explicit assumption that every woman *can* be
won if one were patient, persistent, and followed the narrator's
suggestions, which were notable for their insistence that flattery is
more effective, and considerably cheaper than gifts. First, a short
course in personal hygiene: clean your teeth and nails, trim your beard
and your hair (including the hair in your nose), freshen your breath,
clean the spots from your toga and wear it loosely draped over your
shoulder (a signal that you are looking for love), and tighten the
bindings on your sandals. Only foppish dandies, for whose effemi-

nate traits Ovid had the utmost disdain, used pumice to smooth their legs, or curled their hair, or wore scented hair oil and more than one ring at a time. (One must bear in mind that the *Ars* dealt exclusively with heterosexual love; unlike the Greeks, Roman society did not hold pederasty in high regard, and Ovid seems to have had no use whatsoever for homosexuals.)

Persuade the servants of your prospective mistress to press your case in unguarded moments. (Ovid briefly considered the advisability of seducing her maid for good measure, but rejected the notion.) Send her love notes written in a bold, passionate style, without big words to slow her down. Weep, swear, promise her anything. Compliment her beauty no matter what she looks like—if she's skinny, call her slender; if stout, say she's buxom: "She'll swallow all. No girl, however plain, dislikes her looks or thinks her beaux insane." Write messages in wine on a tabletop, or if her chaperone forbids direct contact, write a note on a go-between's back using fresh milk for ink, so your lover can dust it with charcoal and make it reappear. Above all, praise her to the heavens:

> But whoso would a mistress' love retain
> Must act as spellbound by her beauty's
> chain. . . .
> Her hair is neatly parted? Praise it thus.
> Curled with hot irons? Curls are marvellous.
> Her limbs in dance, her voice in song, adore,
> And when she stops, complain, and ask for
> more.
> Even the joys of night, her blissful ways
> In bed, may be the subject of your praise.

Once the fish was firmly on the hook, however, the truly difficult part began. In his advice on "How to Keep Her" ("By my art she's been caught, by my art she must be held"), Ovid's narrator recommended constant vigilance and almost total subservience to a woman's whims, running errands for her and letting her think she was the real boss, though occasionally it might be wise to inspire a bit of jealousy to keep her on her toes.

By the end of the second book of the *Ars,* a gentleman was ready for anything. "I have armed you," Ovid boasted. "But whoever overcomes the Amazon with my sword, let him inscribe on his spoils, 'Naso was my teacher.' "

Then Ovid turned completely around and, in the final volume, provided advice in a similar vein to young women, to help them entice suitors. He had already published a tongue-in-cheek instructional manual on makeup, with a recipe for face cream that called for two pounds of Libyan barley, and equal amount of vetch, ten eggs, the horns of a young stag, "twelve narcissus bulbs stripped of their outer layers and pulverized on pure marble. . . . Then add nine times as much honey. If you pamper your face with such a mixture, your skin will be smoother and more radiant than your own mirror."

Perhaps. But most of the suggestions in the *Ars* were of a more practical nature. Dine by lamplight, and encourage your companion to drink at dinner: "Though you be plain, their cups will lend you grace, and night itself your blemishes efface." Don't drink too much yourself—"A fuddled woman is a shameful sight, a prey to anyone, and serve her right"—and mind your manners: "Eat daintily. Good table-manners please: No dirty fingers smear your cheeks with grease. . . . Had Paris seen fair Helen eat with greed, revolted, he'd have rued his famous deed." Choose your hairstyle to fit the shape of your face (a round face calls for a small knot on the top of the head, allowing the ears to show), use only German hair dyes, and make love in the positions that show off your charms to best advantage. Above all, play hard to get most (but not all) of the time. Bribe the doorman to refuse admittance to your lover so he will have to climb in through the window; have your maid burst into the room in the middle of your tryst, crying out, "We're undone! Quickly, hide in the closet!"

Well, all this was written in an eminently good-natured way, and anyone with a sense of humor would recognize it for the sophisticated satire it was. Unfortunately for Ovid, it appeared—probably in a second edition—around 2 B.C.E., at precisely the time when Augustus discovered the full extent of his daughter Julia's epic sexual escapades, revelations which were made all the more embarrassing and dangerous by the foolish girl's liaison with the son of Augustus' old enemy, Marc Antony.

Augustus may have held Ovid partly responsible for encouraging the sort of licentious atmosphere that corrupted his daughter. Certainly the emperor had already complained publicly about the flagrant decline of moral standards and civic responsibility in Rome, at least among the upper classes. He saw symptoms of degeneracy everywhere. Young noblemen shunned the rigors of military service, forcing the empire to depend upon barbarian auxiliaries and, in an emergency, freedmen and slaves. The gods of ancient Rome were treated

with an appalling lack of respect in certain sophisticated circles, scorned as outmoded relics of a primitive past or even ignored altogether. To Augustus, this attitude of contemptuous irreverence was positively dangerous to the safety of the state, for Roman religion was at its heart a reciprocal agreement between gods and humans: only if the Roman community, as a whole, conscientiously performed certain rituals—including prayers, vows, and ceremonial sacrifices (usually of animal flesh) upon specified occasions—would the gods grant the city their aid and favor. Hence the importance of interpreting auguries and omens, which were the primary means by which the gods imparted their desires and decisions to the human world. Throughout the centuries of the Republic, Romans had always taken very seriously their duties to the deities, from the household gods of the common people to the national gods of Mars and Capitoline Jupiter, and most citizens believed that the success of the Roman state was the direct result of this devotion. "To understand the success of the Romans," argued Dionysius of Halicarnassus, "you must understand their piety."

Now the impious smart set was threatening to upset this arrangement. Moreover, the bonds of family life were disintegrating, as an increasing number of Roman citizens refused to marry at all or else married and divorced one another with a frequency that made a mockery of the marriage vows; adultery appeared to be on the rise; bachelors postponed the obligations of fatherhood by engaging themselves to little girls; and women in the prime of life refused to encumber themselves with children, thereby depleting the supply of native Roman stock at a time when the purity of the city's population was already being diluted by an influx of immigrants from the provinces and freed slaves. And, of course, the arts were filled with irreverent, ribald performers and grossly pornographic literature (some far more explicit than Ovid, who was often naughty but never really obscene).

Too many Roman citizens, Augustus believed, were devoting their lives exclusively to the unbridled and degrading pursuit of wealth and luxury. Consider a typically lavish dinner party in an aristocratic household—and compare it to the common people's monotonous diet of bread, wine, olive oil, garlic, and salted fish. The first course might consist of a buffet of such delicacies as leek or mint hors d'oeuvres, followed by olives, snails, crabs, and oysters. Then came perhaps a Trojan pig (stuffed with black pudding, almonds, or sausage), young kid, peacock, whole boar, roast goose, lamprey, sows' udders, fattened pheasants, or the day's catch of homegrown pike

from the Tiber River. After the guests had stuffed themselves with such rich dishes, they might recline on the sofas (three of which surrounded the table, with the fourth side left open for service) and engage in a drinking contest. Or they might stick peacock feathers down their throats to make themselves throw up, and then eat some more. "Men eat to vomit, and vomit to eat," complained the Stoic philosopher Seneca, who disparaged such excesses partly because he suffered from chronic gastric distress and could not partake of them himself. "Their dishes are fetched from every corner of the earth, and then they do not even deign to digest them."

To stem the tide of moral decay, Augustus rammed a program of patriotic and pro-family legislation through the Senate, and exercised his personal influence to pressure the patrician class into compliance. The most controversial Augustan statute made adultery a public crime (heretofore it had been a private matter) punishable by banishment for life and confiscation of at least a third of both guilty parties' property. Tiberius, for one, thought this sort of legislation infringed far too much on the traditional aristocratic family prerogatives, but he was unable to dissuade Augustus from enacting the measure. Another statute required all male citizens under the age of sixty, and women under fifty, to marry or risk losing their inheritance; couples were required to have children or face the same harsh penalty. Divorce requirements were tightened to discourage frivolous marriages. Descendants of senators were forbidden to marry into the lower classes—i.e., actors, prostitutes, and anyone else who was not a citizen—and from time to time Augustus personally interrogated government officials and army commanders to ensure that their private lives, including their financial dealings, met his rigorous standards of probity. To encourage procreation, every Roman mother who bore three or four children received special financial, social, and political privileges from the government. No detail seemed too small for the emperor's attention; on one occasion, outraged by the fashion of wearing casual Greek cloaks, Augustus banned everyone who was not garbed in a proper Roman toga from the vicinity of the Forum.

Not surprisingly, this barrage of puritanical legislation aroused a vehement storm of protest from the privileged classes. Indeed, some critics—Ovid among them—denounced the entire Augustan reform movement as hypocrisy of the grossest sort, coming as it did from a man who in his youth had been a notorious libertine, renowned for his ability to seduce the wives of his rivals. (In his defense, Augustus

claimed that he had taken them to bed only to find out what their husbands were plotting.) Even in his later years, the emperor's private life was hardly exemplary; gossip in the street claimed that he constantly cheated on Livia.

If Ovid had not given a political twist to his verses, poking fun at Augustus personally, he might have escaped punishment. But once again, he could not leave well enough alone. His *Metamorphoses,* which followed the *Ars Amatoria,* consisted of a learned and occasionally lewd mixture of legend, history, mythology, and satire, wherein the ribald, short-tempered, and power-mad Jupiter resembled Augustus far too closely for comfort. Ovid laughed aloud at the emperor's nostalgia for the Roman past, when innocence and modesty supposedly reigned. And he demolished Augustus' claim that first-century Rome, where everything and everyone had a price, was ushering in a new "Golden Age" of virtue and simplicity: "Golden, truly, is the present age," mocked the poet; "for gold most honors are sold, by gold love is won."

By the year 8, Augustus had finally had enough of this subversive verse. Exasperated by yet another revelation of wanton sexual behavior and political intrigue within his own family—this time Julia's daughter, also named Julia, was guilty of consorting with men who allegedly were plotting to oust Augustus and steal the succession from Tiberius—the emperor banished his grandaughter and then sent Ovid, too, into exile, as far away from Rome and to as dreary and dismal a spot as possible.

The poet professed innocence of any wrongdoing and asked Caesar to reconsider, but Augustus refused to budge. In his defense, Ovid later claimed that he had been banished for something he had "seen," and generations of scholars have searched in vain for evidence that he had witnessed some unspeakably dangerous or unseemly event. It is more likely that the poet was merely speaking as a poet; what he "saw," with devastating clarity, was the hypocrisy and sham of Augustan Rome in the troubled last years of the emperor's life. And he dared to write about it.

"I have lost everything," Ovid wrote from exile on the shores of the Black Sea; "nothing but life is left to afford me pain and the sense of it. Where is the joy in stabbing a dead body? There is no place on me for a new wound."

The Gods Bereaved

Germany and Rome, 9–14 C.E.

> The most common beginning of disaster was a sense of
> security.
>
> —VELLEIUS PATERCULUS

I t was autumn in Germany. In late September of the year 9,
three of the five Roman legions stationed in that province—
the XVII, XVIII, and XIX—were withdrawing from their outposts on
the Weser, heading westward to the army's winter quarters on the
Rhine. As far as Publius Quinctilius Varus could see, there was noth-
ing ahead on the line of march except overcast skies, treacherous
marshes, and thick, black forests, endless and forbidding: a man could
ride all day without seeing the sun. For Varus, the Roman aristocrat
who had been governor of Syria when Herod died and Jesus was born,
the dismal German landscape was a complete and not particularly
welcome contrast to the teeming cities and dusty, sun-baked hills of
the Near East. Augustus had sent him to Germany to serve as imperial
legate after Tiberius had hurriedly departed to crush the Illyrian re-
bellion in 6, but three years' experience in the province had brought
Varus neither riches—unlike Syria, where he had managed to extort
a healthy sum from the native citizenry—nor understanding; he sim-
ply did not realize the depth and extent of anti-Roman hostility that
still existed among certain German tribes.

No more did Augustus Caesar comprehend how tenuous Roman

military control of Germany really was, or how thin was the veneer of imperial civilization in the province. If he had, Augustus would never have appointed Varus to be governor in the first place, for the lethargic Varus, whose career owed much to his marriage to the emperor's grand-niece, was known primarily as an administrator and a diplomat with little practical experience of military command. Apparently the ease with which Tiberius had swept through Germany in the campaigns of 4 and 5 had misled Augustus into believing that the territory between the Rhine and the Weser had been thoroughly subjugated. So upon his arrival from Damascus, Varus had been instructed to treat Germany as a conquered province, to speed up the pace of romanization and assimilate the German tribes into the imperial system as rapidly as possible, with the ultimate objective of providing a secure base for further Roman expeditions into the unexplored lands east of the Elbe. In short, Varus acted as if Germany's inclusion in the empire was a forgone conclusion; as Velleius quaintly put it, Varus made the dangerous mistake of assuming that the Germans could be treated like civilized human beings.

On this day in September, Varus was leading his troops—three legions of infantry, accompanied by three cavalry divisions, over a thousand auxiliary soldiers, and a ragtag band of women and children who were trailing along beside the supply wagons—on a circuitous route toward the Rhine. He had embarked on the journey largely because a young native warrior named Arminius, the son of a prince of the Cherusci tribe, had informed him that the tribes in the northern sector of Germany (the Chauci and the Bructeri) were growing restive and needed to be taught another lesson. There seemed no good reason to doubt this intelligence. Arminius was a respected veteran officer in the imperial auxiliary forces whose service as a prefect had earned him Roman citizenship and the privileges of equestrian status, along with the romanized name of Gaius Julius Arminius. Yet on the evening before the legions left their camps on the Weser, Quinctilius Varus had received a warning from Segestes, the chieftain of the Cherusci, that the reports of rebellion were false, a ruse devised by Arminius to lure the Roman forces into an ambush in the countryside. Varus refused to believe him. The governor may have known that Segestes bore a personal grudge against Arminius because the young warrior had stolen and married the chieftain's daughter; besides, what barbarian would be foolhardy enough to attack three veteran Roman legions?

Hence Varus took no unusual precautions to protect his men as they trudged through the trackless, seemingly interminable forests. No scouts examined the route ahead, no reserve forces stood by in case of trouble. Quite the contrary; Varus had already weakened his forces by dispatching some units to provincial villages that had taken this moment to ask for Roman military assistance, ostensibly to protect their outposts and supply centers from brigands.

On the first day out of camp, Arminius and his colleagues had excused themselves from the main column, explaining that they needed to return to their own territories to recruit additional auxiliary forces to help the regular legions put down the risings in the north. Varus let them go.

By the second day, as the Roman column neared Barenau, just north of the Teutoburg Forest, the tangle of undergrowth through which the legionaries hacked their way had become nearly impenetrable. Wagons bogged down, their wheels unable to move across the slimy, swampy ground; constantly the soldiers had to stop and build causeways over the marshes for the carts and pack animals. As the troops struggled through the ravines and up the steep, thickly wooded slopes, massive trees, felled by invisible hands, barred their path and hemmed them in on either side. Suddenly the leaden skies opened and a violent thunderstorm broke upon the legions in full fury, soaking the men and turning the ground into a slippery, hazardous mire. Lightning and high winds cracked off the tops of trees, sending them crashing to the ground. In the bedlam created by the downpour and the shouts of the centurions and the frantic cries of the animals, all semblance of order and formation vanished.

Then they heard the bloodcurdling screams from behind the thickets, and a deadly rain of arrows and vicious, short-bladed German spears began to pour down upon the Romans. When the stunned and dangerously disorganized legions failed to respond, Arminius and his men—who had already slaughtered the Roman detachments Varus had naively dispatched to the native towns—crept in closer to strike more efficiently. Unable to mount an effective counterattack or break through the German lines, the legionaries attempted to regroup and make their way to the nearest open ground. Darkness brought a temporary halt to the carnage. That evening, Varus burned his supply wagons, which had become more of a burden than an asset.

As far as the highly unimaginative Varus could see, there was no way to break out of the trap without first passing through more miles

of deadly forest; he would have preferred to turn south and make for the Roman fort of Aliso, but Arminius had effectively blocked the route. The following morning, the German prince waited until the Romans had once more marched themselves into an awkward tactical position, and then the deadly fusillade resumed. Unencumbered by armor and clad only in their customary loose cloaks, fastened at the neck with pins or brooches, the lightly armed German warriors had the advantage of mobility in the dense woods. None of the traditional Roman battle formations or strategems proved effective; when the infantry and cavalry attempted a coordinated advance through a narrow corridor, they did more damage to themselves than to the enemy as horses and men collided with one another and collapsed in total disarray. It was the heaviest day of casualties for the legions.

The end came on the third day of fighting. With the skies still black with rain, the Roman troops, sodden and desperate and buffeted by the cruel winds, resumed the hellish retreat. By this time, the German forces had been reinforced by other tribes in the area who realized that they were faced with an unprecedented opportunity to wreak vengeance on the suddenly vulnerable Romans. Thus encircled, the main body of legionaries attempted to make a stand in a shallow ditch behind a makeshift breastwork, but they could not even find a foothold on the waterlogged ground to use their javelins or draw their bows; their wooden shields were so soaked with rain and blood that they were virtually useless. The Germans cut them down where they stood. When one of the last remaining cavalry units failed in a last-ditch effort to hack its way through to the Rhine, the Roman general staff simply gave up. Varus, badly wounded, took his own life. In a stunning reversal of two decades of unchallenged Roman supremacy in Germany, the shattered, pathetic remnants of the legions were butchered—"exterminated almost to a man," said Velleius, "by the very enemy whom [the Romans] had always slaughtered like cattle." Those who did not die fighting were bound in chains and then hanged or crucified or—in the case of the senior Roman officers—beheaded and their severed skulls nailed to tree trunks as offerings to the nameless bloodthirsty gods who dwelt deep within the forest. When the Germans found the partially burned body of Varus among the fragments of spears and broken horses' limbs, they mutilated it and cut off the head. Arminius sent the grisly trophy to Maroboduus as an invitation to join the revolt, but Maroboduus simply passed it along to Rome for a decent burial.

A handful of women and children who had managed to conceal themselves during the slaughter eventually made their way to the fortress at Aliso with word of the massacre. More than fifteen thousand Roman soldiers had perished in the holocaust, and the standard of the three lost legions—the haughty imperial eagles—remained in German hands. When the news reached Rome, Augustus seems to have suffered a sort of nervous breakdown. According to Suetonius, the emperor refused to cut his hair or shave his beard for months; unkempt and overcome by the magnitude of the tragedy, he was often seen beating his head against a door, weeping and crying out, "Quinctilius Varus, give me back my legions!"

It was a staggering blow to Roman martial pride, the most devastating defeat the empire ever suffered under Augustus and the second worst military debacle in Roman history, behind only the Parthian annihilation of the republican armies under Crassus in 55 B.C.E. For centuries to come, the date of the German disaster was remembered as an official day of mourning. And even though the eagles were later recovered, the units were never reformed, and no Roman army ever again bore any of the accursed numbers—XVII, XVIII, and XIX—of the three legions lost in Germany.

Following hard upon the persistent famine, the floods, and the fires that had recently afflicted Rome, and the economic strain of three long years of active campaigning in the Balkans, the numbing German catastrophe threatened to unleash a new round of protests among the discontented elements in the Senate and the streets of the capital. As a precaution against outbreaks of domestic violence and a sympathetic rising of the numerous expatriate Germans living in Rome, Augustus established a special body of militia to patrol the city at night, and the German members of the Praetorian Guard—the elite soldiers who formed the emperor's personal bodyguard—were temporarily reassigned to various distant Mediterranean islands. Since there was, as usual, no rush of patriotic volunteers to rally round the colors, the emperor once again had to comb the civilian population for military reinforcements to help hold the line if Arminius tried to invade Gaul or turned southward toward Rome. A lottery was established, and every fifth able-bodied male citizen under the age of thirty-five was conscripted into the army, along with every tenth older man; a number of veterans who had already completed their service were also recalled to active duty. Even in this state of emergency, there was substantial resistance to the draft—though not be-

cause of a sudden outbreak of pacificism, for there was no shortage
of knights willing to fight as gladiators in the arena—until an example
was set by summarily executing a handful of protestors who refused
to serve.

In hopes of obtaining divine aid to help the empire through the
crisis, Augustus also promised to sponsor a festival and athletic games
in honor of Jupiter as soon as life in the city was back to normal. In
fact, the more Augustus thought about the shattering debacle in Ger-
many, the more he became convinced that the gods must have been
somehow involved. "It struck him," recalled one observer,

> that for such a great and overwhelming calamity to have taken place,
> the wrath of some divinity must have been incurred; besides, the por-
> tents which had been observed both before the defeat and afterwards
> made him inclined to suspect that some superhuman agency was at
> work. The temple of Mars in the field of that name had been struck by
> lightning; many locusts had flown into the very city and had been
> devoured by swallows; the peaks of the Alps had appeared to collapse
> upon one another and to send up three columns of fire . . . spears seemed
> to fly through the air from the north and to fall in the direction of the
> Roman camps . . . [and] a statue of Victory which stood in the province
> of Germany facing the enemy's territory had been turned around so as
> to face Italy.

There was only one man to whom Augustus could turn with
confidence in such a situation, and so, despite the fact that Tiberius
had just returned from Illyria, the emperor dispatched his adopted son
to Germany at the head of six veteran legions, drawn from Spain and
southern Europe, to prevent Arminius from storming across the
Rhine. But any barbarian threat to Gaul had already been thwarted
by the energetic intervention of Lucius Asprenas, Varus' nephew,
who had ordered the two surviving legions in Germany to bar Ar-
minius' path, and by the concurrent failure of the German rebels to
subdue the Roman stronghold of Aliso (although Arminius had, in
the meantime, destroyed every other Roman outpost east of the
Rhine).

Once Tiberius had determined that neither Gaul nor Rome was
in imminent danger from Arminius, he turned his attention toward
the painstaking task of calming the panic-stricken local inhabitants,
restoring the shattered morale of the garrisons up and down the

Rhine, and reorganizing the defense structure along that border. Finally, a year and a half later, in the spring of the year 11, Tiberius felt sufficiently confident to venture rather tentatively across the Rhine, using the same scorched-earth tactics he had employed in putting down the Illyrian revolt. But he never advanced very far toward the Weser. It was painfully clear to any experienced observer that the Roman army was far too short of trained soldiers to take any unnecessary risks; besides, Tiberius had no intention of acting rashly and opening himself up to unflattering comparisons with the late Quinctilius Varus. Only on those rare occasions when Tiberius received a promising sign from the gods—as, for example, when the lamp by which he was working at night was blown out by a sudden puff of wind, an occurrence he and his family had always found to be a reliable omen of good luck—did the general feel confident in taking even the slightest chance.

A stalemate ensued. Unwilling to challenge Tiberius, Arminius remained well behind the east bank of the Rhine; for their part, the Romans limited themselves to an occasional sortie across the river to probe the German defenses. Meanwhile, the prolonged absence of the imperial legions from the interior encouraged tribes from northern and eastern Germany to migrate into the vacated territories, and by the time Tiberius relinquished his command to Germanicus and returned to Rome in the year 12, it would have taken a major offensive to push them back out again.

Roman armies never again established permanent encampments on the Weser. In the end, Augustus was forced to give up his dream of an imperial border on or beyond the Elbe, though he was loath to admit it publicly. Perhaps Rome had lost its nerve. Or perhaps Augustus and Tiberius had finally come to understand that the potential rewards of conquest could never outweigh the dangers inherent in challenging the apparently inexhaustible reservoir of uncivilized humanity residing beyond the Baltic. It was the legacy of Publius Quinctilius Varus that central and eastern Germany were destined to remain permanently outside the pale of the Roman Empire, leaving an ominous gap in the line of imperial defense. The consequences for the future of Rome and, in time, for all of Europe, were incalculable.

Augustus was dying.

The savior of Rome, the father of his country, was seventy-five years old in the summer of the year 14. He had long ago stopped

attending public banquets and most other official ceremonies. He excused himself from regular meetings of the Senate, and asked the senators kindly not to bother him at home either.

Disturbing omens of the emperor's imminent demise appeared with increasing frequency. "There was a total eclipse of the sun, and the greater part of the sky appeared to be on fire. Glowing embers appeared to fall from it, and blood-red comets were seen," recalled Dio Cassius, who was invariably impressed by such heavenly portents. At a festival celebrating Augustus' birthday, a madman sprinted up to the vacant gilded chair dedicated to the memory of the emperor's foster father, Julius Caesar, and, to the horror and alarm of the the spectators, sat down with a facsimile of Caesar's crown firmly on his head. And soon thereafter, a well-aimed bolt of lightning struck the pedestal of Augustus' statue in the Capitol, obliterating the C—the Roman numeral for one hundred—from the word *Caesar*; since the remaining letters formed the Etruscan word for *god*, it was prophesied that the divine Augustus had but one hundred days left to live (though admittedly it was not at all clear why Jupiter had chosen to speak to the Romans in Etruscan instead of Latin).

All the arrangements for an orderly transition of power seemed to be in place. Tiberius, by now the inevitable choice for the succession, was elected tribune and awarded joint control of the provinces. His son Drusus was made consul; his nephew Germanicus was appointed governor of Gaul and commander-in-chief of the armies of the Rhine. In the springtime, Augustus had sailed secretly (that is, as secretly as the emperor could travel anywhere) to the island of Planasia, where his ruffian grandson, Agrippa Postumus, lived in well-deserved exile. It was undoubtedly a farewell visit. Augustus had excluded Postumus entirely from his will, and before he left the island, the emperor instructed the officer of the guards to kill the brutish young man as soon as word came of Augustus' own death.

As the fourteenth midsummer of the new century arrived, Augustus dispatched Tiberius to Illyricum to reorganize the administration of that recently pacified province, and supervise an extensive road-building program designed to facilitate the movement of imperial troops and military material in the event of another rebellion. Then the emperor decided to leave the sweltering capital himself, to spend the rest of the season at one of his villas in the southern Italian countryside. En route, he caught a chill during an evening sea crossing and developed a debilitating weakness in his intestines. (Later, some

suspected that Livia had poisoned him, to hasten the accession of her son to supreme power.) Augustus spent four days recuperating on the island of Capreae (Capri) before proceeding to Neapolis (Naples), where he caught up with Tiberius, who had been traveling overland with his entourage. Still suffering from the lingering effects of his sickness, the emperor managed to sit through a sort of miniature Olympic tournament staged in his honor by the Neapolitans, and then accompanied his adopted son on his journey for a day or two, going as far as Beneventum before turning back toward the coast.

By the time he reached the town of Nola, almost in the shadow of Mount Vesuvius, Augustus was critically ill. They laid him in a house belonging to his family, in the same room in which his father, Octavius, had died decades earlier. Sensing that the end was near, the emperor sent a messenger to Tiberius, who immediately hastened back to his stepfather's bedside. As the two men whom fate had thrown together, much against their wills, met for the last time, Augustus gave Tiberius his blessing and a few dying words of advice for the preservation of the empire. When the dour Tiberius departed again for Illyricum, the emperor reportedly turned to his attendants and muttered, "Poor Rome, doomed to be ground between those slow-moving jaws."

Augustus lingered for a few more days. He seemed obsessed by the possibility that news of his condition might be producing political upheaval and civil disturbances in Rome, unaware that Livia had already sealed off the house in Nola and the nearby streets from prying eyes and was issuing optimistic bulletins indicating that the emperor was valiantly rallying. On the nineteenth day of August, the old man was too weak even to comb his own hair; his jaw was so slack he could barely talk. He called for a looking glass and asked his servants to brush his hair and prop up his chin. Then he turned to a handful of friends who were waiting with him and asked with a wan smile and a touch of sarcasm, "Have I played my part in the farce of life creditably enough?"

A messenger brought him tidbits of family gossip from Rome. Shortly after noon, Augustus kissed his wife and murmured, "Goodbye, Livia: never forget our marriage." Just before the end, he opened his eyes and screamed in terror, "Forty young men are carrying me off!" Then, at three o'clock in the afternoon, Augustus Caesar, the most powerful man in the world and the sole ruler of Rome for forty-four years, passed into eternity.

Now the empire was on its own.

For a few hours, Livia attempted to keep her husband's death a secret, to provide her and Tiberius with sufficient time to ensure the loyalty of the Praetorian Guard. Within days, Postumus Agrippa had been slain by the commander of the guard on Planasia; the unfortunate Julia, Augustus' estranged daughter, whom Tiberius kept under house arrest, died, too, before the end of the year. But no one ever uncovered any concrete evidence linking Tiberius or Livia to either death.

A procession of senators and magistrates carried the body of Augustus in relays from Nola northward to Rome, a distance of approximately one hundred miles. Tiberius marched silently behind the casket all the way. Because of the oppressive heat, they traveled only by night; during the day, the body was placed in a local temple or municipal building. When the cortege neared the capital on September 3, an honor guard of knights took over and escorted Augustus' remains into Rome under cover of darkness, laying it to rest in the vestibule of his home on the Palatine Hill.

The next day, the will which Augustus had written the previous spring, and lodged with the Vestal Virgins for safekeeping, was brought into the Senate and read aloud by a freedman. Then, because Tiberius—who was dressed entirely in gray—was far too overcome with grief to speak, Drusus read the late emperor's final charge to the senators and his chosen heir. The Senate responded by proposing all sorts of extraordinary rituals and procedures to commemorate Caesar's passing; among the least outrageous was the suggestion that the month in which Augustus had died should henceforth bear his name. Naturally the great man was deified; the Senate declared Augustus immortal, appointed a special order of priests to conduct his sacred rites (Livia was named high priestess of the cult), and erected a golden image of the new god in the Temple of Mars, which eventually became the repository for all his posthumous honors.

The funeral itself was a dazzling spectacle worthy of the majesty of the young empire. At dawn on the appointed day, troops lined the streets of Rome to prevent any unseemly public displays of emotion (i.e., popular riots either in favor of or in opposition to the principate). Augustus' body, in a coffin covered with a cloth of gold and purple, was laid upon a couch of ivory and gold; atop the coffin rested a wax effigy of the dead man, dressed in the traditional victory garb of a Roman conqueror. The consuls and tribunes and magistrates who had

Tiberius as a youth

recently been elected for the following year acted as pallbearers, carrying the remains on their shoulders from the emperor's palace to the Forum. A second golden image of Augustus was brought to the Forum by a select band of senators; a third arrived seated in a war chariot, accompanied by effigies of Augustus' deceased ancestors—except for Julius Caesar, who was already a god and therefore disqualified from taking part in any human ceremony—and emblems of all the foreign lands Augustus had brought under Roman authority.

As the audience gazed respectfully upon the coffin that concealed the late emperor's corpse, Tiberius delivered the eulogy from the steps of the Temple of Jupiter. It was, of course, suitably flattering to Augustus ("We all understand that even if all mankind were gathered together, they could not pronounce a tribute worthy of him") but not terribly tactful toward the assembled dignitaries: "So far from feeling envious that not one of you could equal him," Tiberius intoned in his plodding, no-nonsense style, "you will rather rejoice in the fact of his surpassing greatness. Indeed, the greater he appears when you compare him to yourselves, the greater will seem the benefits which he conferred, so that there will be no rancour in your hearts through any sense of feeling diminished by comparison with him, but rather pride on account of the good things you have received at his hands."

The bearers then picked up their burden and, escorted by the entire Senate, resumed their procession through the triumphal arch in the old city wall and out to the Campus Martius, where the body was placed on a pyre. Priests, knights, senators, and the Praetorian Guard marched one last time around Augustus, tossing decorations and awards onto the bier, before several centurions lit the fire with torches. As the flames leaped upward, a senator named Numerius Atticus swore that he saw the spirit of the deceased emperor ascending toward Heaven. (Livia later gave him a million sesterces as a reward for his perceptive vision.) The widow remained grieving by the smoldering pyre for five days, accompanied by some of the more prominent knights of the empire. Then they gathered up the ashes and the charred bones and stored them in the family tomb.

"At the time, there were not many who mourned the dead man with genuine emotion," remarked Dio Cassius. "But later all came to do so."

PART TWO

Trial

The Heir of Confucius
China, 12–22 C.E.

> Verily, since I have ascended the throne, the Yin and
> Yang principles have not been harmonious, so that the
> wind and rain have not been timely, and the country has
> several times met withering drought, locusts, and
> caterpillars, which became calamitous visitations. The
> harvests of grain have been sparse or lacking, so that the
> people have suffered from famine. The barbarians have
> troubled the Chinese and robbers and brigands have
> caused disorder outside and inside the government. . . .
>
> —WANG MANG, 19 C.E.

Three years after he proclaimed himself the Son of Heaven
and ascended the imperial throne, Wang Mang sat in the
Weiyang Palace in Chang'an, absentmindedly stroking his imperial
mustache and pondering his imperial predicament. Where, he won-
dered, had things started to go wrong? Why had Heaven withheld its
favors from his regime? Had he not been a faithful disciple of the
golden age? Had he not spent whole days meditating with scholars
upon the meaning of the ancient books of wisdom known collectively
as the Five Classics? And more to the point, had he not attempted to
scrupulously follow the paths of correct behavior outlined by Confu-
cius five centuries ago?

Indeed he had; and therein lay the roots of his present difficulties.

By posing (probably with all sincerity) as the champion of a
thoroughgoing Confucian renaissance designed to cleanse the impe-

rial court of the evil and corruption bequeathed by the last dissolute Han emperors, Wang Mang had severely restricted his own freedom of movement even before he assumed power on January 9. He could do nothing that was not explicitly sanctioned by classical precedent; unless he wanted to expose himself as a hypocrite and make a sham of his avowed purpose in overthrowing the Hans, his first priority had to be the restoration of virtue and the reformation of society in accordance with Confucian principles. Unfortunately for Wang Mang, the immediate problems he faced upon his accession were not amenable to a strict application of five-hundred-year-old idealistic prescriptions. The rapid changes induced by the Qin and Han dynasties had irretrievably altered the foundations of Chinese society, and not even Heaven and ten thousand righteous scholars all facing in the same direction could turn back the clock.

In the first hectic months of his regime, Wang Mang had issued a flurry of imperial decrees, which were clearly intended to establish his Confucian credentials beyond a reasonable doubt while—not coincidentally—stabilizing the fledgling Hsin dynasty and raising as much hard cash as possible to satisfy his supporters and meet the exceptional expenses that inevitably accompanied the founding of a new ruling house. He entered upon the task of government with a substantial reservoir of popular good will; most of his subjects were so disillusioned with the incompetence of the recent Han emperors that they were willing to give this usurper-reformer an opportunity to prove he deserved the mandate of Heaven. Wang Mang encouraged this attitude by sending twelve generals to ride through the empire, publicizing the forty-two supernatural portents which purportedly demonstrated that he was, in fact, the gods' choice to rule China.

Thus the masses did not object when Wang Mang demoted most of the Han nobility and condemned the infant Han prince to permanent seclusion; he was not cruel or foolish enough to put the child to death. Nor did the intelligentsia or the peasantry see any reason to complain when Wang Mang nationalized all stocks of gold in the empire, forcing everyone (i.e., all nobles and officials, who were the only people wealthy enough to own any precious metals) to bring their gold to the imperial wardrobe, where it was exchanged for bronze knife-coins, which almost certainly possessed less intrinsic value than the gold itself. The obvious Confucian justification for such a blatant program of legalized robbery was that wealth had become so badly distributed in China that the government had to

intervene to reestablish some measure of equality. Yet Wang Mang somehow neglected to dispense this immense windfall on public welfare measures to benefit the poor, so that the net result was the accretion of a huge stockpile of gold in the imperial treasury. Reliable estimates placed the emperor's total hoard at nearly five million ounces—probably more than the entire stock of gold in Europe during the Middle Ages, and far more than the available supply in first-century Rome. In fact, this is where much of the Roman Empire's gold ended up, exchanged for the fine Chinese silks imported by traders of the eastern Mediterranean provinces.

But the nationalization of his subjects' gold reserves was just the first of Wang Mang's radical economic reforms. Like most Confucian social critics, the emperor had long ago recognized that the concentration of land ownership in the hands of a relatively small group of wealthy families, along with a corresponding increase in the number of tenant farmers, represented an unhealthy development with potentially disastrous social consequences. With each poor harvest, the unfortunate peasantry sank further into debt: "Fathers and sons, husbands and wives plowed and weeded for a whole year," the emperor explained, "[but] what they got was insufficient to keep themselves alive. Hence the horses and dogs of the rich had surplus beans and grain and [the rich] were proud and did evil, while the poor could not satiate themselves with brewer's grains, became destitute, and acted wickedly. Both [rich and poor] fell into crime, so that the punishments had to be employed. . . ."

Since the venerable *Book of Odes* stated unequivocally that "under the vast Heaven / There can be nothing but the King's lands," Wang Mang decided that all the cultivated agricultural property within the empire legally belonged to him, to do with as he pleased. And what he chose to do was prohibit the private purchase and sale of land—which until that time had been the primary source of wealth in China—and carve up the huge estates of the rich, alloting acreage to every family on the basis of need. Wealthy clans with less than ten males were allowed to keep no more than one hundred and two acres of arable land; the government distributed the excess property among their neighbors. This was done by dividing each parcel of nationalized land into nine equal squares of approximately four and a half acres apiece, the minimum holding to which every household of five people was entitled. The central square of each li was set aside and reserved for the government. Each household was required to work one section

of this common square, and all its produce went directly to the imperial tax collector.

Born of laudable motives, this idealistic, socialistic scheme—which possessed the additional and not entirely coincidental advantage of bringing extra tax dollars into the state's coffers—was based upon a plan reportedly employed by the sages of the Chou dynasty nearly a thousand years earlier. In an area of limited size, where all agricultural property was of approximately equal value, Wang Mang's proposal might have succeeded, but in the circumstances of first-century China, it was manifestly unworkable. How could hills and streams and rocky mountainsides be divided equitably? Who would decide where the lines should be drawn and what quality of land was to be given to which family? The opportunities for bribery and corruption boggled the mind. Besides, in most regions of China, four and a half acres of marginal land could never support a family of five, even in the best years.

Anticipating mass protests from the gentry, Wang Mang announced that anyone who dared publicly criticize his land reform program would "be thrown out to the four frontiers [and be made] to resist the elves and goblins," a colorful euphemism for a sentence of imprisonment and death. And many citizens were indeed executed, for the decree met with widespread resistance and lawsuits from the large landowners of the empire, most of whom were—alas for Wang Mang—bureaucrats, nobles, or both. (Since the imperial civil service consisted primarily of the landed aristocracy, the two groups were virtually identical.) The resulting chaos persuaded Wang Mang to abandon his land reform program only two years after its inception.

Meanwhile, the economy had been further disrupted when Wang Mang instituted a series of currency reform measures, frustratingly complicated pieces of legislation that introduced a whole range of new coins (including certain varieties of rare sea shells) which were supposed to be facsimilies of the media of exchange employed in the Golden Age of antiquity, while eliminating some older coins, including the very money-knives the government had just given out as part of its gold exchange program. Since most of the new, lighter coins contained significantly less metal than the old ones, the net effect of these maneuvers was to drastically devalue the coinage again and thereby augment the imperial treasury even more, throwing the whole currency structure into total confusion. The volume of trade declined drastically as buyers hoarded their specie and a rash of dis-

putes arose over the proper relative valuation of the old and new coins. Instead of giving up their old coins, many merchants and bureaucrats—the backbone of the Chinese financial system—chose to risk the death penalty by melting down their cash themselves and forging counterfeit currency. The empire's smaller businessmen, who possessed no such recourse, suffered heavy monetary losses from the cumulative effect of all the exchanges.

Wang Mang fared no better with his humanitarian efforts to ban the sale and purchase of slaves. Bearing in mind Confucius' admonition that "of all living things [in] Heaven and Earth, man is the noblest," the emperor unilaterally abolished China's slave markets, with their cruel pens where men and women were herded together like cattle. Yet when the aristocracy vehemently objected to this limitation on its traditional source of domestic labor, Wang Mang relented after only two years and substituted instead a heavy tax upon all slave owners; once again, a reform measure had been jettisoned in favor of a plan that brought vast new funds into the imperial treasury.

All of these imperial decrees—and particularly the land and currency reform programs—proved ineffective primarily because they failed to recognize the reality of Chinese society in the early decades of the first century. No longer was China the simple agrarian utopia of antiquity; the economy was far too complex, and there were far too many politically powerful interest groups whose privileges were threatened by Wang Mang's Confucian-based proposals. And, much to the despair of the new emperor, the imperial bureaucrats and Han court favorites who were supposed to implement the new programs were precisely those people whom the reforms were designed to regulate. Although Wang Mang regarded them as chiselers and venal schemers and attempted to replace them with disinterested Confucian civil servants, he lacked the time and resources to root out all vestiges of the traditional system of official extortion and bribery. For their part, the bureaucrats repaid Wang Mang's suspicion by deliberately sabotaging his socialistic innovations, and particularly the proposals that adversely affected their fees—the most notable of which was a plan to alleviate agricultural distress by reducing official salaries in times of poor harvests.

Within three years of his accession, the mutual hostility between Wang Mang and his civil service had reached the critical point. Unable to delegate responsibility to trustworthy subordinates, the emperor spent an inordinate amount of time and energy dealing person-

ally with insignificant matters of detail, altering minor aspects of imperial regulations, and arguing arcane points of Confucian philosophy. Night after night he worked until dawn, but he kept falling further and further behind. Correspondence went unanswered, posts were left vacant, petitions went unheard and lawsuits unresolved. Troops on the borders nearly mutinied for want of regular pay, clothing, and food. The problems were exacerbated by the fact that many of the civil servants he brought into the bureaucracy were inexperienced or incompetent or both. The end result was intolerable delays, confused directives, countermanded orders, and complete administrative bewilderment.

Foreign affairs provided no respite for Wang Mang. For the past eighty years, following the vigorous burst of expansion under Wudi, the Chinese court had been moving steadily away from political involvement in Central Asia toward a policy that would replace military force with the less expensive and presumably safer tactics of diplomacy and peaceful suasion. This trend toward noninvolvement was motivated by the belief that the expenses of full-scale punitive expeditions against the Xiongnu far outweighed any potential benefits; since Chinese armies could never catch the seminomadic herdsmen to deal them a decisive defeat, military campaigns into the interior were, in the words of one contemporary critic, like "fishing in the Yangtse River or the Ocean without nets."

But Wang Mang, desperate for a victory to enhance his personal prestige and divert public attention from his faltering reform program, rashly elected to stir up trouble with the natives of Further Chu-shih, a strategically critical state in Central Asia, by beheading the son of their chieftain, who had been residing in Chang'an as a hostage. This provocative and wholly unnecessary action, taken in the year 10, was intended to serve as an example to the tribesmen and the Xiongnu, who had lately resumed their annoying incursions against the empire's northern and western borders. Its net result, however, was to provoke the tribes of Central Asia into open rebellion and lead them right into the arms of the Xiongnu. In an attempt to raise an army of three hundred thousand men to crush the incorrigible tribesmen once and for all, Wang Mang was forced to resort to the unpopular expedient of conscription of men and material from the various commanderies. His lieutenants finally managed to assemble a motley force of veterans, convicts, and freedmen who were given the collective title of "boar braves who are porcupines rushing out," to instill pride in

their mission. But the brave boars proved manifestly unwilling to rush out anywhere: a number of units flatly refused to take the field against the barbarian enemy, killed their commanders instead, and fled into the hills to become vagrants and robbers. Wang Mang thereupon decided that "he did not consider the barbarians of the four [quarters] worth destroying," and so the imperial position in Central Asia continued to deteriorate until, by the end of the Xin dynasty, Chinese influence had virtually vanished from the region.

But all these difficulties faded before the blow that nature now delivered against the hard-pressed regime of Wang Mang.

For centuries, the Yellow River had periodically overflowed its banks and flooded the surrounding Great Plain, which happened to be one of the most densely populated regions of China at the start of the first century. In normal times, the vast quantities of silt that gave the Yellow River its name were carried along harmlessly for as long as the current maintained its speed coming out of the northwestern hills; but as the river approached the sea, it grew sluggish, and the deposits of silt sank to the bottom, gradually raising the level of the bed above the countryside in the lower reaches. Eventually the bed became so elevated that a violent flood would actually force the river to cut itself a new course. Recurrent flooding during the reigns of Wudi and his successors had signalled the imminence of such a disaster (the government's efforts to contain the river with makeshift dikes proving nothing more than a stopgap solution), and in the brief, unhappy reign of Pingdi, the river had indeed burst its banks and inundated the southern part of the Great Plain, dividing itself into two branches and sending the second channel southward into the Huai River.

If this calamity had been a tangible sign of Heaven's displeasure with the Han emperors, worse was yet to come. In the year 11 C.E., the surging river again breached the dikes and unleashed another new arm along the northern edge of the Shandong peninsula. Thousands of people drowned in the ensuing deluge, and millions more were rendered homeless and forced to flee the devastated provinces. As the effects of the catastrophe spread to nearby regions, one of the most significant mass migrations in human history commenced; by the time it had ended more than a hundred years later, nearly ten million Chinese had forsaken the stricken northern provinces to settle in the sparsely populated southern sectors of the empire.

For Wang Mang, the immediate consequences of this over-

whelming natural disaster were widespread famine—exacerbated by recurring invasions of locusts and droughts in other areas of China—and an outbreak of banditry among the starving refugees who thronged the roads leading out of Shandong. In this difficult situation, even the most efficient central government would have been hard-pressed to avert massive social upheavals; with the imperial bureaucracy already in a state of near paralysis, Wang Mang was virtually powerless to quell the spreading disorders.

And so for a time he did nothing, preoccupied by the death of the Grand Empress Dowager in the winter of 14 and the persistent incursions of barbarian raiding parties along the northern and western borders. Late in the year 18, however, the myriad bands of displaced peasants in and around Shandong merged into a vast inchoate army of tens of thousands of desperate, discontented men who proceeded to terrorize the region, looting and murdering everyone who stood in their way. They had no ideology except hunger, no goals save mere survival. As a visible sign of the desperation that bound them together, they painted their foreheads crimson and soon became known and feared as the Brotherhood of the Red Eyebrows. The fact that red had been the symbolic color of the Han dynasty probably never occurred to these illiterate rebels.

At first, Wang Mang attempted to suppress the Red Eyebrows with the local militia in the eastern commanderies, but the rebels easily overpowered the government troops. In the spring of 19 the emperor tried a different approach. He ordered the Grand Astrologers to calculate a new calendar, changed the official titles of his two surviving sons, constructed ancestral temples to invoke the supernatural aid of his forbears in perpetuating the Xin dynasty, and announced that he was inaugurating a "New Beginning, in order to conform to the Mandate of Heaven given through portents." "Because of my lack of penetration," Wang Mang acknowledged, "my performance of [Heaven's] commands has not been intelligent, yet now I have been informed of the correct procedure." The rebels paid absolutely no attention.

So Wang Mang raised another army, supplying it through requisitions of grain and horses and a three-percent levy on all the taxable property in China. Those who resisted were executed. Simultaneously, the emperor put out a desperate call for any new strategies or military technology that might give him an advantage against his enemies. The search attracted all sorts of crackpots, including one man

who claimed he could fly across a thousand li (about three hundred miles) in a single day. Wang Mang immediately granted him an audience, whereupon the would-be aviator stuck the plucked feathers of a large bird onto his head and body and jumped off of one of the towers of the Weiyang Palace at Chang'an, furiously flapping his wings. Aided by the height of the tower and the momentum of his running start, the poor man actually covered several hundred yards before he crashed to earth.

This was not the only omen that presaged doom for the beleaguered Wang Mang. On March 17 of the year 20, the emperor and his subjects were terrified by the appearance of a clearly visible black spot on the face of the sun. Less than twelve months later, there was a conjunction of Saturn and Venus in the heavens, a sign which, according to one widely disseminated interpretation, indicated that there would soon be a gathering of the common people in the imperial palaces. This prophecy, which seemed to foretell the overthrow of Wang Mang, was publicly endorsed by the emperor's eldest son, Wang Lin, the heir apparent, who, having watched his father murder several of his younger offspring, was understandably nervous about his own future. Unfortunately, Wang Mang learned of his son's rash indiscretion and threw him into prison. Shortly thereafter, Wang Lin committed suicide. Later the same month, Wang Mang's last legitimate son died of an illness. Like the last Han emperors, Wang Mang was now bereft of a natural heir. Grief-stricken and fearful that the malicious spirits of the dead Han emperors had caused the extinction of his own line, he ordered the destruction of the sole remaining Han sanctuary, the temple of the venerated Emperor Kao, in retribution.

Meanwhile, in the eastern commanderies of Nan and Jiangxia, near the modern city of Nanyang, the Red Eyebrows swept away all the imperial forces Wang Mang sent against them. By then grain prices had spiraled out of control; the famine was so bad that the government was reduced to teaching the people how to make soup from boiled grasses and the leaves and bark of trees. In Chang'an, the sky was blotted out by yet another plague of locusts; the insects even invaded the sacred precincts of the Weiyang Palace, crawling through the ornate halls and silk-draped pavillions.

In the spring of 22, a desperate Wang Mang ordered two of his top lieutenants, the veteran General of a New Beginning (Lien Tan) and the Grand Master (a cowardly young man named Wang K'uang), to lead a new assault against the Red Eyebrows. As they passed

through the Capital Gate on their way out of Chang'an, the commanders paused to offer a sacrifice to the gods of the highways. But the skies opened and the troops were soaked with rain. "This," the sages declared with great sadness, "is because Heaven weeps for the army."

VIII

The Heir of Augustus
Rome and Germany, 14–26 C.E.

> I am master of the slaves, *imperator* of the soldiers, and
> chief of the rest.
>
> —TIBERIUS CAESAR

N o sooner had the ashes of Augustus been laid to rest than
mutinies broke out among the legions in Illyricum and
Germany.

In both cases, the uprisings were largely a protest—fanned by
loud-mouthed agitators—against the onerous terms and conditions of
military service in the regular army. During the crises of 6–12 C.E.,
Augustus had unilaterally extended the length of service for most
active recruits from sixteen years to twenty, or even longer in the
event of emergencies; then when they were finally discharged, veter-
ans discovered to their dismay that the customary cash retirement
bonuses had been replaced with grants of nearly worthless swamp-
land. Within the legions, the traditional Roman preoccupation with
discipline, rigorous at all times, had been carried to absurd lengths by
sadistic officers such as the centurion who was nicknamed "Another-
please" by his men because "every time he broke a stick over a
soldier's back he used to shout loudly for another and then another."
And profits had been scarce of late, because neither the campaigns in
Illyricum nor Germany had offered the opportunities for wholesale
looting and pillaging that the civil wars or the attacks upon other
civilized Mediterranean societies had afforded.

So the legionaries were in a surly mood in the summer of 14, ripe for manipulation by the malcontents in their midst. It should be noted, however, that except for those few souls who still harbored chimerical dreams of a return to republicanism, the army's protests were certainly not expressions of opposition to the accession of Tiberius as Augustus' heir; instead, the troops chose this moment to act because they knew that the brief period of transition and uncertainty in Rome would provide them with a once-in-a-lifetime opportunity to bargain with the new regime from a position of relative strength. Even those who urged Germanicus to overthrow Tiberius and seize power for himself were motivated less by a love for Drusus' son than by a desire to use the young man as a vehicle for achieving their ambitions, as witnessed by their rough treatment of him when he refused to champion their cause. For the first time since the civil wars had ended, the Roman army was flexing its muscles—albeit in a rather blundering, uncoordinated manner—and sending a pointed reminder to the feckless politicians in the Senate that from that time forward, any political settlement in the empire would need to take the interests of the legions into account.

The trouble in Illyricum began when the regional commander, Quintus Junius Blaesus, permitted his three legions to abandon their routine duties during the period of mourning for Augustus. With too much time on their hands, the idle troops paid more attention than they might otherwise have done to a rabble-rouser named Percennius, a former theatrical stagehand with years of experience in arousing the emotions of a crowd. "You will never be brave enough to demand better conditions if you are not prepared to petition—or threaten—an emperor who is new and still faltering," Percennius shouted to an impromptu assembly of his comrades. "There will never be improvement until service is based on a contract—pay, four sesterces a day; duration of service, sixteen years with no subsequent recall; a gratuity to be paid in cash before leaving the camp."

These demands quickly gathered the support of a majority of the regular troops. Rioting erupted at scattered points around the encampments, gathered momentum, and broke into open acts of violence. Nearby towns were ransacked; the army's jail cells were stormed and all the prisoners released; and unpopular senior officers were assaulted and mercilessly beaten, sometimes fatally.

As the situation in the Balkans rapidly deteriorated, Tiberius refused to be intimidated. He recognized perfectly well that his throne

rested, ultimately, upon the swords of the legions—and the troops in Illyricum were less than two weeks' march from Rome. But his long years of field command had also taught him that discipline could never be effectively restored once a commander began granting concessions to his men under duress. In its last days, the republican army had disintegrated into just so many semiautonomous juggernauts rampaging through the provinces, precisely because discipline and the hierarchy of command had deteriorated beyond recall, and Tiberius was determined above all else to prevent a recurrence of the horrors of civil war.

His resolve was strengthened by the fact that he had agreed to succeed Augustus as *princeps* only as a final act of obedience to his late father-in-law and patron. After serving as co-*imperator* with Augustus in the years 12 to 14, Tiberius had discovered that he had no taste for the imperial purple after all; when he greeted the Senate immediately after Augustus' funeral, Tiberius candidly advised the legislators that "a State which could rely on so many distinguished personages ought not to concentrate the supreme power in the hands of one man—the task of government would be more easily carried out by the combined efforts of a greater number." Naturally the Senate thought he was only feigning reluctance, an impression that was strengthened by Tiberius' well-known penchant for never saying what he really meant, and the assembly pressed him repeatedly to accept the power the divine Augustus had bequeathed him as his legal heir. But Tiberius, exasperated at the Senate's refusal to credit his sincerity, continued to complain and demur until at last one politician, irritated by the seemingly interminable farce, called out petulantly, "Oh, let him either take it or leave it!" In the end, of course, despite his ill-tempered grumbling that the Senate was forcing him to become "a miserable and overworked slave," Tiberius reluctantly consented to take the job. It was his filial duty, he decided, to follow Augustus' plan for the preservation of the empire, and no Roman was more grimly dutiful than Tiberius Julius Caesar, though he did venture to suggest hopefully that if and when he reached old age, the Senate "may be good enough to grant me a respite" from the rigors of office.

At the same time, Tiberius warned the assembly that the current period of transition was fraught with danger and uncertainty. The imperial government, he declared, was "holding a wolf by the ears," proof of which statement arrived with alarming haste in the form of reports of the mutiny in Illyricum. Instead of riding to the scene

himself, as he might have done if Augustus were still alive, Tiberius sent his son, Drusus, to quell the rising; that way, the emperor's dignity would not be directly compromised in case the rioting troops rejected his orders. Besides, by staying in Rome, Tiberius could always later conveniently disavow any promises his son might make to the mutineers.

So Drusus set out for Illyricum, accompanied by two battalions of the Praetorian Guard plus a generous portion of the emperor's German bodyguard, along with an adviser named Lucius Aelius Sejanus—nephew of Quintus Blaesus, a former staff officer in the entourage of the late Gaius Caesar and currently joint commander (with his father) of the Praetorian Guard. (Sejanus had first met Tiberius during the famous conference on Samos, when Gaius was on his way to Parthia to settle the Armenian question thirteen years earlier. Obviously the handsome young officer had made a favorable impression on the emperor-to-be.) When Drusus reached the legionary camps on September 26, after eight days' hurried travel, he was received by a delegation of dirty, sullen veterans who ushered him inside and then locked the gates and posted armed guards at strategic points around the perimeter. They listened impatiently as Drusus mounted a platform and read a letter from his father bearing assurances that the empire's fighting men, with whom he had served in so many campaigns, remained dear to his heart (here there were even some rude catcalls from the audience), and promising to refer their grievances to the Senate as soon as propriety permitted. This reply struck many mutineers as a blatant delaying tactic—"Why have you come," they shouted angrily, "if you are not going to raise salaries, improve terms of service, or help us at all?"—and though they permitted Drusus to retire peacefully to his tent for the evening, they were clearly contemplating criminal violence on the morrow.

Then Drusus was saved by the heavens. That night, the moon was swallowed up in an eclipse. Exceptionally superstitious as a lot, the soldiers watched terror-stricken as the lunar light steadily waned in a cloudless sky. To them, it seemed an indication of Jupiter's judgment upon their mutinous endeavors; only if the moon goddess shone brightly again would their plans be crowned with success. Like savages, they beat on drums and blew their trumpets to frighten away the darkness, but to no avail: eventually the moon disappeared altogether. "Men's minds, once unbalanced, are ready to believe anything," observed Tacitus. "And now they howled that heaven was

sickened by their crimes and endless hardships were in store for them."

Taking advantage of this timely natural phenomenon, Drusus and Sejanus rounded up the most popular officers and instructed them to circulate through the camp, threatening and cajoling the shaken and bewildered troops until order was finally restored. The next morning the ringleaders of the mutiny were executed on Drusus' orders. Whatever embers of rebellion still smoldered were soon extinguished by a prolonged, torrential downpour, which drenched the legions—"It rained so hard they could hardly set foot outside their tents," reported one writer—and confirmed their fears that the gods were furious at them for their disobedience. There was nothing left to do but depart the accursed camp and return, chastened, to their winter quarters, even before they received the emperor's official reply to their petition of grievances. Soon after the mutiny disintegrated, the province of Illyricum was divided into two separate entities, Pannonia and Moesia, with permanent and separate garrisons along the Danube—closer to the barbarian enemy and a more discreet distance from Rome.

The mutiny in Germany was not quelled quite so easily.

Germanicus, the commander-in-chief of the armies of the Rhine, was overseeing routine administrative affairs in Gaul when he heard the news that the four legions stationed along the lower Rhine—I, V, XX, and XXI—had risen en masse and slaughtered their officers. Reports from the scene of the disturbances indicated that the riots had been instigated by agitators from among the ranks of the slaves and Roman rabble whom Augustus had hurriedly rounded up and conscripted, much against their will, during the recent frontier crises. Unaccustomed to the rigors of martial discipline and eager to return to civilian life in the capital, they played upon the discontent of the veterans and incited them to demand the same sort of concessions as their comrades in Illyricum. "There was universal, silent fury," said Tacitus, "as resolute and unanimous as if they were acting on orders." As the commanding general, Aulus Caecina Severus, looked on helplessly, the rioters assaulted and flogged their officers—one company commander was dragged away as he clung to Caecina's feet, begging for protection—and threw their battered bodies in the Rhine.

By the time Germanicus arrived, the men had thrown off all traces of discipline and organized their own independent patrols and

guard units, and there was considerable concern that they might desert their defensive stations along the river and storm into Gaul in search of plunder. Although the mutineers had been loudly touting the affable, flashy, twenty-three-year-old Germanicus as their champion—certainly the young man enjoyed an impeccable lineage, being both the husband of Augustus' granddaughter Agrippina and the son of the late Drusus the elder (Tiberius' brother, whose memory was still revered by the German legions)—they gave him the same sort of grumbling, guarded welcome the younger Drusus had received in Illyricum; instead of kissing his hand, grizzled veterans stuck his fingers into their mouths so he could feel their toothless gums. With considerable difficulty, Germanicus managed to restore sufficient order to harangue the assembled troops, reminding them of the debt they owed to the memory of the divine Augustus, and to Tiberius, who had personally commanded them in that very region not so very long ago. Unimpressed, the men responded by ripping off their tattered uniforms to display the scars left by wounds or brutal floggings. "End this crushing service!" they screamed. "Give us rest—before we are utterly destitute!" Before the situation passed completely out of his control, Germanicus decided to adopt a melodramatic tack. Drawing his sword from his belt, he brandished it in the air and aimed it in the general direction of his breast, shouting that if the mutiny did not end at once, he would kill himself: to a noble native Roman, suicide was preferable to dishonor. The initial effect of this gesture, though substantial, was blunted by a shout from an irreverent soldier in the back of the audience who offered Germanicus the use of his sword instead, because it was sharper. Germanicus' friends prudently hurried the emperor's nephew off to his tent before any more harm was done.

Now Germanicus was really in a bind. He knew that the four legions on the upper Rhine had not yet been infected with the contagion of mutiny; but how long would they remain immune? (Their commander, Gaius Silius, later confided to a friend that if his troops had joined the mutiny, Tiberius would undoubtedly have been toppled.) Nor could Germanicus be assured of the loyalty of the considerable force of auxiliaries he possessed; after all, Arminius and his colleagues had once been auxiliaries, too. And, speaking of Arminius, the German rebel was reportedly lurking in the forests not far to the east, ready to take advantage of any perceived weakness in the Roman

position. The crisis clearly seemed to cry out for some bold, decisive stroke to end the uprising.

Instead, Germanicus—who lacked the fundamental, flinty toughness that his uncle, the more arrogant and self-assured Tiberius, possessed in abundance—caved in to the mutineers' demands. He consented to the immediate discharge of all veterans who had served more than sixteen years and, under additional pressure from the impatient troops, agreed to pay their demobilization bonuses from his own expense funds. Legions V and XII thereupon departed for their winter camp sixty miles away, but the insurrection was not yet at an end. Fearful that the recent arrival in camp of a senatorial delegation from Rome signaled the government's determination to rescind Germanicus' concessions, the mutineers refused to relinquish control of the situation. In fact the prospect of violence appeared so imminent that Germanicus, under considerable pressure, consented to send away his wife, Agrippina (who always traveled at his side), and their youngest child—a handsome, curly-haired three-year-old boy named Gaius who had lived most of his life in army camps, earning the nickname Caligula ("little boots") for his habit of wearing miniature army footwear—to stay with a loyal German tribe until order had been restored.

When some of the troops intervened to prevent Agrippina from leaving, however, Germanicus finally erupted in anger. Such a blatant challenge to the dignity and safety of the imperial family could not be tolerated under any conditions. "In these last days you have committed every possible crime and horror!" he roared.

I do not know what to call this gathering! You men who have used your fortifications and weapons to blockade your emperor's son can hardly be called soldiers.

This, it seems, is the report I must make to my father—amid the good news that he has from every other province—that his own old soldiers, his own recruits, they and they alone, not content with releases and gratuities, are slaughtering their company-commanders, ejecting their colonels, arresting their generals, until the camp and the river are soaked in blood, and I myself, surrounded by hatred, live only on sufferance! . . .

Divine Augustus, I call upon your spirit now in heaven! Nero Drusus my father, I invoke your image that is in our memories! Come to these soldiers of yours . . . [and] wash clean this stain! Direct these revolutionary passions against enemy lives instead!

Now, the typical Roman soldier in those days was exceptionally emotional and notoriously susceptible to an impassioned oration delivered with force and flair, and according to Tacitus, this speech by Germanicus stirred enough emotions to swing back toward obedience the majority of men, who doubtless felt the mutiny had gone too far and were beginning to fear drastic reprisals. Seizing this opportunity to prove their loyalty, the troops promptly rounded on the ringleaders of the uprising, dragged them before a makeshift tribunal, and executed the mutineers by throwing them off a platform onto a sea of upraised swords. Germanicus watched it all happen but did not interfere; since the men themselves had taken the initiative, his reputation remained unsullied by the butchery.

There remained, however, the unrepentant Legions V and XXI (still commanded by Caecina), stationed at their winter camp at Vetera Castra, near modern Birten, along the Rhine. By now Germanicus felt sufficiently confident of the loyalty of the rest of his troops to organize a punitive expedition to Vetera to reestablish order forcibly, though he hoped the mission would prove unnecessary. To keep his own hands clean, Germanicus sent advance word of his plans to Caecina and suggested that if the two legions punished the agitators themselves, Rome would consider honor satisfied and the matter would be closed. Caecina took the hint. That evening, loyalist officers fell upon the rebel leaders in their tents, massacring them as they slept. "This was unlike any civil war," reported one horrified Roman writer. "It was not a battle between opposing forces. Men in the same quarters, who had eaten together by day and rested together by night, took sides and fought each other. The shrieks, wounds, and blood were unmistakable." Germanicus arrived a few days later and pretended to be appalled by the bloodshed—"This is no cure," he allegedly declared, "it is a catastrophe!"—but it is difficult to imagine what else he could have expected.

To salvage his sullied reputation and channel the soldiers' rage toward more constructive ends, Germanicus then embarked upon a spectacular expedition into Germany for the avowed purpose of avenging Varus' death. Doubtless he had at least the tacit consent of Tiberius for crossing the Rhine, but the project certainly appears to have originated with Germanicus himself. In fact it violated the cautious policy favored by both Augustus and Tiberius, and directly contravened Augustus' explicit admonition in his last will and testament, urging his successors to forego further expansion of the em-

pire's borders. Furthermore, it was not at all clear what permanent strategic goals Germanicus hoped to accomplish. But off he went anyway. Leading a force of twelve thousand regular infantry, eight cavalry regiments, and twenty-six battalions of auxiliary troops, he surprised a barbarian camp just across the river. The Germans, it seems, had been indulging in their favorite pastime—drinking themselves into a stupor—and were in a complete state of disorganization and disrepair when four Roman columns fell upon them. Eager for redemption, the legionaries slew everyone in sight: unarmed warriors, old men, women, and children; and then, for good measure, they burned the land for fifty miles around and ransacked the sacred tribal sites. Then Germanicus turned around and headed back to the winter camps on the Rhine.

He returned the following year to raid the Chatti and Cherusci tribes, burning more settlements and slaughtering more noncombatants; this time he even managed to "rescue" (i.e., kidnap) the wife of Arminius. Arminius responded by exhorting his followers to join him in another crusade against the Roman invaders. "There is nothing to fear in an inexperienced youth and a mutinous army," the German rebel reportedly sneered. "Germany will never tolerate Roman rods, axes, and robes between Rhine and Elbe." Nonetheless, Germanicus continued to advance eastward through the forests until he reached the heartwrenching site of the Varian disaster: broken shields and splintered spears; bones bleached white, piled high in the ditches or scattered across the ground; human skulls nailed to tree trunks. The Romans buried the decaying remains of their lost comrades and then soberly pressed on until they encountered Arminius once again. And once again the German chieftain took advantage of the marshy terrain to inflict extensive casualties upon the imperial forces. That night, Caecina dreamt he saw the ghost of Varus, bloodsoaked, rising out of a swamp, calling his name and holding out his hand to draw him further into the morass. When daylight returned, a series of inconclusive skirmishes followed, whereupon the Romans prudently retreated for the winter to their garrisons on the Rhine.

Undaunted, Germanicus devised plans for an ambitious seaborne invasion for the following year (16), on the quite proper assumption that protracted, exhausting marches across the German interior provided too much opportunity for the barbarians to ambush his drawn-out columns. A fleet of about a thousand ships was hurriedly—perhaps too hurriedly—constructed during the winter respite. Despite

some blundering and confusion at the rendezvous point in the vicinity of Batavia, the operation actually qualified as a minor success: in the climactic battle on the banks of the Weser, thousands of German warriors were slain, captured, or drowned, though Arminius himself escaped by smearing his face with blood to disguise his features. On the homeward voyage, however, the Roman ships ran into hailstorms and gales in the North Sea. The legionaries, poor seafarers under optimum conditions, were completely overmatched by the elements, as Tactitus' account reveals in dramatic detail:

> Now the anchors held no longer, and no bailing could keep the torrential waters out. Horses, baggage, animals, even arms were jettisoned to lighten the ships as they leaked at the joints and were deluged by waves. . . . The disaster was proportionately terrible—indeed it was unprecedented. On one side were enemy coasts, on the other a sea so huge and deep that it is held to be the uttermost, with no land beyond. Some ships went down. Others, more numerous, were cast on to remote islands, where the men were obliged to eat the horses washed up with them or starve to death.

Despondent at the disastrous loss of life, Germanicus reportedly had to be restrained from drowning himself in sympathy with his men. Some of the survivors were rescued or ransomed from hostile German tribes in later years, returning with lurid tales of the fantastic monsters and grotesque creatures they had seen—or imagined—during their captivity.

Germanicus might have plunged back into Germany the following year had he not been restrained by a flurry of countermanding orders from his uncle in Rome, who by this time was beginning to understand Augustus' point of view about the downside of foreign adventures. Here was the voice of experience speaking, from a commander who had served in the German campaigns on nine separate occasions; and considering how many lives had been lost and how slim were the permanent gains from Germanicus' adventures, the emperor's tone was surprisingly temperate. "There have been enough successes, and enough misfortunes," wrote Tiberius. "You have won great victories. But you must also remember the terrible, crippling losses inflicted by wind and wave—through no fault of the commander. I was sent into Germany nine times by the divine Augustus," the emperor concluded, "and I achieved less by force than by diplo-

macy." Obdurate, Germanicus pleaded for one more year of active campaigning to allow him to complete the conquest of all of Germany, but Tiberius insisted that he return to Rome to enjoy his triumphs and assume his responsibilities as a newly elected consul.

For the first three years of his reign, Tiberius had barely set foot outside of Rome. He had not been joking when he complained to the Senate that in granting him the sovereign powers and authority Augustus had enjoyed, the assembly was forcing him to spend the rest of his life in miserable and burdensome slavery. Unlike Augustus, who had reveled in the role of *imperator* and excelled in the art of political manipulation, Tiberius carried out his imperial obligations with ill-concealed distaste. His conscience was constantly wracked by the vexing conflict between his loyalty to his late stepfather and his lifelong adherence to the traditional aristocratic republican ideology, and so he stubbornly persisted in trying to turn over to the Senate as much of the responsibility for the administration of the empire as he could. Tiberius repeatedly went out of his way to seek advice from senators on revenue matters, deferring to their judgment on diplomatic affairs, consulting them on military questions such as troop movements and command appointments, and even transferring the election of magistrates from the people to the Senate. Fearful that any expression of his opinion on matters under active consideration might unduly influence the assembly, the emperor seldom intervened in legislative debates, and when he did reluctantly rise to express his opinion, he begged the Senate's indulgence for "speaking rather more plainly than I should." (Actually, he might more properly have apologized for boring them half to death with his long-winded, ponderous orations which were often scripted well in advance.) And to impress his senatorial colleagues with a proper sense of their own importance, Tiberius flattered them nearly every chance he got; on more than one occasion, he informed the assembly "that a right-minded and true-hearted statesman who has had as much sovereign power placed in his hands as you have placed in mine, should regard himself as the servant of the Senate; and often of the people as a whole; and sometimes of private citizens, too." No matter; the Senate obstinately (and supinely) refused to share the burden of imperial government.

Muttering privately that the once-proud assembly now consisted of nothing but "men fit to be slaves," Tiberius retaliated by declining practically every title and honor the Senate sought to thrust upon

him. He would not be known as *imperator,* Tiberius insisted, nor as *pater patriae,* because, he explained, "if you ever feel any doubts about my character or my sincere regard for you . . . the title 'Father of His Country' will not recompense me for the loss of your regard, and you will be ashamed either of having given me the title without sufficient deliberation, or of having shown inconsistency by changing your opinion of me." He refused to let the Senate change the name of his birth month (September) to Tiberius—"What will you do, then," he asked sarcastically, "if there are thirteen Caesars?"—and flew into a rage when servile flatterers addressed him as "My Lord and Master." All requests to set up graven images of his likeness were rejected out of hand, and he refused to encourage the practice of emperor-worship in the provinces. Despite his notoriously thin skin, Tiberius seems to have grown resigned to the fact that public criticism was an inevitable accompaniment to his exalted position; even that old gossip-monger Suetonius, who otherwise had little love for the emperor, admitted that Tiberius was "quite unperturbed by abuse, slander, or lampoons on himself and his family, and would often say that liberty to speak and think as one pleases is the test of a free country."

Essentially, Tiberius interpreted his role as *princeps* in a profoundly conservative manner: his task was to preserve the Augustan achievement, nourish the traditional Roman virtues, and ensure that the state operated in an efficient, impartial manner. He refused to approve any ambitious military ventures to expand Rome's far-flung frontiers and enhance his own prestige. The sort of victories enjoyed by the glory-seeking Germanicus in Germany, Tiberius observed drily, were more than Rome could afford. To provide stability to the administration of the empire, provincial governors and procurators were often allowed to remain in office for a decade or longer, so long as they managed their territories with discretion and a fair measure of regard for the welfare of the local inhabitants: "A good shepherd shears his flock," Tiberius reminded them, "he does not flay them."

Within the Italian homeland, Tiberius dutifully carried on Augustus' quixotic crusade to stem the moral decay that threatened to ruin the traditional ruling class, though there is considerable evidence that the emperor, who by this time had shed what few illusions he once had, realized the ultimate futility of any attempt to legislate morality. Appalled at the spectacle of indigent senators and noble families squandering their fortunes on ponderous, oversized mansions, frivolous jewelry, and dissolute living, or sinking into depths

of indebtedness from which they could never recover, Tiberius approved a wide-ranging series of sumptuary laws. Price ceilings were imposed on certain luxury goods, including ornate household decorations and furniture; the use of golden dinner plates was prohibited; male citizens—whose garments were becoming indistinguishable from women's wear—were forbidden to wear clothing of Chinese silk (the fact that Tiberius found it necessary to specifically proscribe this fashion demonstrates how widely popular it had become); restrictions were imposed on the amount of expensive imported food that could be sold in the capital's markets and restaurants; and the presentation of New Year's gifts to the emperor (a seemingly innocent practice which seems to have gotten completely out of hand, particularly since Tiberius felt obliged to return the favor with another gift worth four times as much) was outlawed. At one point Tiberius even banned the sale of pastry, apparently on the grounds that it was an extravagant waste of grain.

Forsaking his previous reputation as a heavy wine-drinker—he had been known by his army comrades as Biberius—the emperor now insisted that his household establish an example of frugal living. He kept few slaves on his modest estates in the Italian countryside, and guests at his formal dinner parties were often served either unappetizing leftovers or a single side of wild boar, with the explanation that the other side contained nothing that was not already on the table. Government spending on public entertainments was severely curtailed, which was fine with Tiberius because he felt uncomfortable attending gladiatorial combats and theatrical spectacles anyway. (Not for nothing did Pliny the Elder describe him as "the grimmest man alive.") Augustus had promoted these games as a means of enhancing his popularity with the masses while stimulating their sense of Roman pride and encouraging their emotional identification with the city's majestic empire, but Tiberius cared nothing for such matters. "Let them hate me," he once said of the Roman plebs, "so long as they respect me!" In fact, the plebs did soon come to hate Tiberius for his frigid, formal public manner, and their hostility eventually left its mark on the emperor's personality and policies.

Since the upper classes continued to fall away from the old Roman deities, adopting more exotic eastern gods instead, Tiberius found it necessary to issue a decree abolishing all foreign cults in the capital—particularly Judaism and the worship of the Egyptian goddess Isis, both of which had apparently been attracting substantial

numbers of converts among freedmen and the nobility. Male Jews of military age living in Rome were drafted into the army and dispatched to Sicily to fight bandits; most of the rest of the city's Jewish population were abruptly sent packing and threatened with slavery if they ever returned to Rome. When the government uncovered a half-baked anti-Tiberian conspiracy that had been encouraged by the prophecies of an ambitious soothsayer, the city's astrologers were also exiled, except for Thrasyllus, the emperor's own seer.

Sex, too, came under Tiberius' scrutiny. In the later years of Augustus' reign, a growing number of aristocratic women had renounced the privileges of their birth and officially enrolled themselves as prostitutes to permit them to carry on adulterous affairs without the usual penalties; in the same vein, young noblemen and equestrians of a thespian bent had deliberately obtained formal reductions in social rank to circumvent Augustus' restrictions against their participation in theatrical productions, wherein homosexuality reportedly was rife and riots had broken out among fans of rival performers. Tiberius put a stop to both subterfuges by threatening to exile anyone who resorted to such immoral chicanery. In the year 23, he went a step further and actually threw all professional actors out of Italy. The government also attempted to outlaw "promiscuous kissing," though there is no indication of how the ban was enforced, if at all. And, though he considered himself a devotee of fine literature, Tiberius refused to overrule Augustus and grant Publius Ovidius Naso, the poet of love, any reprieve from his exile among the semicivilized barbarians on the bleak and distant shores of the Black Sea.

"Here am I, bereft of country, home and you [my family], everything that could be taken from me," wept a heartsick and desperately lonely Ovid in his final collection of poems, the *Tristia.* In that wild, barren wasteland where the long dark winters were so terrible that even the mighty Danube froze solid and men's beards were encrusted with thick shards of ice, where bands of marauding horsemen armed with poisoned arrows swooped down upon cities and farms without warning in any season of the year, even Ovid's oldest and most intimate friend—his beloved muse—seemed to have deserted him. "Poems require the seclusion and peace of the writer," he mourned. "I am tossed by the sea, by winds and wild storms. . . . Words often fail me when I try to say something (I'm ashamed to confess it), and I've forgotten how to talk. . . . I am the barbarian here, understood by no one; and the stupid Getans laugh at Latin words." Ovid pleaded

with his friends at Rome to intervene for him with Tiberius, to no avail. The emperor remained unmoved. For Ovid there was nothing left but "to wander forever, a foreigner among Sarmatian shades," to await a burial beneath a barbarian earth, and to hope that his art would, in the end, outlive the Caesars themselves:

> Aye, and though sword should take away my
> breath,
> Yet shall my fame outlive my body's death:
> While Rome shall from her hills survey
> outspread
> The conquered world, so long shall I be
> read. . . .
> Therefore, if bards can truly prophesy,
> Earth, I shall not be thine, whene'er I die.

Ovid was not the only condemned man to vainly petition Tiberius for clemency. The emperor was no more eager to intervene in the workings of the legal system than he was to impose his will upon the Senate. For the most part, Tiberius allowed the law to take its own course, submitting even his own private disputes for adjudication; whenever he was called upon to read an indictment in a courtroom, the *princeps* adopted a flat, expressionless tone to avoid either aggravating or deprecating the accusations. For him, favoritism had no place in the judicial system. Occasionally Tiberius would attend a court hearing, uninvited, and sit at the side of the platform or on the front bench, facing the magistrate, to make certain that all parties received fair play during the proceedings.

Yet Roman law did not always operate in a wholly impartial manner, despite Cicero's oft-quoted assertion that "law is the bond which secures our privileges in the commonwealth, the foundation of our new liberty, the fountainhead of justice." Under the Republic, the Roman science of jurisprudence had originally been founded upon the pragmatic (and often merciless) guidelines that regulated the relationships within and between families. Instead of following a set of general philosophical or theological precepts, it had developed painstakingly on a case-by-case basis, one precedent at a time, and so considerable leeway usually existed for the court's selection and interpretation of the statutes relevant to any specific matter. This naturally made it easier for verdicts to be influenced by corruption, intrigue, or

social pressure (i.e., the presence of distinguished acquaintances of the plaintiff on the front benches), and the testimony of a dozen character witnesses to the sterling personal qualities of the defendant was often accorded as much weight as the word of actual eyewitnesses. Naturally, Roman citizens were deemed more reliable as witnesses than foreigners or freedmen; the testimony of slaves—who were presumably susceptible to pressure from their masters—was allowed only if it was obtained under torture (generally the rack or the whip).

Eloquence, one of the most highly respected virtues in ancient Rome, abounded in the courts of the capital. Courtroom audiences had been known to give standing ovations to some of the more spectacular and entertaining displays of verbal pyrotechnics. Virtually all professional advocates (all of whom were male, since women were prohibited from pleading in Roman courts) were accomplished orators, because that had been the primary focus of their education. By the time of Tiberius many of them were also skilled jurists, having learned the law by studying under practicing attorneys, though a substantial minority were nothing more than cheap pettifoggers who had a talent for manipulating the sorts of technicalities upon which a large percentage of Roman cases turned. By law, advocates were not permitted to receive fees for their services; this was a holdover from the idealism of republican days, when litigants were required to swear that they had not promised their attorneys money in return for their appearance in court. After the case had been settled, however, an advocate could receive a "gift" of up to ten thousand sesterces per case from a grateful patrician client, plus generous New Year's presents or handsome bequests in a client's will. The unfortunate barrister who represented a poor widow or an impoverished businessman might receive no cash at all, but only "a dried-up ham, a jar of sprats, some veteran onions, or five flagons of very cheap wine that has just sailed down the Tiber!"

Criminal cases in Rome were generally assigned to one of seven permanent courts, each of which had been established to deal with a particular type of offense (e.g., extortion). Augustus had divided the work of these courts into two terms, winter and summer, so that most legal proceedings occurred during the first eight months of the year. Except in the event of emergency, no case was permitted to begin after September 1, though cases already in progress could proceed until a verdict was reached; although this arrangement forced jurors and magistrates to suffer through the sweltering Roman summers, they

were subsequently free to return to their farms or estates to assist with or supervise the harvest. Appeals were permitted to the next highest level of magistrate, and if the defendant was a Roman citizen accused of a capital crime, he had the right to plead his case directly to the emperor himself. In the meantime, no one could lay a hand on him. And Tiberius, of course, heard every appeal with the same sober, detached judgment the world had come to expect of him.

He applied an identical steady if uninspiring virtue—moderation, Tiberius called it—to his stewardship of the public treasury and the protection of the commonweal. In short, he did his duty, and nothing more. All spending proposals were subjected to a rigorous analysis of costs and benefits. Upon completing a few construction projects left over from the reign of Augustus, Tiberius refused to initiate any ambitious public works programs of his own because he thought Rome already had enough impressive civic structures, though he did authorize funds to repair buildings that had been damaged by fire or storm. Unfortunately, Tiberius' conservative fiscal policy looked very much like mean-spirited niggardliness to the masses, and also had the effect of aggravating the economic recession that soon enveloped the capital. In much the same manner, Germanicus' ill-conceived concessions to the legions in Germany were canceled less than a year later because they would have caused an intolerable drain on the imperial treasury, and because the Roman troops on the Rhine were too preoccupied with Arminius to raise any protest.

Yet Tiberius could be extraordinarily generous in times of crisis. When a shortage of corn forced the cost of grain in the capital up sharply in the year 19, Tiberius did not hesitate to fix prices at a reasonably affordable level while compensating the grain merchants with government subsidies. And when the Tiber once again flooded its banks in the early months of his reign, causing heavy loss of life and property—the water rose so high that the city's residents were forced to use boats to get around—Tiberius pooh-poohed suggestions that the disaster was a sign of heavenly displeasure. It was more likely, he said, that the overflow was simply the result of heavy rains and deficient surface drainage, and he established a five-man board of senators and engineers to develop an effective flood-control system. Alas, all proposed changes in the course of the Tiber and its tributaries were thwarted by the religious sensibilities of the local inhabitants, who refused to disturb the shrines and altars they had dedicated to the river gods.

There was one vexing problem, however, which Tiberius could never handle in his customary rational fashion: what to do about Germanicus? Handsome, charismatic, and wildly popular despite his recent embarrassing difficulties in Germany, the son of Tiberius' late brother was everything the morose and misanthropic Tiberius was not. And here the emperor's own cryptic, inscrutable nature proved fatal—to Germanicus, if not to himself. Painfully shy and awkward in difficult social situations, Tiberius had long ago adopted the habit of masking his true feelings, a tendency that unfortunately was reinforced by his decision to play a passive role as *princeps*. Apprehensive lest a clear expression of his own position on policy matters might unduly influence the Senate or the courts, Tiberius almost never voiced his real opinions, and sometimes even bent over backward to compliment the opposite view. The end result, quite unintended, was complete confusion. As Dio Cassius put it, "he certainly gave people a vast amount of trouble whether they opposed what he said or agreed with him; for inasmuch as he really wished one thing to be done but wanted to appear to desire something different, he was bound to find men opposing him from either point of view, and therefore was hostile to the one class because of his real feelings, and to the other for the sake of appearances."

All this would have been bad enough by itself, but Tiberius compounded the difficulty by projecting his own shortcomings upon others. In other words, Tiberius felt that he could never be sure whether Germanicus was being sincere when he assured Tiberius of his unswerving loyalty, or whether Germanicus, too, was hiding his true feelings. For the moment, the emperor decided to play it safe and try to keep his nephew away from temptation. Tiberius had removed Germanicus from command of the armies of the Rhine to keep him from either garnering an unwonted share of glory or bankrupting the imperial treasury with his expensive forays into the interior. But it would be too dangerous to keep Germanicus in Rome for very long, where he could serve as a convenient rallying point for the opposition.

So Tiberius decided to send Germanicus to the East. He certainly had enough valid reasons of state for doing so, for practically all of Asia Minor was in turmoil. In one of its periodic outbursts of nationalist fervor, the ill-tempered Parthian aristocracy had ousted its king, named Vonones; fleeing for his life, Vonones attempted to recoup his fortunes by seizing the throne of Armenia, which happened to be temporarily vacant. Tiberius, however, refused to recognize the

usurper and ordered the governor of Syria to arrest Vonones and keep him locked away in Damascus. But that left a vacuum in the perennially troublesome powder keg of Armenia. At the same time, immediately to the west, the long-time king of Cappadocia (in what is now eastern Turkey) finally breathed his last, as did the monarchs of the nearby states of Cilicia and Commagene. To add to the confusion engendered by this sudden rush of dynastic change in the region, a devastating earthquake ravaged the most heavily urbanized section of Asia Minor, virtually demolishing Sardis, Philadelphia, and a dozen other densely populated cities. And from virtually every corner of the eastern provinces—particularly from Judea and Syria—there came increasingly bitter complaints of misgovernment and extortionate taxation.

After dispatching emergency relief funds to the stricken areas, Tiberius resolved the most pressing succession questions by asking the Senate to acquire Cappadocia as a separate province and annex Commagene as part of the province of Syria; the additional revenues, he explained, would permit him to slash the imperial sales tax from one to one-half percent. But the rest of the eastern problems required closer examination, and so Tiberius decided to send a prominent member of the government to the scene, someone whose popularity and reputation could help restore order and bring calm to the whole troubled region.

Germanicus was the ideal candidate for the job. He left Rome late in the year 17, armed with the powers of *imperator,* which technically made him superior to every other Roman official in the East. Like the ill-fated Gaius seventeen years before, Germanicus took his own sweet time reaching his destination. First he stopped off to visit Tiberius' son Drusus (despite everything, the two young men genuinely liked each other), who had been given command of the armies in Illyricum; then he set off on a tour of the famous historical sites of the eastern Mediterranean: Athens, Rhodes, Lesbos, Byzantium, and the Oracle of Apollo at Clarus.

In the meantime, Tiberius—in a fit of malevolent mischievousness—appointed one of his father's oldest and closest acquaintances, Cnaeus Calpurnius Piso, the scion of a violently republican family, as the new governor of Syria. According to Tacitus, "Piso was certain that the purpose of his Syrian appointment was the repression of Germanicus' ambitions," and perhaps it was. Piso was well known in Rome for his irascible, querulous personality, and it must not have

been a coincidence that Tiberius chose this moment to send him to Syria.

Piso set to work at once. To preempt any possible bid by Germanicus to subvert the loyalty of the eastern legions, he tried to bind the troops to himself personally (and through him, to Tiberius) by the relaxation of camp discipline and a liberal distribution of bonuses and gifts. When Germanicus at last arrived in the East, Piso refused to acknowledge Germanicus' authority over him. Several months of constant bickering and acrimony convinced Germanicus that it was time for him to resume his diplomatic tour with an inspection of Egypt. Although he may have believed that his vague instructions from the emperor permitted him to make such a voyage, it was a foolhardy act, which immediately set off alarms in Tiberius' suspicious mind, for it directly contravened Augustus' long-standing prohibition against any high-level official visits to that strategically vital province (always the most dangerous rival to the primacy of Rome) without the explicit consent of the emperor—which Germanicus apparently did not have.

As soon as Germanicus was out of Syria, Piso canceled all the civil and military directives Germanicus had issued before his departure. Following his enthusiastic reception in Egypt, Germanicus returned to Damascus in full fury over Piso's arrogant disregard of his orders. Before he could move against his enemy, however, Germanicus fell seriously ill with a mysterious, debilitating sickness. Rumors spread throughout the city that Piso and his wife, Plancina, had poisoned Germanicus and bewitched him as well, a notion that gained considerable credence from the reputed discovery of such bizarre relics as human bones, bloodstained ashes, runic tablets inscribed with the victim's name, and assorted spells and curses behind the walls and under the floor of Germanicus' sickroom. Germanicus himself certainly believed that Piso was killing him, and whether this conviction of supernatural practices hastened his demise or not, the emperor's nephew slowly wasted away, unable to shake off the enervating effects of the illness. From his deathbed the feverish young man hurled a damning accusation at his antagonist, who was calmly sailing back to Rome at the time: "It is the wickedness of Piso and Plancina that have cut me off," Germanicus whispered to his friends. "Tell my father and brother of the harrowing afflictions and ruinous conspiracies which have brought my wretched life to this miserable close. . . . You must avenge me!" Then he died.

News of Germanicus' passing was greeted in the capital with

loud lamentations and massive outpourings of grief that, through skillful exploitation by the late prince's political supporters, rapidly degenerated into anti-Tiberian riots. An outraged Senate insisted that Piso stand trial for the murder of Germanicus. Faithful to his code of legal impartiality, Tiberius removed himself from the legal proceedings, disavowing all knowledge of Piso's alleged conspiracy and refusing to lift a finger to help his erstwhile appointee. Bereft of the emperor's support and condemned universally by public opinion, Piso stabbed himself before the conclusion of his trial.

Drusus now emerged as the obvious choice as heir apparent, though there remained considerable sentiment—fanned by the widowed Agrippina, who was fast becoming obsessed by her hatred for Tiberius—for Germanicus' two eldest sons, Nero Caesar and Drusus Caesar, who were then thirteen and twelve years old, respectively. No one paid very much attention to Claudius, Germanicus' surviving brother, who by all accounts was a clumsy, stammering halfwit. ("No one appeared a less likely candidate for the throne," noted Tacitus.)

But lately Drusus, too, had revealed some disturbing flaws in his character. He had always possessed a nasty temper—in his lifetime, an especially sharp and cruel weapon became known as a "Drusian sword"—and was something of a bully. These unpleasant juvenile traits intensified as the emperor's son reached manhood. Drusus drank excessively, hung around with a disreputable crowd of dissolute actors who delighted in debauching Roman virgins, lusted for the sight and smell of blood at the gladiatorial games, and deliberately picked fights with men much older and less powerful than he; one disgraceful incident in which Drusus brutally assaulted a distinguished middle-aged knight shocked the capital. Finally even his father was moved to rebuke him publicly. "While I am alive you shall commit no deed of violence or insolence," Tiberius warned him, "and if you dare to try, not after I am dead, either."

In the year 17, Tiberius had awarded Drusus command of the legions in southern and central Europe to remove him from the sybaritic temptations of Rome; doubtless the emperor also hoped that the discipline of army life might instill in his son the same sort of self-control that had enabled Tiberius to control his own vicious temper. And, of course, a few well-publicized victories in the field would enhance Drusus' political prospects and provide a springboard for higher civil office.

Drusus could hardly have walked into a more promising situa-

tion. In the absence of an aggressive Roman presence on the east bank of the Rhine, a deep rift had developed among the German tribes, between the belligerently nationalistic forces of Arminius on the one hand and the kingdom of Maroboduus, who was seeking to expand his sphere of influence from Bohemia into northern and western Germania. Following a series of inconclusive skirmishes, the two forces gathered for a single, decisive struggle to win native supremacy in Germany. After a close-fought battle in which both sides showed how much they had learned from their Roman mentors by eschewing the outmoded German tribal tactics of madcap, chaotic charges in favor of disciplined assaults, fought with considerable quantities of captured Roman weapons, and the orderly employment of reserve forces at critical points along the line of fire, Maroboduus conceded defeat. Licking his wounds, the chastened chieftain retreated to his stronghold in Bohemia, whence he sent a message to Tiberius asking for assistance in fighting their common foe.

Tiberius, however, had always considered the wily Maroboduus—the head of a powerful, well-organized, sophisticated Germanic state—a far graver long-term threat to Roman security than the mercurial Arminius. So he answered Maroboduus' plea by dispatching Drusus to the region, ostensibly to negotiate a settlement, but really to encourage further tribal desertions from the king's crumbling confederacy. Eventually Drusus succeeded in provoking a renegade German nobleman to invade Maroboduus' kingdom; broken and isolated, Maroboduus fled across the Danube in the year 18 and, with as much dignity as he could retain, petitioned Tiberius for sanctuary. The emperor graciously allowed him to reside in Italy for as long as he pleased, which turned out to be the rest of his natural life. Seduced by the fruits of Roman civilization, Maroboduus never returned to his native land; he passed away peacefully, in exile, eighteen years later.

At least the deposed monarch had the comfort of knowing that he had far outlived his younger rival. Drunk with success and ambition, Arminius grew so obnoxious and overbearing that his own jealous relatives murdered him within months of his ballyhooed victory over Maroboduus. He had ruled his people for twelve years, never losing a war to Rome or another tribe, and history would know him as the man who liberated Germany from the domination of Rome. Arminius was only thirty-seven years old when he died.

Drusus, meanwhile, returned to Rome in triumph, to be elected consul, along with Tiberius himself, for the year 21. Tiberius took

advantage of his son's presence in the capital to enjoy an extended vacation in the relaxing countryside of Campania, where he remained for the better part of a year, conducting most of his official business by post.

In fact, the longer he stayed away from Rome, the more the emperor's interest in affairs of state waned. His correspondence tapered off, he lost all sense of urgency, and sometimes he neglected altogether to inform the Senate of critical developments in the provinces. When a revolt broke out in Gaul in the spring of 21, Tiberius waited until the legions had put it down before writing to the Senate, so he could tell them simultaneously of the outbreak of the rebellion and its termination. Domestic affairs evoked a similarly lackadaisical response from the weary emperor. Since his previous efforts to reform Roman society had come to naught—"the sums spent on gluttonous eating were widely discussed," reported one observer from the capital, "the law restricting expenditure was being ignored, [and] prohibited food prices were increasing daily"—Tiberius simply gave up trying and advised the Senate not to pass any more sumptuary legislation. "If our energetic aediles [the Roman municipal officials charged with enforcing religious and moral regulations] had consulted me earlier, I should perhaps have advised them not to tackle such deepset, flagrant evils—so as not to publish our helplessness against them," the emperor wrote. "The remedy lies with the individual. If we are decent, we shall behave well—the rich when they are surfeited, the poor because they have to."

At Tiberius' urging, the Senate invested Drusus with the power of a tribune the following year, as another step in his preparation for the eventual succession to the principate, but the favorable impact of this promotion was largely negated by Drusus' decision to spend his term of office touring the lakes and coasts of the Italian countryside. No matter; he had not long to live anyway, for Drusus had recently been heard to complain about the scandalously spreading power of the prefect of the Praetorian Guard, Lucius Aelius Sejanus.

The Dragon Who Flew Too High

China, 22–23 C.E.

> Of the rebellious ministers and evil sons of the unprincipled men who are recorded in books and records, if we investigate the calamities they produced and the ruin they wrought, there have not been any as severe as those produced by Wang Mang.
>
> —PAN KU, HISTORIAN OF THE LATER HAN DYNASTY

October 5, 23: Clad entirely in purple and armed with the imperial seals and an ancestral dagger, Wang Mang sat on his mat in the Xuan Room of the Weiyang Palace and stared disconsolately at the heavens. The emperor was exhausted; for days he had slept little and eaten almost nothing. Before him stood an astrologer with a divining board covered with zodiacal symbols. Outside the palace, the royal city of Chang'an was burning, the flames spreading even into the Front Hall of the imperial residence.

Wang Mang had fixed his attention on the position of the constellation known to the Chinese as the Northern Bushel (the Big Dipper), for it was the chariot of the deity Taiyi, the Supreme One, who resided in the Pole Star. It was Taiyi who bore the responsibility for maintaining the Son of Heaven upon the throne of China, and in the midst of the present crisis Wang Mang desperately needed to invoke the assistance of the gods. Because the walls of Chang'an had been shaped to resemble the Northern and Southern Bushels—hence

the capital's nickname "the Bushel City"—Wang Mang was able to sit in his palace and face in the direction of the handle of the dipper, turning himself as the stars turned in the heavens, striving to attract Taiyi's attention and, with luck, his protection. "Heaven bestowed the virtue that is in me," the emperor murmured aloud. "The Han troops—what can they do to me?"

Outside, his empire was collapsing in fiery ruins. Near the end of the year 22, a contingent of Red Eyebrows in Liang commandery, near the western edge of the Shandong peninsula, had demolished the imperial forces led by Wang Kuang and Lien Tan (the soldiers for whom the sky had wept upon their departure from Chang'an). Afterward, the armies of the Red Eyebrows, so swollen with converts and hangers-on that they could not act as a coordinated unit, divided themselves into three main branches. One band swarmed in a rather desultory manner toward the capital; another amused itself by laying siege to towns in the surrounding countryside; and a third turned directly westward and invaded the commandery of Nanyang.

This latter region, so fertile and prosperous, straddling the modern provinces of Hubei and Henan, had long been dominated by a well-entrenched clique of wealthy aristocrats, chief among whom were powerful members of the prestigious Liu clan, which had formed the central core of the Han dynasty. A few members of the Nanyang gentry had rebelled against Wang Mang before, when he had proclaimed himself regent in the year 6, but the rising had foundered from a lack of popular support. Since then the twenty-odd clans had occupied themselves largely by fighting one another; the area was notorious for its bitter blood feuds. Now, however, the noble families found themselves in danger of being overrun not only by the Red Eyebrows, but by the waves of half-starved peasant warriors flooding in from the south. Known by their place of origin (e.g., "the troops from Jiangxia" and "the troops from Pinglin"), these makeshift armies were commanded, after a fashion, by uneducated commoners with no coherent political program and no purpose save plunder and day-to-day survival.

Their presence in the autumn of 22 presented the Nanyang nobles with an intriguing possibility. Instead of remaining behind the walls of their fortified camps, fending off the advance of the teeming masses, the gentry decided to try to co-opt the rebellion and channel this formidable insurrectionary energy to gain their own objectives; to wit, the overthrow of the usurper Wang Mang and the restoration of the Han dynasty. Setting their feuds aside for the moment, they

coalesced behind the leadership of a distant relative of the former Han rulers, an ambitious minor aristocrat named Liu Po-sheng, who was subsequently able to convince the captains of the various peasant bands currently in Nanyang to cooperate with him. At first the alliance proved successful, but after the rebels were routed and scattered at Xiaochang'an by a government offensive, the entire enterprise nearly came to an abrupt halt. It was saved only by the force of Liu Po-sheng's will and the unexpected appearance of yet another peasant army, the troops from the Lower Yangtze, in the first month of the year 23. Fortified with these reinforcements, Liu Po-sheng defeated two separate government armies in less than a month and advanced to the commandery capital, Wan, which he proceeded to besiege.

These victories provided the Nanyang insurrectionaries with a propitious moment to proclaim a new emperor. Indeed, this step had become politically imperative. To consolidate and legitimize the rebellion and attract vital outside support, the rebellion needed a figurehead, an alternative Son of Heaven. But it would not be Liu Po-sheng. Their brief association with the Nanyang aristocracy had provided the peasant army commanders with a practical crash course in political intrigue, and they knew that as emperor Liu Po-sheng would undoubtedly function as the creature of the nobility. So they preempted the nobles and proclaimed their own sovereign: Liu Xuan, a distant descendant of the late emperor Jingdi (156–141 B.C.E.). Several years earlier, Liu Xuan had been forced to flee Nanyang as the result of a particularly vicious feud, and he had spent the past year fighting alongside the troops from Pinglin; now, taking the sovereign title of Gengshi, he ascended the throne on March 11 of the year 23, in a ceremony on the shores of the Yu River, just south of Wan. Following the customary practice of a new regime, Gengshi proclaimed a general amnesty and announced that his reign would be known as "A New Beginning." Messengers spread out through the countryside, proclaiming the good news as they denounced Wang Mang and his perfidious crimes.

Back in Chang'an, Wang Mang was not at all pleased by this turn of events. So long as the opposition had consisted of uneducated and poorly organized peasants—"a crowd of thieves," one top-level adviser sniffed in disdain, "like dogs or sheep that have gathered together"—Wang Mang had scorned the danger. The formal investment of a rival emperor of the Liu clan, however, and the involvement of

a growing number of gentry in the insurrection created serious concern in the palace. Wang Mang's schizophrenic reaction was typical of the man. After taking the eminently practical step of sending several armies totaling four thousand soldiers—designated as the Tiger Teeth Troops and the Troops of the Five Majestic Principles—into the field, armed with an edict promising a generous bounty for the heads of the rebel leaders, the emperor took refuge in magic and the wisdom of his beloved classics. As a visible sign that he was not unduly concerned about the unrest in the provinces, Wang Mang dyed his hair and beard (this is, incidentally, the earliest recorded instance of dyed hair in Chinese history) and then reorganized his harem according to the practices prescribed in the *Book of Odes,* marrying a daughter of the powerful Xi clan and promoting the prescribed number of concubines to the status of Harmonious Ladies (three), Spouses (nine), Beauties (twenty-seven), and Attendants (eighty-one).

As Wang Mang dallied with his ladies-in-waiting and his astrologers, the rebel forces in Nanyang united in an uneasy alliance under the Gengshi emperor's direction. By the early spring they had conquered virtually all of the surrounding area, save for the capital of Wan. At the end of April, they pushed northward into Yingxuan commandery, gathering much-needed provisions and new recruits, including some deserters from the government troops that Wang Mang had dispatched to stop them. At the same time, the Red Eyebrows—still the largest independent fighting force in China, having remained outside the Nanyang coalition—continued their inexorable march westward, crushing all imperial resistance in their path. Instead of attacking Chang'an directly, however, they veered off to the north, until they found themselves hemmed in by one of the newly created branches of the Yellow River. There they rested for a while.

On July 4, the city of Wan at last surrendered to the Gengshi emperor, who made the wealthy metropolis his temporary capital.

Meanwhile, Wang Mang's main army of three hundred thousand soldiers awaited approximately seventy miles away, besieging a town called Gun'yang (about three hundred miles southeast of Chang'an), which had recently been captured by pro-Han forces. Determined to make an example of Gun'yang, the commander of the imperial troops, Wang Yi (a.k.a. the Minister of Grand Works and the Tiger Teeth General), contemptuously rejected the rebel garrison's offer to surrender. "Wherever an army of a million passes," he boasted, "it is due

to annihilate the enemy. We will now massacre the defenders of this city, trample in blood, and then advance. The van will sing and the rear will dance; would that not be enjoyable?" But Wang Yi had forgotten the sage advice of the general Sun-tzu and the classic handbook *Military Methods*: "When an army wishes to return home, do not stop it; in besieging a city, leave an opening for them."

Under cover of darkness, a rebel lieutenant general named Liu Xiu, a younger brother of Liu Po-sheng, slipped out of Gun'yang and raised a relief brigade from the surrounding countryside. When he returned and began to pummel Wang Yi from behind, the rebel garrison broke out of Gun'yang and trapped the imperial troops in a deadly vise. Amid the howling of a fearsome thunderstorm—"a great wind blew away tiles, and the rain was as if water were being poured down"—the government troops broke and ran. Most of them threw away their weapons and fled back to their homes; by the time Wang Yi's retreating columns reached the secondary capital of Luoyang, he had only a few thousand soldiers left.

Like lightning in a black sky, this crushing defeat sounded the death knell for the Xin dynasty. Disorder spread throughout the disintegrating empire in a chain reaction, as chaos fed upon itself. Secondary insurrections erupted all around the Yellow River basin, led by opportunistic warlords, discontented nobles, displaced bands of peasants, secessionist tribal chieftains, and disloyal, self-seeking government bureaucrats. Most of these proceeded independently of the central uprisings of the Red Eyebrows and the Gengshi emperor's forces, but the peasant commanders who—for the time being—dominated the Gengshi court feared that the ever-widening rebellion might seduce the powerful Liu clan of the Nanyang gentry away from their alliance and into cooperation with other aristocrats. As a preemptive measure, therefore, they brought trumped-up charges of treason against the aristocrat who remained their most dangerous rival—Liu Po-sheng—and sentenced him to death. Liu Po-sheng's brother, Liu Xiu, the officer who had played such a critical role in the rout of the government troops at Gun'yang, judiciously decided not to protest the execution of his kinsman, and was accordingly rewarded with a promotion to the rank of general in the service of the Gengshi emperor.

While the battered remnants of the imperial armies strove to defend Luoyang against the rebels' advance, Wang Mang worked and worried himself into exhaustion. Existing on a meager diet of shellfish

and wine, he spent hour after hour reading texts on military strategy until he fell asleep in his chair in the early morning hours. As the Xin dynasty crumbled, even Wang Mang's personal staff deserted him. In August, an informant brought the emperor evidence of a conspiracy at the highest levels of the imperial household, involving the General of the Guard, the State Master, and the Commander-in-Chief himself. Arrested and confronted with the details of their betrayal, the first two men committed suicide; the third was beheaded and his family buried alive in a pit, along with a gruesome cache of lethal poisons, vinegar, masses of thorns, and vicious double-edged daggers to prevent their ghosts from rising out of the grave.

On September 2, the armies of the Gengshi emperor marched out of Wan. Within two weeks they had captured Luoyang. Frantic, Wang Mang lashed out at the ancestral spirits of the former Han dynasty, defiling their temples in Chang'an with axes and black paint in hopes of erasing their memory from the minds of his subjects. Then he betook himself to the southern edge of the capital, where the emperor regularly sacrificed to the gods. He reminded the deities of the supernatural portents they had issued to reveal his selection as the Son of Heaven, and he issued a final plaintive appeal for divine justice: "Since thou, August Heaven, hast given thy mandate to thy subject, Mang, why doest thou not immediately order extirpated the bands of troops and the robbers? But if thy servant Mang has done wrong, I wish that thou wouldst send down thy thunderbolt to execute thy servant Mang." Wang Mang wept, beat his breast, and threw himself facedown on the ground, but nothing happened.

At the end of September, the armies of the Gengshi emperor stormed through the Wu Pass, the eastern entrance to the plateau of Chang'an. Ringed by mountains, the capital was easily defended against all but the most massive assaults; but once an enemy force had bludgeoned its way through the passes, Chang'an became a deathtrap, for the defenders were left with no escape route. Sensing the imminent fall of the Xin dynasty, the populace rioted in the suburbs of the city; the local nobility hastily assembled armed gangs of retainers and, greedy for plunder, joined the rebellion. They broke through the Capital Gate on October 4 and swarmed into Chang'an, scattering a motley brigade of convicts who had been drafted, much against their will, by Wang Mang, in a last-ditch attempt to defend the city.

The following day, a band of young rebels set fire to the Weiyang Palace and waited for the emperor to appear, taunting him with the

chant "You rebellious peasant, Wang Mang; why do you not come out and surrender?" The flames spread to the imperial harem, where Wang Mang had sought solace in the arms of the Princess of the Yellow Imperial House. Amid the wails of his concubines, the emperor fled to the Xuan room and, with the stench of smoke all round him, begged the Supreme One for protection. "Heaven bestowed the virtue that is in me," he cried out, over and over again. "The Han troops—what can they do to me?"

By dawn the next day Wang Mang was too weak to move. His servants carried him to his chariot and drove him to the Tower Bathed by Water, a terraced pond whose reputed magical powers represented his last line of defense. Shielded by several hundred loyal followers, Wang Mang held in his arms the scrolls and inscriptions that represented the visible evidence of Heaven's mandate. Informed of Wang Mang's whereabouts by a frightened concubine, the rebel archers advanced toward the terrace and engaged in a brief duel with the defenders; when the imperial bowmen had exhausted their sparse supply of arrows, they reached for their daggers and died in hand-to-hand combat.

As his retainers made their final futile stand, Wang Mang retreated to the top of the tower, where he hid in the northeast corner. Just before the sun went down, the invaders mounted the stairs and broke into the emperor's room.

Wang Mang was slain by a butcher who apparently had no idea who his victim was. As soon as an officer identified it, Wang Mang's body was sliced into tiny pieces; scores of soldiers fought for one of the grisly trophies.

When she heard of her father's death, Wang Mang's daughter, the widow of Pingdi, called out piteously, "How can I face the House of Han!" and threw herself into the flames of the burning palace.

Wang Mang's head was carried back to Wan and presented to the Gengshi emperor; he declared himself disappointed with the usurper's unworthy features, especially his bulging eyes and receding forehead. The head was then put on public display in the marketplace of Yuan, where the people threw stones and garbage at it. Some even cut out Wang Mang's tongue and ate it. His epitaph was written by Pan Ku, the court historian of the Later Han dynasty; like the ferocious first emperor of the short-lived Qin dynasty more than two hundred years before, Wang Mang was officially condemned as a "dragon who had flown too high, and whose breath was cut off."

The new imperial government spent the rest of the year in mopping-up operations, subduing the last bastions of Wang Mang's adherents. Diplomatic missions fanned out from Wan, traversing the empire to obtain the allegiance of warlords and clan chieftains to the Gengshi emperor; one of the three official messengers sent to the provinces north of the Yellow River was Liu Xiu, brother of the late Liu Po'sheng. Out of sight of the Gengshi court, Liu Xiu was able to formulate his own covert plans for seizing the throne of Heaven.

By the end of the year 23, nearly forty percent of the Chinese empire—including the most economically vital regions around Chang'an, Luoyang, and Wan—lay under the control of the Gengshi emperor. Save for a few changes at the very top, the imperial bureaucracy proceeded with business as usual, essentially unaffected by the change in sovereigns. Many families of minor government officials had deliberately placed representatives in both camps during the rebellion, to maintain their influence and position no matter which side won; when it became clear that the Xin dynasty's days were numbered, those who had sided with Wang Mang deserted en masse to the Gengshi emperor. Besides, there was such a scarcity of educated, literate civil servants that the new regime could scarcely have done any wholesale housecleaning even if it had wished to.

But the army of the Red Eyebrows remained intact and dangerously discontented. Although the commanders of the Red Eyebrows had offered their loyalty to the Gengshi emperor at the end of the year, they had been awarded only empty titles of honor, with no significant authority and no revenue-producing fiefdoms. Shut out from the privileged inner circle of the Gengshi court, the disappointed chieftains withdrew from the capital, kept their troops together, and waited.

And all around the countryside, in every direction, there arose a dozen pretenders to the imperial throne, each of whom proclaimed himself the Son of Heaven, while scores of minor warlords sought to carve out their own independent kingdoms. The civil war in China had just begun.

The Spider in the Center of the Web

Rome and Capri, 23–26 C.E.

> Nobody willingly submits to being ruled, but a man is driven to it against his will; for not only do subjects delight in refusing obedience, but they also enjoy plotting against their rulers.
>
> —TIBERIUS CLAUDIUS NERO

D rusus would have to die, Lucius Aelius Sejanus decided. Of course this had been painfully obvious ever since the death of Germanicus, but recent events had forced the hand of the ambitious commander of the Praetorian Guard. The two men, both strong-willed and arrogant, had come to despise each other. Certainly Drusus made no secret of his jealousy of Sejanus, whom he saw as a rival for his father's affection and trust; more than once, Drusus had been heard to complain that Tiberius, in relying so heavily upon Sejanus as a partner, was ignoring his own flesh and blood in favor of an outsider, and a lowly knight at that. For his part, Sejanus recognized clearly that Drusus represented the major stumbling block in his relentless drive to be the de facto ruler of the Roman Empire. Despite his extravagantly dissolute lifestyle, Drusus remained far more popular among the masses than the dour Tiberius; "better to spend the day enjoying shows and the night banqueting," noted one anti-Tiberian writer, "than to lead the emperor's isolated, joyless life of gloomy watchfulness and sinister machinations." Not long ago,

Drusus and Sejanus had actually come to blows during a heated quarrel, and though the emperor and his son had never been particularly close, Sejanus knew that Tiberius would not look kindly upon a physical confrontation between the heir apparent and himself. Before affairs got completely out of hand, the Praetorian prefect decided to end the rivalry once and for all.

Months earlier, the urbane and handsome Sejanus—who enjoyed a well-earned reputation as a ladies' man—had seduced Drusus' wife, Livilla, who perhaps had grown tired of her husband's orgies with his debauched actor friends and their never-ending quest for virgins. Whatever her original motive, she fell in with Sejanus' plans to murder Drusus. ("A woman who has parted with her virtue will refuse nothing," was Tacitus' acid explanation.) According to the later testimony of Sejanus' wife, Apicata, and two of Livilla's slaves, Sejanus supplied Drusus' favorite eunuch with a vial of slow-acting poison, which the slave administered to his master bit by bit, in imperceptible doses.

On September 14 of the year 23, Drusus died. Tiberius, who refused to show the public whatever grief he may have felt, delivered the eulogy for his son in the Senate. "I know that I may be criticized for appearing before the Senate while my affliction is still fresh," he told the sobbing legistlators, whose tears were probably shed less for Drusus than for themselves, now that they were facing the unappealing prospect of a Sejanus unrestrained by any rival. "Most mourners can hardly bear even their families' condolences—can hardly look upon the light of day," remarked Tiberius stoically. "I, however, have sought sterner solace. The arms in which I have taken refuge are those of the Senate." Then he commended to the Senate's care the two eldest sons of Germanicus, now the heirs apparent to the throne: Nero (who was engaged to the late Drusus' daughter, Livia Julia) and young Drusus. Tiberius might as well have signed their death warrants, for Sejanus now turned his baleful gaze toward the two boys and their mother, the imperious Agrippina, who as the widow of Germanicus, the daughter of Julia and Marcus Agrippa, and the only remaining second-generation descendant of Augustus enjoyed such abundant public affection that she was popularly known as "the glory of her country."

Sejanus, on the other hand, was loved by few and feared by practically all of Rome. By birth, Lucius Aelius Sejanus was a member of the equestrian class: his father, Lucius Seius Strabo, had been a knight from Tuscany; his mother came from an ancient patrician

family. His meteoric ascent was the outstanding example in the early first century of the way in which the political and social changes accompanying the establishment of the Roman Empire opened a wide array of avenues for advancement by so-called new men, members of the minor nobility and freedmen. Under the Republic, the highest offices of state had been reserved for the aristocracy, though the Senate had often employed knights as financial administrators in the provinces to allow the patricians to keep their hands clean of the stain of collecting taxes or disbursing government monies. When Augustus—who (with good reason) never quite trusted the loyalty of the Roman nobility—assumed power, he made the equestrian class the core of his imperial bureaucracy, elevating a chosen few to the highest levels of government.

Sejanus himself wasted no time in marching through the doors opened by Augustus. At an early age, Sejanus had been adopted by a nobleman named Aelius Gallus, a former prefect of Egypt who was famous for his extraordinary profligacy. (The process of adoption, a modified form of the fundamental patron-client relationship upon which Roman society rested, was a traditional means of providing ambitious young men with an entrée into elite society, while extending the influence of the "parents" as their protégés climbed ever higher.) Then, before he turned twenty, Sejanus joined the army, the primary vehicle of social mobility under the principate, where young men of obvious talent and at least a modestly respectable lineage were brought to Augustus' attention and promoted quickly through the junior ranks of the officer class.

As one of his initial assignments, Sejanus had served as a staff officer to Gaius Caesar on that prince's ill-fated mission to the East. Then he had been transferred to the Praetorian Guard, where his father served as one of its two prefects. Shortly after Augustus' death in 14, Tiberius promoted Sejanus to serve as Praetorian co-commander with Seius Strabo, though the mutiny of the Balkan legions several months later forced the emperor to send him off to Illyricum with Drusus to quell the uprising. The following year, Strabo was appointed prefect of Egypt—a position that, according to the precedent established by Augustus, was always filled with a knight rather than a senator, on the assumption that any prominent patrician who commanded the resources of that strategically vital province might be tempted to essay a rebellion. Since Tiberius deliberately refrained from filling the vacancy created by Strabo's departure, Sejanus be-

came sole prefect of the Guard in the year 15, a post he held until his death.

An indefatigable worker, Sejanus eagerly accepted Tiberius' public challenge, originally made to the Senate, that "any officials who can offer enough severity and energy may, with my compliments, relieve me of part of my burdens." By his seemingly selfless devotion to his master's interests, he convinced Tiberius that he, above all other men, could be trusted. And Sejanus must either have been sincere or one hell of an actor to win the heart of the grim old soldier, for Tiberius soon came to refer to him with true affection, fondly calling him "my Sejanus," and "the partner of my labors."

In the absence of any institutionalized imperial bureaucracy with well-defined responsibilities, Sejanus was thus able to extend his personal authority throughout the administration. As the intimate confidant of the emperor, a sort of executive secretary through whom all the business of imperial government was channeled, Sejanus enjoyed access to every sort of private communication and secret information. It was widely believed that he knew everything that happened in Rome and in every corner of the empire. Since Tiberius in his old age was becoming increasingly inaccessible, or at least inhospitable to petitioners, any citizens who wished to file a complaint or beg a favor from the government went to Sejanus instead; every morning at dawn, one could see a queue of prominent Romans—including senators and even consuls—waiting outside the door of his house. And though it was highly unusual for statues of living mortals to be erected in the capital, likenesses of Sejanus began to appear in public places, including one striking bronze statue in Pompey's Theater which was donated by the Senate and Tiberius himself, in gratitude for Sejanus' yeoman work in quelling the fire that gutted the theater in the year 21.

It was about this time that Sejanus ordered the concentration of the entire Praetorian Guard, which hitherto had been scattered in separate bases around the capital, into one central barracks on the Viminal Hill, just outside the city limits. Sejanus defended this provocative move on the grounds that it would improve discipline, enhance morale, and shorten response time in emergency situations, but in reality it was precisely what it appeared to be to his contemporaries: an attempt to consolidate his own power base as sole commander of the Guard—which was still the only significant fighting unit in or around Rome. Then, in case some recalcitrant politicians still did not

get the message, Sejanus persuaded Tiberius to parade the Guard, in all its saber-rattling splendor, in front of the Capitol, in full view of the Senate. From that moment on, the Praetorian Guard began to evolve from its original function as the bodyguard of the emperor into an agency whose primary responsibility was to ensure internal security. To assure himself of the loyalty of his men, Sejanus provided them with extra pay and privileges that the regular legionaries lacked; and he personally selected their officers, a practice that also allowed him to curry favor with influential senators by awarding lucrative staff jobs to their relatives or clients. By the time of Drusus' death, the Guard—and indeed the entire top rank of the imperial administration—was honeycombed with Sejanus' informants and underlings, who functioned as a highly efficient internal surveillance network.

At first, few citizens outside of Rome paid any attention to the rise of Sejanus, and indeed there was no good reason why they should. With the exception of a brief flare-up in the East and few chronic trouble spots such as Judea, the first dozen years of Tiberius' reign were characterized by peace, public order, and widespread prosperity. According to the Jewish author Philo, a resident of first-century Alexandria in Egypt, Tiberius "gave peace and the blessing of peace to the end of his life with ungrudging bounty of hand and heart." If Tiberius' devotion to duty made him one of the dullest men alive, it also made him one of the most competent emperors Rome ever knew. Determined to keep provincial unrest to a minimum, Tiberius reproved or removed imperial officials who dealt too harshly with their subjects. To suppress banditry, additional military posts were established along the empire's main highways, and riots in the cities were crushed with an overwhelming display of force. Free of the dreadfully expensive military emergencies that had marred the last decade of Augustus' regime, Tiberius had no need to impose heavy new taxes. Food prices did continue to escalate, but Tiberius took most of the sting out of the inflationary cycle by granting government subsidies to keep the cost of bread at a reasonable level. And the military remained obedient and relatively content; there were enough minor skirmishes with the natives in Gaul, Germany, and North Africa to keep them sharp and provide a little extra loot, but there were no major campaigns and very few casualties.

In fact, it was really only among the political elite of Rome that the pernicious effects of Sejanus' advance manifested themselves. It began in the year 22, while Germanicus' sons were still too young to

challenge his authority, when Sejanus started to use the Roman legal system to dispose of his opponents by invoking the law of *maiestas* (treason) and branding them as conspirators. Here was a strategy perfectly calculated to appeal to the emperor's notoriously suspicious nature, for Tiberius had never really been able to rid himself of the republican convictions of his youth; he was often heard to say that free men did not willingly submit to the shackles of despotism, no matter how benevolent. So, according to his own political philosophy, he expected rebellion against his regime and was more than willing to credit Sejanus' accusations when the prefect laid even the flimsiest evidence before him.

Before the advent of Sejanus, Tiberius had managed to keep his fears and suspicions under control. He had repeatedly defended the right of Roman citizens to voice their political views openly, and he stubbornly resisted the Senate's prodding to prosecute his most outspoken critics. "We cannot spare the time to undertake any such new enterprise," Tiberius chided the assembly. "Open that window and you will let in such a rush of denunciations as to waste your whole working day; everyone will take this opportunity of airing some private feud."

Treason and conspiracies against the life of the emperor, however, were a much more complex matter. In formal cases of treason, as in most other legal proceedings, Tiberius refused to intervene, insisting that "the laws must take their course," unless of course the laws were being twisted out of all recognition. But that was precisely what appeared to be happening with increasing frequency to the law of *maiestas*, which had originally developed as a senatorial weapon against inept military commanders who by their incompetence had imperiled the safety of the state during the declining years of the Republic. By the time of Tiberius, this measure had been transformed into a weapon of judicial terror that allowed citizens to pursue their personal vendettas in the courts. Since there were no official government prosecutors, any citizen who wished to bring an accusation against another could do so by simply filing a complaint and then presenting the evidence before the court. The system also encouraged the exploitative use of informants, because the accusers and witnesses for a successful prosecution were all entitled to a share of the loot when the court appropriated the guilty party's property. By the same token, witnesses for the defense were deterred by the possibility that they might be tarred with the brush of guilt by association if the

defendant were convicted. Under Augustus, the law—which had originally applied only to deeds—had been extended to include treasonous or libelous utterances as well.

Before the death of Drusus, Tiberius had faced only a few minor, amateurish conspiracies that he had quashed with a minimum of difficulty. (Whenever he heard rumors of a plot, Tiberius' initial reaction was to investigate the horoscopes of the alleged ringleaders, to determine if their destiny was sufficiently promising to pose a real threat to his government.) But the emperor's growing weariness and impatience with the burdens of government, and his mounting fears for his own safety—subtly encouraged by Sejanus—eventually exhausted his tolerance, and allegations of treason and libel began flying thick and fast. In 23, Tiberius stunned the capital by bringing charges against a dilettante who had recited some scurrilous and probably seditious poems about him. After the Senate convicted the unfortunate satirist, he was taken to the Tarpeian Rock and thrown to his death down the Capitoline Hill.

Soon it became a capital offense to insult the divine Augustus by changing one's clothes (and hence displaying one's naked posterior) within sight of a statue of the late emperor. Anyone who carried a coin or ring bearing Augustus' likeness into a whorehouse or bathroom was likewise liable to punishment. Provincial cities that neglected the worship of Augustus were deprived of their privileges. In the year 25, an eminent elderly historian named Cremetius Cordus was put on trial, ostensibly for praising Brutus and Cassius (whom he called "the last of the Romans") as honorable men—and hence indirectly condemning Augustus—in his writings. The real reason for his prosecution, however, was that he had run afoul of Sejanus. When it became clear that he would receive no help from Tiberius, Cordus starved himself to death. The government pulled his books off the shelves and burned them all.

Tiberius no longer cared. Sixty-nine years old, weary of the drudgery and friction of politics, and sick of his mother's incessant nagging, the emperor left the capital on a business trip to dedicate temples to Jupiter and Augustus in the countryside of Campania. Tiberius generally despised this sort of ceremonial public appearance—before the tour commenced, he ordered the Guard to keep everyone away from him, and stationed troops in the towns along the route to disperse crowds of curiosity-seekers—but anything was better than the stifling existence he had been living in Rome.

He never set foot in Rome again.

Traveling with only three close friends, including Sejanus, and a few Greek poets and astrologers, Tiberius sailed to the island of Capreae (modern Capri). Longing for calm, seclusion, and peace, he fell in love with the island's Greek culture, its blissfully mild climate, the beautiful bay encircling it—and most of all, its extreme inaccessibility. The mainland was three miles away. There were no good harbors along the entire coastline of Capreae and only two landing places for small boats; with sentries stationed along the top of the cliffs, it was impossible for anyone to approach the island unobserved.

Almost as soon as he and his entourage had settled into a suite of twelve grandiose villas atop the eastern heights, Tiberius was recalled to the mainland briefly to inspect the scene of an appalling tragedy: in the town of Fidenae, a jam-packed amphitheater, jerry-built with inferior materials by a former slave who was trying to make a quick buck, had collapsed during a gladiatorial contest. Between twenty and fifty thousand men, women, and children were crushed to death or suffocated beneath the rubble. Tiberius supervised the relief efforts, granted donations to the families of the victims, and then returned to Capreae.

The Fox and
the Prophet
Galilee and Perea, 27–29 C.E.

> Now in the fifteenth year of the reign of Tiberius
> Caesar, Pontius Pilate being governor of Judea, and
> Herod being tetrarch of Galilee . . . the word of God
> came to John the son of Zechariah in the wilderness.
>
> —The Gospel of St. Luke

H erod Antipas was helplessly in love. Unfortunately, he was also in deep, deep trouble, because the object of his affections—a middle-aged Jewish noblewoman named Herodias, whom Antipas had met during a recent trip to Rome where he had gone to discuss affairs of state with Sejanus—was not only his niece (the daughter of his half-brother Aristobulus) but, more to the point, was already married to another one of his half-brothers, Herod Philip. Hence a union between Herodias and Antipas would be a flagrant breach of the Jewish scriptural law which specifically forbade a man from marrying his brother's wife so long as that brother was still alive. Furthermore, Antipas already had a wife, to whom he had been married for nearly thirty years. But none of this mattered very much to the love-smitten prince. Obsessed by his desire, Antipas insisted that Herodias divorce Philip and return home as his wife; eventually she consented.

It was one of the few rash moves Herod Antipas ever committed. By the end of the year 27, he had established himself as one of the

most capable rulers in the Mediterranean world. Over the past three decades, ever since the death in 4 B.C.E. of his father, King Herod (who was awarded the posthumous appelation "the Great"—meaning "the Elder"—only to distinguish himself from his sons and grandsons), Herod Antipas had ruled his provinces of Galilee and Perea with a skillful balance of firmness and delicacy, successfully navigating a course between the competing political demands of Rome, the Jews, and the large Gentile population in the northern half of his principality.

Like his father, Antipas was a devotee of Hellenistic culture, expressing his admiration through an impressive program of public construction. He completely rebuilt Sepphoris, the original capital of his principality, after Roman troops leveled it in retribution for the Galileean uprisings following the death of Herod in 4 B.C.E. When the reconstruction was complete, Antipas—always searching for creative ways to curry favor with Rome—changed the name of the city to Autocratoris ("Of the Emperor"). He also rebuilt the town of Bethramphtha—his father's primary residence in Perea—which had been burnt to the ground by rebels during the same time of troubles, and renamed it Livias in honor of Augustus' wife. (Honoring rulers in the Roman world was no easy task; when Livia later changed her name to Julia, Antipas had to change the name of the city to Julias.) Finally, between the years 19 and 20, Antipas erected a whole city from scratch on the west bank of the Sea of Galilee, called it Tiberias after the reigning emperor, and made it his new capital. At first, most Galileean Jews literally avoided Tiberias like the plague, because Antipas had built it over an ancient graveyard, thereby rendering it unclean ground according to the prescriptions of the Torah. It took several royal edicts forcibly relocating Jewish farmers and ex-slaves from the surrounding countryside to provide the capital with a level of population commensurate with its political importance.

More than just an expression of his architectural preferences, Antipas' extensive urban building program was actually a calculated effort to bolster the stability of his regime, because, like his father, Antipas found his greatest political support among the city-dwelling segment of the population, most notably among Gentiles and wealthy hellenized Jews. His traditional Jewish subjects regarded him with considerably less enthusiasm. His pedigree was hardly impeccable: his father had been an Idumean, and his mother had come from the despised half-breed stock of Samaria. Then, shortly after he assumed his throne (his subjects referred to Antipas as a king even though he

was actually only a tetrarch in the Roman imperial hierarchy), Antipas offended pious Jewish sensibilities even further by consummating a marriage—probably for reasons of state—with an Arab princess from the seminomadic kingdom of Nabatea that stretched out across the desert to the southeast of Judea. Fortunately for Antipas, the Jewish inhabitants of Galilee and Perea were never as intolerant or reactionary as their brethren in Jerusalem—after all, they had only been converted to Judaism themselves several centuries earlier. Besides, Antipas, whatever his faults, was at least a Jew and not a Roman, unlike the recently installed prefect of Judea, an Italian knight named Pontius Pilate. Hence there is no record of any organized party of opposition to Antipas for the first thirty years of his reign.

Then along came Herodias. Initially, it seemed that the damaging repercussions of Antipas' infatuation with his sister-in-law would be limited to the arena of regional diplomacy. While the happy couple were disporting themselves in Rome, Antipas' Nabatean queen heard rumors of her husband's intention to seek a divorce and immediately betook herself for safety to the fortress of Machaerus near the Arab frontier, whence she fled to her father's court after Tiberius gave his assent to Antipas' marital plans. Normally Tiberius might have been reluctant to sanction such a match, since it provoked precisely the sort of discord between two Roman vassals—Antipas and the Nabatean king, Aretas—that he had always worked so hard to prevent. But the emperor was persuaded by the fact that Herodias' mother, Berenice, was a bosom friend of his own sister-in-law, Antonia, the widow of his late brother, Drusus. So the divorce went through and Antipas married Herodias; humiliated and furious, King Aretas set to work plotting his revenge upon Antipas.

Unexpectedly, however, the most troublesome opposition to the marriage arose within Antipas' own principality. Soon after Antipas returned to Tiberias from Rome, there appeared on the fringe of his realm a radical and uncompromising religious fanatic named John. The only son of a Temple priest named Zechariah, John in his early thirties took up the life of an itinerant preacher, conducting most of his ministry in the bleak, stony wilderness of Perea along the River Jordan (at that point, the boundary with Judea) just north of the Dead Sea. Announcing himself as the direct heir of the rich prophetic tradition of Israel, which had remained generally quiescent for the past four hundred years, John was regarded by many of his contemporaries as the reincarnation of the great prophet Elijah—who had purportedly

ascended to heaven in a flaming chariot from the banks of the Jordan nine centuries earlier, vowing someday to return—or perhaps his successor Elisha, who was said to have worked healing miracles with the Jordan's sacred waters.

Certainly John was an ascetic of the first order; he had raised a life of self-denial to such an exalted level that his Jewish brethren regarded him with an uneasy mixture of awe and fear. Dressed only in a rough coat of camel's hair tied by a leather belt around his waist, John reportedly subsisted on a diet of locusts and wild honey, which were practically the only fruits of the desolate wasteland he had chosen as his home.

From the vantage point of his elegant mansion in Tiberias, Herod Antipas might initially have dismissed John as just a particularly vocal and fractious representative of one of the pietist Jewish sects known collectively as Essenes. Although the origin of the name is obscure, by the early first century the term *Essene* was being used as a sort of umbrella description under which all sorts of semimonastic and millennial groups were gathered; the first-century historian Josephus, who claimed to have resided in an Essene community for several years during his youth, considered them so important that he listed them as one of the three major forces in contemporary Jewish spiritual life, along with the Pharisees and the Jerusalem-based Sadducees.

At the time John began his prophetic ministry, there reportedly were several thousand Essenes living in Judea, Galilee, and Perea. While some resided in cities or towns, where they pursued ordinary, everyday occupations, most lived in the hills or the desert, in closed settlements far removed from the contaminating distractions and temptations of temporal civilization. They adopted a communal lifestyle, sharing their food and their possessions among themselves according to their needs and among outsiders as the dictates of mercy demanded. These Essenes also shared a common discipline: rising each morning before the sun to recite their ancient prayers, they worked silently in the field or at their chosen crafts until the fifth hour (around noon), when it was time to bathe themselves in cold water to purify their bodies and don ceremonial white linen robes before breaking bread together; after lunch, they changed back into their work clothes and resumed their tasks until the evening meal. In routine matters, Essene communities were governed by "curators," the forerunners of abbots and curates in medieval monasteries; in extraordinary situations, such as the expulsion of a wayward member, deci-

sions were made collectively, by the will of the majority of the entire community.

Given their attitudes toward females—"They guard against the lascivious behavior of women," explained one observer, "and are persuaded that none of them preserve their fidelity to one man"—it was not surprising that Essene communities were apparently almost exclusively male; most of their members rejected sexual relations and human passions as evil, though the presence of women and children was not absolutely forbidden in all cases. Because of their quest for a higher spiritual consciousness, Essenes also scorned the traditional Jewish practice of animal sacrifice (and hence were seldom found in the vicinity of the Temple in Jerusalem, whose priests they condemned as hopelessly corrupt) and abhorred the contemporary practice of anointing with oil, which they considered a sign of excessive wealth, preferring instead their own ritual ablutions with water. They considered the Sabbath strictly inviolable. Not only did they refuse, like the Pharisees, to work or even cook on the Lord's day, preparing their meals on the sixth day so they would not have to kindle a fire or lift a pot on the seventh, but a devout Essene also considered it an offense to defecate on the Sabbath. In short, as Josephus summarized the metaphysical Essene creed, "their doctrine is this, that bodies are corruptible, and that the matter they are made of is not permanent; but that the souls are immortal, and continue for ever, and that . . . when they are set free from the bonds of the flesh, they then, as released from a long bondage, rejoice and mount upward."

Their preoccupation with otherworldly matters rendered most Essene communities unobjectionable to the political authorities; in fact, since most Essenes believed that all rulers held their office by the will of God, they scrupulously refrained from any organized opposition or disobedience to the government, although they did resist all attempts by the secular authorities to force them into military service. But there were numerous splinter groups outside the mainstream of Essene philosophy that were less willing to eschew violence to achieve the final victory of righteousness on earth.

Perhaps the most militant of these factions was located at Wadi Qumran, a settlement founded approximately one hundred and fifty years earlier at the northern edge of the Dead Sea overlooking the hills of Moab. Physically, it was a bleak, heartbreaking region of relentless heat, swirling winds, and barren rock, where men went mad and visions were commonplace and devils seemed to lurk in the lonely

emptiness. It was here that the warrior-monks of Qumran isolated themselves from the contamination of the world to preserve a remnant of the righteous, to study the apocalyptic message of their master, the Teacher of Righteousness (for whose return they fervently prayed), and to prepare for a holy war and the final battle on the Day of Judgment.

On that climactic bloody day—which the Qumran community expected in the very near future—the forces of God (the Sons of Light) would arise and slay the Sons of Darkness (i.e., Rome and the apostate hellenized Jews), in accordance with the ancient prophecy that "a star shall come forth from Jacob, [and] a sceptre shall rise from Israel." "There shall gather together for the great slaughter a congregation of angels and an assembly of men," predicted the Qumran *Battle Manual*, "doing battle together to reveal the might of God, with the sound of a great tumult and the battle cry of angels and men at the day of destruction." Written on leather scrolls sewn with flaxen threads, this manual, which may have evolved out of a prolonged visionary or hallucinatory experience by one or more of the Qumran leaders, provided the community with detailed instructions on the assigned roles of the various members of the community during the forthcoming conflict, to ensure the purity of God's warriors:

> The officers . . . shall be forty to fifty years old. Those who strip the slain, who take the plunder, who clean the land, who guard the equipment, and who serve the rations—all of these shall be twenty-five to thirty years old. No mere lad or woman shall come into their camps from the time when they leave Jerusalem until their return. No one who is lame, blind, or paralytic, no one who . . . is afflicted with an uncleanness in his flesh—none of these shall go with them to battle. They shall all be volunteers for the war, perfect in spirit and body, and ready for the day of vengeance.

According to the manual, the battle would begin with an exhortation by a specially ordained Qumran priest ("Do not be alarmed nor tremble before [the enemy]. . . . Their defenses and their power are dissipated like smoke"), followed by an infantry attack by three battalions armed with javelins inscribed with such names as The Lightning Flash of a Spear for the Power of God; then an assault with spear and shield by two more battalions, climaxed by a blast on a ram's horn by the priests "to control the battle until the enemy is defeated and

turns his back." Whereupon a New Covenant would be sealed between God and the faithful remnant of Judaism, to usher in the Kingdom of Heaven on earth.

All in all, it was not exactly the sort of scenario to which Herod Antipas might have been expected to enthusiastically subscribe. For the militant Jews at Qumran, unlike their cousins the Essenes, there was no valid distinction between heavenly power and temporal authority, or between religion and nationalism. They confidently expected that Antipas, the Sadducees, and perhaps the Pharisees, too, would all be swept away in the cataclysm that was fast approaching. And this undercurrent of anticipation that the Judgment Day was close at hand when all of Israel would be forced to choose sides was precisely what made the solitary figure of John—who now appeared suddenly in the desert not far from the Wadi Qumran—so dangerous to Antipas.

John's message drew heavily upon the tradition of the Essenes in general and the Qumran community in particular. Like them, John emphasized the importance of baptism as a purification ritual, a physical reflection of the spiritual cleansing of the human soul. But John, who may well have spent some time at Qumran before venturing out on his own, elevated the baptismal ceremony to an even higher level of importance and made it the central focus of his ministry. While other *haverim* baptised themselves, John baptized others in the name of God's mercy; and in his hands, the ritual was not something to be repeated on a daily basis, but a transcendent, once-in-a-lifetime experience for each individual. For those who truly repented of their sins—and John insisted that a contrite heart was an essential prerequisite for God's forgiveness—the rite of baptism signaled their acceptance into the kingdom of God, a visible sign that they had joined the angels in anticipation of the forthcoming apocalypse.

Although John had separated himself from civilized society, as had his brethren in the Qumran community, he obviously had not withdrawn altogether from humanity. His message was not reserved for any one economic class, or alone for those faithful Jews who had done their best to keep the Law; so long as they repented of their sins, John readily welcomed even such social pariahs as Jewish auxiliary soldiers in the Roman legions, and tax collectors, who were shunned for their collaboration with the corrupt alien ruling regime and their extortion of monies from their Jewish brethren. After their baptism, of course, these converts were expected to change their lifestyles

radically; no longer would the taxmen cheat their prey, nor would the troops bully civilians or steal money from them. Again reflecting the antimaterialistic influence of the Essenes, John urged all his listeners not to amass treasures on earth but to share their wealth with the less fortunate: "He that has two coats, let him give one to him that has none; and he that has meat, let him do likewise." For the pious Jews (including, no doubt, a number of Sadducees and Pharisees) who insisted that their scrupulous observance of the Law rendered baptism unnecessary, John had nothing but contempt. "O generation of vipers, who told you that you could escape from the punishment God is about to send?" he shouted to the crowds who hung back on the shores of the Jordan. "And do not say to yourselves, 'We have Abraham for an ancestor,' for I say to you that God can take these rocks and make descendants of Abraham."

Again and again John was asked, "Are you the Messiah, the Chosen One, the Deliverer of Israel whose coming was foretold by the scriptures?" And each time he replied that he was not, quoting the words of the prophet Isaiah:

> A voice cries out:
> Prepare in the wilderness
> the way of the Lord,
> Make level in the desert
> A highway for our God.
> Every valley must be raised,
> And every mountain shall be brought
> low;
> And the crooked roads shall be made
> straight,
> And the rough paths shall be made
> smooth,
> The presence of the Lord shall appear,
> And all flesh shall see it together.

"And now also the axe is laid to the root of the trees," he told the people, "therefore every tree which does not bring forth good fruit will be cut down and cast into the fire. I baptize you with water, but one mightier than I cometh . . . who shall baptize you with the Holy Spirit and with fire. He has his winnowing shovel in his hand, to thresh all the grain and gather the wheat into his barn; but he will burn the chaff in a fire that never goes out."

By all accounts, the Baptist's solitary ministry proved remarkably successful, a development that enhanced Herod Antipas' sense of security not at all. The fact that John was preaching in an area not far from the border between Perea and Nabatea caused Antipas intense concern, as did John's implacable opposition to his marriage with Herodias. Probably the thought crossed Herod's mind that John might be a Nabatean agent, with orders to foment discontent along the frontier. For tension and restlessness were growing among the Jewish population of Perea and Galilee, and even in Judea itself, where procurator Pontius Pilate, who had assumed office in the year 26, had already suffered several confrontations with zealous Jewish patriots.

As John journeyed up and down along the lower reaches of the Jordan River, sometimes wandering as far away as Samaria, seeking new converts and winning a solid core of disciples, Jews came from hundreds of miles away to seek his confirmation of God's forgiveness for their sins. Presumably they departed with an exhilarating sense of spiritual liberation and grace. An account exists of one such experience undergone by a young Galilean named Jesus (Joshua in Hebrew) when he was about thirty years old—just a few years younger than the Baptist himself. According to a first-century source, when Jesus was baptized by John in the Jordan, he felt the heavens open to him, and he saw a blinding light, and sensed a holy spirit descending upon him. And he heard the voice of God saying, "You are my beloved Son; in you I am well pleased." It was such an overpowering and intensely personal mystical experience that Jesus retreated into the desert, alone, for forty days, during which time he fasted and prayed for guidance.

The Baptist, meanwhile, continued his mission.

For a year or so, Herod permitted John to preach unmolested by the government, on the assumption that any attempt to arrest him would provoke more trouble than allowing him to remain at liberty. Furthermore, Herod appears to have been genuinely intrigued as well as irritated by John's highly unconventional ministry. Finally, however, the rising tide of agitation—and perhaps a few well-chosen words from his wife, who had become exasperated with the prophet's endless stream of denunciations—convinced Antipas that he had to seize John and imprison him in the dungeons of the royal fortress at Machaerus.

The Baptist would not emerge alive.

The Monstrous Fool

Rome and Capri, 26–30 C.E.

> Give us back Germanicus!
>
> —GRAFFITI ON WALLS IN ROME

All his life Claudius had been an object of ridicule and scorn. From the moment of his birth—perhaps premature—on August 1 in 10 B.C.E. at Lugdunum (Lyon), the capital of Gaul, it was obvious that the boy named Tiberius Claudius Drusus was not quite right. His own mother reportedly shunned him with the disgusted comment that he was "a monster . . . whom Nature had not finished but merely begun." As a child, Claudius stuttered and stammered; chronic illnesses left his muscles slack and his arms and legs feeble; at times his face twitched uncontrollably; his nose ran almost incessantly; and he had a most repulsive habit of drooling out of the corner of his mouth.

In short, Claudius was hardly the sort of offspring one might have expected from a union of the venerated soldier Drusus, the brother of Tiberius, and Antonia, the daughter of Marc Antony. He suffered even more from the inevitable comparisons with his only brother, Germanicus, the darling of the Roman people, who cut such a splendid figure in martial attire. In an aristocratic civilization, which prized physical prowess and comeliness and viewed deformity as a mark of idiocy or degeneracy, Claudius found himself an outcast within his own family. His father, unfortunately, died when Claudius

was still an infant, and maternal affection for the poor boy was so lacking that Antonia was wont to insult her foes with the taunt that they were "a bigger fool even than my son Claudius!" Great-aunt Livia, wife of Augustus, avoided the boy's presence as much as possible and prayed publicly that Rome might never be subjected to the misfortune of being ruled by such a sniveling dolt. Not surprisingly, Claudius' uncle Tiberius, that paragon of social snobbery, likewise treated him as a retarded child, and attempted to keep him hidden away from public view as much as possible. Later, Tiberius went so far as to hire a retired army mule driver as a "tutor" to beat some sense and a proper respect for decorum into the teen-aged Claudius.

Only Augustus, whose own physical limitations allowed him to rise above the prejudice of his class about such matters, recognized the latent abilities within that unseemly form. "I am sorry for the poor fellow," he once wrote to Livia, "because in serious matters, when not wool-gathering, he shows a very decent character." And, even more strongly, in another note to his wife, the emperor remarked that "I'll be damned if your grandson Tiberius Claudius hasn't given me a very pleasant surprise! How on earth anyone who talks so confusedly can nevertheless speak in public with such clearness, saying all that needs to be said, I simply do not understand." In the end, however, Augustus feared that the possibility of the handicapped boy's committing an embarrassing gaffe at an important ceremony was just too risky; it might provoke ribald jokes at the emperor's expense, or bring ridicule upon the entire imperial family, which was something the sensitive Augustus could never allow. Hence, during the reign of his grandfather Claudius was denied all but the most innocuous appointments, and for those infrequent public appearances that could not be avoided, he was muffled in a cloak or smuggled into the Capitol in a closed litter under cover of darkness.

Rejected by his family and deprived at an early age of an official career, Claudius—like many social misfits—sought solace in the company of books. History held a special fascination for him. As a young man he eagerly devoured the classic sources and, encouraged by the scholar Livy, launched himself upon an ambitious series of studies of the recent Roman past. By the time he was finished, Claudius had completed a history of Augustus' regime (he had wanted to write an account of the civil wars, but memories were still too raw for that), along with a scholarly study of the Roman alphabet, a manifesto defending the late republican orator Cicero (this display of a pro-

nounced antimonarchical bias did nothing to endear Claudius to Tiberius and Livia), and—in Greek—eight volumes on the history of Carthage and twenty on Etruscan history. Nor were these merely the jejune endeavors of an enthusiastic amateur; as a whole, the treatises were so well respected that Pliny the Elder ranked Claudius among the most distinguished scholars of the day, and the academics at the prestigious Museum at Alexandria—where a special wing was erected in his honor—decreed that his Etruscan and Cathaginian tomes should be read aloud in a special public performance every year. Indeed, all Claudius' works were best read by others, because he had an unfortunate habit of interrupting his own recitations with tedious asides or uncontrollable fits of giggling.

These impressive scholarly accomplishments notwithstanding, Claudius also developed a well-earned reputation in his youth as an irrepressible glutton and an incorrigible womanizer. He loved to eat; the smell of roast meat could send him into a frenzy, and Suetonius later testified that "it was seldom that Claudius left a dining-hall except gorged and sodden." He often fell asleep on his back so his servants could push a feather down his throat, making him throw up the excess food and drink. Like Augustus, Claudius had a passion for gambling, and especially for dice; he had a special gaming board fitted to his carriage so he could play while he was riding, and in later years he even wrote a learned discourse on the subject. He told vulgar jokes, spent his evenings tavern-hopping through the less savory sections of Rome, attended gladiatorial shows where he could be seen cheering madly at the sight of blood, and managed to get himself betrothed three times before he was forty. "In brief," noted one observer, "he dissipated like a Roman gentleman."

In pursuing these carnal pleasures, Claudius naturally fell into some rather disreputable company from time to time, but his unabashed pursuit of the conventional vices of his day, combined with a generous and unpretentious personality, earned him considerable popularity among both the masses and the lesser nobility. Whenever Claudius entered the theater, all the knights rose and removed their cloaks as a sign of respect; twice the equestrian order selected him to represent their interests before the reigning consuls. When his house burned down, the Senate decreed that it should be rebuilt at public expense, and they voted to let Claudius participate in their debates as if he were a consul, though Tiberius petulantly vetoed the latter suggestion.

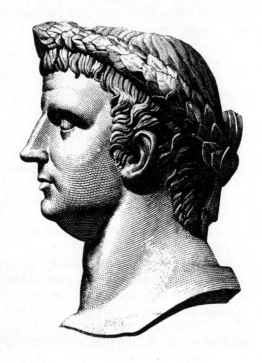

Claudius

More than anyone else, Tiberius was responsible for keeping Claudius out of public affairs in the decades following Augustus' death; twice he rejected his nephew's nomination for magisterial posts. Sejanus, however, actively cultivated Claudius' friendship, and eventually succeeded in arranging a marriage between his daughter and Claudius' eldest son. Although the couple was formally engaged, the marriage was never consummated, because shortly before the ceremony, the bridegroom-to-be threw a pear into the air, caught it in his mouth, and choked to death.

Despite the unfortunate and untimely conclusion of this betrothal, the prospect of a matrimonial alliance between his clan and the imperial family continued to intrigue the Praetorian prefect. Shortly before Tiberius' departure for Capreae in the year 26, Sejanus himself had sought the emperor's permission to marry Julia Livilla, the widow of Tiberius' son, Drusus. This was too much to swallow even for Tiberius, whose rigid sense of social convention could never accept a union between his daughter-in-law and a mere knight. And it may have been the first warning to the emperor—who was growing increasingly paranoid about his personal safety—that Sejanus' ambitions might conflict with his own plans for the future of the empire. "You have long ago eclipsed all other knights and risen above any friend of my father's," Tiberius reminded Sejanus in curtly rejecting his request, and under the circumstances the statement was nothing less than a thinly veiled warning to the Praetorian prefect not to overreach himself.

The setback hindered Sejanus hardly at all. With Tiberius safely out of the way at Capreae, he could proceed with increasing arrogance and confidence to consolidate his hold upon the reins of power. For the first several years of the emperor's self-imposed exile, Sejanus shuttled between the capital and Capreae, serving as the sole channel of communication with the *princeps,* consulting frequently with Tiberius at his island retreat between crossings to the mainland to grant audiences to the long lines of petitioners who sought his advice or assistance. "His arrogance obviously battened on the sight of this blatant subservience," remarked Tacitus sourly. "Access to him was harder now. It was only procurable by intrigue and complicity. . . . Anxiety gnawed those whom he had not deigned to address or see."

Through an adroit use of the enormous patronage under his control, Sejanus acquired the loyalty, or at least the neutrality, of a significant bloc of senators between the years 27 and 30. At the same

time, he encouraged popular support for his ambitions by ostentatiously touting himself as the champion and benefactor of the people, a self-made man who had risen from the lower ranks of the nobility to the very top of the imperial bureaucracy, much as Marcus Agrippa had done a generation earlier—and Sejanus never passed up an opportunity to stress the parallels between his own career and that of Augustus' foremost lieutenant.

While he curried favor among both patricians and plebs, Sejanus redoubled his clandestine efforts to eliminate any potential rivals for Tiberius' favor. It was impossible to tell whether he seriously projected himself into the imperial line of succession or merely aimed to protect his status as the de facto ruler of Rome; nor did it greatly matter, because by posing as the emperor's disinterested collaborator, Sejanus could present all attacks upon his own primacy as threats to the security of Tiberius' regime.

Because Sejanus could never be safe while Agrippina, the headstrong and fiery widow of Germanicus, and her two eldest sons, Nero and Drusus (the heirs apparent to the throne), remained alive and at liberty in the capital, they naturally became the principal targets of his sinister machinations. As early as the year 24, opposing political factions had begun to coalesce around Sejanus and Agrippina. At about that time, shortly before Tiberius departed for Capreae, Sejanus launched a covert campaign to completely demolish the already tenuous relations between the emperor and Agrippina. His agents provocateurs persuaded Agrippina—who was convinced that Tiberius had ordered Piso to murder her husband—that the old man wanted to poison her, too; hence when Tiberius offered her an apple at a dinner party, she promptly handed it to her servants without taking a single bite. Just as Sejanus hoped, the embarrassing incident convinced Tiberius that Agrippina's obsessive suspicions had turned her into an implacable foe.

Having adroitly secured his master's blessing, Sejanus struck first at Agrippina's close friends, most notably Claudia Pulchra, the widow of Quinctilius Varus, and a powerful aristocrat named Titius Sabinus, who was Agrippina's staunchest champion among the Roman aristocracy. In typical fashion, one of Sejanus' agents wormed his way into Sabinus' confidence and persuaded him one evening to voice his complaints against the increasingly brutal and arbitrary nature of the regime; the critical remarks were overheard by three senators concealed on the roof of the agent's house; and on January 1 of the year

28, a letter from Tiberius was read in the Senate laying forth these private statements as evidence of treason against Sabinus. As he was dragged unceremoniously from the assembly with a noose around his neck, Sabinus shouted that he was being offered as a New Year's Day sacrifice to Sejanus. Certainly it was a most inauspicious omen for the start of a new year. According to one account, public opinion in the capital was shocked that Tiberius would order such an act on that day, "for it seemed that no day would be free of convictions when, at a season in which custom forbade even an ominous word, sacrifices and prayers were attended by manacles and nooses." After an execution without trial, Sabinus' body was thrown down the Stairs of Mourning, as part of the ritual punishment for traitors, and cast into the Tiber River.

Nero was next, and an easy target at that. Agrippina's eldest son had inherited his mother's impulsive nature. Provoked by deliberate insults from Sejanus, he let slip some indiscreet and unflattering remarks about Tiberius' regime, which were dutifully reported back to Capreae by informers and a few of Nero's own bodyguards. Sejanus' agents secretly confiscated the young man's correspondence and ransacked it for evidence of sedition. His wife, Livia Julia, was suborned by her mother, Julia Livilla (the lover of Sejanus), into passing along bedroom confidences, which were then carried straight to Sejanus. Within months Nero's fate was sealed. Ominous rumors of Tiberius' displeasure with the foolish young man swirled through Rome. Nero's friends, recalled Tacitus, suddenly began avoiding him, "or turned away after greeting him, or, very often, broke off conversations abruptly."

Meanwhile, Sejanus patiently compiled a dossier on Agrippina, too. By this time (the summer of 28), Tiberius' self-imposed isolation was beginning to undermine his grip on reality, and so he needed little encouragement to dispense with the insufferable woman who had long been a thorn in his side. From Capreae he dispatched a letter to the Senate denouncing both mother and son: Nero was accused of perverted sexual behavior (i.e., homosexuality), but the charges against Agrippina were necessarily more vague; in the end, Tiberius accused her of "insubordinate language and [a] disobedient spirit," and of planning a seditious flight to her husband's former legions in Germany, which she presumably would have tried to raise in revolt. Tiberius' letter was intercepted by the aged Empress-mother Livia, who for political reasons suppressed it while she lived; the disagree-

able old woman still terrified her son. But after her death early in 29, at the age of eighty-six, Tiberius' accusations were finally introduced to the assembly. The bewildered Senate was afraid to either approve or dismiss the indictment, for Agrippina—as the widow of Germanicus—still commanded substantial popular support, which now erupted in the form of street riots in the capital. Crowds bearing images of Nero and Agrippina thronged around the Senate, screaming that the message from the emperor was a forgery concocted by the evil genius of Sejanus. Naturally the specter of mass uprisings scared the hell out of Tiberius—as it did all the Roman emperors before and after him—and confirmed his suspicions that Agrippina was trying to oust him and steal the throne for her son. So he sent another, even more strongly worded denunciation to Rome, this time harshly rebuking the plebs, too, for their high-handed impudence in challenging his authority.

This time both Nero and Agrippina were arrested. The Senate declared Nero a public enemy, and Tiberius exiled him to the island of Pontia, where he either starved to death or committed suicide. Agrippina was hustled out of Rome in chains, in a closed carriage, and lodged on the island of Pandateria; there her guards beat her so savagely that she lost her sight in one eye. Eventually she, too, succumbed to starvation. Then Tiberius and Sejanus turned on the degenerate Drusus—whose wife reportedly had also been seduced by the indefatigable prefect—and imprisoned him beneath the imperial palace on the Palatine Hill.

By the middle of the year 30, all opposition to Sejanus had been effectively silenced. A reign of terror descended upon the governing class in the capital; "people behaved secretively even to their intimates, avoiding encounters and conversation, shunning the ears both of friends and strangers," wrote Tacitus. "Even voiceless, inanimate objects—ceilings and walls—were scanned suspiciously." Rome celebrated Sejanus' birthday as if he were actually a member of the imperial family, and in fact Sejanus now announced that the emperor had finally consented to his engagement to Julia Livilla. More statues of the Praetorian prefect appeared throughout the city; sacrifices were offered to his likeness, and oaths were sworn in his name. To climax his remarkable ascent, Sejanus was elected consul for the year 31, to serve in that office alongside Tiberius himself.

Only three potential heirs to Tiberius remained alive and at liberty: a ten-year-old grandson of the emperor; poor old Claudius, the

laughingstock of the dynasty, whose physical disabilities had kept him out of harm's way; and Gaius (nicknamed Caligula), the youngest son of Agrippina and Germanicus. During the tumult of 29 and early 30, Gaius had been residing in unobtrusive privacy at the home of Antonia, Claudius' mother and the emperor's sister-in-law. Soon after celebrating his eighteenth birthday on August 31 of the year 30, he was summoned by Tiberius to Capreae.

Tiberius had used Sejanus to dispose of his enemies, both real and imagined. Now the emperor, watching from afar and slowly descending into voluptuous cruelty on his island hideaway, decided that the time had come to destroy his alter ego.

The Conqueror

China, 25–30 C.E.

> Liu Xiu will mobilize troops and arrest the impious.
> The barbarians from all directions will gather like clouds.
> Dragons will fight in the open country.
> At the junction, fire will be the ruler. . . .
>
> —PROPHECY OF XIANG HUA, 25 C.E.

From his headquarters along the northern edge of the Great Plain, Liu Xiu watched with cruel satisfaction as the realm of the Gengshi emperor disintegrated into chaos. By the first month (February 17–March 16) of the year 25—only a year and a half after he had conquered the usurper Wang Mang—the reigning Son of Heaven had committed a critical series of blunders that threatened to extinguish his political career, if not his life. First, the Gengshi emperor had foolishly alienated the generals of the peasant armies by awarding all the most prestigious and profitable offices in his administration to his aristocratic supporters, leaving the chieftains out in the cold. Meanwhile, the Red Eyebrows—who had also failed to reap the anticipated spoils of victory (the emperor's second mistake)—had reassembled their scattered forces, some three hundred thousand strong, and were now battering their way through the eastern passes that sheltered the imperial capital of Chang'an. Around the periphery of empire, rebellious warlords and regional chieftains had severed large chunks of rich, fertile territory from the control of Chang'an, leaving the Gengshi emperor with a rump kingdom that included less

than one-quarter of the total population of China and—most importantly—was wholly incapable of producing enough food to meet the requirements of the central government. And off to the north, just across the swollen waters of the Yellow River, sat Liu Xiu himself, the foremost contender for the throne, waiting patiently as the drama in the capital entered its final bloody act.

A year earlier, few rational observers would have predicted that the fortunes of Liu Xiu would experience such a drastic resurrection. The Gengshi emperor had dispatched him to the north (a third miscalculation) with the title of Acting Commander-in-Chief for that region, but had neglected to provide him with any troops; given Liu Xiu's smoldering resentment over the imperial court's recent murder of his brother—Liu Po-sheng, leader of the Nanyang aristocracy's uprising against Wang Mang—it seems clear that the government in Chang'an wanted him to first prove his loyalty before entrusting him with any viable fighting force. Liu Xiu and his tiny band of retainers were thus forced to spend the first half of the year 24 requisitioning supplies and forcibly recruiting an army (very few first-century Chinese peasants ever volunteered for military service) to subdue a local pretender known as Wang Lang, an erstwhile astrologer and fortune-hunter who was posing as a son of one of the former Han emperors. The campaign got off to such a miserable start that Liu Xiu was several times on the brink of resigning his commission and retiring to a life of banditry. But each time his lieutenants, who understood Liu Xiu's long-range political potential far better than he did himself, persuaded him to persevere.

Finally, in the summer of 24, reinforcements from the imperial army arrived, enabling Liu Xiu to trap and kill the elusive Wang Lang. As soon as the rebel had been eliminated, however, the Gengshi emperor—still doubtful of Liu Xiu's faithfulness—demanded his troops back; in fact, he ordered Liu Xiu to disband his entire northern army and return at once to Chang'an. Liu Xiu refused. With a full-fledged army at his command, he could finally avenge his brother's death. But he would have to hurry if he wished to be in on the kill. Informed by messengers that the rampaging Red Eyebrows, who had just elected their own candidate for emperor, were advancing relentlessly toward Chang'an from the east, Liu Xiu quickly dispatched an offensive detachment to circle around and assault the capital from the west.

Within Chang'an, meanwhile, the peasant army chieftains,

whom the Gengshi emperor had spurned, launched their own rebellion against the government. For much of the summer of 24, the capital served as the battleground between these insurgent bands and the imperial troops. Finally, in October, the Red Eyebrows bludgeoned their way into the city and indulged in an orgy of indiscriminate destruction that lasted for nearly six months. Betrayed by a former servant, the Gengshi emperor was captured just outside the gates of Chang'an as he attempted to flee. In return for his peaceful abdication, his captors promised leniency; they let him keep his life but put him to work herding horses in the open plains. Several weeks later, he was strangled by an agent of the peasant chieftains.

It soon became apparent that the Red Eyebrows—whose uneducated commanders really never had any objective but the acquisition of food for their troops—were completely ignorant of even the most basic political processes and incapable of restoring any semblance of order or government in Chang'an. Liu Xiu, on the other hand, surveyed the wreckage of empire and realized that heaven had sent him a golden opportunity to seize the throne. Like most of his contemporaries, Liu Xiu believed in the power of visions, and in recent days he had dreamt he mounted a red dragon and ascended into the skies. Already he had formally proclaimed himself emperor in a ceremony on the northern banks of the Yellow River on August 5, 25; henceforth his reign would be known as "The Inauguration of Firmness." Obviously Chang'an, still tortured by the renegade bands of armed retainers who roamed through the city's streets, could not serve as the capital of the new regime. Besides, Liu Xiu—who was better known by his imperial name of Guangwudi—was a gifted military tactician who understood the fatal deficiencies of Chang'an as a defensive stronghold. So on September 14 of the year 25, he headed southward to take personal command of the siege of the city of Luoyang, in modern Henan province. Eight weeks later, Guangwudi entered Luoyang in triumph and proclaimed it the capital of a new Han dynasty.

An important crossroads for both communication and transportation routes, Luoyang was protected by mountains to the north and by the Luo River to the south. It had previously served as capital of the Eastern Zhou dynasty of classical times and the secondary capital of the Former (Eastern) Han Empire. Visitors approaching Luoyang from any direction saw first the thick, sturdy walls of tamped yellow earth, between fourteen and twenty meters thick and nearly ten me-

ters high. As they came closer, they could discern the moat that ringed the city, crossed by wooden bridges and one stone causeway, and the shipping canal that brought supplies into the capital from the east. Unlike Chang'an, which was designed as a square, Luoyang was basically rectangular in shape: the eastern and western walls were the longest, each approximately thirty-seven hundred meters in length, while the southern and northern ramparts were only about two-thirds as long. There were twelve painted gates built into the walls; foreign dignitaries would probably have entered the capital through the southern wall, where the Pingchengmen Gate provided access to the emperor's South Palace.

Inside the city, the bustle of traffic was directed into five primary avenues that ran on a north-south axis, crisscrossed by another five streets running from east to west. The central north-south thoroughfare, forty meters wide, connected the North and South Palace complexes. Elevated above the other streets and sheltered by a roof, this passageway contained three parallel lanes: pedestrians were restricted to the two outer "one-way" lanes, while the middle lane, known as the imperial byway, was reserved for the exclusive use of the emperor, certain members of the nobility, and top-level government officials, all of whom were sheltered from public view by a high mud wall.

After selecting the South Palace as his official residence, Guangwudi inaugurated a massive program of improvements, adding an anterior wall, raising an entrance tower that reached over a hundred feet high, and strengthening the ramparts that ringed the palace. Nevertheless, his successors chose to reside in the North Palace, with its elegant array of gardens and ponds; between them, the two palaces and the surrounding grounds covered two hundred and fifty acres. Naturally, most of the government offices (known as imperial inns)— including the ministries of the imperial secretary, the chancellor, and the grand commandant—were located near the South Palace. The armory and the Grand Storehouse, or Great Granary, stood in the northeastern corner of the capital. In between were police stations and prisons, shrines devoted to the gods of soil and grains, the Gold Market—one of Luoyang's three major commercial centers—and the residences of nobles, bureaucrats, and the emperor's inner circle of advisers.

A typical house of an upper-class citizen of Luoyang would have been surrounded by walls, with a main gate that opened into an outer

courtyard where visitors could park their carriages; there were then two or three inner courtyards where servants performed the necessary menial tasks of everyday life: cooking, drying the laundry, tending the watchdogs or the pigs, and fetching water from the family's private well. Between the courts ran covered and ornately decorated hallways, where guests would be received and invited to sit on embroidered cushions or woolen rugs. There might be a low table and a box or other receptacles in the room, but otherwise the ground level of the house was starkly devoid of furniture. At the back or in an unobtrusive corner, many houses included a separate storeroom for grain, usually built on stilts to keep rats away. According to the prevailing Han fashion, the owner's private sleeping quarters were most often located in a brick or timber-walled pavilion, which doubled as a watchtower, rising several stories high from one of the courtyards. These pavilions, adorned with magnificent paintings or carvings of stylized mythological figures or scenes of everyday life, were topped by a tiled roof set in an elaborate geometric pattern.

As the city grew, so did its need for water, and thus a complicated system of sluices and water wheels was designed to pump water through the southern moat. Guangwudi's program of capital improvements also included the construction of an imperial academy, the Tai Xue, which eventually housed more than thirty thousand students and an impressive collection of classical texts. Much more than Chang'an, which had acquired a lamentable reputation for vulgarity and degenerate luxury, Luoyang was dedicated to the Confucian ideal of moderation and austerity—this was the place where the business of government was transacted, with few distractions. "In the city of Luo," recalled one of the *Nineteen Old Songs,* "great is the bustle, officers chasing one another, vying for speed."

Obviously this layout left little room for the dwellings of the common people, most of whom were relegated to the suburbs that sprawled outside the city walls; there the working class could purchase provisions at Luoyang's two other commercial markets or observe the ceremonies at the Altars of Heaven and Earth and the Four Seasons, though the hunting preserves in the neighboring countryside were reserved for the local aristocrats whose mansions dotted the landscape. Various minor government buildings were scattered throughout the suburbs, including the imperial tombs, the funeral workshops, and the imperial observatory (the "transcendent terrace") where the emperor examined "the cosmic breaths" of the cycle of yin

and yang. Whatever open land remained was used as farmland. As Guangwudi expanded his power, Luoyang's population swelled and eventually reached nearly half a million, making it only slightly smaller than Rome and hence the second largest city in the world; since it covered only three-fourths the area of Rome, however, Luoyang was actually the most densely populated urban center in the world in the first century.

By the end of the year 25, Guangwudi ruled most of modern Shanxi province, one of the most populous and wealthiest regions of first-century China. Regional warlords had carved the rest of the provinces into independent fiefdoms; none of the other chieftains, however, possessed Guangwudi's strategic vision or his tenacious determination to reunify the Han Empire under a single hand. So there was nothing to stop Guangwudi from conquering his rivals one by one, picking off the weakest first.

He turned his attention first to the Red Eyebrows, who had so ravaged Chang'an and the surrounding countryside ("like a swarm of locusts," someone said; they even looted the imperial graves) that they were forced to depart the former capital in search of food. Completely ignorant of what lay ahead on their line of march, the peasant army headed south in March of the year 26 until they ran into the Tsin'ling Mountains. Then they turned westward. Struggling through the rugged, unfamiliar terrain, the Red Eyebrows lost two pitched battles against an especially formidable local chieftain who resented their invasion of his domain. Turning back, they slowly retraced their steps; but late autumn found them lingering in the sparsely populated and barren hill country, where a dearth of food combined with heavy snowfalls and freezing temperatures to take the lives of thousands of their ill-equipped troops. Weakened and dispirited, they straggled back into Chang'an at the end of the year, only to find that the city remained desperately short of provisions. This time when they left Chang'an they headed east, but before they had gone very far Guangwudi's forces caught them in a vise. On March 15 of the year 27, the leaders of the Red Eyebrows surrendered unconditionally; their exhausted and starving troops laid down their weapons in a huge mound of iron. The greatest peasant army in the history of the Chinese Empire simply melted away, leaving no trace.

Guangwudi spent the next two years pacifying the rest of the Great Plain and the Shandong peninsula. It was essential for him to gain control of this economically vital region—which provided him

with the resources he needed to subdue his rivals in the south and northwest—because the most pressing problem facing the armies of first-century China was a constant shortage of provisions. The difficulty became especially acute during the civil war, when disruptions in communication and transportation made it almost impossible to accumulate sufficient supplies—including horses and bamboo arrows, as well as foodstuffs—for a lengthy campaign. Armies operated on a hand-to-mouth basis in most cases, and soldiers were usually forced to live off the land, stealing whatever food they could find. Sometimes this meant subsisting on berries and herbs, as did Guangwudi's troops while they chased the Red Eyebrows through the devastated lands around Chang'an in late 26 and early 27.

The chronic shortage of supplies during the civil war of 24 to 36 also had a tremendous impact upon the selection of military tactics and the course of operations. Offensive campaigns almost invariably began in the spring or summer of the year, to maximize the chances of finding food along the line of march; if a general could not feed his troops, the customary trickle of desertions quickly turned into a flood. Walled fortresses and other strongholds were accorded little strategic significance, for they could usually be starved into submission with relative ease. Instead, all sides devoted their energies to the conquest of as much open, cultivated territory as possible, because the army that controlled the harvest stood an excellent chance of eventually emerging victorious. Sometimes a pitched battle could be avoided altogether if one side cut the other's supply lines; otherwise, the overriding objective became the destruction of enemy forces in battle and the enlistment of locally powerful gentry and generals, who—for a price—could deliver both men and material to the commander of an invading force when it moved into a new region.

Armies in first-century China consisted of three distinct branches of troops: the infantry, who, like their Roman counterparts, were also responsible for constructing fortified camps every night they spent in the open country; archers, including crossbowmen; and cavalry. Although Chinese armorers had developed crossbows with an exceptionally precise bronze firing mechanism that were greatly feared by foreigners, it was the cavalry—particularly the battle-toughened "shock troops" recruited from provinces along the northern border—who played the decisive role in the civil wars. They performed most of the vital reconnaisance duties and carried out hit-and-run raids to disrupt the enemy's supply lines. And when a full-scale battle did

occur, the cavalry dominated the action: Chinese commanders, who were wont to employ deceit whenever possible, loved to mislead their opponents by feigning weakness and hiding mounted troops in reserve until the battle hung in the balance, at which point they would suddenly swoop down upon the enemy from the flanks or behind. By the time of the civil wars, these horsemen were armed with long steel swords or lances, and wore protective armor consisting of metal plaques and scale-like plates.

Army units were organized in a strict hierarchy, from platoons to companies, regiments, and divisions. Each division was commanded by a general who customarily bore a title designed to describe the function of his troops (General Who Scouts and Attacks, General of Strong Crossbow-men) or to overawe the enemy (General Who Routs the Traitors or General-in-Chief Who Exterminates the Barbarians). Even after joining the army of an imperial contender such as Guangwudi, most common soldiers reserved their primary allegiance for the general of their particular unit; if he mutinied, they invariably followed his lead. So to keep a closer eye on his generals and enhance his own prestige, Guangwudi occasionally took personal command of a campaign. Once, in the year 25, it almost cost him his life; trapped by enemy soldiers, he escaped only by sliding down the steep bank of a river.

But after four more long years of incessant warfare, by the end of the year 29, Guangwudi had conquered nearly all of the Great Plain, having eliminated his rivals—who stubbornly refused to unite to resist him—one by one. With the wealthiest and most populous region of China firmly under his control, the end of the civil wars was in sight. Accordingly, Guangwudi stepped up the pace of psychological warfare, publicizing the prophecies and auspicious omens that revealed him as the true heir of the Han dynasty. By the time the fighting finally stopped seven years later, when the last fractious warlords of the border territories in the south and northwest lay dead or in chains, the sages formally proclaimed that Heaven had bestowed its mandate upon a new son.

The Apostle to the Apostles

Galilee, 29–32 C.E.

> They said to him, "Tell us who you are so that we may
> believe in you."
> He said to them, "You read the face of the sky and of
> the earth, but you have not recognized the one who
> is before you, and you do not know how to read this
> moment."
>
> —THE GOSPEL OF THOMAS

I t is I who am the light which is above them all. It is I who am the all. From me did the all come forth, and unto me did the all extend. Split a piece of wood, and I am there. Lift up the stone, and you will find me there."

For years the voices had tormented Mary. Seven damnable spirits, the magical number of seven, incessantly demanding and screaming inside her. Their names were legion, for they were the same primal demons that had possessed humanity since the dawn of time, driving generation after generation to despair and madness and suicide.

"When the unclean spirit is gone out of a man, he walks through dry places seeking rest, but finds none. Then he says, 'I will return to my house from which I came.' And when he comes he finds it empty, swept, and put in order. Then he goes and and brings with him seven other spirits more evil than himself, and they enter and dwell there; and that man is then worse off than he was before."

She came from a fishing village called Magdala, also known as Tarichaea, on the western edge of the Sea of Galilee. She had never married; she was far too emotionally and psychologically disturbed for that. Yet Mary appears to have enjoyed some independent means of support, and in that she was far more fortunate than most unmarried Jewish women of the first century. Social convention prevented all but the lowest classes of women from earning their own livelihood, and the Torah permitted daughters to inherit property only if there were no surviving close male relatives. Thus spinsters—and widows, too, for that matter—were usually forced to live on the sufferance of their fathers or brothers, who were charged by scripture with an explicit obligation to support them.

"They that are well have no need of the physician, but they that are sick; I came not to call the righteous, but sinners."

Magic was afoot; God ruled; God was alive; the Kingdom of God was at hand. Throughout Galilee the stories had spread, the tales of miraculous cures, and now wherever Jesus the Nazarene appeared, the sick and the crippled came to beg him to heal their infirmities. Mary of Magdala was one of a multitude who had gone to him to seek peace from the demons within.

Following his baptism by John in the Jordan River, when he saw the skies open and heard the voice of God speak directly to him, Jesus had withdrawn alone into the hellish wastelands to the east of the Dead Sea for forty days, to fast and pray for divine guidance, for it was in the wilderness that the God of Israel traditionally spoke to His people. It was there, after the hunger set in, that Jesus felt the presence of overpowering evil: He heard a voice beseeching him to turn the stones around him into bread to feed himself and the starving multitudes of the world, but Jesus refused; his mission, he realized, must be effected not through miracles that fulfilled the material needs of men, but through the salvation of their eternal souls. Later, in another moment of weakness, Jesus felt himself standing on a mountaintop where all the kingdoms of the world stretched out beneath him, awaiting his command; but he turned away, because the prospect of earthly political power held no appeal for him. Jesus of Nazareth would not be the avenging, militaristic Messiah some Jews had so long awaited. Then, in a vision, Jesus recognized the spirit he knew as Satan, and the Temple in Jerusalem in all its glory appeared before him; upon the very pinnacle he saw himself, and from his side he heard Satan urge him to leap off the tower to prove that God would always protect him. But such spectacular signs of divine favor held

no place in his mission, and so for a third time Jesus refused the spirit of temptation, and at last the evil presence vanished. At the end of forty days, Jesus returned to the Jordan. For a time he remained in the area, perhaps working alongside John the Baptist while John continued to propound his message of repentance, forgiveness, and spiritual transformation.

When Herod Antipas arrested John, probably early in the year 29, Jesus returned to Galilee and commenced his own ministry. His preaching focused on one central and overriding theme: that the Kingdom of God on earth—long foretold by the prophets of Israel—was dawning at last, and Jesus himself had been chosen by God to proclaim the apocalyptic gospel and lead the way toward the path of salvation. He was the one, Jesus claimed, who would usher in the millennium and fulfill God's age-old promises to the chosen people, and at every opportunity he cited the scriptural references that foretold the coming of a Deliverer who would rescue Israel from the forces of evil. To an audience in a synagogue at Nazareth, for instance, Jesus quoted the verses from the prophet Isaiah that read, "The spirit of the Lord is upon me because he has anointed me; he has sent me to announce good news to the poor, to proclaim release for prisoners and recovery of sight for the blind; to let the broken victims go free, to proclaim the year of the Lord's favor, and the day of vengeance of our God." "Think not that I have come to abolish the law and the prophets," he announced; "I have come not to abolish them but to fulfill them." And on scores of occasions he associated himself with "the Son of Man" (in Aramaic, *bar Ehnash*), thereby claiming a sense of identity with the mysterious harbinger of vengeance and salvation described by the writer of the Book of Daniel nearly two hundred years earlier.

This was the revelation that Jesus imparted to a place and time of enormous religious ferment, when zealous Jewish nationalists were searching anxiously for the messiah who would lead them out of their bondage to the heathen empire of Rome, when tensions between the Sadducees, Pharisees, Essenes, and scores of other splinter groups were surging toward the flash point, when John the Baptist's enthusiastic fundamentalist crusade had already aroused a profound reaction in hundreds upon hundreds of Jews yearning for redemption and a return to the vivid living faith of their fathers, and when the warrior monks of Qumran were preparing for the imminent, ultimate battle with the forces of darkness. "The time is fulfilled, and the Kingdom

of God is at hand," warned Jesus. "Repent, and believe the good news."

The movement began slowly, but like John the Baptist and those Pharisees who specialized in the instruction of the common people, Jesus—who by all accounts was a remarkably gifted teacher with a thorough, scholarly knowledge of the Torah—soon attracted an inner core of Galileean disciples (i.e., "learners"). As one might have anticipated, the first four students he recruited from that predominantly rural region were rough, rugged, and probably poorly educated young fishermen, two sets of brothers named Simon and Andrew, and James and John. The fifth disciple, Levi, was a member of the despised fraternity of tax collectors and customs officials whose occupation led them to be reviled by their fellow Jews and excluded from all religious offices; in fact some orthodox scholars questioned whether such individuals could ever accomplish enough good works to compensate for the extortionate evil they had done in the course of their professional duties. By accepting Levi—a traitor to his own people—into his inner circle, Jesus made two points perfectly clear: first, he would not reject any Jew who chose to seek salvation by accepting his message, no matter how severely he or she had betrayed the interests and faith of Judaism in the past; and second, that Jesus was no Zealot bent upon secular, political insurrection.

Insofar as an itinerant, charismatic preacher could call any place home, Jesus made the town of Capernaum, on the northern shore of the Sea of Galilee, the center of his ministry. It was there that he began his work by performing one of the first in a long list of exorcisms, reportedly casting a demon out of a man in a local synagogue; later someone claimed that the spirit had recognized Jesus as the Son of God and called him by name as it departed.

For Jesus, the crucial first step in his campaign to liberate Israel from its state of sin lay in precisely this type of supernatural struggle, the prelude to a cataclysmic holy war—a spiritual, not a temporal conflict—against the powers of hell on earth. In an age that blamed physical and mental illnesses upon malignant spirits, it was not surprising, therefore, that the early stages of Jesus' ministry consisted primarily of healing the sick and the distressed, thereby releasing suffering prisoners from the grasp of evil. But, like John, Jesus insisted upon an essential precondition for redemption: he would heal only those souls who acknowledged and accepted his special relationship with God and thus granted him the power to cure their infirmities.

Where there was no faith, as the gospel of Mark pointed out, "there he [Jesus] could do no mighty work."

The battle with Satan began in earnest when Jesus cured the mother-in-law of his disciple Simon, who had been suffering from a high fever until the Nazarene came to her bedside. Then, with the marked sense of urgency demanded by matters of eternal life and death, Jesus embarked upon a far-ranging journey through the villages and countryside of Galilee (apparently skirting, however, the capital of Tiberias, whose majority population of Gentiles rendered it unsuitable for his purposes), reading and interpreting the scriptures in the synagogues, and in the open air preaching to his fellow Jews the gospel of the dawning Kingdom of God as he sought to heal the afflicted: in one town a paralytic; in another a twelve-year-old girl who had been given up for dead, and a woman who had endured a chronic hemorrhage for twelve years; in another village a pair of blind men—"Do you believe that I am able to do this?" Jesus asked them. They replied, "Yes, Lord," and he touched their eyes and said, "According to your faith be it done to you"—and in yet another district a man with a type of leprosy (the term was used in the ancient world to describe many related skin ailments), until Jesus had banished a multitude of diseases, which may or may not have been psychosomatic in origin. He even reportedly healed the servant of a Roman centurion—again, the disregard for conventional political attitudes—who had professed his faith in Jesus' restorative powers: "Go," Jesus told him; "be it done for you as you have believed." And, of course, he freed Mary of Magdala from the demonic voices that had tortured her for so long.

This sort of spectacular display provided an immediate aura of legitimacy for his mission, and the audience of curiosity-seekers—both Jews and Gentiles—began to grow around him. "So his fame spread throughout all Syria," observed one first-century Jewish writer who heard the stories of the miracles, "and they brought him all the sick, those afflicted with various diseases and pains, demoniacs, epileptics, and paralytics, and he healed them. And great crowds followed him from Galilee and the Decapolis [the league of ten Greek cities in the Transjordan] and Jerusalem and Judea and from beyond the Jordan." Often the stream of souls clamoring for cures proved too oppressive, and Jesus was repeatedly forced to retreat into the desert, or take ship upon the Sea of Galilee, to obtain the solitude he required for prayer and spiritual renewal. And on at least one occasion his

reputation as an exorcist earned him a hostile reception, when the inhabitants of a town on the east bank of the sea—frightened that Jesus might set loose forces they could not control—asked him to leave and practice his magic elsewhere.

But there was another, even more disturbing problem. As he traveled throughout Galilee, Jesus was increasingly troubled by signs that very few among his audience truly understood what he was telling them. Partly this was due to his penchant for wrapping his lessons in the somewhat obscure fashion of parables: vivid, enigmatic, and often paradoxical stories that employed everyday situations and characters (though often wildly exaggerated for effect) to convey layers of deeper truth, which listeners were expected to dig out for themselves. Jesus was by no means alone in using this method of teaching, however; it was also a favorite instructional device of the Pharisees, who frequently used parables as a rhetorical device to illustrate the meaning of the scriptures to their students.

Even more puzzling than the form of Jesus' teachings was their highly unorthodox content. On the surface it appeared that many of his ethical teachings stemmed directly from the heart of mainstream Judaism, though they may have been honored all too seldom in the past. For instance, Jesus' commandment to his followers to "do unto others as you would have them do unto you" echoed a moral sentiment that the revered Rabbi Hillel, one of the most famous Pharisees of the late first century B.C.E., often voiced in the admonition "That which is hateful to you, do not do to any man." And when Jesus roundly condemned the wealthy Jews of his generation ("Woe unto you who are rich, for you have received your consolation! Woe unto you that are full now, for you shall hunger!") and urged his listeners to share their possessions with their less fortunate brethren, he was voicing the same stubborn demand for social justice that had formed an integral part of the reformist wing of Judaism for centuries, recently reappearing in the doctrines of John the Baptist and the Essenes.

But Jesus deviated radically from conventional Judaic tradition when he raised these moral imperatives to an extreme and seemingly unattainable level. According to him, the ancient prescriptions of the Law were no longer sufficient for salvation:

> You have heard that it was said, "An eye for an eye and a tooth for a tooth." But I say to you, Do not resist one who is evil. If any one strikes

you on the right cheek, turn to him the other also; and if any one would sue you and take your coat, let him have your cloak as well; and if any one forces you to go one mile [here Jesus was specifically referring to the Roman legions' habit of conscripting Jewish civilian labor], go with him two miles. Give to him who begs from you, and do not refuse him who would borrow from you. You have heard that it was said, "You shall love your neighbor and hate your enemy." But I say to you, Love your enemies and pray for those who persecute you, so that you may be sons of your Father who is in heaven. . . . You, therefore, must be perfect, as your heavenly Father is perfect.

Nor could one fulfill one's obligation to aid the poor under Jesus' new covenant by simply donating one-tenth of one's income to charity, as required by Levitical tradition. When a devout Jew, who presumably had followed all the scriptural commandments, asked Jesus what else he must do to assure himself eternal life, Jesus told him to "sell what you have, and give to the poor, and you will have treasure in heaven; and come, follow me." At this startling response, the seeker, who was quite wealthy, turned away in disappointment. As Jesus watched him leave, he murmured to his disciples, "How hard it will be for those who have riches to enter the Kingdom of God!"

Now, many Jews liked to characterize the poor as the special children of God, who needed, and presumably received, a special measure of divine mercy and assistance. And holy men and ascetic prophets, such as John the Baptist and the Essenes, wore their poverty as a badge of moral virtue. But poverty could also be seen as a punishment for sin, and the condemnation of a rich man simply because he possessed abundant wealth—after all, it was money that made it possible for him to perform certain religious duties—seemed unnecessarily harsh even to Jesus' disciples. No more did the pacifistic commands to love one's enemy and to turn the other cheek appeal to Jews in the troubled circumstances of first-century Galilee and Judea. How, they wondered, could God's chosen people of Israel regain their independence and inaugurate the new Kingdom of God on earth without first throwing the heathen Romans and the apostate Herod Antipas and his Hellenistic allies out of the promised land?

To Jesus, such political concerns were not only totally irrelevant but positively malicious, because they must lead Israel down the path toward eventual destruction; worse, they distracted mankind from the spiritual crisis at hand. And this was precisely why Jesus—who

inherited the anti-materialistic bias of the Essenes and John the Baptist—denounced material wealth in such violent terms, for men could give their hearts to God only when they were free from their deadening daily preoccupation with the accumulation and protection of temporal possessions. Hence the point of Jesus' admonition to "sell all you have" was directed not at the material requirements of the poor, but at the spiritual needs of the wealthy man. "Where your treasure is, there will your heart be also," Jesus warned. "You cannot serve two masters. . . . Do not lay up for yourselves treasures upon earth, where moth and rust consume and where thieves break in and steal, but lay up for yourselves treasures in heaven."

By the same uncompromising rule, Jesus insisted that his followers forsake the comforts and responsibilities of family life, lest they conflict with their higher obligations to God: "He who loves father or mother more than me is not worthy of me; and he who loves son or daughter more than me is not worthy of me." This was an extraordinary demand to make upon Jews of that time, whose whole sense of identity was wrapped up in their status as a member of a nuclear or extended family. No clearer example of Jesus' attitude on this point exists than the story of the young man who desired to follow Jesus but asked for permission first to provide a decent burial for his recently deceased father—one of the most sacred obligations imposed by tradition upon a Jewish son. Jesus refused: "Let the dead bury their own dead" was his terse reply.

Over and over again, in parables and sharply worded epigrams, Jesus drove home the point to his fellow Jews—for his preaching was directed entirely toward them, and not at all to the Gentiles—that they could be saved only if they trusted God wholly and without reservation, putting aside their petty daily concerns and anxieties and placing their lives entirely in God's care. "Do not be anxious about your life, what you shall eat or drink, nor about your body," he told them. "Is not life more than food, and the body more than clothing?" Not for nothing did the one prayer he taught his disciples include a plea to God that "Thy will be done, on earth as it is in heaven." For in Jesus' view, if the Jewish nation acknowledged God's sovereignty and accepted the new covenant that was offered through Jesus, God would provide everything that the people of Israel needed—"Give us this day our daily bread," asked the same prayer—though not necessarily all that they wanted or expected. Jesus, whose own family had largely rejected him by this time (and may in fact have considered him

a dangerous lunatic), was fond of speaking metaphorically of a spiri-
tual family of true believers: "Whoever does the will of God," he said,
"is my brother, and sister, and mother." Hence his favorite word for
God was *abba,* the affectionate name for "father" used by the children
within a particularly close-knit family. Those who came to God as
obedient children to a loving father would obtain their reward on
earth and, to a far greater extent, in an afterlife. (Yet one must remem-
ber that the notion of the resurrection of souls, which Jesus held in
common with the Essenes and the Pharisees, was still a relatively
recent innovation in Jewish theology, and one that was not accepted
by all members of the community.)

"What man among you, if his son asks him for bread, will give
him a stone?" Jesus asked. "Or if he asks for a fish, will give him a
serpent? If you then, who are evil, know how to give good gifts to
your children, how much more will your Father who is in heaven give
good things to those who ask him!" And again, at greater length:

> Ask, and it will be given you; seek, and you will find; knock, and it will
> be opened to you. . . . Look at the birds of the air: they neither sow nor
> reap nor gather into barns, and yet your heavenly Father feeds them.
> Are you not of more value than they? And which of you by being
> anxious can add one cubit to his span of life? And why are you anxious
> about clothing? Consider the lilies of the field, how they grow; they
> neither toil nor spin; yet I tell you, even Solomon in all his glory was
> not arrayed like one of these. But if God so clothes the grass of the field,
> which today is alive and tomorrow is thrown into the oven, will he not
> much more clothe you, O men of little faith? . . . For your heavenly
> Father knows that you need all these things. But seek first his kingdom
> and his righteousness, and all these things shall be yours as well.

Here Jesus called for nothing less than a cataclysmic revolution
in human behavior, and he demanded it *right away,* in the present
moment of spiritual crisis. Thus it was not surprising that few of his
listeners responded with the unreserved enthusiasm he expected;
after all, the Jewish nation had a long tradition of rejecting the sum-
monses of their self-appointed prophets. In fact, the message Jesus
expounded was so unconventional that even John the Baptist con-
fessed himself rather perplexed by it. Although John was still locked
in prison in the royal fortress of Machaerus when Jesus was journey-
ing through Galilee, Antipas did permit the prisoner to receive occa-

sional visitors, and from several of his own disciples John heard the stories of Jesus' healing activities and his highly unorthodox preaching. The Baptist appears to have been entirely uncertain what to make of them; while Jesus obviously possessed an intense spiritual force, he just as clearly did not fit John's preconception of the Messiah. Doubtless the Baptist was expecting a more fiery, violent figure, such as the Teacher of Righteousness whom the monks of Qumran awaited. So John sent two messengers to Jesus to ask point-blank, "Are you he who is to come, or shall we look for another?" In reply, Jesus recommended that they observe him as he taught throughout the land and then "go and tell John what you hear and see: the blind receive their sight and the lame walk, lepers are cleansed and the deaf hear . . . and the poor have good news preached to them."

By this time, Jesus had gathered an inner council of a dozen disciples to help him spread the news across a wider territory; their number, of course, corresponded to the twelve tribes of ancient Israel. There was also a wider circle around Jesus of about seventy devoted followers, including numerous women—a development that was at least as upsetting to first-century Jewish conventions as Jesus' acceptance of a tax collector as a disciple. But since distinctions based on sex were of an earthly nature, they were no more valid to Jesus than those of wealth, family, or politics. In fact, since women suffered from considerable religious and legal discrimination in Jewish society (as they did in practically every other first-century society), they were more likely to be responsive to Jesus' message—like the poor and otherwise downtrodden—and worthy of his special attention. This is why Jesus spoke so strongly against divorce, because a Jewish woman who had been cast aside by her husband was virtually bereft of protection or independent financial resources in Jewish society. And if men were almost universally believed to be inherently superior, then the women among the faithful (such as Mary and Joanna, the wife of Herod's steward), who were providing financial support for Jesus' ministry, would be transformed—in a spiritual sense—into men by their unwavering belief. Jesus was quite adamant about this; when the disciple Simon, who resented Mary's presence, once urged him to throw her out of their group on the grounds that "women are not worthy of [eternal] life," Jesus flatly refused, telling Simon that "I myself shall lead her in order to make her male, so that she too may become a living spirit resembling you males. For every woman who will make herself male will enter the kingdom of heaven."

Bestowing upon the chosen twelve the authority to cast out evil spirits and heal the sick in his name, Jesus sent them out in pairs to prepare the way before he entered a town, so the people would be better equipped to understand and accept his message. "Go nowhere among the Gentiles, and enter no town of the Samaritans," Jesus ordered the twelve, "but go rather to the lost sheep of the house of Israel."

> And preach as you go, saying, "The kingdom of heaven is at hand." Heal the sick, raise the dead, cleanse lepers, cast out demons. You received without pay, give without pay. Take no gold, nor silver, nor copper in your belts, no bag for your journey, nor two tunics, nor sandals, nor a staff. . . . And whatever town or village you enter, find out who is worthy in it [i.e., any Essenes or sympathetic Pharisees], and stay with him until you depart. . . . Behold, I send you out as sheep in the midst of wolves; so be wise as serpents and innocent as doves.

The message he gave them bore no hint of compromise. "Everyone who acknowledges me before men, I also will acknowledge before my Father who is in heaven; but whoever denies me before men, I also will deny before my heavenly Father. Do not think that I have come to bring peace on earth; I have not come to bring peace, but a sword. For I have come to set a man against his father, and a daughter against her mother . . . and a man's foes shall be those of his own household."

Several months later, the disciples returned full of enthusiasm for the work they had accomplished, though it appears that they were considerably less successful than Jesus himself in battling the forces of evil. But in reaching a wider audience among the ordinary inhabitants of Galilee, they had simultaneously provoked a menacing reaction from Herod Antipas, who was in no mood to tolerate another charismatic holy man in his principality.

For weeks, Herod had been growing increasingly alarmed at the rising tide of religious fundamentalism in his territories. The same dangerous currents of instability were provoking serious disorders for the Romans in their province of Judea to the south (including armed clashes in Jerusalem), and Antipas feared that if he were to set the Baptist free, the prophet might ignite the smoldering powder keg and inspire a mass revolt against his regime. Although Herod remained intrigued by the compelling personality of the Baptist, there seemed to be no other choice but to order the execution of his notorious

prisoner; and with the active encouragement of Herodias, who possessed an implacable hatred for John, that is precisely what Antipas did.

When he heard the news of the Baptist's death, Jesus realized that he too was in danger, for his enemies among the Jewish elite in Galilee—who likewise had displayed little love for John—were forming an alliance with the urban Herodian party of Gentiles and hellenized Jewish aristocrats. Almost from the very beginning, Jesus' work had caused considerable consternation among some of the more conservative Pharisees in Galilee, who objected to his practice of healing on the sabbath and, more to the point, to his insistence that his curative powers extended to both the body and the mind, because, unlike John, Jesus claimed the power to forgive his listeners' sins, an authority that heretofore had been reserved for God alone. For many devout Jews, this claim crossed the line into blasphemy and could not be tolerated. Already it had earned Jesus a hostile reception from the leaders of the synagogue in his hometown of Nazareth, where he barely escaped with his life from a mob of enraged Jews that threatened to cast him off the hill overlooking the city.

Doubtless this reaction caused Jesus considerable anguish. Originally he had no desire to quarrel with the majority of the Pharisees of Galilee; surely he must have hoped that they would join him in the apocalyptic battle against the armies of Satan. But their emphasis upon a clear-cut, disciplined, and rational path to salvation clashed in a very fundamental way with Jesus' prophetic, individualistic ministry. Although some Pharisees still recognized Jesus as a preacher of considerable power and authority, many others clearly did not, and eventually Jesus took the extraordinary step of asking the people he healed *not* to advertise his miraculous cures, in an effort to avoid needlessly antagonizing those Pharisees who had not yet made up their minds about him.

Antipas, though, remained the primary threat. As more rumors of Jesus' activities reached his palace, Herod wondered aloud whether this new holy man was John the Baptist—whose lifeless body had been taken away from Machaerus and buried by his disciples—risen from the dead. (If nothing else, this royal conjecture indicated that Antipas was willing to entertain the notion of a physical resurrection of the body, or else was terribly superstitious, or both.) So ominous was the atmosphere that Jesus called his disciples together and suggested that they accompany him "to a lonely [and safe] place,"

namely the town of Bethsaida, in the less turbulent realm of Herod's brother, Philip.

Their departure was delayed, however, by the appearance of an agitated throng of Galileeans ("an army without a captain," someone called them), who apparently assumed that the Messiah was deserting them forever. Realizing that the crowd was bound for disaster if it persisted in seeking a militant deliverer from Israel's bondage to Rome, Jesus spent the afternoon trying to explain to his listeners the meaning of the new covenant that God had authorized him to bestow upon them. Then, as darkness gathered and the time came for the evening meal, he gathered a small basket full of barley loaves and smoked or pickled fish (a typical meal for the poor in Galilee) and offered it to the people as a tangible symbol of both the food God would provide to his children and the salvation tendered to everyone who accepted Jesus' call to enter the Kingdom of Heaven. There was no indication that anyone understood the importance of this action—including the twelve disciples who were present—but the crowd took the food anyway, and in the darkness Jesus commanded his disciples to set sail for Bethsaida while he again retreated to a mountaintop to pray.

He met them on the other side of the sea. But they found no respite there, for word of Jesus' presence soon brought a flood of desperate sick and crippled men and women from the surrounding countryside, many carried by family or friends on makeshift stretchers; in the absence of any hospitals or medical clinics, they were forced to wait in the streets or the marketplaces until Jesus arrived in their town. Throughout the region the Nazarene walked, performing more healings as he ventured into the Decapolis, and then heading northwest through the pockets of Jewish settlement outside the Phoenician and rabidly anti-Semitic cities of Tyre, about forty miles from the tip of the Sea of Galilee, and Sidon, twenty-five miles further up the coast.

By this time, affairs in Herod's territories had presumably returned to something approaching normality, and so Jesus turned and headed back to Galilee, stopping briefly for respite and renewal at Mary's hometown of Magdala before departing again for the region around Caesarea Philippi, the capital of Philip's principality. Such was the unsettled life of an itinerant preacher; no wonder Jesus warned a potential disciple that "foxes have holes, and birds of the air have nests, but the Son of man has nowhere to lay his head."

As they walked, Jesus—who had lately begun to display signs of increasing loneliness and isolation—asked his disciples, "Who do men say that I am?" Back came the standard replies: "Elijah," answered one; "John the Baptist," said another; or simply, "one of the prophets." So little impression had the substance of his extraordinary message made upon his listeners. "But," Jesus went on, undeterred, "who do you say that I am?" Only one of the twelve (who, according to the writers of the gospels, were a singularly obtuse group of men) hazarded an opinion. "You are the Messiah, the annointed one of God," said Simon, the first disciple Jesus had called. Here at last was a man who might carry on the work after Jesus was gone; from that point on, Jesus referred to Simon as Kepha ("The Rock")—or, in Latin, Peter.

This public confession of faith on Peter's part, combined with John the Baptist's execution and the mounting frustration of the previous months, signaled a shift in the emphasis of Jesus' ministry and seemed to instill a renewed sense of urgency in his mission. From that time forward, Jesus began to identify himself much more frequently with that grim and self-sacrificing symbolic figure known as "the Suffering Servant," who, according to the sixth-century (B.C.E.) book of Deutero-Isaiah, would assume the crushing weight of the sins of the whole people of Israel and redeem them by his own death, thereby inaugurating the Kingdom of Heaven in all its glory. (This concept stemmed directly from an apocalyptic and not entirely conventional strain of Jewish theology which held that extreme suffering conveyed virtue and the power to cancel sin.) "The Son of man must suffer many things," Jesus now told his disciples, "and be rejected by the elders and chief priests and scribes and be killed, and on the third day [i.e., after a very short time] be raised." At this gloomy prediction Peter balked; this was not the victorious fate he had projected for the authentic Messiah, and he said so. Furious, Jesus rounded on Peter and berated him for his failure to understand the deadly price of the mission upon which he—and they—had embarked. For if Peter had misunderstood, how much less could the other disciples grasp the truth? Their rewards lay not in this world, but in eternity; Jesus had invited them not to a celebration, but to a funeral, and it was likely to be theirs as well as his: "If any man would come after me, let him deny himself and take up his cross and follow me. For whoever would save his life will lose it; and whoever loses his life for my sake and the gospel's will save it."

Nor did the disciples have long to choose, for the battle against Satan was nearing its climax: "Truly, I say to you, there are some standing here who will not taste death before they see the kingdom of God come with power."

All the way back to Galilee, Jesus continued to press this melancholy theme upon his followers. "The Son of man will be delivered into the hands of men," he repeated, "and they will kill him; and when he is killed, after three days he will rise." Not surprisingly the disciples resisted the suggestion that their teacher, their revered commander in the war against the powers of evil, would permit himself to be captured and slain by the enemy.

When at last Jesus returned to Capernaum, the initial enthusiasm that had accompanied his mission in Galilee seems to have dissipated; in his absence the movement had obviously lost momentum. Certainly Jesus' repeated references to the hardships involved in following the path of redemption were not calculated to attract any but the most fanatical adherents: "If any one comes to me and does not hate his own father and mother and wife and children and brothers and sisters, and even his own life, he cannot be my disciple." This was hyperbole, of course, but with a hard edge of truth beneath. And by then it was clear that Jesus was not the avenging messiah whom the militant Jewish patriots sought. Nationalistic feeling was running particularly high in Galilee at that time, because a group of Galileean pilgrims had recently been slaughtered in Jerusalem by the Roman prefect, Pontius Pilate, during a violent disturbance in the vicinity of the Temple. To Jesus, the incident provided a timely illustration of the futility of seeking change through political action without first experiencing a more critical transformation in the spiritual realm. When someone asked him why God would allow pious Jews to be killed by a pagan government, Jesus replied that earthly pain and calamities were largely irrelevant compared to the urgent necessity of establishing a right relationship with God. "Do you think that these Galileeans were worse sinners than all the other Galileeans, because they suffered thus? I tell you, No; but unless you repent you will all likewise perish."

With each passing month, the lines between Jesus and the Galileean religious and political establishment grew more rigid. There were an increasing number of incidents of open antagonism; Jesus' denunciations of the blindness of certain members of the Jewish elite

became more passionate. Again, not every Pharisee or every leader of a local synagogue opposed Jesus, but his claim to superior spiritual authority naturally irritated the existing leadership more than anyone else. For his part, Jesus objected most strenuously to the "hypocrisy" of those Jews who were convinced that their steadfast observance of the Law would save them from the coming divine judgment. Jesus understood that pious students of the Law would not repent and ask God for forgiveness so long as they believed they had done nothing wrong; nor would they adopt the radically different lifestyle Jesus demanded so long as they believed they were already following God's commandments as revealed in the scriptures. But for Jesus, the Pharisees' strict devotion to such matters as ritualistic cleanliness (washing their hands before meals, for instance, especially after coming from the marketplace) tended to distract them from the more important matter of spiritual purity. "Do you not see that whatever goes into a man from outside cannot defile him?" Jesus asked. "What comes out of a man is what defiles him. For from within, out of the heart of man, come evil thoughts, fornication, theft, murder, adultery, coveting, wickedness, deceit, licentiousness, envy, slander, pride, foolishness." Hence the intemperate language Jesus used to try to shock these devout Jews out of their complacency: "You leave the commandment of God, and hold fast the tradition of men," Jesus told one group of Pharisees and scribes. "Well did Isaiah prophesy of you hypocrites, as it is written, 'This people honors me with their lips, but their heart is far from me; in vain do they worship me, teaching as doctrines the precepts of men.' " Not only did these learned men neglect their own salvation, but—far, far worse, in Jesus' eyes—they misled the people who looked to them for spiritual guidance. "Woe to you!" Jesus shouted, "for you have taken away the key of knowledge; you did not enter yourselves, and you hindered those who were entering."

And clearly few were entering. Angry and perhaps bitterly disappointed, Jesus condemned those who heard but did not believe, calling them "an evil generation":

It is like children sitting in the market places and calling to their playmates,

> "We piped to you, and you did not dance;
> We wailed, and you did not mourn."

> For John came neither eating nor drinking, and they said, "He has
> a demon"; the Son of man came eating and drinking, and they say,
> "Behold, a glutton and a drunkard, a friend of tax collectors and
> sinners!"

Then he denounced in scathing terms the cities and towns that
had witnessed his healing miracles but still refused to believe, await-
ing some even more spectacular sign that the millennium was dawn-
ing—despite Jesus' assurances that "the kingdom of God is not com-
ing with signs to be observed . . . for behold, the kingdom of God is
in the midst of you." "Woe to you, Chorazin!" Jesus cried out. "Woe
to you, Bethsaida! For if the mighty works done in you had been done
in Tyre and Sidon [those notoriously anti-Jewish cities], they would
have repented long ago, sitting in sackcloth and ashes. But it shall be
more tolerable on the day of judgment for Tyre and Sidon than for
you. And you, Capernaum, will you be exalted to heaven? You shall
be brought down to Hell."

Only the downtrodden and the outcasts had responded enthusi-
astically to Jesus' mission, probably because he held out a promise
that their lowly status in this life would not prevent their salvation
after death. Of course the liberal (in the populist sense) elements
among the Pharisees had long been preaching the same message, but
with a different prescription for eternal life. At any rate, the parables
Jesus told in these last weeks in Galilee stressed the special love and
concern God had for the socially and spiritually poor Jews who had
gone astray but returned home seeking forgiveness. Here were the
stories of the lost sheep—"I tell you, there will be more joy in heaven
over one sinner who repents than over ninety-nine righteous persons
who need no repentance"—the lost coin, and of course the prodigal
son. And in a more terrifying vein, the tale (almost certainly adapted
from oriental legends) of the beggar named Lazarus and an anony-
mous wealthy Jew, whose earthly stations were reversed in the after-
life, plunging the rich man into the never-ending torments and an-
guish of hell, described by Jesus in vivid detail.

Amid this mounting sense of crisis in his mission, Jesus suddenly
received a warning from several sympathetic Pharisees that Herod
Antipas wanted to kill him. Herod himself may have inspired the
warning, hoping that Jesus would depart Galilee quietly and take his
disturbing message of the Kingdom of God with him, thereby reliev-
ing Herod of the responsibility for executing another martyr. And

Jesus did choose to leave Herod's principality again; not for fear of his life but because his work in Galilee was done. This time he and Peter and the rest of the disciples, along with Mary of Magdala, headed southward to Jerusalem and certain disaster, to the final confrontation with the Sadducees and the imperial power of Rome.

The Eagle Who Flew Too High

Rome and Capri, 30–33 C.E.

So—would you have liked to have been Sejanus . . .
Seeking excessive renown, excessive wealth, and
 preparing,
All the time, a tower whose stories soared to the heaven,
Whence he had further to fall, a longer plunge to his
 ruin.

—JUVENAL, *The Satires*

Sejanus would have to die, Tiberius decided.

In the spring or summer of the year 30, the emperor received a letter from his sister-in-law Antonia—widow of his brother, Drusus, and mother of Germanicus and the bumbling halfwit Claudius—intimating that Sejanus' agents had recently attempted to foment a conspiracy against her grandson Gaius, the youngest son of Agrippina and Germanicus, who had been living at her villa for the past year and a half, since the death of his great-grandmother Livia. Perhaps the perfect's spies had sought to lure Gaius into the sort of treasonable utterances that had destroyed his older brother Nero; perhaps Sejanus really intended to kill the eighteen-year-old Gaius. Certainly Antonia was already infuriated with Sejanus for having the audacity to propose marriage to her daughter, Julia Livilla.

No matter. Sejanus had overreached himself at last. Tiberius could never countenance a plot against the only great-grandson of the

divine Augustus who remained alive and in line to inherit the throne. The only other viable candidate for the succession was Tiberius' ten-year-old grandson, Tiberius Gemellus. But the emperor himself was now seventy-two years old, and he could hardly have counted on surviving until Gemellus assumed the toga of manhood; Sejanus, however, clearly would have expected that the Senate would choose him as the boy's guardian in the event of Tiberius' death. It was Tiberius to whom Augustus had entrusted the care and safety of the empire, and the sternly dutiful and increasingly paranoid old soldier would not permit anyone—especially a mere knight, no matter how mighty he had grown—to remove the vital decision of the dynastic succession from his control by meddling in the internal affairs of the imperial family.

With no explanation, Tiberius summoned Gaius to Capreae shortly after the boy celebrated his eighteenth birthday, on August 31 of the year 30. Less than a month later, Sejanus departed for Rome to begin his tenure as consul; Tiberius, his partner in the consulship, excused himself from the journey on the grounds of ill health. Typically, the emperor appeared to waver indecisively for nearly a year, sending letters to the Senate praising Sejanus, then dispatching other notes that referred to the prefect in noncommittal, almost cold terms. In the month of May, Tiberius resigned his consulship and forced Sejanus to do likewise, though he promised the prefect that he would soon compensate him by granting him the power of a tribune. Either Tiberius was toying with Sejanus, or the aged emperor simply could not make up his mind.

Sejanus, however, sensed that something was very wrong, and there is considerable evidence that at this point—in the summer of 31—he set in motion a plot to topple Tiberius and seize the throne for himself, possibly in the name of young Gemellus. Tiberius, in turn, finally decided to remove Sejanus; and once he had determined to act, no power on earth could dissuade the relentless *princeps* from carrying out his plans with alacrity and savagery. He summoned to Capreae a veteran officer named A. Naevius Cordus Sutorius Macro, who was then serving as prefect of the capital's watchmen (the *vigilum,* who acted as a sort of combination fire and police brigade), and handed him a commission to replace Sejanus as prefect of the Praetorian Guard, along with a letter to be delivered to the Senate, denouncing Sejanus as a traitor. At the same time, Tiberius gave Macro secret instructions for the commander of the Roman *vigilum* and one of the reigning consuls, P. Memmius Regulus, whose loyalty was above

suspicion; in the unlikely event that Sejanus managed to evade his trap, those two officials were supposed to release Agrippina's son, Drusus, who was still lodged in the prison beneath the imperial palace on the Palatine Hill, and appoint him commander-in-chief to lead the battle against the Praetorian prefect. Once Macro was safely on his way to Rome, Tiberius took one last precaution against the failure of his mission, outfitting a fleet of naval vessels to carry him to Egypt or Syria, where he would presumably have launched a civil war against Sejanus. Then the emperor established a relay of bonfire signals to alert him of the outcome of the coup; as the crucial day approached, Tiberius anxiously awaited the flames from the top of the highest cliff in Capreae.

Macro arrived in Rome on the evening of October 17 and passed the emperor's instructions to Regulus and the watch commander. At dawn he greeted Sejanus at the Temple of Apollo on the Palatine, where the Senate was meeting that day, and informed the prefect that Tiberius was ready to grant him the power of a tribune at last. Suspecting nothing, Sejanus marched into the temple and took his customary seat. Macro, left alone, showed the Guards on duty his commission from Tiberius as their new commander and ordered them to retire to their barracks; he then replaced them with armed members of the *vigilum*. After delivering the emperor's letter to the appropriate officials of the Senate, he hurried back to the Praetorian barracks to bestow a special bonus upon the Guards (the better to secure their allegiance) before he told them what was about to happen. Despite their long years of service under Sejanus, they made no move to rescue their former commander.

Meanwhile, Tiberius' letter—long-winded and rambling, as usual—was being read aloud to the Senate,. But the import was plain enough; as the emperor's intentions gradually dawned upon the assembly, a number of the prefect's senatorial supporters stood up and moved away from Sejanus, who sat speechless, thunderstruck. At the end, Tiberius ordered the Senate to seize Sejanus. Regulus stood and asked one senator whether Sejanus should be arrested. (Undoubtedly the precaution of asking only one member had been Tiberius' idea, so uncertain was he of the mood of the entire body.) The answer came with a swelling chorus of denunciations from practically every corner of the temple. Sejanus was ordered to rise and step forward; the summons had to be repeated twice before his legs were steady enough to support him. The Senate handed him over to the commander of the watch, who dragged him off to prison. Then, feeling positively fear-

less, the legislators sentenced him to death. Later that evening Sejanus was strangled. His lifeless body was dumped on the steps of a public building, where an enraged mob spent the better part of three days thinking up obscenely creative ways to abuse it; finally the remnants were tossed into the Tiber River.

"And what are the people of Rome doing now?" wondered the poet Juvenal. "What they always do; they are following fortune, hating her victims, as always." Once the plebs learned of the prefect's downfall, they went on a rampage through the capital, aided by the Praetorian Guards, who felt compelled to demonstrate their loyalty to Tiberius, rioting and looting as they lynched a few of Sejanus' closest known associates and ripped down and smashed all the tributes erected in his honor. "Down came the statues, following the rope," wrote Juvenal:

> And next the crashing axe breaks up the chariot wheels,
> Fracturing the legs of the poor undeserving horses.
> Now the bonfires roar, now under bellows and blasts
> Glows the head once adored by the public, and crackles the
> mighty
> Sejanus: out of the face once second in all the world
> Are molded jugs and basins, pans and chamber-pots.

Next the mob turned on the family of the fallen favorite. His uncle, Quintus Blaesus, former commander of a part of the legions in Germany, was one of the first to die. Sejanus' eldest son, Strabo, was executed within the week. Then Apicata, the prefect's widow, committed suicide, but not before she sent a letter to Tiberius revealing that Sejanus and Julia Livilla had planned and perpetrated the death of the emperor's only son, Drusus. Disgraced, Livilla reportedly was starved to death on orders from her mother, Antonia.

News of his former deputy's complicity in the death of Drusus appears to have sent Tiberius into a frenzy of sadistic fury and grief. Nearly two months after the death of Sejanus, long after the mob's passions had cooled—but just long enough for Apicata's message to reach Capreae and the emperor's vengeful reply to arrive in Rome— Sejanus' two youngest children, Capito Aelianus and Junilla, were murdered by the Guard; since ancient Roman custom forbade the execution of a virgin, the little girl was first brutally raped and then slain.

For the next two years, the capital wallowed in an orgy of retri-

bution. The political allies of Sejanus were ferreted out and denounced; some committed suicide, others were executed, while a few managed to escape unscathed by the honest admission that they had only connected themselves with Sejanus to advance their own careers. Once the mania for persecution had taken hold, it spread like cancer through the body politic, while the pace of treason trials in the Senate quickened. "There grew up a frenzied passion for bringing accusations, which increased till it became almost universal, and proved more destructive to citizens than any civil war," observed the Stoic philosopher Seneca. "Words spoken by men when drunk and the most harmless pleasantries were denounced. There was safety nowhere; any pretext was good enough to serve for an information. Nor, after a time, did the accused think it worth while to await the result of their trials, for this was always the same."

Betrayed by the one man he had trusted, haunted by the memory of his dead son, Tiberius spent the last years of his life searching desperately—and vainly—for peace and security. On several occasions he crossed over to the mainland and approached to within a few miles of Rome, but each time he withdrew, fearful of his astrologers' predictions that he would never again enter the capital alive. So the emperor retreated to Capreae, where he sank further and further into the depths of sadism and sexual depravity. He had paid the most terrible price for the throne; the empire had cost him his conscience, his son, and in the end his life. "My lords," he wrote in abject misery to the Senate, "if I know what to tell you, or how to tell it, or what to leave altogether untold for the present, may all the gods and goddesses in Heaven bring me to an even worse damnation than I now daily suffer!"

The Judge

Jerusalem, 33 C.E.

What is truth?

I t had not been a particularly easy or enjoyable seven years for Pontius Pilate. Back in the year 25, Tiberius had appointed the tough-minded veteran military administrator, whose family hailed from central Italy, as prefect of Judea on the recommendation of Pilate's patron, Lucius Aelius Sejanus. It was not a post for a knight of squeamish disposition. Judea represented a vital link in the Roman Empire's eastern defense structure, a security buffer between the obstreperous kingdom of Parthia and the vital granaries of Egypt. Since it took at least two months, under the best of conditions, for messages to go from Jerusalem to Rome and back again, the official representative of the imperial government in Judea was very much on his own, particularly in times of crisis, when events moved too quickly for consultation with his superiors at home. Moreover, the incorrigibly unruly Jews had noticeably failed to grow more mellow (quite the opposite) after two decades of Roman rule than they had been in the time of Herod the Great. Had Pilate not previously displayed a considerable measure of proven ability and grit, Tiberius would never have sent him to such a turbulent region in the first place.

Already, Pilate had endured three full-scale protest demonstrations, and probably a host of minor fracases staged by his Judean

subjects. Of course, Pilate himself bore more than a little responsibility for these incidents, having displayed precisely the sort of arrogant behavior one would have expected from a protégé of the notoriously anti-Semitic Sejanus, who personally resented the Jews' stubborn refusal to worship the emperor (not to mention himself) as the rest of the civilized world did. If nothing else, Pilate was determined to teach his subjects to respect the ponderous dignity of Tiberius.

Shortly after his arrival at the provincial capital of Caesarea Maritima, Pilate had ordered the auxiliaries under his command into their winter quarters in Jerusalem. But unlike his predecessors in office, who had apparently been more sensitive to the Jews' peculiar religious customs, Pilate had taken the provocative step of instructing his centurions to carry into the city—under cover of darkness—their regular military standards, which bore medallions of the emperor's features. Had there been no imperial cult, or no official Roman pretense that Augustus was a deity (which made Tiberius the son of a god), the Jews might not have objected so vehemently when they learned that these pagan religious images had been introduced surreptitiously into their holy city. But protest they did, particularly since Pilate lodged the standards in the royal fortress of Antonia where the Romans also kept the vestments of the High Priest of the Temple, thereby compromising the sanctity of the sacred garments.

As the news of Pilate's irreverent action circulated through Jerusalem, outraged Jews swarmed through the streets of the city; the demonstrations soon spread to the surrounding countryside, until finally a procession of angry protestors marched all the way to Caesarea Maritima to confront the prefect face to face. Pilate refused to budge, however, whereupon the demonstrators staged a first-century version of a sit-in, throwing themselves upon the ground around the prefect's palace and remaining there for five full days. Unimpressed, Pilate ordered them to meet him at the local *agora,* or public square. But when the Jewish delegation, assuming Pilate was prepared to revoke his order about the standards, arrived at the marketplace and presented the petition again, Pilate had them surrounded with armed troops, three columns deep, and threatened to slice them all into tiny pieces if they did not go home at once and leave him in peace. The Jews hesitated; Pilate, sitting upon his official judgment seat, ordered his men to draw their swords. Then the protestors suddenly threw themselves on the ground a second time while their leaders shouted that they preferred death to such a desecration of their religious laws.

At this point, Pilate decided that his instructions from Tiberius—who valued peace and order in the provinces so highly—would not support a wholesale massacre, so he backed down for the moment and agreed to withdraw the offending ensigns from Jerusalem.

Nevertheless, tensions remained high. Not long after the incident of the standards, Pilate authorized a public works project to construct an aqueduct to bring water to the Temple cisterns from fifty miles away. To fund the project, he appropriated part of the money known as *korban* ("sacrifice," in Hebrew) from the Temple treasury. Such a project could hardly have been carried out without the consent, if not the active cooperation, of the Sadducees and the other Temple authorities, and Pilate's expenditures almost certainly fell comfortably within the existing limitations on the use of the korban funds. But when an influx of Jewish pilgrims—most likely fundamentalist troublemakers from the bumptious northern realm of Galilee—came to Jerusalem to worship at the Temple and offer the customary sacrifices at festival time and discovered how their sacrifice money was being used, the city—jam-packed with visitors—was again shaken by mass protests.

This time, though, Pilate, who was in Jerusalem himself at the time, to help maintain order during the festivals, was better prepared. Warned by an informant that he would be attacked the next time he showed his face in public, he dressed some of his troops in plain clothes, with daggers and clubs hidden under their cloaks, and instructed them to mingle with the crowds. Then, when an ill-tempered mob gathered and began cursing and hurling imprecations at him while he was presiding over a court session, Pilate calmly signaled to his men, who threw off their cloaks and assaulted the demonstrators with such vigor that scores were killed and many more trampled to death in the mad rush to escape. Probably there were a substantial number of Galileeans among the victims, the ones "whose blood Pilate had mixed with their sacrifices," in the words Jesus had used to illustrate the futility of political resistance against the Romans. If so, the tragic incident did nothing to improve relations between Pilate and the tetrarch Herod Antipas, which were not particularly congenial in the first place.

Antipas objected to Pilate's provocative policies not because they offended his religious sensibilities (far from it), but because their inflammatory effect was spilling over from Judea into his realm of Galilee and Perea. And Antipas, as we have seen, already had enough

to worry about with fanatics like John the Baptist and Jesus stirring up discontent against the Hellenistic tendencies of his regime. So when Pilate tried again to erect a tangible display of Roman hegemony in Jerusalem—this time by setting up a number of ceremonial gilded shields inscribed with the name of the emperor ("Son of the divine Augustus") in one of Herod the Great's palaces—Antipas and his brother, Philip, personally led the vociferous chorus of protest. Besides, the affair gave Antipas a chance to better establish his Jewish bona fides with the traditionalist Jews in his realm.

When this royally led Jewish delegation appealed to Tiberius, who by this time was well ensconced on Capreae, Pilate dutifully removed the shields, though he saved face by throwing a considerable number of his rebellious subjects in prison. Philo, the first-century author who was a prominent member of the Jewish community in Alexandria, believed that Pilate deliberately introduced the shields "with the intention of annoying the Jews rather than of honouring Tiberius," and though some later critics have greeted this explanation with skepticism, there is no good reason why it should not be accepted at face value. Having been rebuffed, indeed embarrassed, in his initial attempt to dampen Jewish nationalist enthusiasm, Pilate henceforth availed himself of every opportunity to irritate the notoriously thin-skinned residents of Judea.

And now, in the spring of 33, another confrontation was brewing in the Temple district. Several weeks earlier, as huge crowds of excitable pilgrims were beginning to invade Jerusalem for the celebration of Passover, a fanatical rural Galilean preacher named Jesus of Nazareth had created a minor disturbance when he arrived in the city to the welcoming cries of "Blessed be the kingdom of our father David!" and "Hosanna!"—meaning "Save us!" or "Help us now!"— from a group of visiting Jews who recognized him and hoped he had come to release them from the tyranny of Rome. (Most of Jerusalem's inhabitants, however, seem not to have heard of him; "Who is this?" they kept asking those who were shouting.) It was true that this same Jesus, during his long, meandering journey from Galilee to Jerusalem, had explicitly disavowed efforts to designate him the heir to King David's throne; and his rather unconventional method of entering Jerusalem, riding on the colt of a humble donkey, appeared to be a deliberate attempt to squelch any expectation that he was the long-awaited Messiah. Pilate could hardly have been expected to know

that Jesus' entry was also calculated to remind his fellow Jews of the ancient vision of the prophet Zechariah:

> Rejoice, rejoice, daughter of Zion, shout aloud, daughter of Jerusalem; for see, your king is coming to you, his cause won, his victory gained, humble and mounted on an ass, on a foal, the young of a she-ass.

Of course the same prophecy went on to proclaim that this king, whose rule "shall extend from sea to sea, from the River to the ends of the earth," was no military conqueror at all, but a gentle sovereign who would "speak peaceably to every nation." Pilate probably would not have appreciated the distinction anyway. On the one hand, the prefect could not countenance an attempt from whatever quarter to sway the citizens of Judea from their primary allegiance to the emperor in Rome. Yet the presence of Jesus in Jerusalem also provided Pilate with an excellent chance to tweak the noses of the Sadducees and the Sanhedrin, the Jewish high council.

For within forty-eight hours after his arrival in the city, Jesus had antagonized the Jewish establishment in Jerusalem beyond any hope of reconciliation. This should not have surprised anyone familiar with Jesus' radical challenge to the authorities in Galilee, or his recent preoccupation with the deep suffering and violent death he foresaw for himself. From the moment he departed Galilee for the last time, Jesus had spoken openly of the hostile reception he knew awaited him in the south. "I must be on my way today and tomorrow and the next day," he informed his disciples, "because it is unthinkable for a prophet to meet his death anywhere but in Jerusalem. O Jerusalem, Jerusalem, the city that murders the prophets, and stones the messengers sent to her!" Along the southward way, he had made at least one derogatory reference to the Temple authorities when he told his followers the story of the Good Samaritan, who stopped to aid a wounded victim of muggers and thieves after a priest and a Levite had passed by on the other side of the road without even trying to help, fearful that contact with the man, if he were dead, would soil their ritual purity and thus prevent them from carrying out their ceremonial duties at the Temple in Jerusalem. The Temple priests' misguided allegiance to the strict letter of the law, Jesus implied, had blinded them to the true spirit of God's love, and hence rendered them unfit to enter the Kingdom of God.

Nothing was better calculated to infuriate the Sadducees and the

Temple authorities than the suggestion that a filthy Samaritan was better suited than they to obtain God's favor—nothing except, perhaps, an assault upon their stewardship of the Temple itself. And that is precisely what Jesus did next.

On his first day in Jerusalem, Jesus went straight to the Temple, the house of God, where he spent a brief time "looking round about on all things" before leaving the city at nightfall for the solitude of Bethany, about two miles away, safely out of the eye of the storm. But on the following morning Jesus returned and again headed directly for the Temple. To the amazement of the crowds of pilgrims who thronged the outer courtyard, he violently attacked the stations of the money-changers and the wine and oil merchants and the stalls where the sacrificial doves, lambs, and cattle were sold in the shadow of the colonnades in the Court of the Gentiles. "It is written, 'My house shall be a house of prayer,' " Jesus shouted as he overthrew the tables, "but you have made it a den of thieves!"

Now Jesus knew perfectly well that the money-changers performed an essential service for the worshippers at the Temple, exchanging Roman coins, which were likely to bear an image of the emperor or an eagle, for the traditional half-shekels with which the annual Temple tax had to be paid. And of course the vendors of sacrificial animals also provided a convenience to the pilgrims. But the dove-selling concession in those days was reserved for relatives of the reigning High Priest, Caiaphas (the son-in-law of Annas, who had preceded him in that office), and like most monopolies, this one had resulted in graft, corruption, and the setting of extortionate prices for the doves. Moreover, the presence of the money-changers, who set the exchange rate high enough to give them a profit, along with the various other merchants who littered the outer courtyard, and even the water-carriers who used it as a shortcut through the Temple district, gave the whole scene an air of grubby, secular commerce that was utterly repugnant to a man with Jesus' stark and uncompromising sense of God's exalted majesty.

His furious assault upon the source of the desecration, the merchants' stalls—which Jesus perhaps intended as a symbolic preview of the far greater cleansing God was preparing for his chosen people—apparently drew considerable sympathy and support from the bystanders (who understandably resented being overcharged for the sacrificial animals), because the Temple authorities declined to use the police force under their control to arrest Jesus for creating a distur-

bance. But he had clearly earned their enmity by challenging their legitimacy as the spiritual governors of Israel. After all, he had in effect called them thieves, and such a flagrant insult could not be ignored.

Jesus spent the following days teaching and healing in the Temple; his arrival had been well timed to coincide with the holiday when the maximum number of people would hear his words. Occasionally the Temple priests endeavored to embarrass him, or provoke him into an anti-Roman tirade that they could report to Pilate, or draw him into some self-incriminating, blasphemous statement, by asking him leading questions such as, "Tell us by what authority you are doing these things? And who gave you this authority?" To which Jesus—in the usual rabbinical manner of answering a question with another question—replied, "I will also ask you one thing. Tell me, John's baptism—was it from heaven, or from men?" This was a question the priests were most reluctant to answer, because if they argued that John's mission had not been blessed by God (which is probably what they believed, since they had been among the Baptist's most intransigent opponents), they would antagonize the still-powerful adherents of the late prophet; but if they answered that John's authority had come from heaven, they would condemn themselves for their conspicuous lack of sympathy for his ministry when he was alive. So they told Jesus simply that they did not know. "Neither will I tell you by what authority I am doing these things," Jesus replied, thereby suggesting that if the priests, who lived in a highly structured, hierarchical world of their own, had not understood John, neither would they understand his own mystical personal relationship with God.

Then agents of the Sadducees and their Herodian allies began infiltrating Jesus' audiences. One of them asked Jesus innocently, "Is it right for us to pay taxes to Caesar or not?" In reply, Jesus told the man to show him a *denarius,* a Roman coin. (Typically, Jesus had no money of his own. Incidentally, the nature of the question also reveals that the discussion took place in the Court of the Gentiles, since the possession of a Roman coin in the inner courtyards would have been sacrilege.) "Whose portrait and inscription are on it?" Jesus asked. "Caesar's," the man answered. "Then give to Caesar what is Caesar's," commanded Jesus, "and to God what is God's." Once again, Jesus was making it perfectly clear that he had no intention of leading any sort of political resistance to the imperial government—partly because it was a losing proposition under the present circumstances,

but primarily because it would have distracted the Jews from the vastly more important task of preparing themselves for the dawning Kingdom of God. Hence the second half of his answer—the charge to offer one's soul unreservedly to God—represented the crucial part. There was nothing here that even faintly resembled a threat of military insurrection against the Romans.

A third time, several of the Sadducees themselves approached Jesus and posed a hypothetical question intended to ridicule his teachings about the resurrection—a notion they totally rejected. Suppose, they said, a woman married seven brothers (in succession, not at the same time), each of whom died childless; whose wife would the widow be at the resurrection? Jesus, who was probably amused at the absurdity of the question, responded first with a jibe at his inquisitors, saying they understood neither the power of God, to whom all things were possible, nor the scriptures, for God was not "the God of the dead, but of the living." "In the resurrection," Jesus explained, men "neither marry nor are given in marriage, but are like angels in heaven"; the earthly institution of marriage was but a pale imitation of that higher love.

Although the Sadducees and their scribes apparently refrained for the moment from putting any more questions to Jesus, he continued to express disdain for their ostentatious displays of piety and their misguided devotion to the outward trappings of religion. "Beware of the teachers of the Law," he advised an audience that had gathered in the Temple to hear him preach. "They like to walk around in flowing robes and love to be greeted in the marketplaces and have the most important seats in the synagogues and the places of honor at banquets. They devour widows' houses [i.e., exploit the poor] and for a show make lengthy prayers." Such men, Jesus warned, would suffer severe punishment in the afterlife. In the same populist vein, he praised the seemingly insignificant offering of two small copper coins from an impoverished woman to the Temple treasury, claiming that it was worth far more to God than the generous donations of rich men. "I tell you," he announced, "this poor widow has put in more than all the others. All these people gave their gifts out of their wealth; but she out of her poverty put in all she had to live on."

Shortly thereafter, as his disciples—who still had not quite got the point—stood in the Temple admiring the magnificent columns and jewels and decorative stylized sculpture, Jesus made a disparaging comment that would soon come back to haunt him. "As for what you

see here," he proclaimed, "the time will come when not one stone will be left on another; every one of them will be thrown down." Well, of course; despite the love and heartfelt devotion to God that had gone into its construction, the Temple was the product of human ingenuity and skill, and as such could not last forever. But Jesus' statement could easily be twisted by his opponents into an impious, if not blasphemous prediction that the house of God—for that is what the Temple was—was doomed to destruction.

And that was precisely what they did. On the Wednesday (Tuesday evening, actually, but according to Jewish reckoning, each day officially commences at sunset) before the Passover feast, traditionally celebrated on the first night of the full moon following the vernal equinox (the date known as Nisan 15 on the Jewish calendar), the Temple authorities decided to arrest Jesus. Apparently they wanted to get him out of the way before the rest of the pilgrims arrived in Jerusalem for the festival; there was no telling what the volatile rabble might do if it were stirred up by a fanatical demagogue. Originally the authorities may have intended merely to hold Jesus in custody until the celebration was over. If so, the pace of events rapidly overtook them.

The reason the Temple officials decided to arrest Jesus on this particular night was that they had received a tip from a reliable informant that he would be staying within the city walls. Until that time, Jesus had taken special care to be out of Jerusalem each evening before dark, spending most of his nights in the area around Bethany. However, on this Wednesday (or Tuesday evening), he chose to share a final meal with his disciples inside the holy city. He did not reveal the site in advance, even to the disciples; instead, he told them to walk to one of the city gates and wait there for a man carrying a certain water jug, who would lead them to a house owned by one of Jesus' followers. "The master has this message for you," they were supposed to tell the owner. " 'Which is the room where my disciples and I may eat the Passover?' "

Although it was not yet time to celebrate the festival, Jesus and his twelve disciples—the twelve tribes of Israel—partook of a symbolic meal after the fashion of the Passover. There may have been the customary sacrificial lamb (it was the exact symbol Jesus would have emphasized), or they may have eaten only bread and wine, though Jesus had long ago forsaken the ascetic habits of John the Baptist. The food itself, however, was far less important than either the feeling of

fellowship and solidarity around the dinner table which Jewish culture had always cherished so highly, or, most of all, the words Jesus spoke, echoing such ancient Passover Haggadah as: "This is the bread of poverty, which our fathers ate in Egypt. Let everyone who is hungry come and eat, everyone who is in need of it, everyone who keeps this feast. This year here, in the year to come in the Land of Israel; this year as slaves, in the year to come as freemen." But now Jesus had offered mankind a new freedom through his mission and the rapidly approaching Kingdom of God. "How I have longed to eat this Passover meal with you before I suffer," Jesus told them that night. "For I tell you, I will not eat it again until it finds fulfillment in the Kingdom of God." After the meal, they all—save one—retired to the Mount of Olives, to a garden known as Gethsemane.

Given his mood of impending doom, Jesus almost certainly realized that he had a traitor in his midst: the disciple named Judas Iscariot, possibly the only member of Jesus' circle who was not a native of Galilee. By this time Judas had grown disaffected with Jesus' ministry, especially with his refusal to confront the Romans once he had arrived in Jerusalem. His disillusionment led him to a decision to reveal Jesus' whereabouts that evening to the High Priest. At Gethsemane, Jesus realized that Judas was gone; alone, in anguish at the imminent end of his ministry, which appeared to be concluding in abject failure, he prayed as the disciples slept.

When Judas arrived at the head of a detachment of Temple police, and possibly some local ruffian vigilantes hostile to Jesus, he pointed out Jesus and watched as they arrested the rabbi and, after a brief scuffle with one or more disciples (probably Peter), took him away. Peter, following at a safe distance, saw them take Jesus to the residence of Caiaphas; there Peter sat down outside by the fire, with the High Priest's servants, and awaited further developments.

Inside the house, Caiaphas had assembled an extraordinary session of the Sanhedrin to interrogate Jesus. (A slight delay in starting the trial gave the Temple guards a chance to beat their blindfolded prisoner. "Prophet!" they laughed as they struck him. "Tell us who hit you!") The Council listened as a number of informants made vague accusations of sedition against Jesus; the most damning evidence came from two witnesses who claimed they had heard him boast that he could "destroy this Temple that was built by human hands and in three days . . . build another made without human aid." Even though the details of the testimony were inconsistent, Caiaphas,

who acted as chief judge of this extraordinary tribunal, stood up and approached Jesus—who had remained silent throughout the proceedings—and asked what answer he had to make to this evidence. Still Jesus, who was clearly in a no-win situation, refused to say anything.

Then Caiaphas pressed the second and more damning accusation against Jesus. "Are you," he asked him, "the Messiah?"

There was no explanation Jesus could make that would accurately describe the relationship he felt with God. "If I tell you, you will not believe me, and if I asked you, you would not answer."

"Are you then the Son of God?" the High Priest asked.

Jesus neither confirmed nor denied the charge. "You say that I am," was his sole reply.

Had Jesus claimed only to be the Messiah (which he never did), the Sanhedrin would have had a difficult time convicting him of blasphemy. But Jesus' refusal to deny that he felt a special kinship with God and—far more important—his assumption of the privileges reserved exclusively to God, such as the forgiveness of sins, which had disturbed the Pharisees in Galilee from the very beginning of his ministry, condemned him as a blasphemer in the eyes of the High Priest and a majority of the Sanhedrin. Caiaphas thereupon grasped his own robe and tore it, a traditional display of grief which, when performed by the High Priest, also confirmed a guilty verdict.

It was not at all clear, perhaps least of all to the Sanhedrin itself, whether the Jewish High Council possessed the authority to execute a sentence of death in such a case as this. Unwilling to jeopardize the tenuous accommodation they had reached with the Roman provincial government, which permitted them to regulate Jewish religious affairs in Judea, the Sanhedrin therefore passed Jesus along to Pontius Pilate with the explanation that this Galilean (certainly the prisoner's identification with that tumultuous region would have prejudiced Pilate against him before a word was spoken), who claimed to be king of the Jews, had been "causing disaffection among the people all through Judea," and had, in fact, "opposed the payment of taxes to Caesar."

Although the first charge was grossly exaggerated—besides, whatever discontent Jesus had fomented was far more likely to redound against the Sadducees than the Romans—and the second was palpably untrue, the last thing Pilate needed in Judea was heightened tensions among his subjects. On the other hand, he did not need a martyr either, and Pilate realized that the Sanhedrin, if it truly believed Jesus was a dangerous man, would not simply let him go. So,

in a calculated bid to embarrass the High Council, he returned Jesus to its custody with a suggestion that the Jews settle their own theological disputes.

To this challenge the Sanhedrin angrily responded with a threat to appeal the case to Tiberius. "If you let this man go, you are no friend to Caesar," the council warned; "any man who claims to be a king is defying Caesar!" Now this gave Pilate pause. He knew that Tiberius cherished order and tranquility in the provinces above almost all else, and that he dealt harshly with governors accused of extortion or unnecessary severity. Even in normal times Pilate ran the risk of losing his job if the local elite sent a petition to the emperor enumerating his alleged shortcomings—in Philo's words, "his venality, his violence, his thefts, his abusive behaviour, his frequent executions of untried prisoners, and his endless savage ferocity." But the crucial consideration for Pilate in this specific case was the recent coup against Sejanus. Now he had no ally at court to protect him. And, like many imperial officials abroad, Pilate had been one of Sejanus' clients, and as such, he, too, must have come under suspicion during the bloody reign of terror that followed his patron's downfall. This time Pilate could not afford to carry his confrontation with the Sadducees too far. So he took Jesus back into custody and interrogated the prisoner himself at his headquarters in Jerusalem. According to the gospel writer John, the examination proceeded as follows:

"Are you the king of the Jews?" Pilate asked.

Responding as usual with another question, Jesus replied, "Is that your idea, or have others suggested it to you?"

"What?" snorted the prefect with derision. "Am I a Jew? Your own nation and their chief priests have brought you before me. What have you done?"

"My kingdom does not belong to this world," answered Jesus. "My authority comes from elsewhere."

"You are a king, then?"

" 'King' is your word. My task is to bear witness to the truth."

"And what," muttered Pilate in exasperation and possibly with a touch of bitter humor, "is truth?"

Then the prefect struck upon a solution that would smooth his ruffled relations with Antipas; since Jesus was a Galilean, why not hand him over to Herod, who had come to Jerusalem to observe Passover? Eagerly Pilate dispatched Jesus to Antipas—something he surely would not have done had he truly considered Jesus a serious

threat to public order—only to have him promptly sent back, clothed in an elegant robe as a mocking reference to the "King of the Jews" accusation. Herod wanted no part of Jesus. He had already risked a popular uprising by executing one religious fanatic and had no desire to risk killing a second prophet (or the same one again, if Antipas still believed Jesus might be the reincarnation of John the Baptist—a thought that must have terrified the superstitious prince).

For a second time, Pilate pretended he was prepared to let the prisoner off with nothing more than a severe flogging; again the High Council objected vehemently. By this time the game was over. Pilate dutifully pronounced a sentence of death, and on Friday, at the third hour—about nine o'clock in the morning—Jesus was led to a hill called Golgotha ("Place of the Skull"), one of the customary places of execution just outside the city. There, with a crown of thorns on his head and the sarcastic inscription "King of the Jews" on a placard above (Pilate's suggestion, to annoy the Sanhedrin and discourage other potential rebels), he was nailed to a wooden cross. A detail of Roman troops stood guard and threw dice for his clothes and scant possessions. As Mary of Magdala watched in horror and despair, the cross was raised and fixed securely into the ground. Two other condemned prisoners were crucified the same day, one on either side of Jesus.

It was a slow, hideous, excruciatingly painful way to die. Public executions in Jerusalem usually drew a crowd of weeping sympathizers and jeering curiosity-seekers; in the midst of the Passover festival, this particular event may have drawn more spectators than most. "Let the Messiah come down now from the cross," someone yelled to the man. "If we see that, we shall believe." And: "You would pull the Temple down, would you, and build it in three days? Come down from the cross and save yourself!"

The gospel writer Mark told the end of the bleak story:

> At midday a darkness fell over the whole land, which lasted until three in the afternoon; and at three Jesus cried out, "Eli, Eli lema sabach-thani?" which means [in Aramaic], "My God, my God, why hast thou forsaken me?" Some of the bystanders, on hearing this, said, "Listen, he is calling Elijah." A man ran and soaked a sponge in sour wine and held it to his lips on the end of a cane. "Let us see," he said, "if Elijah will come to take him down."
> Then Jesus gave a loud cry and died.

His disciples had long since fled, fearful that they, too, would be arrested. The Romans would have assigned all three corpses to one of the common burial grounds reserved for executed prisoners, had not one of Jesus' few wealthy sympathizers, a man called Joseph of Arimathea, asked Pilate for permission to remove the body for private burial in a grave that had been intended for members of Joseph's family; because Jesus died on the cross, as a criminal, his body was considered unclean, and thus no other devout Jew could be buried in the same tomb. Pilate had no objection.

Mary of Magdala, hiding nearby, watched as Joseph's servants placed Jesus' broken body in a tomb cut into a huge rock. Then they rolled a stone in front of the entrance to seal it.

PART THREE

Rebellion

The General in Winter

Rome, 33–37 C.E.

> What other king or emperor ever enjoyed a happier
> old age?
>
> —PHILO OF ALEXANDRIA

In the spring and summer of the year 33, Tiberius ordered the execution, without trial, of everyone imprisoned in Rome on suspicion of complicity in the alleged conspiracies of Sejanus. For days the lifeless bodies, thrown carelessly into the streets of the city, lay under the watchful eyes of the Guards, who prevented bereaved relatives and friends from grieving too long over their dead. Then the rotting corpses were dragged one by one to the Tiber, where they floated downstream; no one was permitted to cremate or even touch the bodies that washed ashore. Nauseated by this atrocity, one anonymous poet scrawled a verse cursing the soul of Tiberius:

> He is not thirsty for neat
> wine
> As he was thirsty then,
> But warms him up a tastier
> cup—
> The blood of murdered men.

After this final burst of sanguinary vengeance, the pace of prosecutions slowed.

Tiberius spent much of the last four years of his life on the Italian mainland, traveling between his villas in Campania and the countryside around the capital. He continued to perform his administrative duties faithfully, but more than that he refused to do. In the year 33, faced with yet another of the recurrent shortages of bread in the capital, Tiberius imported as much grain as he could from nearby provinces; it was more, he reminded his subjects, than Augustus had ever supplied. But when his efforts were greeted only with an outbreak of rioting and obnoxious anti-Tiberian demonstrations by the plebs, who wanted lower prices as well, the emperor ordered the Senate and the city magistrates to use their authority to crush the disturbances. Shortly thereafter, Tiberius averted a financial crisis—born of a shortage of hard currency—that threatened to ruin a large percentage of the landed classes (to whose welfare Tiberius had always been especially sympathetic) by a huge interest-free loan from his personal discretionary fund. And when a fire gutted the Circus Maximus and the Aventine Hill in the year 36, Tiberius appointed a senatorial commission to assess the extent of the property losses and then generously donated that amount from the imperial treasury to the victims. He refused to rebuild any of the ravaged area himself, however.

Outside Rome, no rebellions disturbed the peace of the empire. Germany remained quiet, though the commander of the Rhine legions, Cnaeus Cornelius Lentulus Gaetulicus, made a thinly veiled threat to raise the garrisons in revolt if anyone dared reproach him for his association with the fallen Sejanus; under the circumstances, everyone in the capital decided he was better left alone. There was a brief flurry in the East in the year 35, when the king of Armenia died and the Parthian monarch, Artabanus III, took the occasion to challenge Roman power in the region by putting his own candidate on the Armenian throne. A vigorous military response by the commander of the eastern legions—ex-consul Lucius Vitellius, who had recently been appointed governor of Syria—quashed the attempted coup, and in fact resulted in the deposition of Artabanus himself.

The following year, Vitellius had to put out another fire in Judea, where the irascible Pontius Pilate had got himself locked into another bitter dispute with the inhabitants of Samaria. It seemed that a self-styled messiah had aroused the religious fervor of the Samaritans by claiming that he could reveal the location of certain sacred relics of Moses, which presumably had been buried on Mount Gerizim, the

most holy place in all of Samaria. Presumably the uncovering of these
ancient vessels would mark the inauguration of some sort of new age
of spiritual enlightenment; certainly the Samaritans had been just as
hard-pressed by Pilate as the Jews of Judea and entertained the same
yearning to escape from the prefect's oppressive interference in their
religious affairs. So, whipped into a frenzy of righteous enthusiasm,
a great throng of Samaritans, many of them armed, gathered in the
town of Tirithana, at the foot of Mr. Gerizim, and commenced to
climb the slope. According to the first-century historian Josephus,
Pilate, smelling trouble, "blocked their projected route up the moun-
tain with a detachment of cavalry and heavy armed infantry, who in
an encounter with the firstcomers in the village slew some in a pitched
battle and put the others to flight. Many prisoners were taken, of
whom Pilate put to death the principal leaders and those who were
most influential among the fugitives."

Outraged by this massacre, a delegation of Samaritan nobles
went to Vitellius and petitioned for the removal of Pilate, who was
officially under the jurisdiction of the Syrian governor. Being a far
more diplomatic man than the hard-bitten prefect, Vitellius installed
one of his own subordinates as temporary administrator of Judea and
ordered Pilate to return to Rome to explain his actions to Tiberius.
Besides, Pilate had already spent ten years in office, and was due for
a transfer anyway. He never returned to Judea. Later, Josephus heard
reports that Pilate had been banished by Tiberius to the south of Gaul.

Peace. Perhaps that was all Tiberius had ever really wanted. Now,
seventy-eight years old in the late winter of 37, the emperor was
dying. Two years earlier he had made a will naming Gaius (Caligula)
Caesar, who was then twenty-four, and Tiberius' grandson Gemellus,
who was barely fifteen, as joint heirs. But this was merely a formality,
done to provide the Senate with the illusion of selecting the next
emperor, and to follow the precedent established by Augustus, who
for safety's sake had always named two potential successors.

By this time it was clear that Caligula was the only viable choice.
As the sole surviving son of Germanicus, he enjoyed tremendous
popularity among the masses, though many of his family's most
outspoken senatorial supporters had been eliminated long ago by
Sejanus. Cities in the eastern provinces had already begun to heap
honorary titles upon the emperor's nephew, striking coins in his
image even though he was not a particularly handsome fellow. Unfor-
tunately for the future well-being of the empire, however, Tiberius—

unlike Augustus, who had personally groomed Tiberius for the succession in the last few troubled years of his reign—never allowed Caligula to assume any positions of real responsibility. Instead, he kept the heir apparent with him as he traveled from Capreae to the mainland, never letting the young man out of his sight for long. "I am nursing a viper for the Roman people, and a Phaëton for the whole world," Tiberius reportedly grumbled with his usual dark humor.

For his part, Caligula affected a respectful loyalty to the man who was responsible for the deaths of his mother and his two brothers and, indirectly, perhaps his father as well. Doubtless dark thoughts of revenge occasionally passed through his mind. He later claimed to have once crept into Tiberius' bedroom with dagger in hand while the emperor lay asleep on his cot; but moved by pity for the pathetic old man, who by this time had awakened, he had silently turned and walked away. At any rate, Caligula prudently cultivated the friendship of Macro, who had replaced Sejanus as Praetorian prefect and the emperor's chief deputy, though Tiberius, once wounded, almost certainly never bestowed upon Macro the complete trust he had invested in Sejanus. In fact Tiberius recognized the alliance between Caligula and Macro for precisely what it was, and criticized the prefect, only slightly in jest, for "abandoning the setting for the rising sun."

Recently Macro had begun to follow the footsteps of his late unlamented predecessor, bringing trumped-up charges of treason against his political opponents. One of them, a senator named Lucius Arruntius, preferred suicide to a protracted trial and, on his deathbed, warned his friends against the dangers that lay ahead:

> If Tiberius, in spite of all his experience, has been transformed and deranged by absolute power, will Gaius [Caligula] do better? Almost a boy, wholly ignorant, with a criminal upbringing, guided by Macro—the man chosen to suppress Sejanus, though Macro is the worse man of the two and responsible for more terrible crimes and national suffering. I forsee even grimmer slavery ahead. So from evils past, and evils to come, I am escaping.

In January or February of the year 37, Tiberius—the dutiful soldier worn out by long, crushing years of solitary responsibility—fell seriously ill. Naturally the impassive emperor refused to cancel his scheduled activities or even admit that he was sick. Tiberius took

great pride in the fact that he had not been treated by a doctor since he was thirty years old; he liked to say that any man who had not learned how to take care of himself by that age deserved to die at the hands of the quacks, of whom there was no shortage in first-century Rome. In the absence of any systematic medical education, virtually anyone could practice medicine in the capital. Most Roman doctors learned their trade by following a practicing physician on his rounds for half a year or, less commonly, by studying the classic multivolume medical treatises by Hermogenes of Smyrna or Tiberius Claudius Menecrates. Hence, despite the advanced state of knowledge about certain diseases, and the existence of surgical instruments that would not be rivaled until the late eighteenth century, the medical profession did not enjoy a particularly lofty status. Pliny the Elder complained that physicians "learnt at the expense of their patients, experimented at the costs of their patients' lives and, unlike the ordinary man, could get away with murder," and Martial later commended the decision of a doctor to throw away his instruments and become an undertaker instead: "At last he's begun to be useful to the sick in the only way that he's able." Although a competent and qualified physician could earn handsome fees by ministering to the nobility, who traditionally paid their medical bills once a year (on New Year's Day), most first-century Roman doctors eked out a precarious living only by selling medicines to their patients, including such dubious concoctions as pills made from ground-up centipedes, bandages of hyena skin, and the ubiquitous powder known as theriac, a compound of sixty-one disparate substances including dried adders. "Whoever takes it," noted one optimistic observer, "is sure to find at least *one* substance that will assist his disease; and it is prescribed by almost every physician at the opening stages of a malady, before he can attempt diagnosis."

But this time, Tiberius' illness proved fatal. On March 16, at his villa in Misenum, near the head of the Bay of Naples, where a large part of the Roman fleet was stationed, the emperor slipped into a coma. Thinking the old man was dead at last, an attendant removed from his hand the ceremonial ring that bore the imperial seal, and Caligula started to issue the first orders of his reign. Then word came that Tiberius had revived and demanded not only his ring, but dinner as well. They brought back the ring, which Tiberius clasped firmly in his left fist; he lay on his bed, motionless and alone, for what seemed like an eternity. No servants came with his food. Exasperated, Tibe-

Caligula as a youth

rius tried to rise. He collapsed on the floor and died.

Rome greeted the news of the emperor's death with rejoicing. People ran through the streets laughing and shouting, "To the Tiber with Tiberius!" Caligula led the procession that conveyed the corpse from Misenum to the capital. The army, on Macro's initiative, had already proclaimed Caligula *imperator*; the Senate followed suit with alacrity, and conveyed to the son of Germanicus in a single vote all the imperial powers enjoyed by Augustus and Tiberius. The late emperor's will—which divided his property equally between Caligula and Gemellus—was declared null, and everything passed to Caligula.

At Caligula's request, Tiberius was given a state funeral and his remains were cremated, but the Senate refused to declare him a god. Instead, prayers were offered to the gods to consign his soul to hell.

The Rock

Jerusalem, 37 C.E.

> Look, I see heaven open and the Son of Man standing at the right hand of God.
>
> —STEPHEN, AT HIS TRIAL BEFORE THE SANHEDRIN

P eter heard the news from the Temple district: Stephen, a member of the tiny community of Jesus' followers in Jerusalem—popularly known as Nazarenes or Nazoreans—had been stoned to death by order of the Sanhedrin. For the past four years, tensions had been smoldering between the conservative Jewish establishment and this cadre of Nazarenes (both men and women), who had been carrying on an increasingly aggressive proselytizing campaign throughout the holy city, and particularly in the area around the Temple, until passions had finally exploded into bloodshed.

Members of the Sanhedrin might have been excused for thinking they had laid this whole matter to rest when they convinced Pontius Pilate to execute Jesus. Had not his disheartened disciples fled in terror from the cross to save their own lives? It was true that three days after the crucifixion, one of Jesus' most dedicated followers, the woman known as Mary of Magdala, had visited the tomb where Jesus had been buried and reportedly found it empty, the massive stone rolled away from the mouth of the grave. Then Mary thought she saw a brilliant apparition, which after a brief moment of panic she identified as the resurrected spirit of the dead Jesus. Such a story could

easily be explained away; besides, who would accept the testimony of a woman in spiritual affairs, and particularly one with a notorious history of mental and emotional disorder?

Indeed, even the eleven remaining disciples—Judas, of course, having abandoned the rest after betraying Jesus—initially rejected Mary's story as the product of an especially hysterical female temperament. But then Peter himself witnessed a vision of Jesus risen from the dead, and at that moment he heard the voice of Jesus ask him, "Simon son of John, do you truly love me more than these?" "Yes, Lord," answered Peter, "you know that I love you." Then, Jesus commanded him, "take care of my lambs." Almost simultaneously, the other disciples underwent similar experiences, either alone or together. Jesus, they swore, had appeared and spoken to them and then ascended into heaven.

More than anything Jesus had said or done during his lifetime, these resurrection appearances inspired Peter and the rest of the disciples and welded them into a brotherhood of believers and apostles. Whatever had actually occurred, these men, and Mary, were absolutely and unshakably convinced that Jesus had risen from the dead, that he was, in fact, the Messiah, the Anointed One (in Greek, *Christos*) sent by God to inaugurate the Kingdom of Heaven on earth, whose resurrection marked the climactic intervention of God in human history. At last Peter understood what Jesus had tried so earnestly to teach him on the road to Jerusalem: that the horrifying and humiliating death of the Suffering Servant of God had been an essential climax to the first act of the drama of salvation. Having missed the point once, Peter now grasped it—and proclaimed it—more vigorously than any of his colleagues.

Had Peter and the other disciples returned to Galilee and kept these revelations to themselves, they, and possibly Jesus himself, might have faded quietly into obscurity. But this is precisely what they did not do. Instead, they remained in Jerusalem, organizing themselves and a few of Jesus' other followers into a pietistic community (they used the term *The Way* to identify themselves, since no one had yet coined the word *Christians*), voluntarily pooling their material goods and apportioning the wealth according to the needs of their members. As the spokesman for the disciples during Jesus' lifetime and the first disciple to witness the risen master, Peter was accorded a position of preeminent authority among the Eleven—who soon replaced Judas with a twelfth disciple chosen by lot (an act that, for

them, reflected the divine selection) from among two of the faithful who also professed to have seen the resurrected Jesus. So far the Sanhedrin probably had no grounds for complaint; after all, the Essenes had been practicing the same type of communal lifestyle for years without disturbing the peace. And at least Peter and the other stubborn Nazarenes continued to keep the Law and, like their late master, respected the preeminence of the Temple in the formal worship of God.

Peter, however, could not keep his mouth shut. For him and his fellow travelers of The Way, the death and resurrection of Jesus was only the beginning of God's plan for the redemption of Israel; both in life and death, Christ had commissioned them to carry on his work on earth in anticipation of the Last Judgment, which they—like a number of apocalyptically minded Jews—believed to be imminent. So Peter and his associates staked out a corner of the Temple, by the Colonnade of Solomon, where they preached their gospel that Jesus had indeed been the long-awaited Messiah. Reportedly they also healed a number of sick or mad or lame worshippers who professed their faith in Jesus, though the vast majority of passersby appear to have avoided their corner as a particularly bad risk. "The God of Abraham, Isaac, and Jacob, the God of our fathers, has glorified his servant Jesus," declared Peter:

> You handed him over to be killed, and you disowned him before Pilate. . . . You killed the author of life, but God raised him from the Dead. . . . But this is how God fulfilled what he had foretold through all the prophets, saying that his Christ would suffer. Repent, then, and turn to God, so that your sins may be wiped out, that times of refreshing may come from the Lord, and that he may send the Christ, who has been appointed for you—even Jesus. He must remain in heaven until the time comes for God to restore everything, as he promised long ago through his holy prophets. . . . Anyone who does not listen to him will be completely cut off from his people.

Such a radical argument obviously could not be tolerated by the Sanhedrin. Besides being a direct attack on the authority of the Sadducees, it implied that a Jew who had been flogged and executed as a common criminal had actually been the Chosen One of God, if not God Himself. This seditious and patently absurd notion made a mockery of the long-standing messianic expectations of Judaism, and directly contravened the scriptural injunction found in Deuteronomy,

which explicitly stated that "a hanged man is accursed in the sight of God." Surely the inglorious circumstances of Jesus' death did not represent the triumphal climax Israel had awaited for so many centuries. The Romans still ruled Judea, and the Jewish people were still dispersed throughout the Mediterranean world. No; the ideal of a messiah as a conqueror, and the fear that Israel might ruin its chance for eventual salvation by adopting a false savior, made it impossible for most Jews—across a wide spectrum of political and theological beliefs, from the hidebound traditionalist Sadducees to the radical Zealots—to regard Peter's words as anything but a threat to the future welfare of Judaism.

So the Temple authorities arrested Peter and several other disciples, who, after receiving a stern lecture from the High Priest (probably Jonathan, the brother-in-law of Caiaphas), promptly escaped from prison, possibly with the help of a sympathetic warder, and went directly back to their usual place in the outer courtyard. The next time the guards brought Peter before the Sanhedrin for a formal hearing. "We gave you strict orders not to teach in this name," complained the High Priest. "Yet you have filled Jerusalem with your teaching and are determined to make us guilty of this man's blood." When Peter refused to retract his offensive remarks or refrain from further proselytizing, some members of the Council were so enraged that they demanded he, too, be sentenced to death for blasphemy. According to one account, Peter was saved by the intervention of Gamaliel, the son of Hillel and one of the most highly respected teachers among the Pharisees of the early first century. "Men of Israel," he reportedly told his colleagues of the Sanhedrin,

> consider carefully what you intend to do to these men. Some time ago Theudas appeared, claiming to be somebody, and about four hundred men rallied to him. He was killed, all his followers were dispersed, and it all came to nothing. After him, Judas the Galilean appeared in the days of the census [6–7 C.E.] and led a band of people in revolt. He too was killed, and all his followers were scattered. Therefore, in the present case I advise you: Leave these men alone! Let them go! For if their purpose or activity is of human origin, it will fail. But if it is from God, you will not be able to stop these men; you will only find yourselves fighting against God.

In the end, the Sanhedrin elected to release Peter and his comrades after a sound flogging and a warning not to teach again in the

Temple, an admonition that, not surprisingly, was ignored by these Jewish followers of The Way, who considered it a privilege to suffer as their master had done.

A short time later, the Council found itself confronting an even more intractable opponent. Through their energetic missionary activities, the Nazarenes in Jerusalem had succeeded in recruiting numerous converts among the Hellenized Jews from the Diaspora who were visiting the holy city. Even before their conversion to The Way, many of these Greek-speaking Jews had never felt the deep-seated reverence for the Temple and strict devotion to the Torah that characterized their more conservative Jewish brethren; after all, their residence outside of Jerusalem meant that they visited the Temple only a few times a year at best, and in most cases much less frequently. Their acceptance of Jesus as the Messiah only exacerbated these liberal tendencies and carried some—including a man named Stephen, one of those who had been appointed to supervise the division of goods among the members of the community—into a wholesale rejection of conventional Jewish theology.

For the Sanhedrin, this was intolerable. Nor did Peter and his colleagues approve, for that matter, though as yet they and their Hellenistic brethren had not yet split irrevocably. At the behest of an orthodox synagogue whose members also came primarily from the Diaspora, the Temple guards hauled Stephen before the Council. Witnesses said they had heard him proclaim that Jesus would return and destroy the Temple—as Jesus allegedly had promised to do during his lifetime—and (even worse) that the coming of the Messiah had abrogated any and all obligations to adhere to the Law. Such a sweeping denial of tradition struck at the heart of orthodox Judaism, which held that the Temple was the House of God, and that it was only through the strict observance of the Law that man could draw closer to God.

Pressed to renounce this gross sacrilege, Stephen remained obdurate. Indeed, he proceeded to lecture the Sanhedrin on the miserable fate Israel had meted out to its prophets ever since the days of Moses ("You are just like your fathers: You always resist the Holy Spirit! Was there ever a prophet your fathers did not persecute?") and the impropriety, if not the irreverent presumption, of attempting to confine God to a man-made temple ("The Most High does not live in houses made by men!"). When his judges replied with exclamations of outrage, Stephen—who surely knew that he was already a dead

man—looked toward the sky and said, "Look! I see heaven open and the Son of Man standing at the right hand of God." Whereupon the Council convicted Stephen of blasphemy and sentenced him to death by stoning.

If Pilate had still governed Judea, the Sanhedrin might not have ventured to execute Stephen on its own initiative. But the prefect had recently been sent packing by the governor of Syria, Lucius Vitellius, who seemed willing to grant the Sadducees far more latitude in religious matters than had Pilate. (It was about this time—Passover of the year 37—that Vitellius, with Tiberius' consent, returned the High Priest's vestments to Jewish custody. Also, in sending auxilliary troops to help Herod Antipas repel an attack by the king of Nabatea Arabia—who was finally getting even with Antipas for his callous divorce of the king's daughter some eight years earlier—Vitellius took pains to keep them clear of Jerusalem, to avoid offending Jewish sensibilities.)

So the guards of the Council hustled Stephen out of one of Jerusalem's gates, to avoid killing him in the holy city. Following the procedure decreed by ancient custom, the witnesses against the condemned man threw the first stones.

The death of Stephen signaled the start of an all-out assault on the nascent Hellenistic community of The Way in Jerusalem. Many fled the city for the more tolerant Gentile cities to the north (including Antioch, the major metropolis of Asia Minor), thereby spreading the gospel of Jesus' resurrection much farther and faster than it might otherwise have gone. Peter himself took this occasion to journey up to Samaria, where he lent his apostolic authority to the baptism of new converts in that region.

But in Jerusalem, the persecution proceeded relentlessly, led by a fanatical young Pharisee named Saul.

The Rising Sun in the East

Rome and Judea, 37–44 C.E.

A man must be either frugal or Caesar.

—GAIUS CAESAR AUGUSTUS GERMANICUS
(ALSO KNOWN AS CALIGULA)

For one brief exhilarating moment, it looked as if Rome had found its savior. Twenty-four-year-old Caligula (né Gaius), the sole surviving son of Germanicus and the fiery Agrippina, would restore the pride and glory of the empire after the last dismal years of Tiberius' unhappy reign. Certainly the new emperor's impeccably noble lineage promised an end to the bloody feuds that had nearly extinguished the imperial dynasty after two short generations, for Caligula personally represented the union of all the best families: his grandfathers were Drusus senior (Tiberius' brother) and the legendary general Marcus Agrippa, and his great-grandfathers were none other than Marc Antony (on his father's side) and, through Julia, the divine Augustus himself. As a child he had accompanied his father on many of his victorious campaigns as a sort of good-luck charm and mascot of the legions; "Born in a barracks, and reared in the arts of war," the soldiers sang, "a noble nativity for a Roman emperor!" Since then, Caligula had acquired an extensive education in the arts—both Greek and Latin—and had displayed promise as an orator of considerable passion and power. Hence, as the prince rode from Misenum to

Rome, at the head of the procession escorting Tiberius' body back to the capital, a crush of enthusiastic spectators greeted him at every town with boisterous cheers and grateful sacrifices and the affectionate nicknames by which he was known: Star, Pet, and even Baby. (The crowds seem to have paid little attention to his unprepossessing physical appearance, for Caligula was balding, with thin sloping shoulders, an excessively hairy body, and a large, protruding stomach.) Had Caligula not previously been disposed toward megalomania, this extravagant display of popular adulation certainly would have given him a vigorous push in that direction.

But by this time Caligula had already traveled far along the path toward self-destruction. Weaned on the aggressive narcissism of his mother, and raised in the household of his grandmother Antonia—daughter of the great Antony, who had experienced first hand the sensual oriental splendor of the Egyptian court of Cleopatra—the youthful Caligula had been steeped in the rudiments of autocracy. Seven years of enforced subservience to the tottering Tiberius had only repressed these influences; freed from their prison, they went straight to his head and, within a very short time, unbalanced his reason altogether.

As far as Rome was concerned, however, Caligula initially made a very promising impression as emperor. After the Senate voted him, in one fell swoop, all the executive powers enjoyed by Tiberius, Caligula unilaterally declared an end to the infamous treason trials of the last regime, recalled numerous exiles and released scores of political prisoners (the records of their trials were supposedly burned by the emperor himself in one massive bonfire), abolished the sales tax in the capital and the surrounding region, rescinded the ban against the publication of anti-Tiberian literature, and decreed further honors to his deceased parents (the month of September was renamed in honor of Germanicus, albeit temporarily). In the midst of a violent winter storm, the emperor journeyed to the prison islands where his mother and oldest brother had died in exile and brought their ashes back to Rome for an honorable state funeral. The Praetorian Guards were awarded twice as large a cash bonus as Tiberius had recommended in his will, and an equally liberal amount was distributed among the lower classes in Rome. It was a remarkable performance by the young emperor, one that displayed an impressive grasp of practical politics and public relations.

To cap it all off, Caligula supervised the completion of the temple of Augustus, which Tiberius, in his usual half-hearted approach to

civic construction, had allowed to languish for twenty-some years, and dedicated it later that first year with a spectacular pageant of games on his own birthday (August 31). Starved of popular amusements under the dour Tiberius, several hundred thousand exuberant Romans packed the Circus Maximus for the occasion, where Caligula treated them to a program of forty chariot races on a single day. Beyond any doubt, chariot racing—and not the bloody and hence prohibitively expensive slaughter of the gladiatorial contests—was easily the most popular form of mass entertainment in the Roman Empire in the first century. From top to bottom, the professional racing business was a highly organized affair. In the days of Caligula, there were four teams (or factions) in Rome, named for the color of tunic worn by their jockeys: White, Red, Green, and Blue. The Green syndicate appears to have been the popular favorite; it was also Caligula's usual preference. Each squad had its own extensive stable, trained its own horses (usually imported from Spain or North Africa), competed for the best professional jockeys, most of whom were slaves or freedman (many of the top riders were Moors), and hired its own doctors to care for both man and beast. Because the rivalry between these four clubs was so fierce, and because tremendous amounts of money were wagered (legally) on the races, considerable security precautions were taken to prevent either horses or jockeys from being drugged before a race, though there was no adequate defense against the use of magic spells to afflict an opponent. "I adjure you, demon, whoever you are," ran an inscription on a tablet found near the scene of the games, "and I demand of you this day, from this hour, from this moment, that you torture with pain and kill the horses of the Greens and the Whtes, and that you kill and bring into collision the drivers Clarus, Felix, Primulus, and Romanus."

There were about twenty days of racing each year in Rome during the reign of Caligula. Virtually all of the contests were staged in the Circus Maximus, after it was extensively renovated following a disastrous fire in the year 36; the oval-shaped arena, located between the Palatine and Aventine hills, stretched for almost six hundred meters in length, though it was only about eighty-seven meters across. Nearly a quarter of a million people could squeeze onto the Circus' benches: wooden planks for the plebs and stone seats with marble facing for the senators. And it *was* a tight squeeze; each spectator was allowed sixteen inches of space for his seat, and it was not unusual to suffer repeated kicks in the back from the person sitting

behind you. The riders themselves were hardly in a more comfortable position: fastened to the reins of their horses by a belt looped around the waist, they spent the entire race bent forward, nearly horizontal, over the front of the chariot. The track of the Circus could accommodate as many as twelve four-horse vehicles, three from each faction, for a single race. A typical contest consisted of seven laps (eight and four-tenths kilometers, or about five miles), which took about fifteen minutes to complete; after each lap, a track official removed one of seven marble eggs and marble dolphins from a stand that served as a counter at the end of the stadium. Once the horses were running flat out, there was considerable danger of collisions on the turns—a certain amount of jostling was considered good strategy—and a driver who found himself tipping out of control had to cut himself free from the traces before he was dragged under the wheels of his vehicle.

Like football in the twentieth century, chariot racing provided a single meeting place for people of all social classes in imperial Rome. Caligula himself was so addicted to the sport that he built a whole new Circus, across the Tiber in the gardens of Agrippina. The races also served as a sounding board for public opinion, for the Circus was one of the few places where common citizens could express their views on current events; shouted insults or rude catcalls hurled in the direction of reigning magistrates were not uncommon. Of course, there were a few snobbish aesthetes, like Pliny the Younger, who sniffed derisively at the popular enthusiasm:

> The races are on, a spectacle which has not the slightest attraction for me. It lacks novelty and variety. If you have seen it once, then there is nothing left for you to see. So it amazes me that thousands and thousands of grown men should be like children, wanting to look at horses running and men standing over chariots over and over again. If it was the speed of the horses or the skill of the drivers that attracted them, there would be some sense in it—but in fact it is simply the color. That is what they back and that is what fascinates them. . . . Such is the overpowering influence of a single worthless shirt, not only over the crowd, which is worth less than a shirt anyhow, but over a number of serious men.

By contrast, gladiatorial games were staged very infrequently; Augustus gave only eight shows during his entire reign, and though Caligula stepped up the pace and provided more bizarre entertain-

ments, it was simply too costly to produce such displays at any time other than the major holidays. On those rare occasions when the gladiators did fight, however, the Forum was invariably packed with spectators screaming for the sight of blood. The custom of gladiatorial duels had originated in Etruria centuries earlier as part of the funeral rites for the nobility, to provide a chieftain with an armed escort in the underworld, or strengthen his spirit with blood; by the time Caligula ascended the throne, of course, the games had lost practically all their religious significance and were nothing more than a particularly savage way for politicians to court popularity with the Roman masses, by picking up the tab for the contests.

Between the munificent bonuses to the army and the long days of chariot racing in the Circus, along with frequent sumptuous public feasts and senatorial banquets, Caligula managed to squander Tiberius' entire legacy of twenty-seven million sesterces in less than a year. Worse, in the autumn of 37, the emperor fell seriously ill with what appears to have been an acute nervous breakdown; for a while the doctors despaired of his life. When his advisers pressed him to name an heir as a precautionary measure, the critically ill Caligula startled everyone by passing over young Gemellus, whom he had recently adopted, in favor of his sister Drusilla. Here was a clear indication of the emperor's troubled mind; in fact the Senate had recently heard rumors that Caligula, like the Ptolemies who ruled ancient Egypt, regularly engaged in incestuous relations with his closest female relatives—in Caligula's case, his three sisters.

Prayers were offered throughout the empire for the recovery of the *princeps;* unfortunately, they were answered. By the end of 37 Caligula had recovered his health but not his mental equilibrium. As a youth he had always suffered from insomnia; now the restlessness grew worse. Often he could sleep only three hours at night. Caligula spent the rest of the evening prowling anxiously through his palace alone in the darkness, longing for dawn. At other times, the emperor's mind seemed about to explode from the appalling pressure within, until he felt an overwhelming urge to escape from everyone and everything. This singularly erratic temperament, combined with Caligula's increasingly obsessive fascination with the oriental cults of divine kings, his determination to tear down the facade of republicanism with which Augustus had disguised the principate, and his growing realization that the emperor could do virtually anything he wished (Caligula loved to kiss the necks of his lovers and friends and whisper,

"This beautiful throat will be cut whenever I please"), led directly to the bizarre excesses that marked the last three and a half years of the emperor's twisted life.

One by one the restraining influences on his godlike ambitions were removed. His grandmother Antonia died in the first months of Caligula's reign; shortly thereafter Macro was removed as prefect of the Praetorian Guard and forced to commit suicide, his place taken by two more pliable officers who did not remind Caligula of those embarrassing days on Capreae. Young Gemellus lasted less than a year before Caligula induced him, too, to kill himself. And the emperor's beloved sister Drusilla died of an illness in June of the year 38.

Toward the Senate, Caligula displayed nothing but contempt from the year 38 on, availing himself of every opportunity to publicly humiliate the members of the assembly; he once joked that his horse could perform the duties of a consul as well as the—horses' asses?—who actually held the post. After studying the official transcripts of the treason trials under Tiberius and Sejanus (the documents had not been burned, after all), Caligula decided that the senators themselves should bear the primary blame for the excesses of those notorious days. "If Tiberius really did do wrong," he lectured them on one famous occasion, "you ought not, by Jupiter, to have honoured him while he lived, and then, after repeatedly saying and voting what you did, turn about now. . . . Therefore I, too, ought not to expect any decent treatment from you."

Such blunt words did nothing to endear Caligula to the Roman aristocracy; nor did his disconcerting habit of taking the wives of his dinner guests to bed, returning to the party with signs of their lovemaking still plainly visible. There is no reliable evidence that Caligula ever attempted to seduce a senator, but he certainly was bisexual, an inclination that, to his opponents, represented another mark of eastern degeneracy. Although he had officially banned male prostitutes from Rome in the early months of his reign, he enjoyed his own catamites, including the youthful nobleman Valerius Catullus—who claimed, presumably after Caligula was dead, to have quite worn himself out servicing the emperor—and the actor *(pantomimus)* Mnester, whom Caligula kissed and caressed in public.

Caligula himself displayed an enthusiastic interest in the theater, though it often emerged in a rather unorthodox manner. Once he summoned three senators to the palace in the dead of night; frightened to death, they were escorted to a makeshift stage and told to

await the emperor's appearance. Moments later, Caligula—dressed in a flowing, floor-length tunic, his face encased in garish theatrical makeup—appeared and began prancing about the stage to the music of flutes. As soon as the bizarre performance had concluded, he disappeared without a word, and the senators were left to find their way home alone.

At least Caligula did not subject his magisterial audience to one of the crude, coarse comedies currently in vogue at the capital. Civilized Greek tragedies had never found a ready audience among the Roman masses; as Horace pointed out, the boorish plebs were likely to interrupt a particularly poignant scene with cries of "We want bears!" or "We want boxers!" At best, they might tolerate an accomplished performance of what was called pantomime, in which a single performer—wearing a succession of masks to represent different characters—told a dramatic and frequently moralistic tale with words, music, and especially with interpretive dancing. Properly done, sophisticated Roman pantomime could be graceful, morally uplifting, and quite moving. Certainly the pantomime seemed remarkably sensitive compared to the gross, obscene revels of the less pretentious mimes, who—often outfitted with an oversized phallus—specialized in sex comedies (*Love Locked Out, The Smooth Adulterer*) or sensational stories of crime and passion (*Laureolus, the Highwayman Crucified*).

By the summer of 38, Caligula had convinced himself that his imperial dignity required some grandiose, flamboyant gesture—achieving the impossible, as it were—to impress his subjects and overawe his foreign neighbors in the East. So he ordered his engineers to "turn the sea into dry land," so he could ride across the water in triumph; specifically, he wanted them to construct a bridge of boats, between three and four kilometers long, spanning the northern end of the Bay of Naples, and topped by a road surface similar to the famous Appian Way. When this remarkable engineering feat was completed, Caligula donned a cloak of gold cloth, studded with precious stones and covered with the breastplate of Alexander the Great (fetched from Alexandria, for the opening ceremony). Thus adorned, he drove back and forth across the causeway in a chariot, boasting that he had conquered the sea god Neptune. Subsequently he assumed the right of adopting Neptune's costume, complete with flowing beard and trident, and later moved on to impersonate the Greek hero Hercules, the goddess (with a wig) Venus, and even the supreme

Jove himself, brandishing a thunderbolt and practicing fierce Jovian grimaces in the mirror.

It was precisely this sort of egocentric behavior, encouraged by the willingness of some courtiers to prostrate themselves in the emperor's presence, that convinced a growing number of senators that Caligula was planning to install the sort of oriental despotism toward which Julius Caesar had appeared to be aiming—and which Augustus and Tiberius had taken such great pains to avoid. Their suspicions were fueled by the results of Caligula's sudden journey to Germany in the summer of 39. The emperor had received warnings from his spies that former consul Cnaeus Cornelius Lentulus Gaetulicus, the governor of that strategically vital province, which still contained the largest number of legions in the empire, had organized a plot to assassinate him. Traveling with almost reckless speed—the Praetorians who accompanied him had grown soft in Rome and were unable to keep up the frantic pace—Caligula arrived in Germany and ruthlessly suppressed the alleged conspiracy. Gaetulicus was summarily executed, as was Caligula's former boon companion Marcus Aemilius Lepidus, whom the emperor, in another fit of capriciousness, had once nominated as his successor. Caligula's two surviving sisters were banished for their reputed complicity in the plot. The emperor remained in Germany and Gaul for the rest of the year 39 and the early months of the new year, organizing and then canceling military expeditions that may have been designed more to keep the troops occupied in harmless training exercises than to actually invade Germany, or the island of Britain that beckoned across the Channel.

Then, suspecting new conspiracies in the capital, Caligula hurried back to Rome in the summer of 40.

If Caligula's tendencies toward despotism worried a growing number of senators in Rome, his pretensions to godhood created a nearly fatal dilemma for the Jews—the largest single bloc of monotheistic subjects in the empire. While the priests at the Temple in Jerusalem were perfectly willing to offer sacrifices in Caligula's name at his accession and again during his critical illness in the autumn of 37, they obviously could not sacrifice *to* him. Not only did the Jews' reluctance to accept his self-proclaimed divinity infuriate Caligula as a personal affront and threaten his policy of employing emperor-worship to unify the mixed populations of the provinces; it also provoked anti-Semitic disturbances in Egypt and Asia Minor, and almost wrecked

the emperor's personal relations with his old boyhood companion, Marcus Julius (better known as Herod) Agrippa.

By the time he was forty-seven years old, at the time of Caligula's accession, Herod Agrippa had enjoyed a remarkably checkered career—in fact, several checkered careers. The grandson of Herod the Great and the princess Mariamme, Agrippa had been raised in Rome in Augustus' own household, where he forged warm friendships with Claudius and Tiberius' son Drusus, and a lifelong alliance with Antonia, who had become a close companion of Agrippa's mother. Although everyone at court loved Agrippa's wit and easy charm, the huge sums of cash required to maintain appearances at the highest levels of Roman society quickly drained his limited resources, and Agrippa eventually ran up such an immense load of debt that he was forced to leave Rome to escape his creditors in the year 23, shortly after Drusus' untimely death. Agrippa landed in Galilee, where his uncle, Herod Antipas, put him to work as a minor bureaucrat at his capital of Tiberias. Humiliated (this was no job for a man of his princely heritage), Agrippa accepted the post for a brief time, then left in search of greener pastures, bouncing from one Mediterranean port to another, and gradually—very gradually, for it was now the year 36—making his way back to Italy and Capreae. There Tiberius, after first insisting that Agrippa repay his long-standing debts to his Roman creditors, appointed him tutor to his grandson, Gemellus.

It was during this last uncertain year of Tiberius' reign that the mercurial Agrippa and the even more erratic Caligula came to appreciate each other's unconventional talents. Upon Tiberius' death, Caligula awarded Agrippa the territories of his late uncle Philip, who had died in 34, along with a chunk of southern Syria, and gave him the title of king, which made Agrippa officially superior to Herod Antipas, who was only a tetrarch. This distinction drove Antipas' wife, Herodias (who was also Agrippa's sister), to distraction. Herodias must have been a shrew of no mean proportions, for she had already nagged Antipas into executing John the Baptist, and now she succeeded in persuading him to sail to Rome to petition the emperor for a kingship of his own. Agrippa learned of Antipas' diplomatic mission, however, and remembering his callous treatment at the hands of his uncle fifteen years earlier, wrote a private note to Caligula, mischievously accusing Antipas of taking an active part in Sejanus' conspiracies against Tiberius. Even more damning, he told Caligula that Antipas had a huge arsenal of weapons, enough to arm

seventy thousand men, in his fortresses in and around Jerusalem, presumably as part of a plan to lead a nationalist uprising and establish an alliance with the Parthians. Agrippa's letter and Antipas arrived at court almost simultaneously; confronted with his nephew's charges, Antipas was forced to confess that the armaments were, in fact, in his storerooms. Alarmed at the strategic implications of a Jewish-Parthian military pact, Caligula immediately banished Antipas permanently to the town of Lugdunum Convenarum in Gaul (Herodias voluntarily accompanied him, as well she might), and handed over his principality of Galilee and Perea to Agrippa, who thereby became the indisputable political leader of the Jewish world. From that moment, Herod Antipas, the Fox, disappears from history altogether.

Meanwhile, Caligula's well-known antipathy toward Judaism encouraged a faction of anti-Semitic extremists—mostly Greeks—in Alexandria to launch a brutal assault upon the Jewish community in that ostensibly sophisticated Egyptian city. (Actually, Caligula found Alexandria's vibrant combination of Hellenistic and oriental cultures so congenial that he once seriously considered abandoning dull, stolid Rome to make it the capital of the empire.) Contemptuous of the Jews' willingness to collaborate with the Roman authorities—for which they received certain civic privileges that the Greeks did not, though this imbalance was offset by the Greeks' favored tax status—these anti-Jewish gangs seized upon the occasion of Agrippa's visit to Alexandria in 38, en route to his recently acquired kingdom, to instigate one of the first and most vicious pogroms in the history of the Roman Empire. First they lampooned Agrippa's royal pretensions as King of the Jews by dressing a drooling lunatic in purple robes and parading him through the streets of the city in mock adulation. Then roving bands of thugs began to assault Jewish households, many of which were extremely wealthy, evicting the owners and seizing or destroying their valuables and furniture; those Jews who did not perish immediately at the hands of the mobs or the elements were herded into a tiny section of the city, where pestilence and famine soon claimed more lives. Although conditions soon grew so crowded that some Jews had to take refuge in the adjoining cemetery and garbage dumps, anyone who attempted to escape the enclave was stoned to death by the vigilante guards, or seized and tossed onto pyres of flaming brushwood. Sometimes the fire was so weak that it did not prove immediately fatal, so the half-dead victims were pulled off the

mounds of smoldering scrub and dragged through the street, where they were trampled, pummeled, and slashed until nothing remained for a decent burial.

All the while, the prefect of Egypt, one Aulus Avillius Flaccus, turned a blind eye to the savage excesses of the mob, apparently out of fear that the gangs would turn against him if he dared oppose them. (Philo's pungent comment was that Flaccus "pretended not to see what he saw and not to hear what he heard.") Emboldened by the realization that neither the prefect nor the emperor was likely to stop them, the gangs next invaded the local synagogues and erected statutes of Caligula; for one such display, they hauled in an old, rusty chariot—originally dedicated to Cleopatra—from their own gymnasium. When three dozen members of the local Sanhedrin protested against these assaults, Flaccus arrested them and turned them and their wives into the centerpiece of a special public entertainment: to the accompaniment of festive music and obscene pantomime and the cheers of the appreciative spectators, the men were flogged while the guards forcibly fed pork to the women.

Much to Flaccus' surprise, retribution followed swiftly. Upon arriving in his own territories, Herod Agrippa wrote a note to Caligula, his former companion in adversity, complaining of Flaccus' disgraceful behavior. The prefect was recalled shortly thereafter; Caligula subsequently confiscated Flaccus' estate and banished him, before finally executing him in 39.

Despite the arrival of a new, more evenhanded prefect in Alexandria, relations between the Greeks and Jews remained so rancorous that both sides decided to dispatch delegations to Rome to lay their grievances before the emperor; Philo, perhaps the most learned and urbane hellenized Jew in the first-century world, and one of the leading advocates of coexistence with the Romans, headed the Jewish mission. After a stormy sea voyage, and months of waiting for Caligula to return from Gaul, the delegations finally caught up with the emperor in Rome in autumn of the year 40.

Unfortunately for the Jews, Caligula was not in a particularly receptive mood to hear their petition. Earlier in the year, a mob of Jews from the coastal town of Jamnia in Judea had destroyed an altar that the local Gentile population had built and dedicated to the emperor. Egged on by two of his virulently anti-Semitic advisers, Caligula avenged the insult to his godly dignity by ordering the recently appointed governor of Syria, Publius Petronius, to construct a

huge golden statue of the emperor as Jupiter and, under the protection of two full legions, take it down to Jerusalem and set it up inside the Temple. Now Petronius—who, like his predecessor Lucius Vitellius, was not unsympathetic to the peculiar demands of his Jewish subjects—understood perfectly well that any attempt to enforce Caligula's plan would set off a full-scale rebellion throughout Judea. Though he dared not refrain entirely from building the statue, Petronius had the work done in the Gentile city of Sidon in Phoenicia, and instructed the workmen not to hurry, but "to perfect the statue with good artistry and aim as far as possible to take a long time to reach the standard of the widely known exemplars, since work, if perfunctory, is generally short-lived."

When Philo and his Jewish colleagues obtained an audience (of a sort) with the emperor, Caligula was thus already predisposed to treat them roughly. Worse, on that particular day, he was preoccupied with the inspection of a grandiose construction project on the Esquiline Hill. According to Philo, the unpredictable ruler greeted the Jews "with a menacing frown on his despotic brow" and then spent most of the interview rushing from one building to the next, selecting window decorations and interrupting their laboriously prepared speech with such disconcerting questions as "Are you the god-haters who do not believe me to be a god, a god acknowledged among all the other nations but not to be named by you?" And, rather capriciously, "Why do you refuse to eat pork?" Once the Jewish delegation managed to stumble through an explanation of its position, Caligula turned to his advisers and said simply, "They seem to me to be people unfortunate rather than wicked, and to be foolish in refusing to believe that I have got the nature of a god," turned on his heel, and walked away, bringing the incident to an annoyingly inconclusive end.

Meanwhile, the great golden statue had been completed, and Petronius had taken it as far as the Galilean city of Tiberias before he stopped, sensing trouble, and requested the emperor to rescind his order. By this time, Herod Agrippa, too, had arrived in Rome. Before he went to pay his respects to Caligula, the king of Galilee seems to have been completely unaware of the catastrophe impending in Judea. Abruptly confronted by Caligula with peevish accusations of Jewish irreverence toward his divinity—"Your excellent and worthy fellow-citizens," he charged, "who alone do not acknowledge Gaius as a god, appear to be courting even death by their recalcitrance"—Agrippa

turned deathly pale and fainted dead away. Upon regaining consciousness, he decided to buy time by pretending to be in a coma. When he finally "revived" a day and a half later, Agrippa composed a lengthy memorandum to Caligula, begging him to desist from his Judean enterprise. Agrippa even went so far as to suggest that if the emperor was determined to persevere, he should kill him (Agrippa) without delay, because his miserable life would not be worth living if he could not retain the trust of both the emperor and his Jewish subjects. Although this gambit was not without considerable risk— Caligula had been known to take people up on invitations of this sort—it was precisely the sort of melodramatic touch Caligula appreciated, and so the emperor finally gave way and instructed Petronius to abandon the project.

More than anyone else, Herod Agrippa emerged from the incident of the gilded statue with enhanced stature, having succeeded where all others had failed in dissuading Caligula from committing the grossest act of sacrilege in Jerusalem in nearly a century. Yet Agrippa's popularity proved to be fleeting; the lasting significance of the episode lay rather in its confirmation of the fears of Jewish leaders in Judea that their religious liberties could never be assured so long as they remained subject to the whims of a pagan emperor far away, in the irremediably corrupt city of Rome.

While this unsettling Judean drama played itself out, Caligula had managed to alienate virtually every segment of the Roman populace. The swift executions in Germany of Gaetilucus and Lepidus distressed the Senate, as did the rash of condemnations and executions that followed Caligula's return to Rome in the summer of 40. Although the emperor's spies did uncover evidence of several verifiable plots against his regime, Caligula brought charges against numerous other wealthy aristocrats solely for the purpose of confiscating their estates, to pay for all those grandiose public spectacles and games and for the exotic luxuries with which he insisted upon surrounding himself; after all, living as a god was an expensive bit of work, and the imperial coffers had been exhausted long ago. The resumption of the bitterly detested treason trials, combined with the emperor's undisguised trend toward eastern absolutism and his offensive personal treatment of the nobility, completely wrecked his relations with the upper class. In the same manner Caligula squandered the considerable good will with which the Roman masses had initially greeted his

regime by imposing a variety of ingenious and obnoxious taxes, including levies on the sale of food, surcharges on every sort of legal transaction (including marriage), and a special duty—frequently collected by officers of the Praetorian Guard—on the earnings of porters, tavern-keepers, prostitutes, pimps, and practically every other sort of common occupation. Indeed, Caligula reportedly developed an extraordinary tactile affection for cold hard cash; rumor had it that he loved to throw himself atop piles of gold and silver and roll about in the stuff.

Perhaps most dangerously, Caligula had also forfeited the respect of the military by his blustering behavior in Gaul and his seemingly cowardly refusal to invade either Germany or Britain. Nor did the Praetorian prefects possess any guarantee that they, more than anyone else close to the throne, were immune from the emperor's capricious and malicious temper—a characteristic Caligula typically believed to be his best feature; like any good Roman deity, he took immense pride in his unpredictability, in the seemingly inexplicable, bizarre actions that conformed to no known human pattern of rationality, or even sanity.

In the end, it was one of the senior Praetorian officers, a grizzled former tribune named Cassius Chaerea, who carried out the plot to assassinate the emperor. As the frequent butt of Caligula's obscene jokes—the emperor liked to playfully accuse him of being a closet homosexual—Chaerea bore an intense personal grudge against the emperor that bordered on obsession. He was not acting on his own initiative, however, when he hid in a narrow corridor beneath the imperial palace on the morning of January 24 in the year 41; there was ample evidence that a number of senators had advance knowledge of the assassination plot, and may well have coordinated it themselves.

Caligula, who had almost decided to pass the entire day in bed, spent that fateful morning at the theater, watching command performances of the tragedy of *Cinyras* and the bloody farce *Laureolus, The Highwayman Crucified*, which coincidentally called for buckets of fake blood to be splashed upon the stage; after the assassination, someone claimed to have seen some of the blood stain the emperor's garments. At any rate, Caligula left the theater to enjoy a private lunch. A few members of his bodyguard trailed close behind him. En route to the palace, he stopped in the passageway to inspect a chorus of young boys specially imported from Greece and Ionia to sing a hymn composed in his honor. As he walked on, suspecting nothing, Chaerea and

two other veteran officers fell upon him with their swords, stabbing him repeatedly, taking extra care that some of their blows pierced his genitals.

Upon learning that the tyrant at last was dead, the Senate ordered the murder of his wife and their infant daughter. Then the assembly entertained proposals to abolish the principate and restore the Republic.

No one knew where poor old Claudius was. Nor, in the immediate aftermath of the assassination, did anyone greatly care—except, perhaps, a few officers of the Praetorian Guard.

The Sisters

China and Vietnam, 40–43 C.E.

> The setting sun must fall.
> How can it last long?
>
> —The Nine Masters of Hsun Shuang

The revolt in Vietnam commenced with the execution of a native chieftain of the people the Chinese called *Yue*—the barbarians of the South.

Actually, trouble had been brewing in northern Indochina ever since the early years of the first century, during the regency and reign of Wang Mang. Prior to that time, the Han emperors had been content with a nominal acknowledgment of Chinese suzerainty by the Lac tribes who occupied the Red River delta, leaving management of affairs in the hands of the local elite, the village headmen, who were drawn from a small circle of prominent clans presumably blessed by the spirits with the quality known as *kdruh,* or "grand charisma." But the situation changed drastically in the first three decades of the new century, when a massive influx of Chinese immigrants—landless peasants, deported criminals, and bureaucrats, scholars, and warlords who had backed the losing side in the civil war—pushed the Lac tribes out of the fertile valleys and threatened to destroy their native civilization.

The region had always sheltered a mixed population, starting probably with an amalgamation of peoples from Malaya, China, In-

donesia, and possibly Japan. Over a number of centuries, these tribes, known collectively as the Lac, had evolved a primitive feudal society dependent primarily upon agriculture (mostly rice), hunting (deer, elephants, rhinoceros), and extractive industries (precious woods from the forests, gold, etc.). By the time the first imperial Chinese expeditionary force ventured into the region in 214 B.C.E., the Lac had organized a confederation known as the Kingdom of Van Lang, or the Country of the Tattooed Men; the tattoos were usually in the shape of sea monsters designed to fend off the crocodiles who had a nasty habit of gobbling up Lac fishermen whenever the occasion presented itself. (The Lac painted fish eyes on the prows of their boats for the same defensive purpose.) A series of inconclusive military encounters between Van Lang and Chinese troops resulted in a treaty that permitted the local chieftains to retain control of their territories in the Red River delta in return for the payment of tribute consisting primarily of luxury items such as ivory, spices, rhinoceros horns, tortoise shells, and spices. This arrangement lasted only a few years; upon the advent of the Han emperors, who were forced to concentrate on domestic affairs to consolidate their regime, the natives broke away and established the independent kingdom of Nam Viet.

As part of the emperor Wudi's aggressive expansionist program, Nam Viet was restored to Chinese control, though again the natives were wisely permitted a substantial degree of autonomy. They were, after all, very far away from Chang'an and the effective control of the central government. All went reasonably well until an imperial governor named Xi Guang, who ruled from 1 to 25 C.E., attempted to "change the people through rites and justice"; that is, to replace the indigenous "barbarian" Lac culture—which was characterized by polygamy, slavery, animal sacrifice (preferably water buffalo, when they were available), and a fascinating variety of witchcraft and sorcerery practices—with the supposedly superior political and religious institutions of a classic Confucian civilization. Specifically, Xi Guang imposed Chinese marriage and burial customs (not to mention a heavy burden of taxes) on the native population, founded schools that taught the art of writing and the Chinese language, organized a militia that was trained according to Chinese army standards, constructed roads and waterways to facilitate trade and communication and the movement of troops, introduced the metal plow to replace the Viet stone hoe, and required the natives to wear Chinese headgear and shoes. In itself, this policy of forced sinicization might not have re-

sulted in open rebellion, but it occurred at precisely the time when the tidal wave of immigration from the north was forcing the Lac tribes out of their traditional agricultural homelands.

It was during these years that China underwent one of the most massive population shifts in its history. In the north and northwest, the disastrous effects of the Yellow River floods, combined with the disorder and physical destruction wrought by the prolonged wars of dynastic succession, forced hundreds of thousands of Chinese peasants to flee southward. This in turn left the imperial boundaries in the northern region vulnerable to incursions by the barbarian Xiongnu, which only exacerbated the situation. In the year 39, for instance, the government evacuated more than 60,000 people from the northern part of what is now Shanxi province because it could no longer protect them from repeated assaults by the plundering nomadic tribesmen, some of whom subsequently settled inside the Great Wall and became a sort of semiautonomous enclave within the empire. Further to the northwest, the heretofore quiescent race of herdsmen known as Qiang (ancestors of the modern Tibetans), exasperated by their exploitation at the hands of corrupt imperial bureaucrats, launched a series of revolts that gradually weakened the central government's control in modern Gansu province and accelerated the flight of ethnic Chinese from that area, too. By the year 40, the northern plains were so deserted that Guangwudi abolished more than four hundred counties—over twenty-five percent of the total number—because the local government and administrative personnel were no longer necessary.

Changes in the structure of Chinese society during the early years of the restored Han regime (usually referred to by modern scholars as the Later, or Western Han dynasty) also contributed to the depopulation of the countryside. Because Guangwudi owed his throne to the support of the Han nobility, which as a group had staunchly resisted Wang Mang's muddled efforts to undermine their political and economic dominance, the new administration generally followed a policy of nonintervention in local and provincial affairs. The efficiency of large-scale private enterprise did the rest. The great aristocratic families were permitted to accumulate vast estates—sometimes augmented by substantial grants of land from a grateful government—where the natural economies of scale and the extensive use of sophisticated tools and management techniques permitted the rise of a highly profitable variety of commercial agriculture, against which the individual peasant farmer could not compete. Thus the displace-

ment of the independent Chinese peasantry, a trend that had begun in the decades preceding Wang Mang's usurpation, now proceeded at an accelerated pace. Each year an increasing percentage of heavily indebted peasants threw in the towel and became tenant farmers, and were subsequently hard-pressed by rack-renting landlords, or signed on as retainers or servants to a narrow circle of wealthy landowners. Others simply took to the road and became vagabonds. Frequently their search for open land carried them all the way to the less-developed southern provinces—over the next one hundred years, the population of modern Sichuan and Quanan nearly doubled, and that of Hunan and Jiangxi increased fourfold—and still further, to what is now northern Vietnam.

This relentless migratory pressure, combined with Xi Guang's aggressive sinicization policy, created in the Red River delta an explosive situation which soon burst into open rebellion. In the third decade of the century, the governor inaugurated a program to train promising native youth for careers as imperial functionaries and militiamen. The Lac nobility vigorously opposed this scheme, of course, since it threatened to displace them from their traditional positions of power. Tensions rose perceptibly after a new governor arrived in 25 c.e. and stepped up the forcible conversion of the Vietnamese barbarians. Early in the year 40, a recalcitrant Lac chief in Me Linh was killed by the government in a heavy-handed attempt to bludgeon the native aristocracy into submission once and for all.

The execution had precisely the opposite effect. In March, the slain chieftain's widow, Trung Tac, and her sister, Trung Nhi (actually both women may have been married to the nobleman, though some accounts erroneously claim that they were his daughters), rallied the Lac opposition and led an insurrectionary force to the capital city of Lien Lau, not far from modern Hanoi. When the governor panicked and fled, the rebels seized the city and proclaimed Trung Tac queen of an independent Viet state. (The notion of a female ruler was by no means a novelty to the Lacs, whose tribal society had strong matriarchal overtones.) Over the next few months, Trung Tac's troops swarmed almost unopposed up and down the coast, subduing most of the countryside and besieging more than sixty of the walled fortresses that the government had constructed as defensive outposts. By the end of the year 41, the region under the Trung sisters' control extended nearly to Hue (just south of the seventeenth parallel) and northward into the provinces of southern China.

It took nearly two years for the empire to strike back. Exhausted by the seemingly interminable civil conflict in China, which had only ended in 39 C.E., Guangwudi was not at all eager to get involved in another military expedition; in fact, for a long time he forbade anyone to mention the word *war* in his presence. But in May or June of 42, when the Trung rebellion showed no sign of dying out of its own accord, the Son of Heaven ordered seventy-year-old General Ma Yuan, a former warlord from the northwest and one of the best soldiers in all China—he had recently defeated a Tibetan uprising—to lead a campaign against the Trungs.

Armed with the honorable title of General Who Calms the Waves, Ma Yuan did not mobilize an army until he reached southern China (else he would have had to feed them all the way down); there he raised twenty thousand conscripts from the local populace and dispatched a fleet of supply ships to sail down the coast and meet him near Lien Lau. Fortunately, Ma Yuan elected to commence his invasion in the autumn, at the start of the six-month dry season. Still, it was no picnic for the hastily recruited imperial troops as they slogged their way across the rugged highlands and river valleys and the malaria-infested swamps, complete with pythons. They reached the Red River early in 43 without encountering any serious Viet opposition. In April, however, the government forces fought a pitched battle with the main Trung army near Lang Bac; completely overmatched, the inexperienced and disorganized native soldiers—whose only weapons were bows and bronze arrows with poison tips—were routed. Trung Trac herself was subsequently captured and beheaded. Her sister met the same fate several months later.

Ma Yuan devoted the rest of 43 to mopping up the scattered remnants of resistance. Then he embarked upon a ruthless campaign to destroy all vestiges of the ancient Viet nobility's influence. The government deprived the Lac chieftains of all political authority and degraded their status, replacing them with professional Chinese administrators. Members of the most prominent Lac clans were deported to southern China; others fled to the highlands, where the indigenous Viet culture still prospered. Their land was expropriated and awarded to Chinese immigrants. The bronze drums that had served as the symbol of the Viet chieftains' authority were melted down and cast in the form of a horse, which Ma Yuan took back to Luoyang in the autumn of 44 as a gift to the emperor. Although the

general died in disgrace just five years later, one of numerous victims of backstairs palace intrigues in the capital, the spirit of Ma Yuan was worshipped as a god by the people of southern China. But in Vietnam, the Trung sisters remained an inspirational symbol of national independence for nearly two thousand years.

The Conqueror

Rome and Britain, 41–45 C.E.

> If you want to rule the world, does it follow that
> everyone else welcomes enslavement? . . . When you
> have all this, why do you envy us our poor hovels?
>
> —CARATACUS, KING OF THE CATUVELLAUNI

Claudius was terrified. Naturally. Fear had been his constant companion since childhood; over the past fifty years, he had seen his father, his brother, his uncle, and an assortment of cousins die in circumstances that were, at the very least, suspicious. No wonder Claudius had exaggerated his natural infirmities and willingly played the buffoon. Now his nephew Caligula had been assassinated by officers of the Praetorian Guard—the very men sworn to protect the emperor. And the Senate, which had seized the Forum, taken physical possession of the Treasury, and stationed guards from the urban cohorts at strategic points around Rome, was meeting in the Capitol to discuss the restoration of the Republic, or at least a modified version of the principate, with one of their own, more pliable nominees (unrelated to the Julio-Claudian dynasty) at its head.

Although rumors that a Guard discovered Claudius cowering behind a curtain in a dark corner of the imperial palace were almost certainly embellished later to make the poor man appear ridiculous, Claudius clearly intended to lie low until he could see which way the wind was blowing. It did not take long. As soon as he realized that he possessed the firm support of the Praetorians (whose very liveli-

hood depended upon the maintenance of the imperial order, and who preferred a prince of the blood and a brother of Germanicus to any other candidate) against the Senate and the urban cohorts, Claudius moved decisively to put an end to the crisis. While the Senate—torn by dissension and wholly unable to agree on any course of action—dithered away its initial advantage, a detachment of Praetorians escorted Claudius to their camp for safekeeping. Although anyone who understood the Guards' instinct for self-preservation should have foreseen this move, the senators appeared to panic at the news; they quickly drafted an official letter instructing Claudius to proceed at once to the Capitol, where he would, as a dutiful citizen, "submit to them and to the law."

But Claudius obstinately refused to budge. Through a messenger—his boyhood friend Herod Agrippa, who just happened to be in Rome at the time—Claudius informed the Senate that the principate had been thrust upon him by the Praetorians, who had acclaimed him emperor against his will (which was not exactly true); nevertheless, he said he had absolutely no intention of deserting his new-found friends, nor could he do so if he wished. This was a thinly veiled hint to the assembly that the gentlemen of whom he spoke had swords and considerable experience in killing civilians whom they found disagreeable. Besides, Claudius added, the Senate had nothing to fear from his reign, for he had no desire to institute the sort of arbitrary despotism Caligula had sought. When the Senate continued to press him to resign, Claudius snapped back that "if they wished to resort to violence, he would not shrink from it."

Forty-eight hours after the assassination of Caligula, the Senate conceded defeat and voted Claudius all the relevant imperial powers. The new emperor promptly promised a hundred and fifty gold pieces to every member of the Praetorian Guard and, as public acknowledgment of the fact that his regime was founded upon the loyalty of the Guard, issued one coin showing him shaking hands with a soldier, and another displaying a military standard outside the Praetorian camp. For all the rest of his reign, Claudius made a conscious effort to keep both the Guard and the regular legions contented through generous allotments of cash, prestige, and glory.

This precautionary policy paid immediate dividends when a rebellion broke out in Dalmatia the following year. The governor of that province, Marcus Furius Camillus Scribonianus, acting in coordination with leading conservatives in the Senate, proclaimed the restora-

tion of the Republic and sent a letter to Claudius ordering him to abdicate. Then Scribonianus attempted to raise the two legions under his command in support of a coup. After several days of general confusion and countermanded orders, the Dalmatian legions turned on Scribonianus and murdered him. This incident, together with several other abortive coups and assassination attempts in the next two years, confirmed Claudius' conviction that he could trust the army but not the Senate; henceforth Claudius never attended a private banquet without an escort of heavily armed Guards, and later he insisted that everyone who came into his presence be searched for hidden weapons. And though he still took great pains to pay homage to the traditional dignity of the Senate, constantly encouraging it to play a more active role in the administration of the empire, Claudius simultaneously purged its ranks of men he considered disloyal or unworthy, and admitted to its rolls his personal supporters and—for the first time—members of the provincial nobility, who presumably posed less of a threat to the security of the principate than those Italian aristocrats who retained an obsessive and by now wholly impractical affection for the republican past.

Unlike Caligula, Claudius scorned personal adulation and excessive honors. Preferring the reality of power to its outward trappings, he refused to assume the permanent title of *imperator* or "father of his country." For the most part, Claudius continued to affect the informal demeanor and sense of good humor that had endeared him to the populace before his accession; at times, though, familiarity bred contempt. Lawyers regularly insulted the emperor while he was judging their cases—one petulant Greek barrister allegedly called him "a stupid old idiot"—and an exasperated equestrian defendant once hurled a stylus at Claudius, gashing his face. Moreover, Claudius' frequent displays of tiresome pedantry in his official proclamations (he was, after all, a trained historian), his notorious absent-mindedness (more than once he asked the whereabouts of someone he had just executed), and his eccentric personal habits (unable to sleep for more than a few hours at night, he often dozed off in the courtroom, and occasionally interrupted a speech in the Senate to partake of a midday snack) made him the butt of numerous crude jokes among his contemporaries, but the emperor generally bore the mockery with good grace. He simply refused to take himself too seriously.

But Claudius was nothing if not conscientious, spending long hours at his desk virtually every day—including holidays and even

his birthday—poring over petitions and official correspondence, until the burden of responsibility, abetted by overindulgence at dinner and between-meal snacks, brought on the horrible abdominal pain (probably ulcers) that sometimes made him seriously consider suicide. Claudius' commendable devotion to duty also resulted, not entirely coincidentally, in a broad expansion of the *princeps'* authority and a corresponding decline in the prerogatives of the Senate in a wide variety of areas, especially jurisprudence, where Claudius acquired a reputation for impatiently cutting through legal sophistry and technicalities in a scrupulous effort to discover the truth and bring justice to the disadvantaged. "Of course I am aware that dishonest accusers will never lack tricks," he admitted. "But I hope we shall find remedies against their evil arts."

In economic affairs, too, Claudius adopted a boldly activist policy of government intervention. He took special care to guarantee the supply of grain to the capital, subsidizing with government funds the construction of additional transport ships, and offering maritime insurance to Roman merchants to encourage them to keep their fleets operating throughout the winter. At prohibitive expense to the public treasury, Claudius turned the outmoded and overburdened ancient harbor of Ostia into a first-class modern port and the capital's major grain emporium, by deepening the entrance and throwing out curved breakwaters on either side. While this work was proceeding, Claudius ordered the construction of networks of new roads throughout the empire, completed one aqueduct begun by Caligula and began another to improve Rome's water supply, and persuaded a syndicate of private businessmen to fund the drainage of one of the largest lakes around the capital to provide the home provinces with desperately needed arable land.

Driven by a compulsion to have a hand in everything that went on in the empire, Claudius obviously needed considerable help from capable subordinates. Whereas Augustus and Tiberius had relied primarily upon the equestrian class—the Italian bourgeoisie—to assist in the day-to-day administration of the empire, Claudius adopted Caligula's policy of employing a small circle of well-educated and highly talented Greek freedmen (usually the sons of ex-slaves, though sometimes they were former slaves themselves) as a sort of imperial secretariat. The three most influential freedmen in Claudius' bureaucracy were Narcissus, who enjoyed such close access to Claudius that he functioned in crisis situations almost as a deputy

emperor; Pallas, the empire's chief financial officer; and Callistus, who assisted Claudius with his judicial duties. Despite their very real personal authority, these secretaries almost always operated under specific lines of policy laid down by the emperor; they certainly were not, as gossip suggested, independent functionaries who dominated Claudius and appropriated his decision-making initiative. They did, however, take advantage of their lofty positions to accumulate so much wealth that their enemies sarcastically suggested that the government, in the throes of a financial crisis, should look to borrow money first from the emperor's own freedmen.

If Claudius found it necessary to adopt innovative, progressive, and often autocratic political and administrative policies to advance the welfare and safety of the empire, he balanced these with an equally deep and abiding conservatism in the realm of religion and civic tradition—which he tried to fuse into a single unified expression of patriotism. Like Augustus and Tiberius, whose reverence for ancient Roman customs he shared, Claudius avoided all offers of divine honors for himself and forbade any Roman citizen to sacrifice to him while he was still alive, though he did permit the cult of emperor worship to continue in the eastern provinces. "I do not wish to be offensive to my contemporaries," he explained, "and my opinion is that temples and such forms of honor have by all ages been granted as a prerogative to the gods alone." To revive the almost forgotten practices of soothsayers—the *haruspices*—Claudius established a special board to support these civic priests with government funds, on the grounds that "this oldest Italian art ought not to die out through neglect. The advice of soothsayers, consulted in time of disaster, has often caused the revival and more correct subsequent observance of religious ceremonies. . . . Gratitude for divine favour must be shown by ensuring that rites observed in bad times are not forgotten in prosperity." Whenever he signed a diplomatic treaty or celebrated a military victory, Claudius ostentatiously sacrificed to the gods, and made certain that their temples were kept in good repair.

To further protect the Roman gods in their own domain, Claudius struck at the growing popularity of foreign cults and religions in the capital. Astrologers were evicted from Rome, and Jews were first prohibited from proselytizing within the city limits and then thrown out of the city altogether, not for the first or the last time. Actually, these anti-Jewish decrees may have been directed at an aggressive though numerically insignificant community of Christians,

because Suetonius refers obscurely to "disturbances" that occurred in Rome at this time "at the instigation of Chrestus." But of all the rude barbarian cults that contaminated the Roman empire in the first century, none was despised and feared more intensely than the vile practices of the Druids, whose stronghold lay at the other end of the world, in the mysterious and forbidding islands of Britain.

In April 43, an invasion force of more than forty thousand troops had assembled at Gesoriacum, in the vicinity of what is now Boulogne, on the shores of northern Gaul, awaiting orders to cross the English Channel. Neither the four veteran legions—three drawn from the German provinces and the fourth from Pannonia—nor the auxiliaries from the Rhine and Belgian garrisons were looking forward to their imminent departure from the civilized world. Three years earlier, during the last year of Caligula's reign, a similar expedition had been canceled when the legions simply refused to move; furious, Caligula had sarcastically ordered the troops to gather seashells from the beach as trophies of their "triumph," the only work fit for such miserable cowards. Now this army—under the command of Aulus Plautius, an experienced battle commander who had been handpicked for the invasion from his post as governor of Pannonia—was proving equally recalcitrant.

Contrary to the notions of later generations, the troops' reluctance to cross the Channel did not stem from Roman ignorance of the British Isles. For more than a century, Roman merchants had carried on an active and increasingly profitable trade with the islands, bringing back information about the interior along with the cargoes of British wheat, cattle, gold, silver, slaves, and hunting dogs, which the natives exchanged for Italian wine, oil, glassware, and jewelry. Additional intelligence of a specifically military nature had been obtained by Julius Caesar in his two hit-and-run raids across the Channel in 55 and 54 B.C.E., though Caesar clearly misunderstood much of what he had seen. Even more importantly, a steady stream of refugee British chieftains had made its way to Rome over the past fifty years, victims of the internecine warfare that had consolidated the control of three principal tribes over the southeastern part of the island: the Atrabates, the Iceni, and the most arrogant of all, the Catuvellauni, who, under their exceptionally able chieftain Cunobelin (whom Shakespeare knew as Cymbeline), had recently established their tribal

capital at Camulodunum—appropriately, the name meant "the fort of Camulos," the god of war.

Ousted from their lands, these expatriate chieftains supplied the imperial government with detailed accounts of current political developments in Britain, which had recently taken an ominous turn. Ever since the reign of Augustus, Rome had attempted to control southern Britain through astute diplomacy, playing off one tribe against another. Even the preeminence of Cunobelin could be tolerated so long as he guaranteed stability, protected trade, and recognized, albeit in a perfunctory manner, the supremacy of Rome. But these arrangements had come unraveled in the late 30s in the wake of Cunobelin's death, when two of his sons, Caratacus and Togodumnus, launched an aggressive expansionist campaign, even deposing one of their other brothers, who promptly made his way to Rome to ask Claudius for assistance in regaining his throne.

Claudius jumped at the chance. By the fourth decade of the first century, the flourishing trade between Britain and the continent had assumed such lucrative proportions that the emperor could not stand idly by while independent-minded native chieftains threatened Rome's profits. Besides, Claudius urgently needed an impressive military victory to enhance his personal prestige—a less soldierly looking figure never governed Rome—and bolster the morale (and line the pockets) of his armies. Perhaps Claudius realized that the principate, too, stood in dire need of a foreign triumph to reinvigorate its sagging martial pride; between Tiberius' cautious foreign policy and Caligula's instability, it had been far too long since the capital celebrated a smashing conquest. Britain, with its air of exotic mystery which masked the fundamental weakness of its strategic defenses, seemed to fit the bill perfectly. The notion appears to have crossed Claudius' mind to carve a whole new province out of the island. Besides, an expedition would permit Claudius, the guardian of Roman religious tradition, to crush the loathsome cult of British Druidism. And *that* was precisely why his troops at Boulogne were so averse to sailing across the Channel.

Nothing terrified the common Roman soldier of this age more than the nightmarish prospect of capture, torture, and mutilation by the Druidic priests who employed human entrails to divine the future. At the start of Claudius' reign, there were still legionaries on active service who remembered the gruesome fate of Varus and his men at the hands of the Germanic armies under Arminius; and just in case

anyone had forgotten, Caligula's otherwise uneventful and abortive foray into Germany had recently turned up a few emaciated survivors of the Varian disaster. Facing civilized Greeks or even the ferocious Parthians was one thing; battling barely human enemies, who according to rumor drank human blood and roasted human flesh, was quite another. Nor did the prospect of a Channel crossing encourage enthusiasm among the troops; memories of the disastrous outcome of Germanicus' amphibious expedition in the North Sea in the year 16 were still too fresh for that.

So the legions under Plautius simply refused to embark and came perilously close to open mutiny until Narcissus, Claudius' alter ego, who was at Boulogne to supervise the invasion preparations, jumped onto the commandant's platform and started to lecture them on their duty to the emperor. Unused to being harangued by a freedman, the men heartily booed both this ex-slave and, for good measure, Plautius, but—having got their feelings off their chest—finally consented to get on board. Even so, the immense logistical difficulties of launching and sustaining such a venture nearly sank the expedition before it began. Since the Romans were sailing in the springtime, they could not rely on living off the land; the fruits of the previous harvest would have been nearly depleted and probably hidden from the invaders anyway, and the newly planted fields would have yielded little until midsummer. A conservative estimate placed the daily grain requirements of forty thousand fighting men at sixty tons of grain per day; plus, the army required more than three thousand mules and five hundred carts to transport supplies—both food and equipment—in a constant stream to the front once the troops started to move into the interior. These figures, of course, did not include the horses (and *their* feed) required for the Roman cavalry, upon which Plautius intended to rely heavily to counter the war chariots of the British. To transport all this baggage, along with the soldiers themselves (at eighty men to a ship) and the mule drivers and other supporting personnel, obviously required a vast fleet of cargo vessels, probably not less than a thousand of the unlovely but eminently practical shallow-drafted barges the Romans preferred for such jobs.

Needing a sheltered anchorage along the southeastern British coast, with easy access to the Thames River network, Plautius chose the area around modern Richborough, in Kent, as his landing place and primary supply base. In hopes of surprising the enemy and thereby reducing the chances of catastrophe during the landing opera-

tion, the Roman forces—divided into three separate squadrons—sailed at night and reached Richborough at dawn; but the British, who had got wind of the near mutiny at Boulogne and assumed that the Romans would not be coming after all, were nowhere to be found, and so Plautius, unlike Julius Caesar a hundred years earlier, enjoyed the luxury of disembarking virtually unopposed. After securing this bridgehead, Plautius led his legions westward toward the Medway River.

Commanding the II Legion (known by its army designation as *Augusta*) was a thirty-three-year-old knight from central Italy named Titus Flavius Vespasianus. The son of a Sabine banker who doubled as a tax collector and had, surprisingly enough, built a reputation for honesty, Vespasian was something of a throwback to an earlier age of unsophisticated, republican Roman virtue. Born in the year of the Varian disaster, he had grown up in an idyllic rural environment at his grandmother's estate on the Tuscan coast. Possessed by a burning lack of ambition, Vespasian probably would have preferred to spend the rest of his life in comparably comfortable circumstances. But his elder brother, Flavius Sabinus, had already embarked upon an illustrious military career, and Vespasian—driven by his mother's constant nagging—soon found himself following in Sabinus' footsteps, joining the army as the first step up a ladder at the top of which, his mother hoped, rested the ultimate prize of a seat in the Senate.

At the time, a senatorial career probably looked like an impossible reach for Vespasian. Although the Senate did contain a number of hard-working and well-connected knights who had overcome their relatively humble social origins, there was no getting around the fact that Vespasian seemed to be stuck with a stolid and wholly uncharismatic personality. Nor was he much to look at: powerfully built, with a hooked nose and tight lips and a square, almost squashed face that looked as if too much flesh had been squeezed into too little space, Vespasian had a perpetual grimace which gave the impression, his contemporaries said, that he suffered from chronic constipation.

But as he matured under the pressure of military command, Vespasian revealed himself as a born soldier, full of dogged perseverance and immense physical courage. He enjoyed sharing the hardships of his men, marching at the head of their ranks, wearing the same plain uniform and eating the same modest rations as they. In return, Vespasian expected absolute loyalty and discipline, and he brooked no complaints. Once, when some of his men whined about

the poor quality of their sandals, he took their footwear away and ordered them to walk barefoot instead. (So far, Vespasian seemed like a bourgeois replica of Tiberius.) Like most enterprising Roman knights in the early empire, Vespasian served in a wide variety of military and civilian positions on his way up. There was a stint as a colonel in the field, chasing bandits through the mountains of Thrace, followed by a brief tenure as financial adviser to the governor of Crete and Cyrene, and a term as praetor in Rome under Caligula, where he attracted the attention of Narcissus. Soon after Caligula's assassination, the imperial secretary recommended Vespasian to Claudius for the position of legate of the II Augusta, which was then stationed in Germany. By the time that Legion sailed for Britain, Vespasian had also fathered a son, a sixteen-month-old infant named Titus.

In Britain, though, he had no time for domestic pleasures. As the four legions ventured inland from their supply base at Richborough, they were harassed by raiders from the hastily reassembled British forces who employed the same type of guerilla tactics that the veterans had encountered in Germany. Being used to this sort of thing by now—at least the British landscape was not an unbroken mass of thick forests—the Roman troops made their way, slowly and not without losses, to the river now known as the Medway. By the time they arrived, a substantial detachment of British cavalry, with their old-fashioned war chariots, had assembled on the west bank of the Medway; having destroyed the only bridge in the immediate vicinity, the overconfident Caratacus and Togodumnus neglected to take defensive precautions. Not for nothing, however, had Plautius insisted upon bringing with him a detachment of Batavians who were experienced in the art of river crossings in full battle gear. At the Medway, these auxiliaries now swam across the river downstream, undetected, and fell upon the Britons with slingshots and lances, aiming their fire at the British horses. The hail of stones and iron created considerable chaos and forced the natives to stand and fight—an unappealing prospect, considering the fact that most of the Britons lacked any armor at all to withstand the vicious Roman short swords that jabbed at their chests and faces from close range. (The average British warrior, however, was considerably taller than his Roman opponent, though not quite as large as his long blond moustache, flashing gold jewelry, blue woad-stained skin, and streaming blond hair—stiffened into quills with lime—made him appear.)

While the main British forces were thus preoccupied, Vespasian's

troops circled around, discovered another bridge, and fell upon them from the other direction, inflicting substantial casualties. Nevertheless, the British—who may well have enjoyed a numerical superiority of about two to one, and who, like their Celtic cousins in Germany, had been raised in a culture that prized military prowess above all other virtues—stubbornly refused to withdraw. When night fell both armies remained in the field. Nor did the Romans succeed in breaking through the British lines the following morning, until reinforcements arrived from Richborough, finally overwhelming the Britons and forcing them to fall back to the Thames, their next line of defense. There the Batavians once more exhibited their amphibious talents, but this time the British were waiting for them. If there were no forests along the Thames, there were more than enough impassable marshes to entrap the Roman auxiliaries, who were cut down en masse in the British counterattack. Nevertheless, the relentless pressure of the Roman advance along several fronts persuaded Caratacus to withdraw after heavy losses of his own; besides, his brother Togodumnus had been fatally wounded. Alone, with his army in tatters and no further natural obstacles between the invaders and Camulodunum, the British chieftain scattered his troops and headed westward toward the midlands, where he could continue a guerilla campaign against Plautius.

Plautius himself probably would have pursued Caratacus right then, had he not been under explicit orders to pause and relay a signal to Rome at this stage of the campaign so Claudius himself could come to Britain to oversee the fall of the Catuvellaunian capital, which was the primary strategic objective of the first phase of the invasion. Of course Camulodunum was not a city in the Greco-Roman sense; strictly speaking, it was nothing more than the sort of village the Romans called an *oppidum,* a fortified settlement of timber and daub huts.

It took ten to twelve weeks for Claudius—who left his drinking crony, Lucius Vitellius, in charge of Rome during his absence—and a detachment of out-of-shape Praetorian Guards to make the twelve-hundred-mile journey, traveling perhaps by sea to Massilia (Marseilles), thence overland to Gesoriacum (Boulogne), picking up along the way some specially trained war elephants (the better to impress the British), then finally crossing the Channel and heading westward toward Durobrivae (present-day Rochester), where the legions were waiting impatiently. Plautius took advantage of the enforced delay to

reorganize the administration of the regions he had already con-
quered, establishing treaty alliances with docile tribal chieftains to
restore order to the war-torn lands in the Roman rear, thereby freeing
his troops from the onerous burdens of garrison duty.

Finally, in August, Claudius and the elephants arrived, and the
march toward Camulodunum resumed at a dignified pace, while Ves-
pasian and his legion mopped up the remnants of British resistance
in the region. There was little or no opposition to the emperor's
advance; by this time, Caratacus was far away and, unfortunately for
Rome, out of Plautius' reach. In the end, the conquest of Camulodu-
num was completely devoid of drama. Upon capturing the practically
defenseless settlement, Claudius celebrated an ostentatious triumph
and offered the appropriate sacrifices, and then returned to Rome for
further celebrations, having spent a total of sixteen days in Britain.

But the legions' task had just begun. Plautius ordered one army
into the northeast and two more into the center of the island to pursue
Caratacus and establish Roman control over the rest of the lowlands.
Meanwhile, Vespasian and the II legion were sent southward to se-
cure the lines of trade and communication from the West Country to
Dubris (Dover) and to subdue an especially obstreperous tribe known
as the Durotriges, whose territory included the modern county of
Dorset, along the southern coast. It took the methodical Vespasian
nearly a year to complete his preparations. First he constructed a
fortress at Chichester to watch his back; then he established a supply
base and stocked it with provisions for the forthcoming campaign.
Next his troops—ten thousand legionaries, along with cavalry and
supporting auxiliaries—built new roads or widened the existing ones
to facilitate the movement of men and supplies; and a naval base had
to be erected on the coast for additional protection. By the time all this
was done, it was too late in the season to launch an offensive, and so
Vespasian took advantage of the winter respite to hurry back to
Rome, where he received official recognition for his role in the Med-
way-Thames victories.

He returned to Britain just in time for the start of the spring
campaign. Vespasian led his force along the coastal route, though not
too rapidly; his progress was slowed somewhat by the artillery batte-
ries that were accompanying the II Legion. This artillery was essential
because of the nature of the Durotrigian defenses. Unlike the tribes
of southeastern Britain, who had adopted the Belgic custom of build-
ing their *oppida* in the lowlands, where they were protected from

Vespasian

enemy chariots by rivers, marshes, and man-made dykes, the Duro-
triges clung to the ancient Celtic practice of residing in hill-forts:
self-supporting clumps of huts, workhouses, animal pens, and
shrines, enclosed by a mazelike defensive structure of multiple
ditches, towers, and earthen ramparts. Some of the larger hill-fort
communities may have housed several hundred people, most of
whom lived as extended family units in circular thatch, mud, and
wattle huts, some as wide as thirty-five feet across, with beds of straw
or animal skins, and clay ovens for roasting grain and beef or pork.

Vespasian's strategy for reducing these forts was straightforward
and simple: he blasted them into oblivion. Because the Durotriges
conspicuously failed to combine their forces for a single, unified
stand, Vespasian enjoyed the luxury of picking off the settlements
one by one. At Hod Hill, for instance, where there was only one
rampart, the Romans fired from long range a hail of iron artillery
arrows, or bolts, into the middle of the settlement until they zeroed
in on the chieftain's hut; once that was destroyed by concentrated fire,
the rest of the fort surrendered.

The stronghold of Maiden Castle, however, was more stoutly
defended. There Vespasian faced a confusing, intricately designed,
four-tiered sequence of deep ditches, banks, ramparts, and winding
entranceways, described by one writer as resembling "loosely clasped
fingers, between which a zig-zag path may be followed—a cunning
construction that puzzles the uninformed eye." Following a ferocious
artillery barrage designed to soften up the defenders, Vespasian's
infantrymen advanced through this maze—probably in the famous
testudo ("tortoise") formation, with tightly interlocked shields above
their heads—slicing their way up the ramparts toward the eastern
gate. It was not easy. The Durotriges and their allies had mastered the
art of slingshot warfare, and their whirling stones and spears, com-
bined with the warriors' formidable skill with the long sword, in-
flicted sufficient casualties to goad the Romans into indiscriminate
slaughter when they finally reached the top. Before Vespasian could
stop them (if indeed he tried), the legionaries had fired the huts
outside the fort and set the wooden gates ablaze; in the ensuing
holocaust of smoke and flame, scores of British men, women, and
children were savagely butchered, their corpses dumped into shallow
mass graves by the entranceway.

The Roman conquest of Maiden Castle sealed the fate of the rest
of the West Country. Vespasian remained in Britain through the year

47, establishing garrison forts at strategic points, building more roads, subjugating the Isle of Wight, and seizing the rest of the hill-forts in the region. The Roman historian Suetonius claimed that altogether, the general fought thirty battles in Britain and captured twenty towns. Certainly the victories on the island vaulted him into prominence back home. Four years later, Vespasian was elected consul in Rome.

The Missionary

Judea and Asia Minor, 37–56 C.E.

> I did not receive my gospel from man,
> nor was I taught it.
>
> —PAUL, IN HIS LETTER TO THE GALATIANS

F or Paul the tension had become unendurable. The struggle
had begun in his youth in the early years of the first century,
a product of his strictly traditional, middle-class Jewish upbringing in
Tarsus, one of the leading Hellenistic centers of commerce and Greek
philosophy in Asia Minor; the difficulties intensified when he left for
Jerusalem to study at one of the rabbinical academies, possibly with
Gamaliel himself, the most famous Pharisee of his generation.

In his fanatical devotion to the Law—for the Pharisees, the exclu-
sive path to a right relationship with God—few students of the Torah
could have surpassed Paul. (Paul was his Latin name—the Hebrew
name his father had originally given him was Saul.) But the brilliant
if high-strung Paul, for all his intense piety—in fact, because of it—
suffered acutely from the frustrating dilemma posed by the concept
of salvation through human endeavor. The more deeply one studied
the Law, the thicker grew the maze of detailed rules and regulations;
and while adherence to those rules provided the Pharisees with their
claim to greater purity, the sheer volume and complexity of regula-
tions rendered complete compliance virtually impossible, no matter
how mightily they strove. For someone like Paul, proud of his righ-

teousness and obsessed with the superhuman objective of absolute obedience to God, and possibly possessed of a manic-depressive personality besides, this seemingly hopeless state of affairs created a profound psychological crisis that found release first in his furious persecution of Jesus' followers in Jerusalem (or at least those who rejected the Law), immediately after the death by stoning of Stephen outside the city walls.

Then, along the road to Damascus, where the High Priest had sent him to persecute more disciples of The Way, all the nervous anxiety and emotional stress that had been smoldering within Paul suddenly burst into an explosion of light behind his eyes that literally blinded him and as he collapsed to the ground he heard a voice he was certain was the resurrected Jesus asking him, in Aramaic, "Saul, Saul, why do you persecute me?" And in that flash of revelation Paul discerned a way out of the impasse that had tormented him: in the shadow of the crucifixion and the resurrection, the bonds of the Law no longer mattered. For if one accepted Jesus as the Son of God, then God had deliberately sacrificed Himself upon the cross to open a new door of redemption for all mankind; and this gift of God's grace, freely given through faith in the risen One, had rendered the Law obsolete. Although Paul was hardly in any condition to articulate the details of this revelation, it represented a unique amalgamation of concepts drawn from Jewish theology (such as the Suffering Servant of the Book of Daniel) and the doctrines propounded by Stephen and the Hellenistic community of The Way, which Paul had been persecuting. And whereas Paul had previously been driven by his militant Pharisaical orthodoxy to stamp out the heresies that threatened the salvation of Israel, he now believed that the Lord, by appearing personally to his persecutor, had imposed upon him an equally compelling obligation to spread the news of the resurrection—to which Paul, like the Twelve in Jerusalem, was now a witness—to both Jews and Gentiles, "to open their eyes, that they may turn from darkness to light."

As he lay at the home of a friend in Damascus, recovering from this overpowering conversion experience, Paul might have been excused for thinking that he was hardly the man to perform this sort of missionary work. He was not an accomplished orator, nor did he have an imposing physical presence; according to one description handed down to a later generation, Paul was a short, solidly built, bandy-legged man, with a receding hairline and thick eyebrows that

met atop a rather prominent nose. He also appears to have been quite near-sighted. Nevertheless, God had favored him with a mission, and so Paul retreated to the desert kingdom of Nabatean Arabia, in the general vicinity of present-day Jordan, to gather his wits and hone his evangelistic skills. And clearly they needed further refinement, for Paul founded no known churches in Arabia, and within two or three years his proselytizing activities had so antagonized the government that he had to be smuggled out of the country by his friends.

At this point, around the year 39, Paul journeyed to Jerusalem— still the unquestioned center of the Nazarene movement—to meet with Peter, probably to seek practical advice on the finer points of preaching the gospel of the risen Jesus. Ever since Stephen's death, Peter had been drifting farther away from his administrative work as leader of the community of The Way in Jerusalem, concentrating instead on his missionary work to Jews—and the occasional Gentile— in Samaria and the Judean coastal cities of Caesarea Maritima and Jaffa. In his absence, the affairs of the Jerusalem community were directed by James (known as "the Just"), a brother of Jesus and a rigidly orthodox Jew who had been converted to The Way in the aftermath of the crucifixion. Paul may have met James, too, during his brief sojourn in the holy city, but the two men would hardly have been compatible, for James adamantly insisted that membership in The Way required strict adherence to the Law—which, for reasons of ritual cleanliness, precluded close association with Gentiles—and particularly to the ancient ritual of circumcision, the visible sign of God's covenant with the children of Abraham. This, of course, was precisely the sort of thinking Paul had thrown over so completely in the wake of his own conversion. "All who rely on works of the law are under a curse," Paul had decided, "for it is written, 'Cursed be every one who does not abide by all things written in the book of the law, and do them.' "

Paul had not sought approval for his evangelistic work from Peter or James, nor did he receive it. Instead, he left Jerusalem to return to Syria and his homeland of Cilicia, to carry on an independent mission, first on his own, and later in cooperation with an old friend, a Cypriot Jew named Barnabas. Wherever Paul went, he tried first to preach in the synagogues, where his scholarly training as a Pharisee provided him with an entree; and of course the local Jewish communities would already be familiar with both the concept of a Messiah and the scriptural references Paul used to support his claim that Jesus of Nazareth

was the Messiah. But even in the synagogues, Paul's audiences were not exclusively Jewish, for in the cities of the Diaspora there were numerous Gentile sympathizers, called "God-fearers," who were attracted to the high moral standards of Judiac philosophy, regularly attended services in the synagogues, and followed some of the ethical precepts of Judaism without submitting to the complete regimen of the Law, particularly its dietary restrictions and the circumcision requirement. Although Paul himself was not personally known to these congregations when he arrived, the fact that he had been transformed from one of the most violent persecutors of The Way to one of its staunchest adherents must have given him a tremendous advantage in winning converts.

Sometime around the year 47, Barnabas asked Paul to come to the city of Antioch, in Syria, where a serious dispute was brewing. Located on the shores of the Orontes River, Antioch was then the third largest metropolis in the Roman Empire, after Rome and Alexandria, with a population of about half a million, including a considerable percentage of Jews. Over the past decade, a number of Hellenistic followers of The Way—ironically, including many of those driven out of Jerusalem during the reign of terror led by Paul—had settled in Antioch and established a number of Christian communities there. In fact, this was where the word *Christian* itself was coined, by Greeks who regarded the Antioch Christian community as "the party of Christ" *(Christianoi)*; it is not clear whether they meant to identify it thereby as an independent sect distinct from the Jews, or merely as one of the multitude of Jewish splinter groups that were gaining adherents in the mid-first century. To an outsider, the early Christians doubtless looked very much like just another faction of Jews, since they spent much of their liturgical service reading the scriptures to demonstrate how all the prophecies that pointed to the coming of the Messiah had been fulfilled in Jesus. At any rate, the Antioch Christians took a critical step toward severing the relationsip with the local Jewish community by establishing the first separate Christian church (separate in a physical sense, that is), which they built onto a cave just outside the city walls.

Throughout this period, most of the Christian communities in Asia Minor gathered and worshipped in house-churches, usually the private homes of wealthier members who provided space for meetings of their "assembly" *(ekklesia)*; in the earliest years, a remarkable percentage of these well-to-do Christian converts were women. Unlike

the typically patriarchal first-century Greco-Roman household, where authority and social status were clearly delineated, these churches attempted to operate on a cooperative, egalitarian basis, breaking down old economic, social, and ethnic distinctions in favor of a new fellowship of faith. Nevertheless, each *ekklesia* tended to develop its own separate identity, based partly upon the nature of its membership and partly upon its particular set of beliefs, for in an age when there was no orthodox Christian doctrine, churches frequently coalesced around the unique, individualistic messages of traveling missionaries and charismatic preachers, each of whom naturally focused his or her message upon a different interpretation of Jesus' life and resurrection.

Not surprisingly, this theological ferment gave rise to considerable tension between Christian factions, and this was precisely why Barnabas had summoned Paul to Antioch. A group of fanatically traditional Jewish Christians—who insisted that God's plan was still working through Israel alone, and hence the old rules for salvation still applied—forced their way into the Antioch church and demanded that the Gentile Christians there submit to the rule of the mother community in Jerusalem and, more specifically, consent to be circumcised. To Paul and Barnabas, this was an affront to the very foundation of their Christian faith and to those Gentiles who believed in Christ but did not want to take on the burdens of the Law; in Paul's words, the Jewish Christians were seeking to "spy out our freedom which we have in Christ Jesus, that they might bring us into bondage."

To break the impasse, both sides reluctantly agreed to take the question to Jerusalem and lay it before a council of elders, later known as the Apostolic Assembly, which included members of the original twelve disciples. Paul professed not to be overly impressed with the spiritual authority of the Twelve—"What they were makes no difference to me," he said, proving it by taking an uncircumcised Greek named Timothy to the council with him—and he might not have accepted a verdict that went against him. But after considerable debate, the Assembly decided to take no formal action. That did not mean it made no decision, however, for by electing not to interfere in the affairs of the Antioch church, the Twelve in effect ruled that Paul could continue to preach his gospel of salvation without the Law *to the Gentiles,* thereby admitting them to the faith while exempting them from the ritual of circumcision. Nevertheless, Jewish Christians

remained firmly bound to the full requirements of the Torah. In the missionary field, each side was expected to refrain from interference with the other.

Despite its admirable intentions, this compromise failed to extinguish the controversy. Few of the primitive Christian churches outside Jerusalem consisted exclusively of either Jews or Gentiles, and so the two factions continued to struggle for supremacy. Soon after the conclusion of the Apostolic Assembly, in fact, Peter himself created an uproar when he visited the Christian community in Antioch, with its mixed congregation, and refused to eat with uncircumcised Christians, citing scriptural prohibitions that strictly forbade Jews to sit at a table with Gentiles. In this particular case, Peter was probably acting on orders from James, because his own views on the subject appear to have been far more liberal. Nevertheless, his actions earned him a stinging rebuke from Paul, who argued that this sort of meddling violated the spirit of the Jerusalem agreement and was especially hypocritical coming from Peter, who was not known for his rigid adherence to every detail of the Law. "You are a Jew, yet you live like a Gentile and not like a Jew," Paul scoffed. "How is it, then, that you force Gentiles to follow Jewish customs? We who are Jews by birth and not 'Gentile sinners' know that a man is not justified by observing the law, but by faith in Jesus Christ." In other words, concluded Paul, "I do not set aside the grace of God, for if righteousness could be gained through the law, Christ died for nothing!"

In any event, armed with the implicit blessing of the Jerusalem Assembly (not that Paul would have cared), Barnabas and Paul set off on their first lengthy journey through the Diaspora, to Cyprus and Asia Minor. As usual, they used Paul's status as a Pharisee to open the doors of the local synagogues. Often they were granted a polite reception—after all, their belief that Jesus had been the Messiah did not automatically exclude them from the fellowship of other Jews—but increasingly they encountered marked hostility, for the rising tide of Jewish separatism was approaching its explosive climax.

Had Caligula not been assassinated in the year 41, the revolt in Judea might have occurred far sooner than it did; had Herod Agrippa lived longer, the crisis might have been postponed indefinitely.

In one of his first official decrees as emperor, Claudius awarded Agrippa control over the province of Judea as a reward for his long years of friendship, and especially for his services in negotiating with

the Senate during the recent brouhaha over the imperial succession. The treaty was sealed with a diplomatic ceremony in the Forum, wherein both emperor and client king swore oaths of loyalty and friendship to each other. With Judea added to the territories he already possessed, including Galilee and Perea, Agrippa now ruled a kingdom even more wide-ranging than that of his grandfather Herod the Great. By October of the year 41, the king was back in Jerusalem, conciliating his newly acquired subjects (most of whom were far more devout than he) by doing and saying all the right things: offering the appropriate sacrifices at the Temple, repealing the hated poll tax, dispensing liberal donations to the masses, and scrupulously obeying the prescriptions of the Torah. Soon after his arrival, Agrippa also renewed the persecution of the Christian community in Jerusalem, probably at the behest of the Sadducees or their allies. At the height of the Passover celebrations of 42, he arrested and beheaded one of the original twelve disciples—James, the son of Zebedee—for allegedly instigating sedition by identifying Jesus as the Messiah. (It is entirely possible that Agrippa coveted that role for himself.) Then Agrippa imprisoned Peter, though he eventually released him on the condition that Peter leave Jerusalem, which the apostle promptly did. It was not a difficult choice for Peter to make, since the de facto leadership of the Christian community in Jerusalem had long since passed to James the Just, whom Peter now recognized as the titular head of the church as well.

For the Jewish population of Judea, Agrippa's enthronement was heady stuff indeed. Not since the golden age of Queen Sh'lom Zion over a century ago had they been governed by a ruler so outwardly sympathetic to traditional Judaism. Although Roman troops were still quartered in Judea, and the governor of Syria exercised a substantial degree of authority over Agrippa (because the governor controlled the troops), the presence of a Jewish king reigning again in Jerusalem aroused tantalizing nationalist dreams of a restored, independent Israel.

But Herod Agrippa was no rebel. To Claudius he remained a devoted client, symbolized by the coinage struck at Caesarea Maritima which bore slogans such as "Lover of the Emperor" and "The Friendship of King Agrippa with the Senate and Roman People." And, like his uncle Antipas and his grandfather Herod the Great, Agrippa sponsored an extensive program of public works to cultivate the goodwill of the Hellenistic Greeks in the northern urban centers

of his kingdom. To Berytus (Beirut), for instance, he donated beautifully decorated baths and porticos that were dedicated with a program of "the most delightful music of the greatest variety," and a vast and sumptuous theater, where he produced a magnificent series of gladiatorial games.

All this cost a great deal of money, of course, and though Agrippa was blessed with a well-stocked treasury—the legacy of Herod the Great's far-sighted economic development policies—his Roman overlords were growing a bit nervous about Agrippa's extravagance. And there were other minor irritants as well. Around the end of 42, Agrippa started repairs on the northernmost (third) wall of Jerusalem, to enclose the area known as the New City. But the Roman governor of Syria, Gaius Vibius Marsus, noticed that the refurbished wall was substantially wider, higher, and thicker than the original. Exactly who, Marsus wondered, were these fortifications designed to protect Jerusalem against? The governor's suspicions were further aroused when Agrippa convened at Tiberias, in Galilee, a conference of six other client kings from eastern Asia Minor. In both cases, Agrippa swore that he had no intention of antagonizing Rome, and especially not his bosom friend Claudius, but a noticeable chill had nonetheless crept into their relations.

In the spring of 44, Agrippa attempted to put things right by staging a Victory Games extravaganza in Caesarea Maritima, to celebrate Claudius' recent conquests in Britain. The king spared no expense for this occasion, inviting a slew of dignitaries and bedecking himself in a dazzling robe made entirely of silver; when Agrippa entered the theater early on the morning of the second day of the games, recalled Josephus, "the silver, illumined by the touch of the first rays of the sun, was wondrously radiant and by its glitter inspired fear and awe in those who gazed intently upon it. Straightway his flatterers raised their voices from various directions—though hardly for his good—addressing him as a god." Agrippa did not correct them. But within hours, according to Josephus, the king collapsed with an excruciating pain in his abdomen. As his servants carried him off in a litter to his palace, the crowd dispersed to their own homes, to don sackcloth and pray for the recovery of their monarch. For five days Agrippa lay in agony. Then, exhausted by the incessant pain and in tears for the country he left behind, he died at the age of fifty-four.

Agrippa's son, Agrippa II, had been living in Rome, learning statecraft at the imperial capital; but since the boy was only sixteen

years old at the time, Claudius decided to return Judea to provincial status, at least temporarily. In fact the emperor turned Agrippa's entire kingdom into a single province, thereby bringing Galilee and Perea under direct Roman control for the first time. Simultaneously, Claudius downgraded the administrative status of the region, making it a third-class province ruled by a procurator instead of a prefect. Given Claudius' lifelong sympathy for the Jews—so long as they kept out of trouble in Rome—this decision seems inexplicably short-sighted, unless Claudius intended to take an active role in the management of Judean affairs himself.

As one might have expected, the first procurator appointed by Claudius in the wake of Agrippa's untimely demise ran into serious trouble almost at once. Upon his arrival, Cuspius Fadus was greeted by riots between Jews and Greeks in Perea (he executed the ringleaders) and an outbreak of banditry in Judea (which he suppressed with typical Roman vigor). Then Fadus insulted the Sadducees in Jerusalem by demanding that the vestments of the High Priest be returned to Roman custody, whence they had been removed during the governorship of Lucius Vitellius. The priests appealed to Rome, and Claudius overruled his procurator; but this was no way to run an empire. Meanwhile, a Jewish preacher named Theudas, who had accumulated a vast throng of devotees throughout the region by working magic or miracles, led his army of believers to the Jordan River and promised to part its waters just has Moses had divided the Red Sea. Fadus, already irritated by his subjects' susceptibility to spiritual charlatans, elected not to take any chances, and ordered his cavalry to intercept the marchers before they reached the Jordan. In the ensuing melee, hundreds of civilians were killed or imprisoned, and Theudas himself was arrested and beheaded for treason.

The next two years, under a procurator named Tiberius Julius Alexander (himself an ex-Jew), passed relatively peacefully, but another round of disturbances erupted soon after Ventidius Cumanus assumed the post in the year 48. At the Passover celebration, when the Temple in Jerusalem was crowded with pilgrims, at approximately the same time that the Apostolic Assembly was convening in the holy city to hear Paul defend his missionary activities, a soldier who belonged to one of the auxiliary units from Samaria that had been assigned to preserve order in the Temple district climbed onto a platform, raised his robe to uncover his genitals, and made a rude suggestion to the passersby. Not surprisingly, the Jews in the Temple be-

came extremely agitated; when Cumanus appeared to see what was the matter, they pelted the procurator with insults and stones. Cumanus then summoned reinforcements to the Temple. Fearing a massacre, the pilgrims stampeded for the exits, trampling scores of people to death in the narrow passageways.

Several months later, another Roman auxiliary soldier ripped apart and burned a copy of the Torah during a punitive raid on a Judean village suspected of harboring bandits. This deliberate act of desecration caused such a massive outcry that Cumanus was eventually obliged to execute the offending soldier (albeit reluctantly) to prevent a wholesale rebellion throughout the province. This restored order for a year or two. But communal violence between the Samaritans and the Jews erupted again when a Galileean pilgrim was murdered by Samaritans en route to Jerusalem for the holidays. Since Cumanus refused to punish the accused killers right away, the Jews took matters into their own hands by forming a sort of militia, which promptly launched a series of savage attacks upon the Samaritan border settlements. The procurator thereupon unleashed his cavalry to restore order, and scores of Jewish irregulars were captured and crucified or beheaded. Finally the governor of Syria, Gaius Ummidius Quadratus, ordered everyone—Cumanus and one of his controversial military tribunes as well as delegations of prominent Jews and Samaritans—to go to Rome to explain their conduct to the emperor. After hearing the case, Claudius banished Cumanus, put several of the Samaritan leaders to death, and permitted the Jews to execute the tribune in a grisly public ceremony, dragging him around the walls of Jerusalem and then cutting off his head.

In the year 52, the emperor nominated a freedman named Antonius Felix, the brother of Claudius' financial secretary, Pallas, as the new procurator of Judea.

By the spring of that year, Paul was preparing to leave Corinth, the rich, cosmopolitan city in the Peloponnese that had ranked second only to Athens during the golden age of the Greek city-states. Its location made it a natural commercial center between Rome and Asia Minor, and a gathering place for merchants from all over the Mediterranean: Jews, Egyptians, Syrians, Romans, and Greeks. Although Corinth was officially known as the city of the goddess Aphrodite, the polyglot nature of the population produced a wide variety of religious cults and sacrificial rites devoted to such disparate deities as Apollo

(who enjoyed a massive temple downtown), Venus, Poseidon, and the oriental goddess Isis. In such a highly charged environment of spirituality, ecstatic visions and prophetic utterances had become commonplace. Over the centuries, however, Corinth had also acquired a well-deserved reputation for libertinism; not for nothing did the Greek word *korinthiazesthai* mean "to fornicate."

Paul had arrived in this sophisticated if oversexed Hellenistic metropolis sometime in the year 50. Over the past two years, he and his companions—first Barnabas and later a pair of Gentile converts, Timothy and Silas—had traveled and preached throughout Galatia (southern Turkey), founding churches in numerous cities before heading westward across the Anatolian peninsula for Troas (ancient Troy). It was there that Paul experienced a nocturnal vision in which he heard a man from Macedonia call him to "come over and help us"; and so, for the first time, the preeminent Christian missionary crossed over the Aegean Sea into Europe.

Upon landing at Neapolis, Paul set out along the broad Roman highway known as the Via Egnatia. It was Paul's great good fortune to carry out his mission during the heyday of the Roman Empire; the presence of political stability and a marvelous network of roads, and the almost total absence of territorial boundaries or language barriers—since most educated men and women in the Mediterranean world spoke Greek—proved invaluable in facilitating his work. These benefits, bestowed by the Pax Romana, also appear to have been at least partly responsible for Paul's steadfast defense of law and order and the authority of legally constituted civil governments, though it should be noted that many contemporary Pharisees shared Paul's viewpoint. One famous sage, Rabbi Hanina, the Deputy High Priest, recommended that the people "pray for the welfare of the ruling power, since but for the fear of it, men would have swallowed one another up alive," and Rabbi Yosi en Qisma even suggested that "this people [the Romans] are sovereign because it is God's will."

After founding a church in Philippi, where Augustus had planted a colony of retired legionaries two generations earlier, Paul moved on to Thessalonica (modern Salonika). He managed to convert a considerable number of Jews and Gentiles there before a band of Jews complained to the city authorities that Paul was preaching about "turning the world upside down"; they had twisted his warnings that the Kingdom of God was at hand into something approaching sedition. Although this was obviously a gross distortion of Paul's mes-

sage, his opponents managed to stir up enough popular discontent that Paul was forced to leave town; thereafter he prudently avoided using the term "Kingdom of God." Paul next spent a brief time in Athens, but the overwhelmingly pagan character of the place made him so depressed that he hurried on to Corinth.

Corinth's tradition of religious enthusiasm provided a far more fertile field for Paul's endeavors. As he had done elsewhere, Paul started by preaching in the city's synagogues; by this time his message had been sharpened and refined to a fine point. Paul's gospel consisted of an impressive synthesis of elements drawn from the Jewish scriptures, his fellow Christians (particularly Peter), and the revelations of extremist Jewish sects such as the monks of Qumran. He evinced no interest at all in Jesus' ethical teachings; for Paul, everything that occurred before the resurrection was almost totally irrelevant, overshadowed by the cross (which had already become a sort of magical charm and symbol of supernatural power in certain Christian circles) and the personal revelation imparted to him that Jesus had, in fact, been the Son of God. He elevated Jesus to the status of a deity—the Alpha and the Omega of the universe—who had been slain by the powers of evil, acting through the earthly agency of the fatally misguided Jews. Here one encountered the same dualistic world view, of a contest between good and evil, that formed such a strong strain in the teachings of Jesus himself, with his emphasis upon the final mighty battle between God and Satan; a view also found of course in the writings of the militant Qumran community, as witnessed by their prophecies about the coming war between "the Sons of Darkness and the Sons of Light," the exact terms Paul later used to distinguish those who obeyed God's will from those who did not. Within a few decades, this same swirling apocalyptic imagery would evolve and crystalize into the writings of the Gnostic Christian sects.

And like Jesus and Peter, Paul adopted the imagery of the Suffering Servant sent by God to inaugurate a new covenant, to be sealed at the second coming of Christ at the Last Judgment—an event that Paul clearly anticipated in the near future. In the meantime, God's sacrifice of His own son had opened the door to salvation to everyone who believed in the resurrection. It had broken down all the ancient barriers that divided mankind—"Here there cannot be Greek and Jew, circumcised and uncircumcised, barbarian, Scythian, slave, free man," argued Paul, "but Christ is all, and in all"—and freed humanity from

the slavery of its own fears and passions. But the resurrection had also imposed a stern moral obligation to follow Christ:

> Put on then, as God's chosen ones, holy and beloved, compassion, kindness, lowliness, meekness, and patience, forbearing one another and, if one has a complaint against another, forgiving each other; as the Lord has forgiven you, so you also must forgive. And above all these put on love, which binds everything together in perfect harmony. And let the peace of Christ rule in your hearts, to which indeed you were called in the one body. And be thankful.

Paul could hardly have been surprised at the hostile reaction this message inspired among Jews in nearly every city he visited. First, he was denigrating the importance of the Law. Man could no longer assure his own salvation or usher in the Kingdom of God, Paul argued, no matter how hard he tried; at most, Paul conceded that the Law might provide a useful discipline to prepare converts for a Christian life. Second, Paul insisted that Jesus had indeed been the Messiah, a claim his Jewish opponents rejected completely. Third, Paul explicitly raised Jesus to the same level as God, a sacrilege that deeply offended the Jewish concept of a monotheistic deity. And fourth, he was directly accusing the Jews of murdering this god/Messiah. So, after about a year and a half, the same pattern repeated itself at Corinth: a group of Jews complained to the governor of the province, Gallio (the brother of the Roman Stoic philosopher Seneca). After listening to their charges that Paul was "inducing people to worship God in ways that are against the Law," Gallio dismissed the case without even bothering to hear Paul's defense. "If it had been a question of crime or grave misdemeanor," he told the Jewish plaintiffs, "I should, of course, have given you Jews a patient hearing, but if it is some bickering about words and names and your Jewish Law, you may see to it yourselves; I have no mind to be a judge of these matters." Whereupon the boisterous spectators in the marketplace (which because of its central location was the customary site of the governor's judgment seat) assaulted the Jews for their intolerant attitude.

Several months later, Paul left Corinth for Asia Minor, stopping first at the great port of Ephesus and then visiting the existing churches in Antioch and Galatia before returning to Ephesus for a two-year stay. It was not an easy city to work. Ephesus had long been the center of the cult of Artemis, the awesome, luxurious goddess of

fertility, often portrayed by her disciples with a dozen or more breasts. Her magnificent temple in Ephesus—one of the seven wonders of the ancient world—was reportedly four times as large as the Parthenon in Athens. Pilgrims flocked to her shrine from all over the world, bringing commerce to the city and taking home silver statues of the goddess. Paul's missionary efforts on behalf of Christ thus posed a direct threat to the primary industry of Ephesus, at a time when the city was still recovering from a devastating fire and earthquake. After only a few months, Paul was forced out of the synagogue into a lecture hall owned by one of his converts, where he preached every day during the midday siesta, between the fifth hour (11 A.M.) and the middle of the afternoon. Over the next two years, Paul was imprisoned on numerous occasions by the local authorities and flogged repeatedly for his refusal to stop proselytizing, until he finally departed Ephesus near the end of the year 55.

It was during this time of gathering crisis in both Christianity and Judaism that Paul composed many of the letters that were later incorporated into the New Testament. Torn between his desire to carry the gospel into new territories and his responsibility to nourish the churches he had already founded, Paul attempted to maintain contact with his old friends through regular correspondence. The letters—each one directed toward a specific historical situation—were dictated by Paul and carried by messengers, to be read aloud to the assembled congregation. And most of the churches desperately needed his advice. The Christian community in Corinth, for instance, suffered from factionalism and an excess of mystical enthusiasm; believing that they had attained divine wisdom and spiritual perfection through Christ, numerous members of the congregation had decided that they were no longer bound by the restrictions of the corporate church or the rules of conventional human morality—in effect, the sexually permissive and ecstatic cultural environment of Corinth had infiltrated the church. Paul's difficult task was to bring the Corinthians back to earth by focusing on the gentle spirit of compassion rather than undisciplined enthusiasm. "If I speak in the tongues of men and of angels, but have not love, I am a noisy gong or a clanging cymbal," the apostle reminded them. "And if I have prophetic powers, and understand all mysteries and all knowledge, and if I have faith, so as to remove mountains, but have not love, I am nothing."

A similar spirit of spiritual excess bedeviled the Christians of Thessalonia, who had become so preoccupied with expectations of

the Second Coming that they had thrown over discipline altogether and were ignoring such mundane matters as their jobs and social responsibilities. "We exhort you, brethren, to do so more and more, to aspire to live quietly, to mind your own affairs, and to work with your hands, as we charged you," wrote Paul. "But as to the times and the seasons [of the Second Coming], brethren, you have no need to have anything written to you. For you yourselves know well that the day of the Lord will come like a thief in the night." And in Galatia, the churches were rent by divisions and backsliding provoked by a faction of Jewish Christians who had visited the churches specifically to denounce the validity of Paul's gospel without the Law. "You are severed from Christ, you who are justified by the law; you have fallen away from grace," Paul retorted. "In Christ Jesus neither circumcision nor uncircumcision is of any avail, but faith working through love. You were running well; who hindered you from obeying the truth?"

And as he wrote, Paul completed his plans for another journey, this time to Jerusalem, whence he would never return.

The Stoic

Rome, 49–60 C.E.

> Man gazes at the stars, but his feet are in the mud.
> —Lucius Annaeus Seneca

C orsica, decided Seneca, was a sinister, savage wasteland. "It is nothing but a vast desolate place [where] no shade smiles at you after the burst of spring," he wrote to a friend. "No grass grows in that accursed soil; it gives neither bread, nor water to scoop, not the slightest spark. Here there are only two things, the exile and his place of exile." Banished to the island by Claudius on a trumped-up charge of adultery with Julia Livilla (the sister of the late emperor Caligula), the urbane and sophisticated Lucius Annaeus Seneca was thoroughly miserable. In words reminiscent of Ovid, languishing at Tomis, he complained that "it is difficult to use the Latin language well when one hears nothing but the jargon of a barbaric people, so coarse that even the barbarians themselves who have some education, are shocked by it. . . . My mind has become rusty by dint of long inertia. If you find [my words] unworthy of your genius, or not suitable to cure your sorrow, think that it is hard to console others when one is preoccupied by one's own misfortune."

This sort of abject self-pity rang a bit hollow coming from the most famous Roman Stoic of the first century, from the same Seneca who later wrote that "the man who is not inflated by prosperity does not collapse under adversity; the man of tested constancy keeps a

spirit impregnable to either condition." But then Seneca was always willing to adapt his Stoic principles to changing circumstances, particularly his own.

Certainly Seneca had come a long way since his birth in Corduba, in the province of Spain—the first great military province of the Roman Empire—a year or two (or perhaps four) before the start of the century. Corduba was then a colony of Roman citizens, planted in the waning days of the Republic, and Seneca's father was one of its leading citizens, an accomplished gentleman of considerable wealth and scholarship who had studied extensively in Rome. As the first step toward the sort of illustrious career in public service that the empire under Augustus had opened up to knights, including even those from the remote provinces, little Lucius was taken to Rome as a very small boy to obtain an education in rhetoric. But he was captivated instead by philosophy, particularly the teachings of the eloquent Stoic Attalus, from whom Lucius acquired the ascetic habits he would observe for the rest of his life: no wine, oysters, or mushrooms; no hot baths, lotions, or deodorants; and every evening, before he fell asleep on a hard bed, Seneca would examine his conscience to determine whether he had lived up to his principles that day. For a while Seneca also practiced vegetarianism, but Tiberius' crackdown on foreign and exotic cults in the year 19 brought even this innocuous fetish under suspicion, and so Seneca gave it up. (Fortunately for him, as it turned out; Seneca's chronically frail physique had grown so emaciated on a meatless diet that he might not have survived for more than another year or two.)

At the age of eighteen, Seneca entered, without much enthusiasm, upon the practice of law. He proceeded very slowly up the conventional career ladder, hindered by his own disinterest in the affairs of state, by poor health—in 23, a bad case of consumption forced Seneca to leave Rome for rest and recuperation, first in Pompeii and then in Egypt—and, after the fall of Sejanus in the year 31, by his family's unfortunately extensive connections with the Praetorian prefect: through the blood relations of his mother and the friendships of his father. Nevertheless, Seneca eventually obtained election to the magistracy as a quaestor, a promotion that—together with his sparkling wit and erudition—at last vaulted him into the charmed circle of the Roman aristocracy. By the year 39, Seneca was sufficiently prominent that his florid and somewhat overwrought oratory in the Senate attracted adverse comment from Caligula, who was either

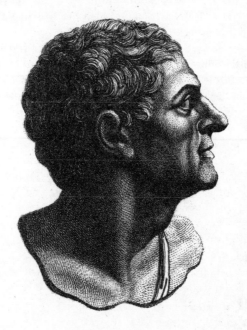

Seneca

jealous or had better taste. Meanwhile, Seneca had struck up an intimate friendship with Caligula's sister Livilla, who was banished by her brother in 39, in the aftermath of the abortive coup of Gaetulicus, but was recalled by Claudius soon after his succession. Instead of profit, though, this liaison earned Seneca only an extended vacation on Corsica, courtesy of Claudius' third wife, the sybaritic Valeria Messalina, whose jealousy of Livilla led her to strike at her rival's most eminent courtiers.

For seven years, Seneca languished on Corsica, ruminating upon human frailties, observing the local wildlife (natural history was his hobby), and burnishing his prose in a series of letters *(Consolationes)* to his friends in distant Rome, while his nemesis, Messalina, carried on a series of spectacular adulterous affairs, which surpassed even the fabled escapades of Tiberius' second wife, Julia, fifty years earlier. Although the excesses of both women were due in part to a simple desire for self-gratification outside the bonds of unhappy marriages (Messalina had been betrothed to the lecherous but occasionally infirm old Claudius at the age of nineteen), Julia and Messalina were also part of an emerging feminist movement—with an overlay of erotic rites borrowed from eastern mystical cults—that sought relief via sexual license from the suffocatingly male-dominated Roman social and legal systems. Messalina apparently possessed an especially voracious carnal appetite, and her nocturnal excursions soon became an open scandal in the capital. "Hear what Claudius had to put up with," mocked Juvenal:

> . . . the minute she heard him snoring,
> His wife—that whore-empress—who dared to prefer the
> mattress
> Of a stews to her couch in the Palace, called for her hooded
> Night-cloak and hastened forth, alone or with a single
> Maid to attend her. Then, her black hair hidden
> Under an ash-blonde wig, she would make straight for her
> brothel
> With its odour of stale, warm bedclothes, its empty reserved
> cell.
> Here she would strip off, showing her gilded nipples and the
> belly that once housed a prince of the blood.

If Claudius knew of her infidelity, he did not object; not until Messalina stepped over the line by engaging in a bizarre ceremony—

part marriage, part Bacchic ritual—with a handsome young senator named Gaius Silius. This affair was nothing less than treason, for Silius and Messalina doubtless meant to seize the throne for themselves as regents for Claudius' son, Britannicus. Confronted with the evidence of his wife's seditious intentions, Claudius froze, paralyzed with anxiety; not until his freedman Narcissus, acting entirely on his own initiative, ordered the conspirators arrested or slain—Messalina killed herself while a Praetorian Guard stood by and made certain she did the job right—did Claudius recover his nerve. But in the aftermath of the crisis, the affairs of the empire lost their fascination for him, and for the last five years of his reign Claudius practically withdrew from sight.

No matter. In 49 the emperor married his niece Agrippina, the daughter of Germanicus and the elder Agrippina and, along with Livilla, one of the surviving sisters of Caligula. The incestuous union, which scandalized conservative opinion, required special dispensation from the Senate. Unlike Messalina, who was interested primarily in sensual pleasures, Agrippina was determined to exert a dominant influence upon the political stage. And at the age of fifty-nine, Claudius was simply too weary of cruelty and betrayal to stop her. Hence Agrippina's unchecked ambitions, observed Tacitus, plunged Rome into "a rigorous, almost masculine despotism. In public, Agrippina was austere and often arrogant. Her private life was chaste—unless power was to be gained. Her passion to acquire money was unbounded. She wanted it as a stepping-stone to supremacy. . . . Complete obedience was accorded to a woman, and not to a woman like Messalina who toyed with national affairs to satisfy her appetites."

Of course Claudius would not long survive, so Agrippina persuaded the emperor to adopt her twelve-year-old son by a previous marriage, Lucius Domitius Ahenobarbus. Before long, the boy—who now assumed the name Nero Claudius Drusus Germanicus—had supplanted Claudius' own son, Britannicus, as the heir apparent. And to educate Nero, Agrippina asked Claudius to recall from Corsica the celebrated writer, orator, and former intimate of her sister: Lucius Annaeus Seneca.

A ticket home, and an appointment as tutor to the future emperor; not even Agrippina's reputation as a first-class bitch could dissuade Seneca from accepting the offer with alacrity. Certainly he knew he would be dealing with a woman completely devoid of scruples, and a pupil possessed of one of the most disturbing pedigrees in

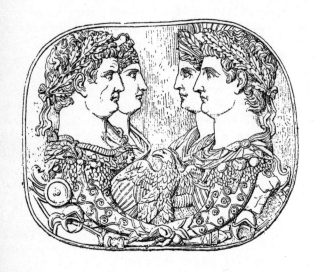

Claudius, Messalina, Britannicus, and Octavia

Roman history. The arrogance and instability of the Julio-Claudian clan—witness the promiscuity of Julia, the bestiality of Postumus, and the madness of Caligula—would have been bad enough, but on Nero's father's side there existed a despicable strain of loathsome cruelty and dishonesty that shocked even the strong-stomached annalists of the first century. At least Nero's father, Cnaeus Domitius Ahenobarbus, was frank about his own character flaws; when his son was born—on a day which the astrologers claimed bore an especially black mark—Domitius Ahenobarbus returned his friends' congratulations with the comment that "any child born to himself and Agrippina was bound to have a detestable nature and become a public danger." Ahenobarbus himself died of dropsy three years later; when Agrippina was exiled by Caligula shortly thereafter, Nero was left in the care of relatives, a barber and a dancer.

Seneca's daunting task was to mold this erratic temperament into a model of Stoic conscience and duty. Fortunately he enjoyed the support of one of the two Praetorian prefects whom Agrippina had nagged Claudius into appointing: Sextus Afranius Burrus, a well-respected veteran procurator who enjoyed such an unassailable reputation for probity that he had been entrusted with the personal finances of Tiberius, Caligula, and Claudius in turn. Although Agrippina forbade Seneca to teach philosophy to Nero (because she thought it a dismal waste of time), Stoicism's concern with the rules of practical conduct permitted Seneca to introduce moral and ethical principles under the guise of statecraft. Stoicism itself had undergone a significant transformation in the three and a half centuries since Zeno of Cyprus first expounded its articles in the twilight era of the Greek city-states. For Zeno, all men possessed a share of the divine spark of the Spirit (variously known as God, or Zeus, or the *Logos*) and hence all men—from aristocrats to common citizens and slaves—were brothers and entitled to humane treatment. Politically, the ideal Stoic state would be a single, unified, worldwide entity governed by the laws of reason and nature. And the highest natural laws—the good life—consisted of compassion and human cooperation, love for one's fellow human beings, and the emotional self-discipline to bear both triumph and tragedy with equanimity.

When the Greeks' hard-headed Roman neighbors got hold of this utopian doctrine, they discarded its hazy notions of absolute virtue and moral perfectibility in favor of the more attainable ideals of relativism and compromise. For instance, the Roman Stoics were able

to justify their loyalty to the autocracy of the Caesars by arguing that even if the Roman Empire were not quite the perfect, humane world state envisioned by Zeno, it represented a giant step along the path, and hence deserved the respect and goodwill of its subjects. It was Seneca who gave the ideals of Roman Stoicism their fullest expression, particularly the concept of the brotherhood of man. "We are all members of one great body," Seneca wrote. "Nature has made us relatives . . . [members of] a vast and truly common state, which embraces alike gods and men, in which we look neither to this corner of earth nor to that, but measure the bounds of our citizenship by the path of the sun."

A deep and abiding humanitarianism formed a natural corollary to this universalist doctrine. "You must live for your neighbor if you would live for yourself," insisted Seneca; and though he agreed that it was impossible for a good man not to be angry when confronted with evil, "how much more human to manifest towards wrongdoers a kind and fatherly spirit, not hunting them down but calling them back." Indeed, so striking were the echoes of Judaism and primitive Christianity in Seneca's writings that later generations invented a fictitious correspondence between the Roman Stoic and Paul the missionary.

Yet there is also a clearly discernible trace of melancholy and wistful resignation in Seneca's work, a realization that life almost inevitably ends in sadness, and that even men who recognize the good often lack the will to pursue it. Far more than his Greek predecessors, Seneca readily acknowledged that the power of circumstances and personalities had to be taken into account when applying the moral precepts of Stoicism to concrete cases. And it was precisely this quintessentially Roman sense of realism that enabled the philosopher to accomplish as much as he did in the terribly difficult situation in which he now found himself.

Between 49 and 54, Seneca tutored Nero in the finer points of eloquence and morals, polishing the young man's character as far as Nero's nature would allow—"We must guide the child between the two extremes," Seneca liked to say, "using now the curb, now the spur"—and literally putting words in Nero's mouth by writing the gracious and literate speeches that the heir apparent delivered before the Senate and the public. Then, in October 54, Claudius died suddenly after eating mushrooms that, according to gossip, had been poisoned by his wife. In this case the rumors were probably true;

Agrippina was entirely capable of killing her husband, and the timing was certainly propitious; had Claudius lived much longer, the supremacy of Nero might have been challenged by Britannicus when the younger boy came of age.

But the Senate was so glad to be rid of the pedantic busybody Claudius, with his obnoxious administrative council of overproud freedmen, that it was willing to overlook Agrippina's minor indiscretion and award Nero the powers of Augustus Caesar. The not-quite-seventeen-year-old emperor was now the most powerful man on earth. In his inaugural address, Nero said all the right things to the assembly—after all, the speech had been scripted by Seneca, who shared both the Senate's outdated and by now faintly ridiculous sense of self-importance, and the equestrian contempt for freedmen in the highest levels of government. Like every other emperor since Tiberius, Nero dutifully promised to clean up the abuses of his predecessor and return Rome to the golden age of Augustus, to restore the rule of law in place of imperial caprice and respect the ancient prerogatives of the Senate. To the Praetorians, Nero donated the same generous bonus Claudius had bestowed when he succeeded Caligula; to the plebs, he awarded a cash bounty and a pledge to lower taxes and maintain the corn supply at a stable price. Nero rejected, for the time being, the Senate's offer of the title *pater patriae,* refused to permit the erection of gold or silver statues of himself or his father, and denied a senatorial request to alter the calendar to commence with his birth-month of December.

All this quasiconstitutional rhetoric pleased the Senate no end, and paved the way for the contemporary legend that the first few years of Nero's reign represented an age of reawakening Roman virtue. Beneath the surface, however, darker forces were already at work. Given the horrifying circumstances of his childhood, and the lavish promiscuity to which he had been exposed through the actions of the dynastic family, it was not surprising that Nero had begun to display a diseased character, an uneasy mixture of fear, egotism, and contempt for nearly any sort of moral standards. For instance, the emperor desperately desired to escape from the domination of his mother, though he was still scared to death of her, and perhaps in love with her as well, in his own twisted way; there were disturbing and persistent rumors of incest between Nero and Agrippina. Relations between the two thus quickly grew strained; within six months of his accession, Nero had begun to shove his mother impatiently into the

background, a tendency that Seneca and Burrus enthusiastically encouraged. In a fit of pique, Agrippina threatened to transfer her affections to Britannicus. And so, at a dinner party in the imperial palace, in the winter of 55, the emperor supervised the murder of Britannicus, his only serious rival within the dynasty; the next day the boy's body was buried secretly, without ceremony, in a pouring rainstorm. Surely neither Seneca nor Burrus played any part in this cold-blooded crime, but neither did they distance themselves from the emperor in its aftermath. (For Seneca, the issue was complicated by the realization that he could make a fortune from his privileged position, notwithstanding any Stoic scruples that might get in the way.) Instead, the emperor's advisers and a generally sympathetic Senate pretended that nothing had happened, or at least that the murder might be excused for "reasons of state."

Since Nero was clearly going to require further training in ethics and morality, Seneca composed a treatise called *De Clementia—On Clemency*—which offered practical advice on acceptable political behavior, adapted from Stoic ethical principles, to both Nero and his subjects. The remarkable thing about this document was its frank admission that the Roman imperial system required an absolute monarchy; twelve months in the palace had shorn Seneca of all his illusions about the rule of law. Nero, Seneca claimed, had been chosen "from out of all the host of mortal beings . . . to do the work of the gods upon the earth," and for that task, the emperor had been given "the power of life and death over all the nations. To determine the condition and to control the destinies of every race and of every individual is [his] absolute prerogative." As the recipient of these despotic powers, Nero's duty was to exercise them for the welfare of his subjects; conversely, the duty of the populace was to remain loyal to the emperor so long as he governed with compassion and a respect for the dignity of his subjects. Here was a deft adaptation of the first principles of Stoicism to the Roman principate, but in the final analysis, the success of the experiment depended upon the character of the ruler. And Nero was quite the wrong man for the job.

Soon after his accession, Nero appeared to grow bored with the details of government and abandoned the day-to-day administration of the empire to his advisers. Together, Burrus and Seneca, who served as consul in 56, kept everything running smoothly. In reality, this was nothing more than the logical extension of the system of delegated bureaucratic authority first introduced by Tiberius and

Sejanus and carried on by Claudius and his freedmen—though under Nero the highest levels of the administration were again staffed by knights instead of ex-slaves. And though there was no comprehensive program of reform, the Senate was placated by the illusion of consultation and cooperation; judicial procedures were streamlined and standardized; provincial governors and bureaucrats who engaged in embezzlement or undue extortion were removed from office and prosecuted (both Seneca and Burrus came from the provinces and hence were especially sensitive to such abuses); and capital punishment was reserved for only the most heinous crimes—when he had to sign his first death warrant, Nero reportedly sighed, with evident sincerity, "How I wish I had never learnt to write!" For the pleasure of the plebs, Nero authorized the construction of a new wooden amphitheater, which opened with a spectacular show of games that featured four hundred bears and three hundred lions, and for a short while the killing of gladiators in the arena was forbidden, though this humane edict was soon revoked because of the resulting public outcry. In foreign affairs, the famous general Cnaeus Domitius Corbulo, perhaps the most capable soldier in the army (and not some "safe" political appointee), was dispatched to the East to evict a Parthian puppet from the Armenian throne, and in Britain a campaign was finally begun to extend the western frontier and complete the conquest of Wales.

Nero, meanwhile, had decided that the cultivation of Greek manners and artistic perfection was the most suitable arena for his imperial majesty. It all began innocently enough. In 55, Nero imported the foremost zither (lyre) player in the empire to give him lessons, and commenced a rigorous regimen to develop his singing technique as well. "He would lie on his back with a slab of lead on his chest, use enemas and emetics to keep down his weight, and refrain from eating apples and every other food considered deleterious to the vocal chords," observed Suetonius with evident bemusement. "Ultimately, though his voice was feeble and husky, he was pleased enough with his progress to begin to nurse theatrical ambitions." Not long afterward, Nero made his public singing debut at Neapolis (Naples); he refused to let the collapse of the theater following his performance discourage his artistic ambitions.

Unfortunately, Nero did not possess a particularly commanding physical presence upon the stage. He had a bulbous shape, with a

protruding belly and skinny legs, a bloated neck, dainty feminine features, small deep-set eyes that gave him a perpetual look of fear or suspicion, and a complexion that was spotted with blotches. He scandalized the more conservative elements in Roman society by flouncing about in flowing, flowered robes; occasionally he held audiences dressed only in a silk dressing gown and slippers, with a scarf tied loosely around his throat.

Beyond his musical ambitions, which he pursued with professional vigor, if not competence, Nero had always harbored a secret desire to be a chariot driver; in fact he wore his yellow hair curled in sets of long rows, in the style preferred by professional drivers of his day. In the first year of his reign, Nero was content to play with model ivory chariots on a board, sneaking into the Circus incognito to watch the real races. But by 56 he had thrown off his disguise, attended the races openly, and started to hone his own skills as a driver. When Seneca insisted that he race only in private, in a specially constructed enclosure in the Vatican Valley, Nero replied huffily that "chariot racing was an accomplishment of ancient kings and leaders—honoured by poets, associated with divine worship." Singing, too, he added, was "sacred to Apollo: that glorious and provident god is represented in a musician's dress in Greek cities, and also in Roman temples."

Nor was this all that Seneca and Burrus had to worry about. Although Nero was married to Octavia, the daughter of Claudius, he had developed an obsessive passion for a freedwoman named Claudia Acte. This, of course, was all part of the emperor's concerted effort to throw off the restrictions imposed by his mother, his tutors, and conventional morality. To divert Nero's attention from this unhealthy infatuation, Seneca, who had always been a terrible snob, despite his egalitarian Stoic principles, dropped his opposition to—and possibly encouraged—Nero's nocturnal forays through the city, when the emperor and several particularly disreputable and dissolute companions prowled the alleys and taverns in search of excitement. Their favorite pastimes were mugging passersby, breaking into shops and stealing the merchandise for resale later, and throwing cloaks over drunks and then tossing them into the river. Occasionally the playful emperor returned from his revels bruised and battered; after a senator once soundly thrashed Nero for molesting his wife, Burrus forbade him to

go out at night without an escort of Praetorians for protection.

Nothing better illustrated the essential policy of Seneca and Burrus than this. So long as Nero could express his dark side in secret, under cover of night, they allowed the young emperor free rein. "I must not add to his power for evil," insisted Seneca, "I must not increase his destructive forces or confirm those he has. . . . But if he entreat me as a great kindness to send him comedians and women, and other such delights which may temper his brutality, I will find them for him willingly." But to Seneca's dismay, Nero pushed his way back into control of imperial affairs between the years 58 and 60, determined to implement his vision of a principate transformed into a worldwide theater dedicated to the glorification of his divine persona. Here was Caligula reborn, armed with an explicit philosophical sanction composed of Seneca's defense of absolutism, plus a generous measure of oriental mysticism.

In 59, Nero adopted a new love, Poppea Sabina, the wife of his longtime drinking companion and bosom buddy Marcus Salvius Otho. Poppea, a ravishingly beautiful woman with more tact than Agrippina and far more brains than Messalina, had long been an enthusiastic devotee of eastern cults (displaying a marked sympathy toward Judaism, for instance), and doubtless encouraged the emperor's predisposition toward despotism. Apparently it was she who convinced Nero that he had to dispose of his mother once and for all, to make certain that Agrippina never interfered in his affairs again. Nero chose a typically flamboyant method for the assassination, rigging a ship to collapse while transporting Agrippina across the Bay of Naples, so her death would look like a sailing accident. Although the boat played its part commendably enough, disintegrating right on cue, Agrippina managed to clutch a piece of driftwood and swim safely to shore. When she naively sent her slave to inform the emperor that she had survived the mishap, Nero—who had stayed up all night, anxiously awaiting news of his mother's death—nearly fainted; Seneca hesitated; and Burrus refused to permit the Praetorians to participate in any plot to murder the daughter of the great Germanicus. Whereupon the commander of the fleet at Misenum, a freedman named Anicetus, went to Agrippina's room with several of his officers and finished the job with his sword. For public consumption, Nero released a story that his mother had committed suicide after she had

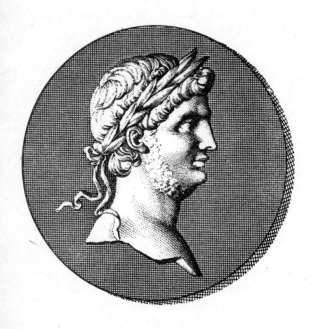

Nero

tried and failed to kill *him*. The Senate, perhaps unaware of how the assassination had actually gone down, officially expressed its relief at the emperor's deliverance. Agrippina's body was cremated that same night, but her vengeful ghost, like a Fury, pursued Nero in his dreams with whips and burning torches for the rest of his life.

The Fury

Britain, 60 C.E.

> There was no form of savage cruelty that the angry
> victors refrained from.
>
> —TACITUS

As the Roman troops crossed the shallow straits to the island of Anglesey, they could see them on the shore: rows of women dressed wholly in black with long unkempt hair falling about their faces, brandishing burning torches and keening eerily like the Furies of ancient legend. Alongside stood the Druid priests, lifting their hands and their voices skyward to invoke hideous-sounding curses and the wrath of their nameless gods upon the invaders. Anglesey, just off the coast of northern Wales, had long been a bastion of the Druidic cult, receiving tribute and sacrifices from all over the British Isles. In recent years, it had also become the base of operation for the native guerillas—their ranks swollen by refugees from the Claudian conquest of lowland Britain—who periodically ventured back across the straits to harrass the Roman forces in Wales. And now, of course, the British warriors, many of them survivors of previous encounters with the Romans, were gathered on the shore with the Druids and the Furies, awaiting the signal to descend upon the legions.

It was not an enticing sight. As the Roman infantry disembarked from their flat-bottomed ships (the cavalry had crossed by nearby

fords, swimming alongside their horses when the water grew too deep to stand), they froze momentarily, transfixed by the bizarre vision, motionless under the first volley of stones and arrows from the Britons. The spell was broken only when their commander, Caius Suetonius Paulinus, governor of Britain, shouted insulting remarks about the family background of Roman soldiers who were frightened by a mere horde of fanatical women. As the legions rushed forward, cutting easily through the lines of the defenders, the torches of the Furies toppled and set off a conflagration that soon enveloped women, priests, and warriors alike. Resistance continued further inland, however, as the Britons sought to protect the sacred groves of the Druids, and when they could no longer withstand the Roman onslaught, the priests consigned their treasures—tributary offerings from the mainland, probably including slaves bound together in chains—to the protection of the spirits of the waters, and buried them all in a bog.

With victory in his grasp, Suetonius ordered his men to demolish the destestable spirit-infested forests. Then he heard the incredible news from Camulodunum (Colchester): a coalition of British tribes in the eastern reaches of the province had risen in revolt, led by a woman named Boudicca, the widow of the chieftain of the Iceni.

It was not the first time the Iceni had rebelled against the Romans. The dominant tribe within the region now known as East Anglia, they had initially welcomed the Roman invaders in 43, in hopes of obtaining assistance against the obnoxious depredations of the marauding Catuvellauni. But when Plautius' successor, Ostorius Scapula, arrived four years later and attempted to disarm all the tribes (including the friendly ones) in the region between the Avon and the Severn—the better to secure his rear before advancing to capture the elusive Caratacus and extend the untenable western frontier line as established by Plautius, along the Fosse Way—the Iceni launched an abortive rising, which ended in a massacre of their badly overmatched forces and the death or deposition of their ruler, Antedios; one of his sons, Prasutagus, who had remained aloof from the rebellion, succeeded to the kingship of the tribe.

Over the next twelve years, the Roman administration of Britain provided a textbook example of how to encourage disaffection. The customary process of romanization proceeded as it had in Gaul and Germany, employing towns—especially the *colonia,* or colonies of veterans at Camulodunum, the rapidly growing port of Londinium (London, of course, which by the year 60 had become the administrative

center of the province), and the newly founded settlement of Verulamium (St. Albans)—as practical schools of Roman culture. But the rapacity of the settlers and the provincial bureaucracy, particularly the procurator, Decianus Catus, destroyed any chance of peaceful assimilation of the vexed natives. The Trinovantes, the leading tribe in the region surrounding Camulodunum, were evicted from their fertile farmland by the veterans of the colonia; many were virtually enslaved and put to work in the quarries nearby to make tiles for the houses of their conquerors. Priests for the temple of Claudius were conscripted from the local populace and forced to spend their own resources for the upkeep of the shrine. The financial subsidies that Claudius had bestowed upon loyal tribes as a reward for their fidelity were reclassified as loans by the unscrupulous Decianus, who now insisted that the British chieftains pay them back; the land grants Claudius had awarded the Icenian noblility were repossessed. And, sometime around the year 58, Lucius Annaeus Seneca, who had loaned considerable sums of his own to the eastern tribes to enable them to purchase the material trappings of Roman civilization, suddenly called in all the loans. Perhaps Seneca realized that his tenure as the emperor's adviser was coming to an end and decided to consolidate his financial assets; in any event, this unexpected action created widespread distress throughout the region.

The death of Prasutagus provided the spark that turned discontent into a full-scale rebellion. The Icenian king had named the Roman emperor as co-heir (along with his two daughters) in his will, apparently hoping that this voluntary display of obeisance would prevent the empire from absorbing his territory entirely, as it usually did when a client monarch died. Alas, his Roman overlords completely ignored his request. Instead, the Iceni aristocracy was dispossessed of its hereditary estates by provincial military officials, and the slaves of the Roman settlers were permitted to plunder Prasutagus' personal property. The king's widow, Boudicca, was flogged, and his daughters raped.

Under the circumstances, Boudicca might easily be excused for thinking that military resistance could hardly engender a worse fate than loyalty. And so, while the main Roman forces were off in the west, chasing down the last remnants of resistance in Wales and completing their preparations for the invasion of Anglesey, she surreptitiously organized an armed rising with the cooperation of the Trinovantes and most of the minor tribes north of the Thames. Bou-

dicca made the hated colony at Camulodunum—a rich prize indeed for the impoverished Britons—her first target.

In the late spring or early summer of 60, Boudicca descended upon Camulodunum with a force of nearly fifty thousand British warriors and women, armed with clubs, hunting spears, and bows and arrows, which were about the only weapons the Romans had left them. Incredibly, the colony had been left virtually unprotected; its ramparts had been trampled several years earlier when the garrison departed for Wales, and were never rebuilt. As news of the rebels' approach spread through the town, hysterical settlers imagined they heard ghastly, inhuman shrieks in the theater, and weird corpselike figures were seen floating in a nearby river. The residents appealed to Decianus (who was in Londinium) for reinforcements, but the procurator could send them only two hundred men—eloquent testimony to just how thinly stretched Roman forces in Britain were at that moment.

It was only a matter of hours before the rebels, who appear to have been obsessed by a desire to obliterate every trace of Roman civilization, overran the tiny garrison and and set fire to the settlement. The retreating Roman soldiers and the civilian population—old men, women, children, and merchants—fled for safety to the stone temple of the deified Claudius, where they held out for another two days before the British juggernaut stormed through their defenses and slaughtered everyone in sight.

Caius Suetonius Paulinus had just completed the hard-won conquest of Anglesey when he learned that all hell had broken loose in the east. A former consul and one of the most respected commanders in the Roman army, Paulinus had been appointed governor of Britain in 59 by Nero (probably on Seneca's recommendation), with orders to complete the subjugation of the Welsh tribe of the Silures and demolish the British stronghold of Anglesey; Rome had finally concluded that the rest of the province could never be secure while the western regions remained untamed. Such an aggressive forward policy suited Paulinus' personal purposes perfectly, since he was eager for an impressive victory to keep pace with his rival, the eminent general Corbulo, who had recently received the plaudits of a grateful empire for subduing the Parthians in Armenia.

But now Paulinus' ambitions seemed likely to vanish in the flames of Camulodunum. Leaving only a skeleton force behind, the governor ordered the rest of the two legions under his command to

march eastward toward Londinium. As he rushed back to the Thames ahead of his troops, accompanied by only a cavalry escort, across nearly two hundred miles of neutral territory occupied by tribes who might have risen against Rome at any moment, (and had they done so, the Roman presence in Britain might easily have been extinguished), Paulinus learned that a substantial portion of Legion IX, commanded by Petrilius Cerealis, had emerged from its winter quarters on the Trent and encountered the rebel force outside of Camulodunum with disastrous results: about two thousand Roman infantry had been slaughtered, and Cerealis and the cavalry had been forced to flee for their lives. Upon hearing this depressing news, Catus, the procurator, had fled to Gaul.

Paulinus himself probably commanded little more than four thousand troops at this time. So as he waited for his infantry to complete its two-week trek (at a forced march) to Londinium, he sent a message to Legion II at Exeter, demanding reinforcements. Unfortunately, the legate of that legion was nowhere to be found, and his subordinate, the camp prefect, refused to move in such a dangerous situation without direct orders from his captain. This left Paulinus in a wholly untenable position; any attempt to defend Londinium—which was already half-starving from a shortage of provisions—with the slender force at his disposal would risk losing everything, inviting the same sort of disaster that had recently befallen Cerealis. So, disregarding the frantic pleas of the residents and countless refugees from the countryside who had sought shelter in the city, he abandoned Londinium to its fate. Those civilians who could maintain the pace of his legions were invited to accompany the supply wagons, and about half of the city's thirty thousand inhabitants did so; the rest, defenseless and bereft of any ships that might have carried them to Gaul and safety, awaited the British fury.

While Paulinus retreated across the Thames to drop off his civilian baggage and summon reinforcements from the Belgic state of the loyalist chieftain Cogidumnus in modern Sussex and Hampshire, Boudicca and her allies swept across the moorlands into Londinium, which apparently also lacked any military fortifications whatever. The timber-framed city was looted and put to the torch, and virtually the entire population tracked down in the narrow alleyways or in their homes and massacred, some by sword, others by hanging, burning, or crucifixion; the British had no desire to take prisoners. According to Dio Cassius, some of the Roman women were tortured before

they were killed. Boudicca's forces, he claimed, "hung up naked the noblest and most distinguished of the women and then cut off their breasts and sewed them to their mouths, in order to make the victims appear to be eating them; afterwards they impaled the women on sharp skewers run lengthwise through the entire body. All this they did to the accompaniment of sacrifices, banquets, and wanton behavior. . . ." When the British left, Londinium was nothing more than a smoldering graveyard; traces of blackened bones and burnt debris from the holocaust could still be found underground nearly two thousand years later.

Verulamium, too, was overrun and destroyed. But Boudicca could advance no farther without entering neutral territory.

By this time Paulinus had obtained five or six thousand additional auxiliary troops—most of them apparently garnered from Cogidumnus' kingdom and the garrisons of nearby forts—bringing his total force to approximately ten thousand men. Autumn was approaching and supplies were running low; Paulinus could not risk leaving the entire southeastern sector in the hands of the rebels over the winter. So he chose the best defensive terrain he could find, somewhere in Warwickshire close to Watling Street (possibly by Battle Bridge), in a defile with dense woods behind him and level, open country in front. As Boudicca's undisciplined mob approached, cheered on by women in wagons who had come to applaud the anticipated slaughter, it became obvious that the Romans were outnumbered by at least four to one.

Paulinus kept his infantry tightly packed in the center at the extreme rear of the defile, with auxiliaries on the flanks and cavalry on the wings. He permitted the British to close within range—in fact, they had sufficient time to draw up their wagons as a sort of grandstand at the entrance to the plain—and then suddenly gave the legionaries the order to launch their javelins. This was followed immediately by a rapid mass advance by all three units: legions in the familiar wedge formation, auxiliaries and cavalry with lances extended. Although this disciplined charge shocked the British badly, it cannot have overwhelmed them entirely; by now they had ample knowledge of Roman tactics and must have expected something of the sort. But it pushed them backward far enough that they ran into their own wagons and, panicking, became entangled in a melee of horses, swords, and falling bodies. Spurred on by the reports they had heard

of British atrocities at the sack of Camulodunum, Londinium, and Verulamium, the legions took no prisoners.

"It was a glorious victory," crowed Tacitus, who claimed with typical exaggeration that almost eighty thousand Britons died in the holocaust, compared to only four hundred Roman soldiers. Boudicca herself died shortly thereafter, probably a suicide. But the insurrection did not die with her. Paulinus unwisely instituted a policy of brutal retaliation, ravaging the lands of the rebellious tribes, thereby convincing the British warriors that surrender would be a bad bargain, so the mopping-up operations continued well into the following year. Aided by the arrival of reinforcements from the Rhine, Paulinus established a new line of forts from East Anglia to Durnovaria (Dorchester) and Coventry. Then, at the recommendation of an imperial fact-finding commission, which had determined that the exhausted province required peace and healing more than punishment, Nero recalled the general to Rome.

The Player

Rome and Judea, 60–65 C.E.

> I shall compel the interests of the citizens because of my increased glory.
>
> —NERO

By the year 60, Nero had decided that he would rather be an artist than emperor. Or, more precisely, he had come to the conclusion that his role as emperor required him to be an Artist on the highest aesthetic and spiritual level, to live a life of such heroic perfection that his awestruck subjects would be inspired to abandon their conventional lifestyles and emulate their sovereign as far as mere mortals possibly could, and finally worship him as a living deity, thereby inaugurating at last the long-awaited Golden Age of paradise on earth—that is, an eternal Roman Empire. Notions of godhood, the universal brotherhood of man, and his own vanity had gotten all jumbled up in Nero's diseased mind. Besides, being a fop was precisely what Nero wanted to do.

So, to celebrate the first shaving of his beard, at the age of twenty-one (he put the hair in a jewel-studded golden box and dedicated it to Capitoline Jupiter), Nero produced a series of extravagant and vulgar games known as the Juvenalia, under the patronage of the goddess of youth. On the banks of the Tiber, the older members of the Roman aristocracy vied, not entirely willingly, to see who could spend the most money on the luxury goods that were offered for sale

in booths, while their sons and daughters competed in obscene dramatic productions and athletic contests. Once the games were over, Nero kept their spirit alive by founding the Neronian Society, consisting in part of a quasimilitary band of five thousand Roman knights known as the *Augustani,* reputedly the best-looking young men in the capital, whose sole duties were to wear wavy hair like Nero, dress in outlandish garb, applaud the emperor shamelessly day and night, and compliment him incessantly on his divine beauty and melodious voice.

The next step was to involve the elderly, dignified (stuffy, to Nero's way of thinking) nobility themselves in the competitions, and thus in the year 60 Nero introduced the Quinquennial (or Neronian) Games, in which senators and their wives were expected to take part in a three-tiered competition—music and poetry, gymnastics, and chariot racing—based on the ancient Greek festivals. Nero himself entered enthusiastically into the spirit of the games, driving a chariot and frolicking in feminine roles in the theater, though he modestly declined all awards for his thespian prowess. If the Roman political establishment had not detested Nero before, the sight of an eighty-year-old matriarch forced to dance upon the stage while distinguished senators fought one another in the gladiatorial arena was sufficiently sickening to put thoughts of revolution into at least a few minds, though it must be said that the masses who came to watch seemed rather to enjoy the spectacle. Nero's relations with the Senate suffered further deterioration when he divorced and later brutally executed his long-suffering wife, the gentle Octavia, the daughter of Claudius, to marry Poppea.

Burrus, for one, no longer had to obey the emperor's egotistical whims, for in 62 the Praetorian co-perfect fell critically ill with cancer of the throat. He actually seemed relieved that the end was near; when Nero visited him and asked politely how he felt, Burrus acidly replied, "I am doing all right." Nero replaced Burrus with a gangster named Ofonius Tigellinus, an odious Sicilian ex-horse-trainer and fisherman whose primary qualification was his gift for running spies. Following the death of his longtime colleague, Seneca requested permission to retire from court, pleading ill health. He was, in fact, suffering from a sort of exercise-induced asthma in his old age. Nero formally declined the request, but a tacit agreement between the two men allowed Seneca to withdraw gradually from active involvement in poli-

tics; the Stoic spent most of the last three years of his life at his estates, with a few close companions.

Meanwhile, unrest swirled around the fringes of the empire. Nero could spare no reinforcements for Suetonius Paulinus during the crisis of Boudicca's rebellion because the situation in the more strategically vital provinces of Gaul and Germany appeared equally threatening; at one point, the emperor considered giving up Britain completely to transfer back to the continent the four legions stationed on the island. In the East, Parthia remained as antagonistic as ever, refusing to accept the Roman nominee for the throne of Armenia and forcing Corbulo back into action before an uneasy compromise was finally reached in 62. And the whole province of Judea was rapidly sliding into a state of anarchy.

During the procuratorship of Antonius Felix, brother of the powerful freedman Pallas and a protégé of Agrippina, Jerusalem had witnessed the rise of an organized urban terrorist movement, the *sicarii,* assassins who boldly stalked their political victims in the streets in broad daylight. Such men had appeared in the holy city before, but now their activities became part of a coordinated, violently nationalistic campaign. "The festivals were their special season," noted Josephus, "when they would mingle with the crowd, carrying short curved daggers [the *sicare*] concealed under their clothing, with which they stabbed their enemies. Then, when they fell, the murderers joined in the cries of indignation, and through this plausible behaviour were never discovered." One of their first victims was the high priest of the Temple, Jonathan, who perhaps had collaborated too freely with the Roman authorities for the terrorists' liking. "After his death," Josephus continued, "there were numerous daily murders. The panic created was more alarming than the calamity itself—everyone, as on the battlefield, hourly expecting death."

Well, this was probably an exaggeration, but the volatile situation was certainly aggravated by the continuing depredations of bandits and anticollaborationist guerillas against the estates of wealthy Jews in the countryside, and the activities of street-corner dissidents who attempted to whip up nationalist feeling in Jerusalem and the surrounding towns. Occasionally the tension spilled over into violence, as when Jewish and Greek toughs in Caesarea Maritima assaulted each other in the streets of the capital. The pervasive feeling of restlessness and expectation in Judea during the mid to late 50s also brought forth from the wilderness a plethora of prophets, several

of whom seem to have joined forces to attempt to free the people of
Israel from the domination of Rome by leading them through the
desert to a new promised land. But Felix, fearful that these proces-
sions might turn into a full-fledged revolt, suppressed the movements
with a vigorous display of military force. The procurator's most for-
midable foe, however, was an Egyptian Jew who claimed that he and
his disciples were the Chosen Ones who had been sent to overthrow
the Romans and restore an independent Jewish kingdom. When the
Egyptian gathered an excited throng of thousands of believers and
curiosity-seekers to the Mount of Olives just outside Jerusalem, and
vowed to work a miracle (with the aid of his personal militia) to knock
down the walls of the city and overthrow the Roman garrison, Felix
again unleashed his troops into the throng, reportedly killing or cap-
turing six hundred Jews. The Egyptian himself fled and managed to
escape with his life; though this enigmatic figure never reappeared,
prophecies of his imminent return continued to circulate through
Judea.

In the midst of this turmoil, Paul returned to Jerusalem. Ostensi-
bly, he had come to deliver a charitable donation collected from the
Gentile Christian churches for the poor of the holy city, but the real
reason for Paul's visit was to inform James the Just, as a matter of
courtesy, of his proposed missionary journey to the west, to Rome
and then Spain. Already Paul had written a letter to the tiny Christian
community in Rome, to introduce himself and his theology (particu-
larly the doctrines of salvation by faith alone, and the supremacy of
the unified church as the body of the resurrected Christ), and encour-
age the faithful through some of his most memorable prose. "Who
shall separate us from the love of Christ?" Paul asked his Roman
brethren. "Shall tribulation, or distress, or persecution, or famine, or
nakedness, or peril, or sword? . . . Nay, in all these things we are more
than conquerors through him that loved us. For I am persuaded, that
neither death, nor life, nor angels, nor principalities, nor powers, nor
things present, nor things to come, nor height, nor depth, nor any
other creature, shall be able to separate us from the love of God, which
is in Christ Jesus our Lord."

To placate the ruling Jewish Christian faction in Jerusalem, Paul
even acceded to James' request that he participate in and pay the
expenses of a purification ceremony for several converts, which was
scheduled to take place in the Temple. But while he was taking part
in the ritual fast, a group of visiting Jews from Asia Minor recognized
Paul and accused him of sneaking an uncircumcised Gentile into one

of the inner courts of the Temple. Although the charge was false, it seemed sufficiently plausible that the assembled pilgrims nearly lynched Paul before the Roman garrison commander—who may have assumed that Paul was the notorious Egyptian Jew for whom the government had been searching—rescued him from the angry mob. Following an acrimonious confrontation between Paul and the leaders of the Sanhedrin (Paul allegedly called the High Priest, Annias, "a whitewashed wall"), the Roman commander decided to kick the problem upstairs to Felix, and sent Paul to Caesarea Maritima with an escort of four hundred infantry and seventy cavalry as protection against the assassins who, according to a source in the High Priest's court, were waiting along the route to murder Paul.

At the capital, however, Felix refused to hear the case, since it appeared to be hopelessly entangled in questions of bewildering religious rituals. To placate Paul's powerful Jewish enemies, however, Felix kept the missionary under arrest on an unspecified charge for two years, until a new procurator arrived. Felix's replacement in the year 60 was a politician named Porcius Festus, who, despite his good intentions, proved equally incapable of comprehending the fundamental dispute between Paul and the Jewish Council. At one point, during a lengthy exposition by Paul detailing his spiritual journey—his Pharisaic training, his vision on the road to Damascus, and his faith in Jesus as the risen Son of God—Festus burst out in exasperation: "Paul! You are raving! Too much learning is driving you mad!" In the end, rather than risk a verdict influenced by Jewish political pressure, Paul elected to appeal to Rome and submit to the jurisdiction of the emperor, a right guaranteed to all Roman citizens living in the provinces.

Late in 60 or 61, therefore, Paul was put on a ship and sent to Rome in the company of several other prisoners and a military guard. Actually, the party had to change ships several times during the journey, eventually making their way to Crete, where Paul recommended that they spend the rest of the year rather than risk the hazards of crossing the Mediterranean in winter. His advice was ignored. Shortly after leaving the island, a violent gale—a northeaster—swept down upon the vessel and, according to the author of *Acts* (who claimed to have been there at the time), nearly demolished it:

> The ship was caught by the storm and could not head into the wind; so we gave way to it and were driven along. . . . We took such a violent battering from the storm that the next day they began to throw the

cargo overboard. On the third day, they threw the ship's tackle overboard with their own hands. When neither sun nor stars appeared for many days and the storm continued raging, we finally gave up all hope of being saved.

For two weeks the ship drifted helplessly, until it ran aground off the coast of Malta; the passengers reached shore by clutching onto planks and other pieces of the broken vessel. From Malta the party finally made its way to Rome, where Paul received a heartfelt welcome from members of the local Christian community. He remained in the city for two more years. Although he was technically under house arrest, the authorities apparently permitted Paul to preach his gospel "quite openly and unhindered." And at that point he fades away entirely from the gaze of history.

Back in Judea, Festus was confronting a rapidly deteriorating situation. The *sicarii* and the rural freedom fighters, better known to the Romans as thieves and bandits, redoubled their efforts to terrorize the towns and countryside into submission. Within Jerusalem itself, a festering dispute between the Temple priests and the impoverished lower priestly orders over the division of the tithe offering (the Temple priests tried to grab it all for themselves before the others could get their share) erupted into a running street battle. "Each of the bands formed and collected for itself a band of the most reckless revolutionaries and acted as their leader," explained Josephus. "And when they clashed, they used abusive language and pelted each other with stones." Since public opinion appeared to side with the lower clergy in this bitter if rather unedifying struggle, the Temple priests tried to deflect the masses' attention by turning against the Jewish Christian church in Jerusalem, for which they needed very little encouragement anyway.

Just as Stephen was executed by the Sanhedrin in the interval following Pilate's departure for Rome, so now the High Priest, Ananias II, took advantage of the sudden death of Festus in 62 to arrest James the Just, the brother of Jesus. Along with several of his colleagues, James was interrogated by the Council and subsequently stoned to death for blasphemy, presumably for insisting that Jesus had been the Messiah.

For the next three years, Judea was a very unhappy place. Jews and Greeks scuffled again in Caesarea Maritima; in Jerusalem, the new procurator, Gessius Florus, seized a substantial portion of the Temple

treasury to replace the shortfall in tax revenues that was a direct result of the disorder rapidly spreading through the countryside; and while the Jewish political and religious establishment occupied itself by shuffling High Priests into and out of office in an ongoing and essentially meaningless power struggle, bloody rioting broke out between the anti-Jewish Roman auxiliary troops and the citizenry.

By the year 64, Nero's wildly idiosyncratic revolt against the moral, political, and aesthetic conventions of his day was approaching its zenith. No expense was spared to magnify the glory of the emperor's divine person. Wherever Nero went, he was accompanied by a train of nearly a thousand carriages, with mules shod with silver and Mauretanian horsemen and outriders wearing jingling medallions and bracelets. The emperor refused to wear the same clothes twice, and his gifts of cash and land to his favorite performers were scandalous, as were his stupendous wagers at the dicing table. Rome had never seen anything like it, even in the final stages of Caligula's madness. "True gentlemen," Nero sniffed, "always throw their money about"; in fact, Nero's admiration for Caligula was heightened by the revelation that his predecessor had squandered in about a year the entire vast fortune he had inherited from Tiberius.

But it was Nero's indisputably perverted sexual activities, which he took great pains to make public, that best symbolized his determination to break—and rise above—the traditional bonds between human beings. "He was convinced," explained Suetonius, "that nobody could remain chaste or pure in any part of his body, but that most people concealed their secret vices; hence, if anyone confessed to obscene practices, Nero forgave him all his other crimes." Nero's incestuous relationship with Agrippina had long been an open secret, as had his bisexual inclinations, which were not surprising in a man who so adored Greek culture. Already he had married—in a mock ceremony complete with the customary accoutrements of dowry and bridal veil (the better to show how meaningless such old-fashioned rituals were)—a freedman named Doryphorus, who joined the emperor in his favorite pastime of dressing in wild animal skins and attacking the genitals of helpless "victims," men and women tied to stakes.

This ridiculous behavior reached its zenith in the spring of 64, at a banquet-orgy given in Nero's honor by his thuggish Praetorian co-prefect, Tigellinus. Tacitus recalled the occasion sourly:

The entertainment took place on a raft constructed on Marcus Agrippa's lake. It was towed about by other vessels, with gold and ivory fittings. Their rowers were degenerates, assorted according to age and vice. Tigellinus had also collected birds and animals from remote countries, and even the products of the ocean. On the quays were brothels stocked with high-ranking ladies. Opposite them could be seen naked prostitutes, indecently posturing and gesturing.

At nightfall the woods and houses nearby echoed with singing and blazed with lights. Nero was already corrupted by every lust, natural and unnatural. But now he refuted any surmises that no further degradation was possible for him. For a few days later he went through a formal wedding ceremony with one of the perverted gang called Pythagoras. The emperor, in the presence of witnesses, put on the bridal veil. Dowry, marriage bed, wedding torches, all were there. Indeed everything was public which even in a natural union is veiled by night.

For Nero, that was precisely the point; this exhibition was expressly designed to shock the public, to break down the traditional Roman morality and reform it to conform with his own ideals, to release the common man and woman from the restrictions that kept them from fulfilling their physical and spiritual potential, and lead them via debauchery toward a type of regeneration or salvation that only Nero (and perhaps not even he) could truly understand. When Nero tired of Pythagoras, for instance, he turned around and married one of his castrated male lovers, a boy named Sporus; this time the emperor played the part of the husband and dressed Sporus in the empress's clothes and rode through the streets of Rome with him, pausing now and then to kiss and fondle his new bride. This obsession with sexual liberation owed much to the influence of the orgiastic oriental cult known as Bacchism, which had been lurking beneath the surface of Roman aristocratic society throughout much of the first century, threatening on occasion to burst through the legal and moral restraints with which Augustus and Tiberius had sought to repress it.

Perhaps it was nothing more than a coincidence that the most devastating fire Rome has ever known broke out in the summer of that same year, on the evening of July 18–19. The conflagration began in the vicinity of the Circus Maximus, between the Palatine and Caelian hills, in shops where stocks of highly flammable merchandise were stored. Fanned by the wind, the flames enveloped the entire Circus within minutes. With horrifying swiftness, the fire spread through the wooden slums and shops in the surrounding low-lying

area, through the narrow crooked alleys and jerry-built tenements with their overhangs and irregular abutments that thwarted all efforts to control the blaze; then, unchecked, it swept up the hills themselves, consuming the entire Palatine, including the emperor's palace. The air was filled with smoke and the shrieks of trapped women and men searching for lost family members or any means of escape; but wherever they ran, the fire reappeared in front of them. Against the background of the flames, some people swore they could see mysterious gangs armed with torches, forcibly resisting all efforts to control the blaze and even adding to its fury with their own firebrands, shouting wildly that they were acting on orders. After six days, when there was virtually nothing left to burn in the ravaged districts, the fire was finally extinguished, only to flare up again in yet another district for another three terrifying days.

When it was all over, ten of Rome's fourteen districts had been gutted; three were completely leveled, and the other seven, Tacitus said, "were reduced to a few scorched and mangled ruins." Gone were innumerable temples, thousands of volumes of irreplaceable historical records, and the treasured trophies and spoils of Roman conquest.

Nero's reaction to the crisis revealed both his humanitarian, rational side and his obsessive desire to escape reality. The emperor had been out of town, at Antium, when the fire broke out. Upon his return, apparently in no great hurry—though he must have arrived before the fire was put out, since he had time to make his famous dramatic recitation from a tower in Maecenas' gardens, comparing the disaster to the fall of Troy—Nero immediately opened his own gardens and the Field of Mars to the homeless, who had been living meanwhile in whatever monuments and tombs had survived the blaze. In short order, the government constructed emergency shelters, established a fire relief fund, and imported vast stocks of grain that were sold at a reduced price, since many of the victims had no money left at all. Then, after offering propitiatory sacrifices to the appropriate gods, Nero ordered the buildings that remained in the ravaged districts demolished by artillery because they were no longer safe, and issued new safety regulations to ensure that such a disaster would never occur again. This time Rome would be built according to a sane, logical plan: the city's streets were widened and the water supply expanded; the height of residential houses was restricted, and semidetached houses were prohibited altogether; builders were required to employ a certain percentage of fireproof stone in their projects; and

householders were ordered to keep some sort of fire-extinguishing equipment in their homes. These eminently sensible and far-sighted measures met with considerable grumbling from the city's residents, however, partly because of the expense involved and partly because Rome's new open, airy environment provided less shade from the broiling summer sun.

But the real controversy in the days following the catastrophe arose from Nero's decision to build his dream palace upon the ashes of the ravaged hillsides. This was the fabled Golden House, the mansion with an arcade that ran for more than a mile, with a colossal hundred-foot-high statue of the emperor (portrayed as the Sun, wearing a star-shaped crown) in the entrance hall, with rooms adorned with precious jewels and gold overlays and ivory ceilings and moving panels, and a circular main dining room with a revolving roof that was synchronized with the movement of the heavens. Outside was an artificial lake and landscaped gardens—vineyards, orchards, forests, and meadows—and herds of animals imported from every corner of the empire. This fantastic creation was built not on the outskirts of the city, as one might have expected, but in the very heart of Rome. When it was finally completed, Nero sighed contentedly and said, "Good, now I can at last begin to live like a human being."

The common citizenry, however, expressed a certain measure of resentment at this ostentatious and callous display of imperial extravagance, when so much of Rome was still suffering from the devastating effects of the Great Fire. Nero might have replied that he had done all he could to help, but still the image of the Golden House—whose immense size preempted anyone else from using the ground for their own dwellings ("The Palace is spreading and swallowing Rome!" ran one piece of graffiti on the walls of the city)—gave rise to angry accusations that perhaps Nero had instigated the fire himself; perhaps those ruffians with torches had been gangs of imperial arsonists.

Even if this indictment were untrue, it rapidly gained widespread credence, and that scared the hell out of Nero. And when Nero was frightened, he always struck out ferociously at someone. This time the emperor found a scapegoat close at hand. The modest Christian community in Rome, with its mysterious rituals and exclusive brotherhood of believers, had long been despised by a majority of the local citizenry, more so even than the Jews; indeed, the fact that the government could now distinguish between Christians and Jews showed how clearly separate the two communities in Rome had become. And

Nero had apparently learned that some Christians had been preaching openly of a Last Judgment or a Second Coming, when the world would come to an end amid a fiery holocaust that would consume the pagan empires. It was entirely possible, of course, that the Christian community in Rome did see the flagrant immorality of Nero's regime as a sign that the apocalypse was fast approaching—witness the pre-occupation of the Thessalonian Christians with the imminent divine judgment, as documented by Paul; nor was it impossible that the fire had indeed been started, or at least encouraged, by a band of fanatical Christians.

So the government blamed the Great Fire on the Roman Christian community and initiated a bloodthirsty round of persecutions. Christians were arrested and tortured until they revealed the names of their brethren; those in turn were crucified, or dressed like wild animals and torn apart by dogs in the arena. But the depths of Nero's cruelty and sadism were revealed only when he impaled scores of Christ's followers on stakes and then burned them alive, as human torches to illuminate the city at night. Probably Paul, and possibly Peter, too, who may have recently arrived in Rome as head of the Jewish Christian missionary movement, perished in the cataclysm. In the end, even such a confirmed bigot as Tacitus was sickened by the emperor's brutality.

Unfortunately for Nero, this anti-Christian hysteria failed to deflect popular anger against his regime for long. His massive rebuilding schemes had exhausted an already depleted treasury, and sent the emperor scurrying desperately for cash. He found it in the temples of Rome, in the gold offered by generations of Roman citizens to accompany their prayers; he found it in the provinces, in the statues of gods which were melted down, and in the legalized extortion committed by his ingenious tax collectors; he found it in a wholesale devaluation of the currency; and most dangerously of all, he found it in the estates of the Roman aristocracy. By the end of 64, the treason trials that had characterized every reign since Tiberius had resumed under the vigorous prosecution of Tigellinus, not primarily for reasons of security, but for the massive fortunes of alleged traitors, now confiscated by the corrupt government.

As the new year dawned, an anti-Neronian conspiracy of disgruntled senators, knights, and Praetorian Guards coalesced around the figure of Gaius Calpurnius Piso, an aristocrat with no particular qualifications for the throne, save his acceptability to most of the disparate factions involved in the plot (though others hoped to entice

Seneca to come out of semiretirement and rule in place of his former pupil). Apparently the conspirators intended to assassinate Nero in the Circus Maximus—where the emperor was most accessible to the public—during the games celebrating the festival of Ceres in mid-April of 65. But too many people had been let in on the plans, and on the eve of the coup an informant leaked word to the palace. By the time it all came unraveled, fifty-one people—including nineteen senators and eleven military officers—had been charged with conspiracy. Nineteen of those who were convicted, including Piso and the Praetorian co-prefect Faenius Rufus, were subsequently executed—sometimes by their fellow conspirators who had not been denounced—or forced to commit suicide. Seneca chose to open his veins, and bled to death.

Shaken by this stunning evidence of the disaffection of the Roman aristocracy, Nero, terrified as usual, gave Tigellinus a free hand to do whatever was necessary to uncover treason, thereby redoubling the official terror. The emperor, meanwhile, retreated into his theatrical dreamworld. At the second staging of the Quinquennial Games, Nero took to the stage. Dignitaries from the capital and the home provinces were compelled to attend; once the captive audience was inside, the doors of the theater were locked and no one was permitted to leave until Nero had completed his performance. There were stories, probably apocryphal, of pregnant women giving birth during a particularly lengthy recital and magistrates dropping over the rear wall of the theater or feigning death so they could be carried out. More reliable was a report about the general Vespasian, who nodded off during the emperor's performance and was subsequently dismissed from court. Fearing for his life, Vespasian spent the next year hiding out in an unobtrusive small town in the countryside, until Nero suddenly called him back.

The Enlightened One

China, 65–71 C.E.

> You must be your own lamps, be your own refuges.
> Take refuge in nothing outside yourselves. Hold firm to
> the truth. . . . Whoever among my monks does this will
> reach the summit. . . .
>
> —LAST WORDS OF THE BUDDHA

O n March 29 of the year 57, the emperor Guangwudi died. The founder of the Later Han dynasty had reigned for nearly thirty-two years, the last eighteen over a reunited Chinese Empire at peace with itself. Guangwudi was succeeded by his son (by his second wife), Liu Yang, who took the name Mingdi upon his accession. The transfer of power proceeded without difficulty; there were no serious challenges to Mingdi's authority.

Outwardly, China was in the midst of a period of vigorous economic expansion. Because Guangwudi chose to rely upon the large landowning and merchant families for support, his administration necessarily adopted a policy of laissez-faire, jettisoning the dismally unsuccessful attempts at government regulation and monopolies that the last rulers of the Former Han dynasty and Wang Mang had attempted to implement. The magnificent walled estates of the nobility grew, as did their personal fortunes; many aristocrats possessed their own markets and industrial enterprises (mostly iron-smelting and salt mining), and their own private militia. Once the dislocations of wartime had ended, commerce within China enjoyed a tremendous revi-

val, aided by an excellent network of roads, rivers, and canals. The fact that a majority of peasants failed to share in this prosperity, and actually declined in status and income, was obscured temporarily by the population shortage in northern China.

Trade between China and the independent states of Central Asia also thrived during these years, albeit with no active encouragement by the imperial court. During the interregnum of Wang Mang and the ensuing civil war, China had abandoned control of such oasis states as Turfan, Khotan, and Kucha along the Silk Route in the so-called Western Regions, along the rim of the Tarim Basin; even a delegation from sixteen states in the Western Regions could not persuade the imperial government to reestablish its protectorate over the region, and hence the oases fell under the control of the Xiongnu in the north and the kingdom of Yarkand in the south. Nevertheless, the overland silk trade between the Orient and southern and western Asia reached its zenith in the last half of the first century, bringing to China an impressive quantity of glass, diamonds, horses, ivory, and fine linen and wool cloth from the Indian subcontinent, Parthia, and the eastern provinces of the Roman Empire. Cultural influences, too, flowed freely between East and West, primarily in the spheres of art—as evidenced by the sudden appearance of motion and realism in previously static, symbolic Chinese sculptural techniques, and innovative depictions of everyday life and the realm of the spirits—and religion.

It was during this period that Buddhism—the most influential foreign religion in Chinese history—first appeared in China, specifically in the urban centers of commerce, probably introduced by merchants or missionaries traveling along the Silk Route. Buddhism had originated in northern India six centuries earlier, as an offshoot or reformation of the ancient Indian creed later known as Hinduism. The legendary founder of the religion, of course, was Gautama, a discontented Indian aristocrat who had abandoned his family and his position to seek a solution to the ancient and apparently insoluble problem of evil and the unrelenting suffering of life. After failing to discover in the prevailing philosophical and theological systems any escape from the seemingly endless cycle of pain and rebirth, carried forward into each new stage of existence by the transmigration of souls, Gautama suddenly experienced a revelation (so the story went) while sitting beneath a tree, at the foot of the Nepal hills. Men suffered so, he realized, because of their desires, which could never be entirely fulfilled; hence one must abandon desire, and forego ex-

cessive attachment to any one person or thing, to emancipate oneself from the eternal wheel of pain. The discipline that Gautama—the Buddha, or Enlightened One—developed to attain that goal (defined as *nirvana,* literally "the blowing out," as of a candle flame) became known as the Eightfold Path: right views, right actions, right aspirations, right meditation, right speech, right livelihood, right mindfulness, and right effort.

For the next forty-five years, Buddha taught these "noble truths" to disciples who subsequently formed a monastic order based upon the vows of chastity, nonviolence, and poverty. Although a few female monks were admitted shortly before Gautama's death, the Buddha himself was never quite sure how women fit into his scheme of salvation. When his foremost disciple asked him how one should behave with women, the Enlightened One answered that it was best "not to see them." But what, the disciple continued, if one happened to see them? Then try "not to speak to them," Buddha replied. But what if one could not avoid speaking with them? "Then keep alert!" warned the Master.

Following the Buddha's death, his disciples—who shaved their heads, wore saffron-colored robes but no shoes, and carried bowls to beg their daily rice—traveled across the Ganges plain, spreading the Buddha's gospel of moderation and a love for all living things, founding monasteries where the faithful could withdraw from the world and seek holiness. The spread of Buddhism throughout India was facilitated by the unification of the subcontinent by the warrior-statesman Chandragupta Maurya, who transformed nearly two dozen fragmented monarchies and republics into a centralized, efficient political state of more than forty million inhabitants in the late fourth century B.C.E. It was under Chandragupta's grandson, the emperor Ashoka, that the Mauryan empire reached its zenith; aided by the construction of the Royal Highway (the Grand Trunk Road), agriculture and commerce thrived, and the capital of Pataliputra—surrounded by a timber wall eight miles long and a mile and a half wide, with five hundred seventy towers and a moat thirty feet deep and nine hundred feet wide—became the most magnificent city in the world. Ashoka himself, who was known as the first *chakravartin,* or "universal emperor" of India, allegedly converted to Buddhism in the tenth year of his reign, and certainly promoted Buddhist principles of duty, compassion, and nonviolence for the rest of his thirty-seven-year regime (269–232 B.C.E.).

Within a century or two, however, the original message of Gautama had evolved into something quite different: Gautama himself had been transformed into a miracle worker; a cult of worship of the relics of Buddha and his immortal saints sprang up, despite the fact that the Buddha had explicitly rejected the power of prayer and worship, on the assumption that each man must work out his own salvation unaided by the intervention of any divine beings; and the notion of a future savior—known as Maitreya—who would one day reign as Buddha, at the end of the world, took hold in the minds of the faithful.

But the major transformation of Buddhism occurred in the early years of the first century, with the development of the school of thought known as Mahayana, or the Greater Vehicle, as opposed to Hinyana Buddhism, which generally became known as the Lesser Vehicle—though that appellation was rejected by its adherents. Mahayana Buddhism represented a synthesis of elements from the original teachings of the Enlightened One, along with a generous dose of Indian mysticism, Zoroastrianism, gnosticism, and Hellenism (which had been spread throughout northwest India by Alexander the Great and the rulers of his successor states). In the Mahayana system, Gautama became a god of transcendent power—though only one of a number of reincarnated Buddhas, past and future—who responded to the prayers of the faithful, and who was served by a hierarchy of saints known as *bodhisattvas*, those who had attained perfection but postponed their entrance into nirvana to labor instead on earth, helping others find the path to salvation. The mortal figure of Gautama was virtually lost in this immense pantheon. Buddhism was no longer the exclusive path chosen by ascetics who separated themselves from the world; it had become a universal means of salvation.

The spread of Mahayana Buddhism outside the Indian subcontinent was aided in the mid-first century by the expansionist thrust of the aggressive Indo-European state of Kushan from its base in Bactria (northwest India). The Kushan dynasty had evolved from one branch of the seminomadic people known as the Yuezhi, who had been pushed out of their homeland along the northwestern border of China about two hundred years earlier by the irrepressible Xiongnu. Now, having accumulated the resources of a settled and united tribal nation, the Kushan rose and overran the land of the Hindu Kush, conquering Kabul around the year 50 under the leadership of a chieftain known as Kadphises I, who promptly struck coins to celebrate the triumph.

These bronze and copper pieces bear a striking resemblance to the coinage of Augustus and Tiberius, a similarity that gives mute testimony to the flood of Roman gold that poured into the region once the Kushan reopened the overland trade route between Rome and India.

Carried along on the eastward tide of Kushan expansion and commerce, Mahayana Buddhism entered China, where it initially received a not particularly friendly reception. The eminently practical side of the Chinese national character had no use for the otherworldliness of Buddhism. Most first-century Chinese considered life to be essentially good, or at least capable of improvement, and philosophers were supposed to propose specific ways to better the human condition. The Confucianists who dominated Chinese thought during the Later Han period found the new religion especially reprehensible (if not incomprehensible) because its dominant theme of escapism threatened to overturn their own complex system of rules for ethical conduct and the management of society; indeed, the Confucian view that man derived his entire significance from his relationship to his family and the state made the Buddhist notion of withdrawal absurd.

At first the Confucian establishment viewed Buddhism as a sort of deviant, barbarian form of Taoism, which also propounded a doctrine of individual salvation and mastery of the world through retirement from human society. Taoism—named for the Tao, an ancient Chinese concept that translates very roughly as "the Absolute," or the great reality that fills the universe—had first appeared in recognizable form in China in the fourth century B.C.E. Its basic precept was that man could acquire knowledge only when he was at one with the Tao, through silent contemplation and "inward illumination"; attempts to teach anyone else the Way were worse than useless, for language invariably corrupted the truth. For the Taoist sages, right conduct consisted of "doing everything by doing nothing," a supremely self-centered notion which meant that anyone who actively sought to change the world was wasting his time. For many Chinese, and particularly for emperors and petty kings, the primary appeal of Taoism lay in its premise that one's life force, or vital principle, could be preserved and strengthened eventually to the point of immortality by doing good works and refining or "lightening" one's body through a rigorous regimen that included dietary restrictions (no wine, meat, or grains, but lots of cinnamon), controlled breathing exercises to recirculate and purify the breath, certain sexual activities, alchemy, magic, and drugs. Eventually Taoism also came to embrace the notion that

its devotees could redeem their sins in advance through good deeds, repentance, and religious rites, and create a type of living substance that would be waiting for them on the other side, in the next world.

Although a huge gulf obviously existed between the Taoist quest to obtain earthly immortality by channeling one's inner force toward the Absolute, and the Buddhist desire to escape forever from a physical existence that it defined as irremediably painful, both religions offered a mystical refuge from a world of immense suffering. It was not surprising, therefore, that many of the first Chinese converts to Buddhism were recruited from Taoism, and as Buddhism developed in China under the Later Han dynasty, it assimilated numerous Taoist precepts and practices. Besides, Buddhism did not represent itself as a monolithic core of beliefs that had to be accepted in its entirety. Sometimes it was not the Buddhist philosophy at all, but the unique architecture of its temples and pagodas and the exotic music and chants of its worship services that most intrigued the sophisticated urban populace of northern China.

By the time Mingdi ascended the throne, a tiny Buddhist community probably already existed at least among the foreign merchants who resided at the capital city of Luoyang. The religion had definitely penetrated to the commercial city of Pengcheng, in modern Jiangsu province, where Prince Ying, a half-brother of the emperor, acted as patron to several Buddhist monks. In the early 60s, this association with an alien religion (which must have been misunderstood and feared by conservative elements at the imperial court) brought Ying under suspicion of sedition; the fact that the prince also dabbled in Taoism and alchemy, in hopes of attaining immortality, did his cause no particular good, either. After Ying offered gifts of silk to the emperor to prove his loyalty, Mingdi exonerated his half-brother with an edict stating that he "held in honor the humane cult of the Buddha" and had "made a pact with these gods [i.e., Buddha]" to observe a three-month period of fasting and purification. Obviously Buddha had become a god who could be propitiated with sacrifices and fasts; just as clearly, Mingdi was not unsympathetic to the new religion, so long as it did not encourage rebellion in susceptible minds.

Five years later, however, Prince Ying was again denounced as a traitor when several of the Taoist magicians in his entourage predicted that he would replace Mingdi on the throne. This sort of thing could not be tolerated, of course; since the Han emperors had always been nervous about reports of black magic among their enemies, the mysti-

cal combination of Buddhism and Taoism was simply too explosive for the security of a frightened regime. This time Mingdi banished his half-brother to the distant southern reaches of the empire, beyond the Yangtze. Upon his arrival there, perhaps accompanied by several monks who had followed him into exile, Ying committed suicide in 71. Subsequently, thousands of Prince Ying's followers in Pengcheng, the center of the alleged conspiracy, were arrested and tortured to elicit information; the trials and executions did not end until the spring of the year 77.

The Traitor

Judea and Galilee, 66–68 C.E.

> What are the troops, what is the armour, on which you
> rely? Where is your fleet to sweep the Roman seas?
> Where is your treasury to meet the cost of your
> campaigns? Will you shut your eyes to the might
> of the Roman empire and refuse to take the measure of
> your own weakness? Have not our forces been
> constantly defeated even by the neighbouring nations,
> while theirs have never met with a reverse throughout
> the whole known world?
>
> —HEROD AGRIPPA II

At the end of 66, Joseph ben Mattathias found himself on the road from Jerusalem to Galilee, as the commander of the military forces of the Jewish provisional government in the northern sector. Joseph's assignment, unenviable in the extreme, was to organize the disparate and mutually antagonistic resistance groups in Galilee into a single effective fighting unit before the springtime, when the inevitable Roman counterstroke against the recent Jewish rebellion was expected to occur.

A less likely candidate for this vital military commission would have been difficult to find. The scion of an aristocratic priestly family, the twenty-eight-year-old Joseph had thus far led the life of a rather spoiled dilettante. At the age of sixteen, dissatisfied with the unexciting prospect of a career in the religious establishment, he had dropped out of conventional society and run off to the wilderness, where he

joined an Essene commune. Joseph appears to have found their rigorous lifestyle too constricting for his taste, however, because after several years in the desert he returned to Jerusalem to resume his education and assume his religious duties. In the year 64, Joseph traveled to Rome as part of a delegation to petition Nero to spare the lives of a couple of radical young priests whom the procurator, probably Luccius Albinus, had arrested on charges of sedition.

Dazzled by the awesome wealth and power of the empire during his brief sojourn in the imperial capital, Joseph sailed back to Judea and found the province in a state of virtual anarchy. By the spring of 66, the high-handed policies of the latest (and last) procurator, Gessius Florus, had thrown Jerusalem into an uproar. Not only had Florus appropriated cash from the Temple treasury to reimburse the government for a shortfall in Judean tax payments, he had also summoned auxiliary troops—mostly ethnic Greeks from the garrison at Caesarea Maritima—to put down the ensuing riots in the holy city. Not surprisingly, these soldiers and the Jews came to blows, spilling considerable quantities of blood on both sides. Although the Sanhedrin and the High Priest managed to persuade Florus to withdraw most of his troops, leaving only one cohort behind, Jewish agitators in Jerusalem refused to let the matter rest.

All the tensions and frustrations of the long decades of Roman rule now came together in a single irresistible demand for freedom and justice. Years of unrest in the Judean countryside, fanned by the depredations of bandits and freedom fighters and the retaliatory raids of the provincial government, had wreaked havoc upon the local agricultural economy. In Jerusalem, unemployment was mounting as the pace of public construction slowed, partly as a result of the reduced tax payments from the hinterland. The impoverished lower orders of priests continued to suffer arrogant treatment at the hands of the Sadducees and the Temple authorities, who were also widely hated for their willingness to collaborate with the Roman establishment; and every segment of the population was oppressed by the rapacity of corrupt provincial officials. Meanwhile, relations between Greeks and Jews in the cities outside Jerusalem continued to deteriorate, while the rapidly growing ranks of the Zealots pressed their uncompromising demand for the restoration of an independent Jewish state. In the midst of such pervasive unrest, it was not surprising that many Judeans grasped at any promise of messianic deliverance from their ordeal.

It would have been difficult to imagine how the situation in Jerusalem could have gotten much worse; but that is precisely what happened in the summer of 66. First, a band of Jewish freedom fighters, led by Menahem, a son of that Judas the Galilean who had rebelled against Rome back in the year 6, managed through a clever piece of treachery to oust the Roman garrison from the Herodian fortress of Masada, in the desert by the edge of the Dead Sea. In the process, Menahem also captured vast stores of weapons from the armory at Masada, some of which he seems to have distributed among the warrior-monks at Qumran. News of this incredible triumph must have electrified Jerusalem. Then, in August, the captain of the Temple guard, Eleazar ben Hananiah, son of a former High Priest, convinced his colleagues not to accept any more sacrifices from foreigners; this rash declaration, which flew in the face of centuries of Jewish tradition, was obviously aimed directly at Rome, for it meant that no longer could the Temple perform the twice-daily sacrifices offered on behalf of Nero, since they were paid for out of the emperor's personal treasury.

It was nothing less than an act of open rebellion, and the reigning High Priest and his collaborationist colleagues wanted nothing to do with it. Leaving the Temple and the eastern part of Jerusalem known as the Lower City in the hands of Eleazar's faction, they withdrew to the Upper City (the western half) and sent a messenger to beseech Herod Agrippa II for help. Earlier that year, Agrippa—to whom Nero had recently awarded additional and very remunerative urban territories in northern Judea and southern Galilee—had attempted to dissuade the hotheads in Jerusalem from doing anything rash, reminding them that "war, if it be once begun, is not easily laid down again, nor borne without calamaties coming therewith," particularly when one considered the overwhelming military superiority of the Roman Empire. "What," he asked them, "do you pretend to? Are you richer than the Gauls, stronger than the Germans, wiser than the Greeks, more numerous than all men upon the habitable earth? What confidence is it that elevates you to oppose the Romans?"

The answer to Agrippa's not entirely hypothetical question was that the Jews had convinced themselves God would intervene on their behalf and smite the Romans, just as He had overcome so many of Israel's enemies before. Many Jews also confidently expected help from the Parthians, who they thought would welcome the chance to inflict an injury on Rome; unfortunately for the rebels, the Parthian

monarch had recently signed a treaty of amity with Rome to conclude the latest tussle over the Armenian succession, and thus had absolutely no intention of aiding the uprising in Judea. Not that it would have mattered greatly, for any effective foreign assistance would take time, and time was of the essence for the Jewish rebels. When Eleazar heard that Agrippa II had sent two thousand cavalry to Jerusalem to help the High Priest regain control of the Temple, he launched a preemptive strike, routed the royal cavalry before it could organize itself, and burned Agrippa's residence in Jerusalem. For good measure, they also set fire to the city's records office, destroying the mortgages and other financial contracts stored there, in a calculated bid to obtain the support of thousands of impoverished Judeans who were staggering under a crushing load of debt. To escape from Eleazar's assault, the hard-pressed conservative faction now found it necessary to retreat to Jerusalem's labyrinthine underground network of tunnels and sewers; the High Priest himself took refuge with a small garrison of Roman troops in the upper palace, by the Jaffa gate.

By this time, Eleazar might reasonably have expected the governor of Syria, Cestius Gallus, to have mounted an expedition to suppress the rebellion, which was gaining momentum every day in Jerusalem and the surrounding countryside. Instead of Roman troops, however, the holy city now witnessed the entry of Menahem, the hero of Masada, who rode into Jerusalem with the pomp and ceremony befitting a king—if not the Messiah—and promptly assumed control of at least one faction of insurrectionists. The appearance of a rival with such haughty pretensions irritated Eleazar beyond control, though beyond the personal ambitions of Eleazar and Menahem, the hostility between the two factions appears to have centered on the conflict between the secular (Menahem) and priestly (Eleazar) wings of the nationalist movement. The two rebel groups split irrevocably when a force under Menahem's command captured and executed the former High Priest Ananias, Eleazar's father, who had been hiding with the Roman garrison in the royal palace while he decided whether he wanted to join the revolt or not. Retaliation followed swiftly. When Menahem appeared at the Temple to celebrate his victory, dressed in purple robes and accompanied by his regal entourage, Eleazar's men assaulted the assemblage with stones and drove them out of the precinct. Although Eleazar subsequently captured Menahem and tortured him until he died, a group of Menahem's supporters—including one of his relatives, who also happened to be named

Eleazar—escaped and fled Jerusalem for Masada, where they entrenched themselves behind the massive fortress atop the flat-crested mountain.

Back in Jerusalem, the garrison of Roman auxiliaries that had remained in the royal palace agreed to surrender to the provisional government, on Eleazar's guarantee that their lives would be spared. Once the troops had laid down their weapons, though, the rebels treacherously cut them all down, except the commander, Metilius, who saved his life by the embarrassing expedient of consenting to convert to Judaism and undergo the rite of circumcision. The slaughter of the garrison—the last remnant of Roman troops in Jerusalem—was subsequently commemorated in Jewish tradition as the day "the Romans evacuated Judah and Jerusalem," a claim that the residents of the province later discovered, to their considerable regret, was not altogether accurate. Moreover, the duplicitous behavior of Eleazar's militia sparked savage anti-Jewish reprisals from Greek residents of cities throughout the eastern Mediterranean, including Tyre, Alexandria—whose prefect, the apostate Jew Tiberius Julius Alexander, lent the legions under his command to the attack, killing more than ten thousand Jews—and the Judean capital of Caesarea Maritima, where thousands of Jews were butchered in the space of an hour; those who survived were seized by the procurator, Florus, and sent to work in the Roman galleys. These outrages, in turn, provoked further Jewish assaults upon the Greek minorities in other Samaritan and Syrian cities, including Sebaste, Philadelphia, and Scythopolis.

With virtually the entire province of Judea collapsing around him, Cestius Gallus finally bestirred himself to action. (Or, in Joseph's trenchant phrase, "Hereupon Cestius thought fit no longer to lie still.") At his headquarters in Antioch, the governor assembled one full legion (the XXII), along with detachments from the other three legions under his command and several thousand cavalry, archers, and infantry supplied by Agrippa II and his fellow client kings in the region, and led them all southward toward Jerusalem. Gallus overran Galilee without much trouble; a majority of the population there appears to have remained loyal to Rome, despite Gallus' policy of deliberately burning and pillaging as he went.

Through most of Judea, too, the resistance to Gallus' advance was notable by its absence; though civil strife was widespread, active popular support for the rebellion was still centered primarily in Jerusalem. The Roman columns reached the outskirts of Jerusalem late in

October. Upon learning from sympathizers within the city that the rebels had abandoned the so-called New City (the northern part of Jerusalem) and withdrawn behind the Antonia fortress and the stout Second Wall, just south of the execution site of Golgotha, Gallus made a few half-hearted and unsuccessful forays to capture their strongholds. Then he suddenly gave up, turned around, and headed back toward the coast, probably because he had met more resistance than he expected and had no desire to subject his troops to a prolonged wintertime siege of the city.

This, however, turned out to be a mistake of major proportions. As the imperial troops retreated through the narrow valleys and steep defiles outside Jerusalem, rebel guerillas constantly sniped at their flanks and rear guard, inflicting severe casualties. (The Romans, observed Joseph drily, "were galled all the way, and their ranks were put into disorder.") To speed the pace of the by now desperate retreat, Gallus ordered most of the supply mules slain, but this barely helped. In the rocky canyons outside Beth-Horon, about a dozen miles outside Jerusalem, the legions' discipline finally broke under a deadly rain of missiles from the hilltops, and their ranks were massacred in one of the worst routs the Roman army had suffered since the Varian disaster in Germany. By the time Gallus finally led the straggling survivors back to Caesarea Maritima, he had lost nearly six thousand men.

To the Jews in Jerusalem, this dramatic victory provided incontrovertible evidence of God's favor. The provisional government—now led by the moderate (under the circumstances) Ananias II, the former High Priest who had ordered the execution of James the Just, several years earlier—issued coins that read The Freedom of Zion, and Jerusalem Is Holy. From that moment on, the conciliatory elements in the city lost all hope of preventing a full-scale rebellion—and the inevitable Roman reprisal. "Many of the most eminent of the Jews," observed Joseph, "swam away from the city, as from a ship when it was going to sink."

Nero was singing and playing his way through the theaters of Greece, in the midst of another cross-country artistic and dramatic competition, when he received word of the rebellion in Judea. The obvious civilian changes were easy enough to make: the emperor quickly recalled the discredited administrators, Florus and Gallus (who killed himself shortly thereafter), and appointed a new governor of Syria, Gaius Licinius Mucianus. More difficult was the choice of a

military commander to quell the insurrection—not because of any shortage of qualified officers, but because Nero, like all his predecessors, was deathly afraid that a general of senatorial rank, with the strength of four or more battle-hardened legions under his command and the prestige that would inevitably accrue from the suppression of the Jewish rebellion, might be tempted to essay a coup. Already the emperor was preparing to force Cnaeus Domitius Corbulo, the hero of the Parthian war, to commit suicide. So Nero was looking for an experienced general of proven ability but no lofty aristocratic qualifications for supreme power.

He found just such a man—or so he thought—in Titus Flavius Vespasianus. Thus far, the conquest of Britain had marked the zenith of Vespasian's career. Although he had subsequently served as consul (in 51) and governor of Africa, no further promotions had been forthcoming; over the following decade, Vespasian's fortunes took a nosedive until he fell heavily into debt and was forced to support himself by going into the mule-selling business. Recalled to court in the mid-60s, he had earned Nero's enmity on one of the emperor's cultural tours by falling asleep while Nero was singing. But this indiscretion was forgiven in the wake of the emergency in Judea. In February 67, Vespasian received his appointment as governor of Judea and commander of the Roman forces in that province; much to the consternation of Mucianus, Nero made Vespasian's command wholly independent of the administration of Syria.

Vespasian sailed at once for Antioch, where he was welcomed by Agrippa II. Taking two legions (V and X) from the capital, along with another contingent of Agrippa's troops, Vespasian marched down to Ptolemais Ace, where his son, Titus, met him with Legion XV, which had just come across from Alexandria in a spell of unseasonably calm early spring weather. Combined with the auxiliaries that continued to flow in from nearby client kings, Vespasian possessed a force of nearly sixty thousand fighting men. He thereupon proceeded to the loyalist stronghold of Neronias (formerly known as Sepphoris), the largest city in Galilee, to take stock of the situation.

Meanwhile, the Jewish government in Jerusalem had dispatched commanders to the surrounding territories to try to drum up support for the rebellion and organize resistance to the Romans. Possibly because of his family connections with the Maccabees—the freedom fighters of an earlier century, whose dynasty had always been popular in Galilee—Joseph ben Mattathias received the task of representing

the provisional government in that habitually turbulent northern region, where there were presently more quarreling factions than one could reasonably be expected to count.

Joseph spent the first few months of 67 drilling the irregular troops under his command, trying to weld them into a reasonable facsimile of a disciplined fighting force on the Roman model, which Joseph, like many sophisticated provincials, admired so greatly. By his own account, he taught his men how "to give the signals one to another, and to call and recall the soldiers by the trumpets, how to expand the wings of an army, and make them wheel about, and when one wing hath had success, to turn again and assist those that were hard set, and to join in the defence of what had most suffered." And above all, Joseph continued, he "exercised them for war, by declaring to them distinctly the good order of the Romans, and that they were to fight with men who, both by the strength of their bodies and courage of their souls, had conquered in a manner the whole habitable earth."

Fortified by this cheerful prospect, the Jewish troops under Joseph's command marched out to meet Vespasian. The mere sight of the Roman columns on their way out of Sepphoris so unnerved the rebels, however, that most of them immediately took to their heels. Bereft of his army, Joseph admittedly "despaired of the success of the whole war, and determined to get as far as he possibly could out of danger," retreating with a handful of supporters to Tiberias, and thence to Jotapata (Jefat). But Vespasian followed relentlessly, and soon had besieged Jotapata. Joseph clearly wished to surrender, but a core of diehard rebels obdurately refused to let their commander out of the city. In the end, Joseph escaped by reneging on a suicide pact, and when Jotapata fell after a siege of forty-seven days, the Romans tracked him down and conveyed him to Vespasian's headquarters. There Joseph struck up a friendship with Titus, who was about the same age, and displayed to Vespasian a disarming eagerness to collaborate with the Romans. Doubtless Vespasian thought that Joseph, as the provisional government's representative in Galilee, possessed more influence with his coreligionists than he really did; in fact, he had very little, as subsequent events would prove. But Joseph clinched the deal by telling the general that he (Vespasian) was destined to succeed Nero as emperor, thereby fulfilling the ancient Jewish prophecy that the ruler of the entire world would arise out of Judea. As a mark of his gratitude for this revelation, the Roman general

showered Joseph with gifts of clothes and jewels and began treating him more as an ally than an enemy.

Vespasian spent the rest of 67 reducing every rebel-held fortified city in Galilee, his task simplified tremendously by the excellent network of roads that the Romans had constructed over the past six decades. By the end of the year, the Romans had recovered control of Galilee, Samaria, and the coastline west of Judea. Then, in the spring of 68, Vespasian resumed his relentless advance through the east and south, conquering Perea, Idumea, and virtually every city in Judea—and almost certainly the settlement at Qumran—except for Jerusalem and the virtually impregnable fortresses of Machaerus and Masada. Refugees from the ravaged countryside streamed into the holy city, exacerbating an already tense situation, as the rebels watched the Roman vise tighten inexorably around them. Then, in July 68, the entire campaign ground to a halt. News had come from Rome that Nero was dead.

The Games

Rome and the Provinces, 66–70 C.E.

> Come, pull yourself together.
>
> —NERO, IMMEDIATELY BEFORE HIS SUICIDE

Nero really had only himself to blame. The Piso conspiracy of 65 had revealed to the emperor just how deeply alienated from his regime the senatorial class had become. Worse, the army had wavered in the crisis, however briefly. So Nero panicked and, as was his wont, struck out wildly at real and imagined enemies everywhere. In 66, several prominent conservative senators were either executed or compelled to commit suicide, thereby widening the already gaping rift between the aristocracy and Nero's regime. Then Nero summoned Corbulo back from the East and ordered him, too, to kill himself; upon receiving the suicide order at Cenchreae, just across the straits from Corinth, the distinguished general's rueful comment was, *"Axios!"*—Greek for "It serves me right"—for obeying Caesar instead of launching a revolt with the backing of the eastern legions. Worst of all, in the following year Nero recalled the commanders of the legions in Upper and Lower Germany, a pair of brothers named Scribonius Rufus and Scribonius Proculus, and commanded them to commit suicide as well.

Nero dispatched all these orders while traveling through Greece, starring in his own unique version of the Olympic Games. (All the while, the freedman whom Nero had left in charge at Rome kept

trying frantically to convince him to return, to quell the rising tide of discontent, but the emperor blithely refused, saying, "You ought to be encouraging me instead and hoping to see me return worthy of Nero.") Unlike the games of ancient Greece, these Olympic-Neronian contests included singing and recitation as well as athletics, the better to display the emperor's musical abilities. Despite a few minor mishaps, such as falling out of the chariot he was driving, Nero won first prize in virtually every competition (actually, the obsequious Greeks offered him all the blue ribbons before the games even began), and returned to Rome with a total of one thousand eight hundred and eight victory crowns. Nero's triumphal entry into the capital early in 68 was meticulously staged to reflect his belief—by now an obsession—that he had elevated Art to the same level of prominence and power as political and military affairs. Dressed in a star-spangled purple cloak to symbolize the heavens, with an Olympic crown perched atop his head, the emperor rode in Augustus' own chariot through a specially carved opening in the Circus Maximus, while flocks of birds were released into the air, saffron sprinkled on the ground in his path, and sacrifices offered to the gods. With an escort preceding him to proclaim his victories, and a phalanx of applauding sycophants and soldiers following behind, Nero proceeded across the Forum to the Temple of Apollo on the Palatine Hill, where he descended from his chariot and gathered his prize crowns and the victory statues of himself dressed as a zither-player, and placed them all in his bedrooms.

He paused in Rome only long enough to catch his breath. In March 68, Nero left the capital for the friendlier confines of Naples, only to be greeted by the news that Gaius Julius Vindex, the native-born governor of Gallia Ludunensis (Gaul), had risen in rebellion against his regime.

Here was the inescapable reaction to Nero's rash executions of so many eminent senators and military and provincial officials. Despite the fact that the empire as a whole was enjoying a period of relative prosperity, the Neronian regime had forfeited the loyalty of the governing classes through its perverse habit of repaying success with orders of self-execution. In launching his revolt, a relatively modest affair at the start, Vindex ignited a chain reaction that eventually swept through the entire empire, culminating in a civil war that lasted for more than eighteen months before peace and stability were finally restored.

Because he possessed no legions of his own, Vindex appealed for support to Servius Serpicius Galba, the governor of Spain (Hispania Tarraconensis). Galba, a wealthy seventy-one-year-old senator of stern, inflexible demeanor, with a bald head and an aristocratic heritage that went far back through countless generations of republicans, decided to join Vindex because he wanted to restore the principate to its days of virtue and glory under Augustus. Besides, the straitlaced Galba's relations with Nero had never been cordial; Nero had packed the old man off to Spain mostly to get him out of Rome, and had recently dispatched several minor officials to that far-away province to uncover evidence of malfeasance in his administration. This, Galba knew, presaged bad news. So he joined forces with Vindex after less than a month's hesitation, and subsequently persuaded his gubernatorial colleague in Lusitania (Portugal), one Marcus Salvius Otho, to throw in his lot with the rebels as well.

Nero received the news of Vindex's revolt with remarkable calm; in fact, he refused to let it interrupt his enjoyment of an athletic exhibition in the gymnasium at Naples, and it took a full eight days before he deigned to take any countermeasures at all. In fact, Nero professed to be more upset by Vindex's reported taunt that he was nothing but a second-rate zither player than by any threat to his throne; probably Nero realized that the overwhelming majority of the legions were still loyal. But even had they not been, Nero had convinced himself by this time that the realities of military power had become outmoded in the new age of artistic government which he had inaugurated. Hence even after he returned to Rome at the behest of his anxious advisers, the emperor spent most of his time inspecting new designs for water-organs instead of organizing resistance to the rebels.

Galba's defection, however, was a far more serious affair. The disquieting reports from Hispania threw Nero into a dead faint, followed by a brief bout of depression in which he apparently entertained thoughts of abdication. Then, displaying a virulent form of paranoia, which was now approaching the edge of psychosis, Nero actively considered executing every army commander and provincial governor in the empire, on the grounds that they were all united in a single conspiracy against him. When his advisers persuaded him that this was not a viable solution (nor was his equally fantastic suggestion that the entire Senate be poisoned at a banquet), the emperor agreed to travel to Gaul in person to confront the mutinous

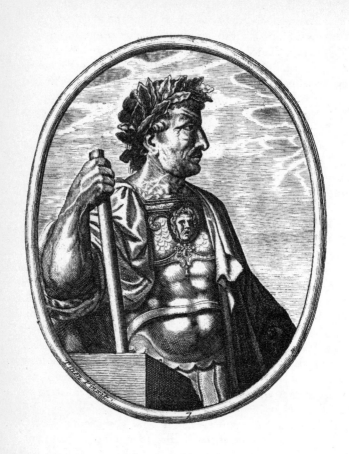

Galba

troops. He would stand in front of them unarmed, Nero said, "and weep and weep." This, he thought, "would soften their hearts and win them back to loyalty; and on the next day he would stroll among his joyful troops singing paens of victory, which he really ought to be composing now."

Fortunately for Nero, this expedient turned out to be unnecessary, because Vindex was defeated in May by the army of Upper Germany, which for the time being remained loyal to the emperor. In Hispania, Galba went into a deep funk and briefly pondered the merits of suicide, but then brightened considerably when emissaries from the Senate assured him that he still enjoyed their support against Nero. Meanwhile, one of the Praetorian prefects, Nymphidius Sabinus—who had concluded that he could no longer trust the whims of a clearly unbalanced emperor—joined the insurrection and began transmitting to Nero, on a daily basis, false reports of deteriorating conditions in the provinces, thereby aggravating the emperor's already morbidly suspicious and depressed state of mind.

In the first week of June, Nymphidius convinced Nero to flee Rome for his own safety. Apparently the emperor entertained thoughts of sailing to Egypt or the East, where he could continue the fight. Working in close cooperation with the Praetorian prefect, the Senate declared Nero a public enemy and, in the emperor's absence, sentenced him to be flogged, naked, with rods until he was dead. In the end, even the Praetorians themselves abandoned Nero; reports of the emperor's flight and the Senate's condemnation, combined with the promise of a sizable cash bonus, persuaded the Guards to acclaim Galba emperor.

Scurrying helter-skelter through the suburbs of Rome, barefoot and in a ragged cloak torn by thorns, bereft of his bodyguard, Nero stopped to rest on the evening of June 9 at the villa of one of his freedmen. While he bemoaned his humiliating fate and his own cowardice—"How ugly and vulgar my life has become," he muttered, and, in Greek, "This is certainly no credit to Nero, no credit at all!"—he heard the sound of hoofbeats from a troop of cavalry coming up the road to capture him. Sobbing, "What a loss I shall be to the arts," the emperor stabbed himself in the throat with the assistance of his secretary, and expired.

Nero's undignified demise marked the extinction of the Julio-Claudian dynasty. For the first time, Rome welcomed an emperor who was not a direct descendant, by blood or adoption, of Augustus Cae-

sar, though it was true that Augustus had personally known and approved of Galba as a young man (which only emphasized how old Galba really was). Later, Tacitus claimed that Galba's accession proved that an emperor could be made outside of Rome, but this was not quite accurate; without the active support of the Praetorian prefect Nymphidius and the Senate—which was not blind to the fact that Galba was not yet in Rome, while it was—Galba might have experienced considerable difficulty in obtaining the throne.

He had enough trouble as it was. As Nero's regime passed through its convulsive death throes, Galba and Otho and their legions remained in Hispania, awaiting the outcome of developments in Rome. As they now made their way slowly across the continent, executing political opponents as they went, Nymphidius' ambition got the better of him and he attempted to usurp power himself; but the notion of a freedman (the son of a gladiator and an ex-prostitute) on the throne proved too much even for the Praetorians, who promptly slew their commander. The Guards were in a nasty mood anyway, because they had not yet received the bonus Nymphidius had promised them in Galba's name. Nor were they particularly looking forward to service under Galba, who enjoyed a well-deserved reputation for strict discipline verging on brutality, much unlike the lackadaisical Nero, and a miserliness that masqueraded as fiscal responsibility (again, unlike Nero). Reports that the haughty Galba had refused to grant the legions their customary bonus upon his accession—"I select my troops," he allegedly huffed, "I don't buy them"— did not enhance his reputation among the rank and file. By the time Galba finally arrived in Rome, Nero's posthumous reputation was already enjoying a considerable measure of rehabilitation.

As the candidate of the reactionary senatorial party, Galba soon proved that his faction was completely bankrupt of any constructive ideas or programs, and was no more capable of governing the empire in an era of bewildering social and political changes—which it understood dimly, if at all—than the Confucian ideologue Wang Mang had been in first-century China. The clock simply could not be turned back to the age of Augustus; no longer could the aristocracy rule by the sort of divine right it had enjoyed in the halcyon days of the Republic. And Galba was quite the wrong man at the wrong time anyway. The Roman plebs, who retained a certain affection for the dramatic flamboyance of the late emperor, sneered at Galba's advanced age and unfashionable appearance. The populace likewise

complained of the rapacity of the emperor's closest advisers, a corrupt and incompetent trio who managed the neat trick of making the new administration thoroughly unpopular throughout the capital within the space of six short months.

Trouble was not long in coming. On January 1 of the fateful year of 69, two of the three legions of Upper Germany refused to swear the traditional New Year's oath of allegiance to the emperor. These were the troops that had put down the revolt of Vindex the previous spring. But Galba had subsequently removed their commander, Verginius Rufus, even though Rufus had swung his legions to Galba's side, much against their will, after the death of Nero. Galba's ungenerous treatment of their former commander, plus the loss of the expected monetary rewards from the suppression of the Gallic revolt (Galba had, after all, been on the same side as the rebellious Vindex), left the German legions angry and frustrated. For the moment their mutiny took on a purely negative character, insisting only that Galba be given the boot while leaving the choice of a replacement to the Senate or the Praetorian Guard.

Farther down the Rhine, however, the legions of Lower Germany were not so circumspect. On January 2, these troops acclaimed their own commander, Aulus Vitellius, as emperor of Rome. Vitellius seems not to have actively sought this honor; in fact, he had only been posted to the Rhine a month or two earlier, by Galba himself. He merely happened to be in an opportune place at a time when the individual legions of the Roman army were beginning to slide back into the habit of attaching themselves to their own particular generals, and not to the central authority in Rome. In a hundred years, the empire at last had come full circle, for this was precisely the chaotic state of affairs Augustus had sought to avoid by establishing the principate in the first place. Yet there was one crucial difference: in the year 69, there was no talk in responsible quarters about restoring the Republic. The question was not whether the principate would survive, but rather who would inherit the mantle of Augustus.

Even more pressing, at least for Galba, was the question of designating a successor for himself. Since Galba himself was childless, there was no clear-cut choice for the succession, a state of affairs that was responsible for much of the instability that marked his brief reign. To end the suspense, Galba formally adopted a handsome young nobleman named Lucius Calpurnius Piso Licianus in a ceremony held, significantly, in the Praetorian barracks on the stormy and

overcast day of January 10, almost within hours after news of the German defections had reached Rome. Lucius Calpurnius Piso was a senator of unimpeachable character, precisely the sort of man who would appeal to Galba; alas, he was also excruciatingly dull and possessed no discernible qualifications for the throne. Ominously, the announcement by Galba failed to elicit any noticeable enthusiasm from the silent and brooding Praetorians, who were still waiting for their money.

Still less did the disgruntled Otho appreciate Galba's selection. Thirty-six years old in January of 69, Otho was a member of one of the "new" families, recently elevated to the aristocracy, who owed their advancement to the increased social mobility wrought by the principate. In his youth, Otho had been a boon companion of Nero, a member of that merry roving band of reprobates who had rolled drunks in their nightly revels through the streets of Rome. Presumably at the behest of Nero, Otho had stolen Poppea Sabina from her husband so the emperor could make love to her; but then Otho, rather inconveniently, fell in love with her himself. Nero, who would brook no competition for Poppea's generous charms, seems to have wanted to kill his amorous comrade on the spot, but Seneca persuaded the emperor to appoint Otho governor of Lusitania instead, which took him about as far away from the capital as one could get. During his ten-year stint in the west, Otho surprised everyone by maturing into a responsible and conscientious administrator. Still, he could not shake his reputation as a dandy—Juvenal called him "that fag of an emperor"—partly because, as Suetonius put it, Otho was "almost as fastidious about appearances as a woman." He allegedly had plucked practically every hair from his body, and always wore a well-crafted wig over his shaved head; every day he applied a poultice of bread soaked in water or milk to discourage the growth of his beard. The image of Otho in the field, at the head of a legion, struck Juvenal as hysterically funny.

> To polish off a rival and keep your complexion fresh
> Demands consummate generalship; to camp in palatial
> splendour
> On the field of battle, and give yourself a face-lack
> Argues true courage. No Eastern warrior-queen,
> Not Cleopatra herself aboard that unlucky flagship
> Behaved in such a fashion.

Otho

But now Otho had got himself into a bind. He had joined Galba's revolt in hopes of succeeding the old man, and had run up a considerable mountain of debt in the process. Double-crossed by the emperor, he plotted his revenge; and Otho's resolve, observed Tacitus wisely, "was not as flabby as his physical condition." Unlike Galba, Otho understood that the key to power in mid-first-century Rome lay with the Praetorians and the legions, and not with the aristocratic civilian cliques in the Senate, which is why Otho had assiduously cultivated the allegiance of the military ever since leaving Lusitania. Hence, as Rome received more reports of the German armies' crumbling loyalty, the troops in the city needed little encouragement to desert Galba's rapidly rotting regime.

On January 15, while Galba was offering a sacrifice at the Temple of Apollo, Otho sneaked away to the Praetorian camp. Although Otho's bodyguard initially numbered only twenty-three members of the Guard (Tacitus was probably right when he wrote that "Otho was appalled that they were so few in number"), the momentum of rebellion carried the majority—who were at least neutral if not outright hostile to Galba—along in Otho's favor, and the Praetorians accordingly saluted him as emperor. Only the distasteful task of disposing of Galba remained. Later that day, the frail old man was cut down by Otho's vanguard as he was being carried in a sedan chair through the city; someone later claimed that Galba's dying words were, "Why? What harm have I done?" His body was sliced into pieces and left to rot, along with the corpses of Piso and several of their intimate advisers, while the assassins cut off his head, impaled it on a stake, and carried it in a triumphant military procession alongside the legionary eagle. When Otho was conveyed across the Forum en route to the Capitol to receive the grant of imperial powers from the Senate, the blood of his predecessor still stained the ground beneath his feet.

Although he was really nothing more than an adventurer and a regicide, Otho might have provided the empire with a reasonably stable and competent administration had not the German legions already begun their march toward Rome, determined to elevate Vitellius to the throne. Otho clearly assumed that these troops would turn around and go home once they learned that Galba was dead; instead, they ignored his envoys and kept moving southward in two columns, through Gaul and Rhaetia, enjoying the occasional sack of a town as they went. Vitellius and Otho then spent the next few weeks attempting to assassinate each other, evidently with no success. Since

his adversary refused to retire, Otho frantically endeavored to consolidate his base of support in Rome, but at this point he must have discovered to his dismay that, unlike Galba—who at least had a senatorial faction behind him—there was virtually no one but the Praetorian bodyguard in his camp. Eight months of chaos, however, had done wonders for Nero's posthumous reputation, and so Otho deliberately chose to emphasize his ties with the last member of the Julio-Claudian dynasty, adding the name Nero to his own, restoring statues of the late emperor throughout the capital, and reinstating many of Nero's appointees to his own administration.

Too late Otho realized that nothing would stop the German legions but superior military force. Unfortunately, the only troops at Otho's command were the Praetorian Guard—most of whom had very little combat experience—and a motley assortment of regular units that happened to be stationed in and around the capital at the time. While this hastily assembled army was given a crash training course, Otho drafted two thousand gladiators as an auxilliary force; but this desperate act earned him so much enmity from the civilian population, which was becoming increasingly obsessed by the fear of a slave revolt, that it was almost counterproductive. Then at last good news came from the Balkans, where the veteran legions on the Danube—jealous of their comrades on the Rhine—had swung around to Otho, and were beginning the long march to Rome.

Now it became a race to the capital. Disregarding the late winter snows, Vitellius' troops (about seventy thousand strong) forced their way through what is now the Great St. Bernard pass and crossed the Alps before Otho—uncharacteristically unshaven and unkempt, marching on foot with his troops—could block the approaches. Otho's forces, perhaps twenty-seven thousand men in all, subsequently took up a defensive line along the Po River. By the second week in April they were reinforced by the vanguard of the Danube garrisons. Otho's generals, including Suetonius Paulinus, the conqueror of Boudicca, advised him to await the arrival of the remainder of the Balkan legions, which promised to add another fifty thousand veteran reinforcements to his cause, but Otho feared that any significant delay might cause the morale of his present troops to disintegrate.

Twenty miles east of Cremona, near a place called Bedriacum, the two armies clashed amid considerable confusion. In the tumult of battle, of course, it was hard to tell one legion from another, and the

field was repeatedly swept by rumors of desertion on both sides. The fight was finally decided by the arrival of fresh reserves from Vitellius' camp at a critical moment, thrown first against the wing and then the center of Otho's line. Although his Praetorian commanders urged him to continue the fight, Otho—his nerves shattered—decided to withdraw. He had never wanted to provoke a civil war in the first place and now he had no wish to prolong one; consoling himself with thoughts of eternal bliss promised by the Egyptian goddess Isis, whom he worshipped (perhaps as a legacy of his brief life with Poppea), Otho committed suicide.

On April 19, 69, the Senate acclaimed Aulus Vitellius emperor. But Vitellius proved an even more unfortunate choice than Otho. From his father, Lucius Vitellius, who had served as governor of Syria and the confidante of Claudius, Aulus inherited a positive genius for expediency. Aulus himself had oozed his way through the reigns of Tiberius, Caligula, Claudius, and Nero, cheerfully encouraging each emperor in the vice of his choice (sex, racing, gambling, and theatrics, respectively); he had recently gained an especially unsavory reputation as one of Nero's most unctuous senatorial sycophants. In November of 68, Galba had sent him to Germany to replace Verginius Rufus, largely because Vitellius seemed to be the most innocuous candidate available, with practically no experience of military command. But the rising tide of discontent among the German legions had borne Vitellius along willy-nilly, all the way to Rome and the imperial throne.

At the very start of his reign, Vitellius executed a few of the most prominent Othonian centurions, and replaced the entire Praetorian Guard with men from his own German legions; from that point on, however, he made a concerted effort to foster at least the impression of clemency. Most of the time, Vitellius' own nasty streak of cruelty was hidden by a bluff, coarse good humor and an indolence that had become legendary in Rome. Fifty-four years of sybaritic life, mostly in the capital, had bestowed upon the latest emperor a ruddy complexion and an immense stomach. Indeed, overeating was Vitellius' avocation. One might have thought that his primary interest in the principate lay in the opportunities it afforded for inviting himself out to dine at his subjects' houses, at their expense. It was during Vitellius' brief reign that the Roman trend toward gastronomic excess reached its zenith, stimulated by the famous banquet, featuring seven thousand game birds and two thousand fish, that Vitellius' brother spon-

Vitellius

sored to celebrate the emperor's triumphant entry into the capital. In those days, many Roman dishes possessed a distinctive sweet-and-sour flavor, resulting from the abundant use of fruit, honey, and vinegar in the kitchen. Among the favorite entrees of the age was a delicacy known as Numidian chicken, prepared from a recipe in the Cookbook of Apicius:

> Clean the chicken, poach it, and then remove it from the water. Sprinkle with assafoetida and pepper, and broil it. Grind together pepper, cumin, coriander seed, assafoetida root, rue, dates, and nuts. Pour over these vinegar, honey, liquamen [a sort of broth, or fish sauce], and olive oil. Stir. When it boils, add starch as a binder. Pour this mixture over the chicken. Sprinkle with pepper and serve.

Of course this concoction, however appetizing it might sound, was much too plebeian for Vitellius' tastes. He preferred instead the sort of luxurious dish he named Shield of Minerva the Protectress of the City, an intriguing combination of such delicacies as pheasant brains, pike livers, peacock brains, flamingo tongues, and lamprey milt.

Even Claudius' hard-earned reputation as an insatiable snacker paled beside that of Vitellius. "While a sacrifice was in progress," noted Suetonius, "he [Vitellius] thought nothing of snatching limbs of meat or cake off the altar, almost out of the sacred fire, and bolting them down; and on his travels would devour cuts of meat fetched smoking hot from wayside cookshops, and even yesterday's half-eaten scraps." Not only did Vitellius' subordinates have to pay for his meals, they had to keep pace with his intake. One of the emperor's friends, Quintus Vibius Crispus, once excused himself from a particularly grueling session by pleading sickness; "If I had not fallen ill," he later confessed to a friend, "I should have died."

But an unparalleled talent for gluttony hardly qualified a man to be *princeps*. Like Otho, Vitellius attempted to build a base of support by currying favor with the former supporters of Nero; yet an odd, uneasy feeling of anticipation still hung over Rome, as if everyone was waiting for the other sandal to drop. They had not long to wait. In the autumn of 69, Vitellius found himself confronting the same peril as Otho six months earlier, because the legions of Egypt, Syria, and Judea had hailed Vespasian as emperor in July; they were soon joined in rebellion by the Danubian armies, still smarting from their

springtime defeat at the hands of Vitellius' German legions at Cremona.

Ever since the death of Nero, Vespasian had behaved with his usual cautious watchfulness, pledging his loyalty to each emperor in turn while patiently biding his time. Following Galba's assassination, however, he began to conspire with Gaius Licinius Mucianus, the erudite and wily governor of Syria, and the prefect of Egypt, the apostate Jew Tiberius Julius Alexander, to seize the throne. While the campaign against the rebellious Jews in Jerusalem was permitted to hang fire for nearly two full years, Vespasian left his son, Titus, in charge of affairs in Judea and traveled to Alexandria, where he hoped to use the threat of a grain embargo to pry Vitellius out of power. The delicate negotiations in the capital were left in the capable hands of Vespasian's eminent if somewhat pompous older brother, Sabinus, whom Galba had appointed city prefect.

Mucianus had just begun to lead a contingent of the eastern legions toward Rome when everyone—not least of all Vespasian and Vitellius—was stunned to hear that the commander of Legion VII in Pannonia, a Gaul named Marcus Antonius Primus (known to his friends as "Beaky"), who had been convicted of forgery during Nero's reign, was racing westward with his troops to seize the throne in the name of Vespasian. Vitellius, lethargic as ever, failed to respond in time. By the time he bestirred himself, Primus had nearly reached the Po River.

Observing the handwriting on the wall, one of Vitellius' two commanding generals deserted to Vespasian; the other was too ill to take charge in the crisis. Nevertheless, Vitellius managed to pull together four whole legions and parts of another seven for the climactic confrontation with Primus, who meanwhile had gathered five legions—mostly from the Danube, but also including Galba's troops and assorted auxiliaries and former Praetorians (the ones Vitellius had canned). By coincidence (or bad planning), the armies again met just outside of Cremona. Because the battle continued into the evening and all through the night, there was even more confusion than usual, with the ranks of combatants barely distinguishable in the darkness. It was an odd sort of fight; both sides alternated between savage hand-to-hand conflict and fraternizing with their foes. Dio Cassius painted a memorable portrait of the almost surrealistic battlefield scene:

Though tired out and for that reason often resting and engaging in conversation together, they nevertheless continued to struggle. As often as the moon shone out (it was constantly being concealed by numerous clouds of all shapes that kept passing in front of it), one might have seen them sometimes fighting, sometimes standing and leaning on their spears or even sitting down. . . .

When the women of the city [Cremona] in the course of the night brought food and drink to give to the soldiers of Vitellius, the latter, after eating and drinking themselves, passed the supplies on to their antagonists. One of them would call out the name of his adversary (for they practically all knew one another and were well acquainted) and would say: "Comrade, take and eat this; I give you, not a sword, but bread. Take and eat this; I hold out to you, not a shield, but a cup." . . . That would be their style of conversation, after which they would rest a while, eat a bit, and then renew the battle. . . . It went on this way the whole night through till dawn broke.

As the sun rose, Primus finally succeeded in breaking the Vitellian lines and scattering the emperor's army. After ravaging the unlucky city of Cremona for four full days, the main body of the Danube legions headed straight for Rome. Outside the capital, they paused to await the outcome of the talks between Vitellius and Sabinus over a peaceful abdication and transfer of power. But the emperor's rabid supporters—doubtless fearing they would be executed if Vespasian assumed power—disrupted the negotiations and forced Sabinus, accompanied by Vespasian's younger son, Domitian, to take refuge in the Capitol. That night, Sabinus sent a message to Primus instructing him to resume his advance; the following day, an angry pro-Vitellian mob stormed the Capitol and set the Temple of Jupiter ablaze. Sabinus was executed, though Domitian managed to escape.

One day later, on December 20, the Danubian legions entered Rome in three columns and, overcoming bitter resistance from the remnants of Vitellius' forces, managed to secure the city. Vitellius himself was dragged from his hiding place by the legionaries, his hands bound behind him, and a noose placed round his neck. Half-naked, his robe torn into shreds, he was pulled through the city streets to the Forum, the place where Galba had been slain. There the emperor was tortured with repeated sword cuts until the soldiers tired of the game and finally killed him. In what had become a depressingly familiar ceremony for the corpses of traitors, the gloating troops

threw Vitellius' body down the Stairs of Mourning and then dragged it by a hook to the Tiber, and dumped it into the river.

As the old tired year came to a close, a tumultuous twelve months that subsequently became known as the Year of the Four Caesars, a weary Senate awarded the powers of Augustus to Vespasian.

The Siege

Jerusalem and Masada, 70–73 C.E.

> Thou foolish woman, why dost thou weep?
> Seest thou not the mourning of Zion, our Mother?
> For thou seest how our sanctuary is laid waste,
> Our altar thrown down, our Temple destroyed
>
> —Book of Ezra IV

I n the spring of the year 70, as Vespasian prepared to sail from Alexandria to Rome, Titus—the new emperor's eldest son—arrived outside the walls of Jerusalem with an army of four legions and assorted auxiliaries, about sixty-five thousand men in all. For nearly twenty-four months, the situation in Judea outside the holy city had remained essentially unchanged while the Roman high command's attention was focused on events in the imperial capital. But now it was time to bring the Jewish revolt to its inevitable conclusion.

Within Jerusalem, the rebel leaders had not spent the respite wisely. Instead of bolstering the city's defenses and stockpiling supplies for a lengthy siege, they had engaged in acrimonious wrangling and almost incessant sniping at one another. There were at least three mutually antagonistic factions in Jerusalem as the year 70 began. The first consisted of Zealots led by Eleazar (the son of Simon, a different person altogether from either of the previous two Eleazars), one of the principal heroes of the Beth-Horon massacre of the Roman legions. The second was made up mostly of Galileeans under the control of a wealthy and cunning Galileean nationalist known as John of Gis-

chala, who had fled his homeland during Vespasian's relentless ad-
vance three years earlier. And the third was commanded by Simon
ben Giora, a visionary freedom fighter from the desert lands of Idu-
mea, who sought to impose his own brand of social revolution on the
independence movement. During the previous twelve months, Elea-
zar and his Zealots—under the pressure of a ferocious assault from
John of Gischala—had taken refuge in the Temple sanctuary and the
inner courts, where they had barricaded themselves. John and the
Galileeans, who had recently adopted the odd practice of "plaiting
their hair and attiring themselves in women's apparel, drenching
themselves with perfumes and painting their eyelids to enhance their
beauty" before pulling their curved knives from beneath their cloaks
and stabbing their victims, had in turn been attacked by Simon's
Idumean forces, and were compelled to retreat to the outer courtyards
of the Temple. Simon therefore controlled most of the rest of the city,
but could dislodge neither John nor Eleazar.

As the Passover celebrations of the year 70 commenced, Eleazar
felt obliged to unlock the Temple sanctuary to permit worshippers to
make their traditional sacrifices. Not surprisingly, John took advan-
tage of this opening by infiltrating the ranks of the pilgrims with his
assassins; once inside, they drew their knives and commenced to
wreak havoc in the inner courts, drenching the altars in the blood of
both men and animals, until the outnumbered Zealots were forced to
flee to the subterranean passages below.

Titus, meanwhile, had made his headquarters about three-
fourths of a mile from the northwestern edge of the city; the rest of
the legions camped just east of the Mount of Olives. The Romans had
really only one viable plan of attack. Jerusalem was protected by three
walls, though the outermost, begun by Agrippa I, had not quite been
completed, and three primary strongholds—the Temple, the Antonia
fortress, and the palace of King Herod, with its trio of massive towers.
To pry the rebels out of the city, the Romans would have to start from
the north and reduce each section of Jerusalem in turn. This would
necessarily be a long and laborious business, but the overwhelming
numerical superiority of the Roman forces, accompanied by their
brutally efficient siege machines, meant that ultimate success was
virtually guaranteed.

Doubtless the same thought occurred to the Jews who stood on
the ramparts of the city watching the Roman columns approach; the
intimidating sight persuaded John and Simon to set aside their differ-

Coin of Vespasian with the inscription "JUDAEA CAPTA"

ences at least temporarily and establish an uneasy modus vivendi. But among the Jewish patriots and refugees within Jerusalem there remained the widespread conviction that God was on their side and would not permit the subjugation of Jerusalem; had He not miraculously halted the Roman advance in the summer of 68, just as Vespasian was preparing to besiege the holy city? More to the point, they sincerely believed that the Temple, the house of the living God, could *never* be destroyed so long as heaven and earth abided.

At the end of April the siege of Jerusalem commenced. Titus built platforms for his artillery, which then proceeded to pour missiles against the city walls, concentrating their fire at a weak spot in the wall just outside the hill known as Calvary, or Golgotha. The battering rams were brought up and put into action; during the occasional lulls, Titus sent his friend and collaborator Joseph, the renegade Jewish commander, to harangue the rebels with lengthy speeches outlining the hopelessness of their cause in the face of the assembled might of the Roman Empire. Both Joseph and the rams were met with rocks and shouts of defiance from the defenders. But after fifteen days, the outermost (third) wall was breached on May 7. Then, four days later, the second wall fell, too, though the first wave of Roman attackers who poured through the breach were beaten back by the Jewish militia.

At this point, Titus attempted to awe the rebels into submission by staging a four-day pay-parade, with his massive lines of troops assembled in full battle gear to receive their pay. This gambit met with a resounding lack of success, and so the siege resumed with the construction of four more artillery platforms aimed at the Antonia fortress and the Temple district. To provide wood for the siegeworks, Titus ordered the leveling of all the groves and orchards in a ten-mile radius around Jerusalem. "Truly the very view itself was a melancholy thing," observed Joseph; "for those places which were before adorned with trees and pleasant gardens, were now become a desolate country every way, and its trees were all cut down; nor could any foreigner that had formerly seen Judea and the most beautiful suburbs of the city, and now saw it as a desert, but lament and mourn sadly at so great a change, for the war had laid all the signs of beauty quite to waste."

Inside the holy city, the shortage of food had become critical. In normal times, the population of Jerusalem numbered about a hundred twenty thousand; but now, packed as it was with refugees, pilgrims,

and soldiers, there were probably four or five times that many. (Part of the Jewish Christian community, however, had apparently left Jerusalem in 68 for the more promising confines of the town of Pella on the east bank of the Jordan.) Those who were fortunate enough to obtain edible grain often failed to take time to grind it before wolfing it down; loaves of bread were snatched half-baked out of the oven. Roaming bands of vigilantes searched for hidden caches of provisions; when they came across a locked house, they broke down the doors on the assumption that the owners had found something to eat. Anyone who hoarded food was beaten or—in the case of women—had their hair chopped off as a warning to others. As the famine deepened, corpses of men, women, and children who had starved to death were thrown over the city wall into the ditch below; even Titus was appalled by the stench from the decomposing bodies.

Every day the gnawing hunger spawned hundreds of desertions, but the runaways found no mercy in the Roman camp. Instead, Titus ordered them tortured and then crucified in full view of the city walls, in another vain attempt to frighten the defenders into surrendering. All his stupid brutality accomplished, though, was to convince the rebels that they might as well die a hero's death fighting as meet a shameful end on the cross. According to Joseph, the defenders shouted down to Titus that they preferred death to slavery, and that "they would do all possible damage to the Romans while they had breath in them. . . . As for the Sanctuary, God had a better one in the world itself, but this one too would be saved by Him who dwelt in it."

Over the course of three days in July, the Romans encompassed the city with a wall of their own, to protect the artillery and cut off all chance of escape for the rebels. As they worked, the legionaries flaunted their abundant provisions in front of the starving garrison. In the streets of Jerusalem, meanwhile, bodies of the famished elderly lay scattered in heaps, and even the living walked about like shadows. Some of John's Galileeans broke into the storerooms of the Temple to steal the sacred wine and oil normally reserved for the sacrificial offerings to God. It made little difference; by this time, Titus had approached so close to the Temple that the daily sacrifice had to be abandoned, a tragedy for devout Jews everywhere.

Near the end of July, Titus captured the Antonia fortress.

Roman progress remained painfully slow, however, hampered by the legions' frustrating difficulty in fighting their way through the

city's narrow, winding passageways. Somehow the process had to be accelerated. And though Titus—whose mistress was Berenice, the sister of the Jewish monarch Agrippa II—appears to have genuinely regretted the military necessity of destroying the Temple, that is precisely what he decided he must do next.

First the Roman battering rams pounded on the thick Temple gates of cypress and silver for several days, to no apparent effect. Then the attackers set up ladders and tried to scale the colonnade walls, but the Jews easily threw them back. So Titus ordered the Temple doors set afire. The blaze burned steadily, and on the second day the desperate defenders emerged and launched a counterattack. In the ensuing melee, a Roman soldier thrust a torch through an open window and started a conflagration that, with the aid of more Roman firebrands, quickly spread through the interior of the Temple. Hundreds, perhaps thousands of Jews were burned to death in the ensuing holocaust; among the victims were the disciples of a self-proclaimed messiah who had all crowded together in one of the colonnades, apparently seeking divine deliverance from the impending catastrophe. As the sanctuary crumbled, the Roman troops plundered what they could carry and indiscriminately killed as many Jews as they could find. Then they set fire to the remaining outer sections of the Temple, until the whole magnificent edifice came crashing to the ground.

Thus was the holy house of God destroyed, and even Joseph mourned.

After offering sacrifices to the gods of Rome amid the smoldering rubble of the Temple, Titus cleaned up—with a notable absence of mercy—the remaining pockets of resistance in the Lower and Upper City. Then, in September, he turned his attention to the underground vaults where thousands of Jews, rebels and innocent civilians, had taken refuge. They were brought to the surface and herded together in a detention camp while Titus decided what to do with them; by this time, even the legions were weary of butchering Jews, though while Titus deliberated, several thousand of his prisoners died of starvation. John of Gischala surrendered at once; his haste won him his life. Simon ben Goria, who held out longer, was less fortunate. Taken to Rome and put on display as a sort of victory trophy, he was subsequently executed.

The siege of Jerusalem had lasted for a hundred and thirty-nine days. Although no one could ever obtain an accurate count of the casualties, at least several hundred thousand Jews had perished from

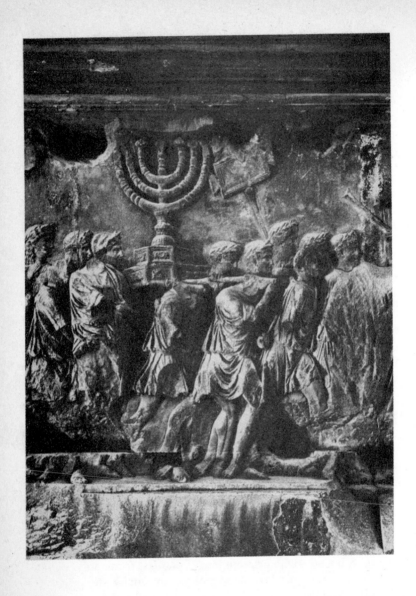

Jewish war captives carrying booty, including the menorah, from the
Temple (From the Arch of Titus, Rome)

hunger, disease, or wounds. When the survivors were rounded up, Titus executed the old and sick, along with those who had taken an active role in the fighting (informants helped the Romans identify these). The tallest and most handsome young men were shipped off to Rome to march in Titus' triumphal procession, along with several of the most precious Jewish relics salvaged from the Temple, including the seven-branched candelabrum known as the menorah. To commemorate the victory, the Senate built the Arch of Titus in the Roman Forum, with depictions of the sacred trophies inscribed on the massive stone. The rest of the able-bodied Jewish survivors were sent to Egypt in chains, as slaves; those who were left were either sold or presented as gifts to provincial officials, to serve as fodder for wild animals in gladiatorial shows. Titus himself kept several thousand prisoners for the celebration of his brother Domitian's birthday at Caesarea Maritima; according to Joseph, more than twenty-five hundred Jews perished on that awful day in the arena, or at the stake. Joseph, however, received for his services a gift of sacred books and a pardon for several hundred of his relatives and friends. He returned to Rome with Titus, became a Roman citizen, changed his name to Flavius Josephus, and received a pension from Vespasian for the rest of his life. In his later years he recorded the grim events of the fall of Jerusalem in his history *Wars of the Jews,* the only eyewitness account of the tragedy to survive the ravages of time.

Before he left Judea, Titus ordered the complete demolition of Jerusalem. All that remained of the holy city thereafter was a stretch of wall on the western side, to protect the local Roman garrison, and the three towers of Herod's palace. "Not its great antiquity," wrote Josephus, "nor its vast riches, nor the diffusion of its nation over all the habitable earth, nor the greatness of the veneration paid to it on a religious account, [had] been sufficient to preserve it from being destroyed."

A year or so later, the fortress of Machaerus—where Herod Antipas had imprisoned and executed John the Baptist—fell to the Romans. Now only Masada remained.

Dominating the desert wilderness on the eastern edge of the Dead Sea, perched high atop a mesa (approximately two thousand by one thousand feet) whose slopes ran almost straight down and disappeared into dizzying ravines ("There is nothing but destruction in case your feet slip," someone pointed out, rather unnecessarily), Masada presented an intriguing problem in siege warfare. Inside the Herodian

fortress, a band of nearly a thousand intransigent Jewish rebels, led by Eleazar ben Yair, a relative of the Menahem who had captured Masada back in 66, had amassed an abundant supply of water and food. Although Eleazar probably knew that he could not hope to hold out indefinitely against the legions that would inevitably be dispatched against him, he had decided to strike one last blow against the Romans, in hopes of avenging the destruction of Jerusalem.

In the year 73, the recently appointed Roman commander in Judea, Flavius Silva, arrived at Masada at the head of virtually the entire provincial army. After encircling the stronghold with a wall to keep the defenders from escaping, Silva discovered a broad, rocky promontory nearly five hundred feet below the ramparts. This outcropping provided the only chance he had—or needed. First the general directed his troops to pile dirt on the ledge until it reached a height of three hundred feet. Since this was not yet high enough for the artillery, Silva had massive stones laid upon the earthen platform, bringing it another seventy-five feet closer to the top. Then he brought up a ninety-foot-high ironclad tower, along with the siege machines, and hurled such a constant rain of missiles at the fortress walls that the defenders were unable to stand up long enough to retaliate. The battering rams came next; but after bludgeoning their way through the first wall, the Romans discovered a second wall, made of softer wood and compressed earth, which was so resilient that the rams hardly made a dent in it. So Silvus set it afire instead, and when a favorable shift in the prevailing winds sent the flames roaring through the barrier, Eleazar realized that the Romans would easily be able to pour through the gates the following day.

That night Eleazar gathered everyone together and suggested that they all commit suicide, to die an honorable death at their own hands instead of waiting for the Romans to butcher them. "Let our wives die before they are abused, and our children before they have tasted of slavery," Eleazar reportedly said, "and after we have slain them, let us bestow that glorious benefit upon one another mutually, and preserve ourselves in freedom, as an excellent funeral monument for us. . . . And let us spare nothing of our provisions, for they will be a testimonial when we are dead, that we were not subdued for want of necessities, but that, according to our original resolution, we have preferred death before slavery." At the end, Eleazar reminded his friends that their immortal souls would join one another once again, at the resurrection.

Each man slew his family first. Then the survivors killed one another, until only one man was left, and he fell upon his sword.

When the Romans approached the fortress the next morning, they were greeted by an eerie silence. Suspecting an ambush, they made their way cautiously through the gates, then through the rooms, one by one. All they found were corpses, and two women and five children who had hidden from the slaughter in an underground cavern.

PART FOUR

The Aftermath

The Raven

Rome, 81–98 C.E.

> There was a raven, strange to tell,
> Perched upon Jove's own gable, whence
> He tried to tell us "All is well!"—
> But had to use the future tense.
>
> —ANONYMOUS VERSE, FROM THE REIGN OF DOMITIAN

I n the autumn of the year 81, Domitian at last emerged from the shadow of Titus. He had always taken second place to his older brother, even in childhood. Titus had been fortunate enough to grow up while Vespasian's career was prospering, during the years of victorious service in Britain, and had enjoyed the comforts and professional contacts afforded the eldest son of a successful general; he had even been a close companion of Claudius' son, Britannicus (he was present at the dinner when Nero poisoned the prince), and participated in the revels at court during Nero's exuberant reign. On the other hand, Domitian, twelve years younger, had been born in 51, the year Vespasian served as consul. From that point on their father's career had gone straight downhill, until at last the impoverished family reportedly lacked even silverware for the dinner table, much less money for Domitian's education.

Domitian had enjoyed a brief moment in the spotlight at the end of 69, after the death of Vitellius, when he was the sole representative of the new imperial family in the capital. But Vespasian had brusquely shoved him aside upon his arrival in Rome, and when Titus

returned to Judea as the conqueror of the stubborn Jews, Domitian was once again relegated to the background. Titus—clearly the heir apparent—was named prefect of the Praetorian Guard, while Domitian had to be content with minor appointments; worse, he had to live at home with his father, who complained that the nineteen-year-old Domitian was always sticking his nose into official matters that were none of his business. (Once when Domitian had spent an especially busy day recommending his own candidates to various bureaucratic posts, an irritated Vespasian observed sourly, "I wonder he did not name my successor while he was about it!") Eager to obtain a military reputation of his own, Domitian planned an ambitious expedition into Germany and Gaul, only to have the enterprise quashed by the emperor himself—who did not quite trust Domitian in command of a substantial troop of legionaries—and by Vespasian's advisers, who were endeavoring to avoid all unnecessary expense in their struggle to restore some measure of political and fiscal stability to the principate.

Indeed, Vespasian found it necessary to dedicate much of his energies to the task of clearing away the debris left by half a decade of civil disorder. Sometimes he did this literally, as when he launched the campaign to restore the burned Capitol, where his brother Sabinus had perished, by loading the first basketful of rubble on his back and carrying it away himself.

One of Vespasian's first priorities, not surprisingly, was the restoration of rigorous military discipline, which had naturally grown slack in the chaos of civil war, when individual legions had nominated their own candidates for emperor; unlike all three of his immediate and short-lived predecessors, the old-fashioned, hard-nosed general knew how to earn and maintain the respect of his troops. To discourage any further notions of independent legionary action, Vespasian also disbanded the Rhine armies that had caused so much trouble in the past, replacing them with three new legions.

Because the old political order had been decimated by Nero's paranoia and the purges enacted by successive rival factions during the upheavals of 68–69, Vespasian undertook the task of reshaping the Senate in his own image, combing its ranks and kicking out the members he deemed undesirable. Like Claudius, who, along with Augustus, served as Vespasian's political role model, Vespasian replaced them with his own appointees, mostly knights from the small towns of Italy and the home provinces, who were more likely to share

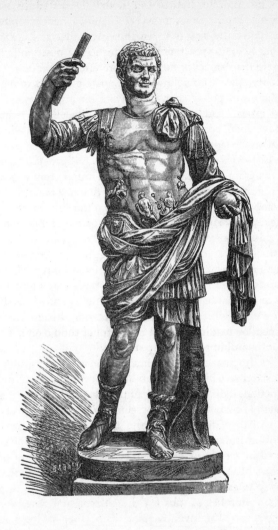

Domitian

his outlook on domestic affairs. And though he treated the assembly with the same formal deference that Claudius had exhibited, and honored prominent senators (even those who disagreed with him) with appointments to prestigious administrative positions, this was nothing more than an act of homage to an outdated republican tradition. In reality, Vespasian allowed the Senate even less of a share in the formulation of policy than had any of his predecessors.

For Vespasian had concluded, correctly, that Rome required an autocratic system of government; certainly the Senate as a whole, torn by internal dissension, was in no position to play any significant positive role. Vespasian adroitly managed to mitigate criticism of his absolutist program by maintaining a modest, unpretentious manner, by abstaining from the sort of treason trials that had marred the reigns of every emperor since Tiberius, and by returning to the original formula devised by Augustus for a *princeps,* as the first citizen among equals. Besides, the experience of the post-Neronian crisis had convinced virtually everyone—with the exception of certain political philosophers who retained an archaic attachment to republicanism—that the preservation of public order was more important than the maintenance of legal fictions. Moreover, Titus executed his duties as Praetorian prefect with such gusto, suppressing dissent swiftly and savagely, that Vespasian was able to ride roughshod over the opposition without staining his own reputation.

To place the finances of the empire upon a sound footing, and to pay for the extensive physical rehabilitation of Rome itself (including the construction, right in the center of the city, of the Flavian Amphitheater, later known as the Colosseum), Vespasian resorted to an ingenious variety of fiscal expedients, including a user's tax on the capital's public urinals. To resuscitate the local economy, the emperor also engaged in a form of first-century government pump-priming. Lavish public banquets were staged, partly to impress the citizenry but primarily to assist the struggling catering trade. And to provide the maximum number of jobs for the citizens of Rome, Vespasian personally squelched an inventive plan to use labor-saving machinery to rebuild the city; "I must always ensure," he explained to the crestfallen engineer, "that the working classes earn enough money to buy themselves food."

In the spring of 79, Vespasian fell ill with a fever. He retreated to his summer estate in the Sabine countryside to take the medicinal baths, but only made matters worse by immersing himself in the icy

cold water. Although he tried to carry on his duties as usual, the seventy-year-old *princeps* was forced to take to his bed. On June 23, he collapsed. Insisting that an emperor ought to die on his feet, Vespasian tried to stand, but fell into the arms of his servants. As he drifted into unconsciousness, the emperor muttered one last ironic, self-deprecatory comment: "Dear me, I must be turning into a god!"

Years earlier, Vespasian had informed the Senate in no uncertain terms that "either my sons will succeed me or no one will." Upon his death, Titus—who had lately been serving as a sort of co-*princeps,* much like Tiberius during the last years of Augustus—moved smoothly into power. Surprisingly, it was the first time a Roman emperor had been succeeded by his natural son.

Though he assuaged Domitian's pride with assurances that "you are my partner and chosen successor," Titus really gave his brother little to do during his brief reign. Actually, there was not all that much going on anyway. Although Rome awaited Titus' administration with considerable trepidation, for he had acquired a reputation for cruelty in his years of military service and particularly as Praetorian prefect, Titus governed with remarkable forbearance and generosity. He had a nice popular touch, frequently staging magnificent shows, including a mock sea-fight at the dedication of the Colosseum; the amphitheater was flooded with water to reenact a famous confrontation between sailors of the Corinthians and the Corcyreans. On occasion, Titus even visited the public baths, where he could be seen in the buff in the company of common citizens. More significantly, Titus adamantly refused to prosecute any but the most serious cases of treason, punishing instead informants who attempted to stir up trouble for their own selfish purposes.

Unfortunately, Titus' otherwise agreeable reign was marred by a series of devastating natural catastrophes. In the oppressively hot and arid summer of 79, the area around the Bay of Naples—one of the most peaceful and luxurious vacation spots on the Italian mainland—had suffered several minor earthquakes, and although these were pale imitations of the catastrophic tremors that had struck the region back in 62, they proved an ominous intimation of more serious instabilities lurking beneath the surface. On August 24, around noontime, the peace of the region was shattered when the long-dormant volcano known as Mount Vesuvius suddenly erupted, bursting apart with a tremendous roar (Dio Cassius said it sounded "as if the mountains were tumbling in ruins") and heaving a thick cloud of huge red-hot

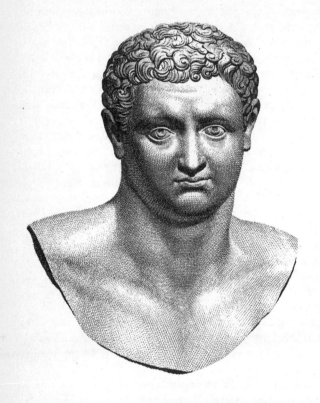

Titus

boulders, pumice stones, ash, and molten gases nearly a dozen miles
into the air. Almost at once the lighter stones, carried by the prevailing
southerly winds, began to descend upon the city of Pompeii, followed
by a rain of fine ash. It seemed, wrote Dio, "that the whole universe
was being resolved into chaos or fire," as the residents of Pompeii fled
"some from their houses into the streets, others from outside into the
houses . . . for in their excitement they regarded any place where they
were not as safer than where they were."

From the naval base at Misenum, about thirty miles to the west,
Pliny the Elder, prefect of the imperial fleet, watched the menacing
cloud rise and spread across the sky. According to Pliny's nephew
(Pliny the Younger, who was seventeen years old at the time), the
cloud resembled "an immense tree trunk . . . opened out with
branches . . . sometimes white, sometimes dark and mottled, depend-
ing on whether it bore ash or cinders." The prefect immediately called
for a galley to sail to the scene, at first merely to satisfy his scientific
curiosity; upon learning the magnitude of the disaster, however, he
attempted to mount a full-scale relief operation.

Upon reaching the house of Pomponianus, a friend who lived on
the far side of the bay, Pliny took the remarkable step of calmly
bathing and consuming a late lunch, to assuage the fears of the panic-
stricken residents. Meanwhile, his nephew watched from the shore as
"great sheets of flame and extensive fires were flashing out in more
and more places, their glare and brightness contrasting with the dark-
ness of the night. My uncle, to relieve his companion's fears, declared
that these were merely fires in villas deserted by their peasants. Then
he lay down and slept." But when the ash began falling, choking the
courtyard, the prefect's subordinates awoke him and the decision was
made to evacuate the area. With pillows tied to their heads to protect
themselves from the falling stones, Pliny and his officers made their
way back down to the shore, through the blizzard of ash that had
turned the afternoon into night, "blacker and thicker than any ordi-
nary night, though relieved by torches and flares of many kinds."
Minutes later Pliny collapsed from asphyxiation, his windpipe
clogged by cinders, ash, and the noxious, sulfurous vapors; when his
lifeless body was discovered lying on the beach several days later,
someone said that he looked "more like a sleeper than a dead man."

Fortunately, most of the twenty thousand residents of Pompeii
managed to escape the holocaust before the fatal cloud of ash de-

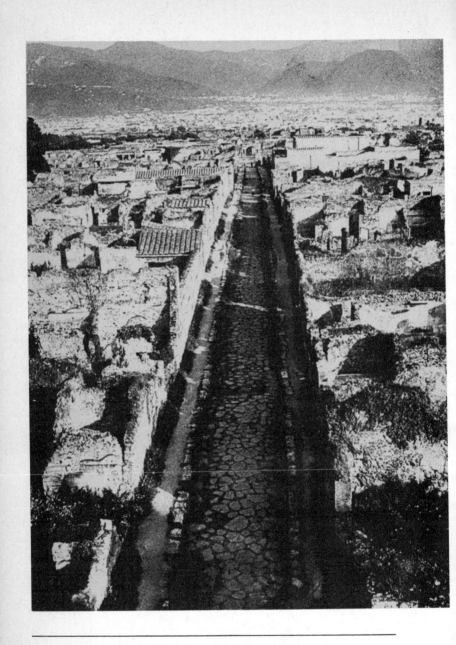

View of Pompeii from a lookout tower

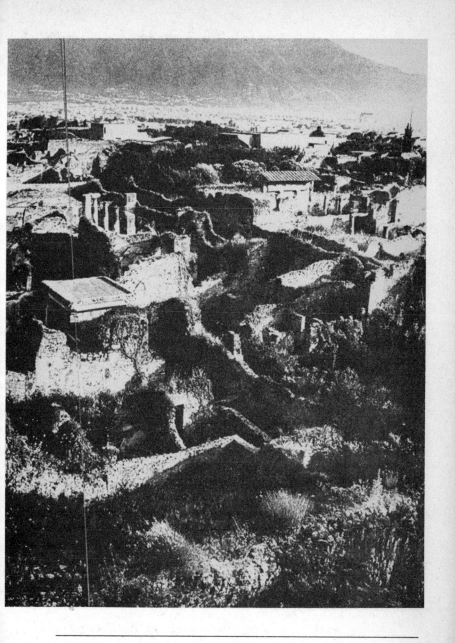

on the wall. The road leads to the Forum.

scended. In the end, only about two thousand people—those who had chosen to remain in the city—lost their lives.

At first, it seemed that Herculaneum, the idyllic resort town due west of Vesuvius, was going to escape the worst effects of the eruption. Sometime during that night, however, an incandescent flood of molten volcanic matter (at an estimated temperature of over 700 degrees Fahrenheit) surged out of the crater and swept down the side of the mountain in waves, heading directly for the heart of the town, scorching or even carbonizing whatever lay in its path. A portion of Herculaneum's population had already run to safer ground; now the rest fled in terror, leaving considerable stores of precious possessions behind. Most of the refugees got away safely. Only those who sought shelter at the harbor perished, struck down in bewilderment by the poisonous gases and the force of the volcanic flood while they waited vainly for rescue ships to appear.

Unfortunately, the sea was far too turbulent for any systematic evacuation effort. Back at Misenum, Pliny the Younger had been awakened after midnight by a succession of earthquakes; at dawn, he and his aunt joined the tide of refugees streaming out of the town:

> When we were clear of the houses, we stopped, as we encountered fresh prodigies and terrors. Though our carts were on level ground, they were tossed about in every direction, and even when weighted with stones could not be kept steady. The sea appeared to have shrunk, as if withdrawn by the tremors of the earth. In any event, the shore had widened, and many sea-creatures were beached on the sand. In the other direction loomed a horrible black cloud ripped by sudden bursts of fire [possibly the flood of volcanic matter which buried Herculaneum], writhing snakelike and revealing sudden flashes larger than lightning. . . .
>
> Soon after, the cloud began to descend upon the earth and cover the sea. . . . And now came the ashes, but at first sparsely. I turned around. Behind us, an ominous thick smoke, spreading over the earth like a flood, followed us. "Let's go into the fields while we can still see the way," I told my mother—for I was afraid that we might be crushed by the mob on the road in the midst of the darkness. We had scarcely agreed when we were enveloped in night—not a moonless night or one dimmed by cloud, but the darkness of a sealed room without lights. To be heard were only the shrill cries of women, the wailing of children, the shouting of men. . . . Many lifted up their hands to the gods, but a great number believed there were no gods, and that this night was to be the world's last, eternal one.

Pliny subsequently observed "a curious brightness" that appeared to be an approaching fire—again, probably part of the volcanic flow—that halted some distance from Misenum, throwing the land once more into pitch darkness as ashes began to fall even more thickly from the sky. "From time to time," he noted, "we had to get up and shake them off for fear of being actually buried and crushed under their weight." At last the blackness dissipated and daylight returned; "the sun shone, but pallidly, as in an eclipse. And then, before our terror-stricken gaze everything appeared changed—covered by a thick layer of ashes like an abundant snowfall."

The vast clouds of volcanic ash thrown up by Vesuvius reached as far as Egypt, Syria, and Rome, where the frightened citizens feared that "the whole world was being turned upside down, that the sun was disappearing into the earth and that the earth was being lifted to the sky." Simultaneously, earthquakes ravaged Neapolis, causing severe damage in that prosperous city as well.

Titus immediately rushed to the scene of the disaster and appointed special boards to supervise the reconstruction program, donating funds from his own treasury to kick off the campaign. A year later, while the emperor was still occupied with the relief effort in Campania, Rome was swept by yet another massive fire, one which gutted so many temples that Dio, among others, concluded that it must have been an act of divine retribution. Then a particularly virulent plague—which contemporary observers blamed on the ash from Vesuvius—ravaged the city.

Throughout this trying period, Titus kept the government actively involved in a variety of humanitarian assistance programs. Partly to divert public attention from the prevailing atmosphere of misery, the emperor produced a spectacular "hundred days of feasts and shows." But at the conclusion of the games Titus wept unashamedly in public, for he had apparently contracted an incurable disease. In the summer of 81, the emperor abandoned his duties and withdrew to the medicinal baths in the Sabine region where his father had gone in his last weeks. Titus, too, caught a chill, and on September 13, the man known as "the darling of humanity" died at the age of forty-one in the same farmhouse in which Vespasian had passed away. Just before the end, Titus complained bitterly that "his life was being snatched away from him quite undeservedly; for there was no action of his which he had reason to be sorry for, except one, and one only." No one would ever know exactly what sin lay so grievously

on Titus' conscience. Perhaps it was his abandonment of his Jewish mistress, Berenice, under pressure from the anti-Jewish bigots in Rome; more likely, it was his failure to train Domitian properly for the succession—or else to kill him, because Titus considered Domitian something of a walking time bomb who threatened to destroy the principate.

Domitian had, in fact, left Titus' bedside even before his brother was dead to hurry back to Rome and assume control of the government. The Senate duly awarded the throne to the thirty-year-old prince, though not without misgivings. For Domitian had a very disturbing way about him; cold, precise, methodical, and above all morbidly suspicious, he was perhaps the most tightly wound of all the first-century emperors: his well-known habit of impaling flies on the tip of his stylus revealed volumes about his character. All the years of bitterness and repressed ambition had instilled in Domitian an obsessive determination to demonstrate his very real abilities as *princeps,* no matter the cost. He trusted absolutely no one, nor did he permit anyone to stand in his way.

Unlike his more diplomatic father and brother, Domitian cast aside the facade of constitutional rule and governed the empire openly as a despot. Some senators—and not merely the usual flatterers— understood that Domitian's assertion of absolutism represented nothing more than a simple recognition of the political realities of late first-century Rome, though nothing galled the Senate as a whole more than an abandonment of the fictions that masked its powerlessness. But the empire could be governed effectively only by a strong, centralized executive; and whatever his faults, Domitian was an energetic and conscientious administrator who immersed himself in the practical day-to-day details of government. Midway through his reign, he began to develop a fascination for the memoirs of Tiberius, which was not surprising, since both men shared an immense capacity for hard work as well as a tendency toward paranoia. But the imperial personality Domitian resembled even more than Tiberius was Augustus himself. Like the first *princeps,* Domitian possessed an unshakable self-confidence, a sharp, clear, supremely rational intellect, and a passionate nature that was held in check only by the force of his will. Augustus, though, had one redeeming attribute that Domitian lacked utterly: a critical sense of balance.

Domitian did understand, however, that if he was going to antagonize the senatorial class, he needed to enlist the military on his side.

And so, soon after his accession, he granted a substantial pay raise (between thirty-three and fifty percent) to the army, the first increase in the legions' regular paychecks since the days of Augustus. But the added drain on the imperial exchequer that this produced could be offset only by a decrease in the total number of troops on active duty, a trend that did not bode well for the future security of the empire. And in the closing decades of the first century, the barbarians on the frontier of empire were becoming increasingly restless.

In 83, Domitian personally commanded an expedition against the Germanic tribe of the Chatti, who had been objecting with increasing vehemence to the gradual extension of Roman control beyond the east bank of the Rhine. Then the emperor turned his attention to the lower Danube, where the Dacian tribes, having formed a powerful, unified state not unlike the Marcomanni kingdom of Maroboduus seven decades earlier, had been pressuring the province of Moesia. The campaign in the Balkans lasted, in a desultory way, for eight full years (85–93), because once the Dacians had been conquered, the Marcomanni and their allies farther to the north rose in rebellion. By the time a rather unsatisfactory truce had been established, the wars had cost Rome thousands of casualties, as well as the standard of the V Legion. This prolonged conflict also required the abandonment of the excellent work done in Britain by Cnaeus Julius Agricola, the father-in-law of the historian Tacitus. Since his appointment as governor of that province in 77–78, Agricola had conquered all of Wales and pushed into northern Scotland, subduing the fearsome Caledonians in a crucial battle in the year 84; afterward he had sent a naval expedition round the tip of Britain to establish that it was, in fact, an island. But the threat to the home provinces from across the Danube led Domitian to recall at least one full legion from Britain—and Agricola, too, whom Domitian mistrusted precisely because of his military prowess—thereby forcing the Romans to withdraw gradually to the Tyne-Solway line, then take up a more permanent position even farther south, along the Stangate road.

In the midst of the on-again, off-again Dacian campaign, the governor of Upper Germany, Lucius Antonius Saturninus, suddenly launched a revolt against Domitian and declared himself emperor on January 1, 89. Assured of the support of influential dissident elements in Rome, Saturninus—who felt personally menaced by Domitian's sanctimonious campaign against homosexuality, though the emperor himself was no stranger to the practice—seized the treasury in which

his legions kept their savings to induce them to follow him, and arranged for reinforcements from the always bellicose Chatti. Domitian responded immediately and vigorously, marching northward with a force under his personal command while ordering the other armies in the area to descend upon Saturninus. It was all over in less than thirty days. The Rhine thawed prematurely, preventing the Germans from keeping their rendezvous; and when the loyalist governor of Lower Germany, Lappius Maximus Norbanus, arrived with his troops, Saturninus was defeated without much difficulty.

Doubtless parallels with the unpleasant events of 68 crossed the emperor's mind, and so the revolt of Saturninus marked the decisive turning point in Domitian's reign. Since Lappius Maximus had deliberately burned the incriminating documentary evidence of the revolt before Domitian could arrive, the emperor resorted to the insidious expedients of informants, torture, and treason trials to ferret out his enemies. A rigorous, systematic reign of terror now descended upon the capital, directed against seditious thought and speech as well as deeds. At the end of 91, Domitian banished from Rome all philosophers and politically dangerous ideologues, particularly the Stoics, whom Domitian especially detested for their stubborn adherence to utopian ideals; several prominent writers were executed for composing treatises on tyranny, or for satirical allusions to the emperor's somewhat unconventional sex life in their verses. Jews and Christians who declined to participate in the rejuvenated cult of emperor-worship—Domitian insisted upon being addressed as "lord and god," though he was careful to place himself within the traditional pantheon of Roman deities—were persecuted for treason, albeit as individuals rather than as entire sects.

But it was Domitian's obstinate refusal to conciliate the aristocracy that led directly to his downfall. In the year 95, the trickle of condemnations for treason turned into a flood, as senators, Praetorian prefects, and even the emperor's own cousin, the inoffensive Flavius Clemens—whose sons had been designated by the childless emperor as his heirs—lost their lives to assuage Domitian's paranoia. ("Those emperors who did not visit punishment upon many men," Domitian liked to say, "were not good emperors, but only fortunate.") As in the final days of Nero's reign, no one close to the emperor could feel safe; thus were born the very conspiracies Domitian sought to repress. But Domitian was a much more wary foe than Nero; the walls of his exercise room were lined with plaques of highly polished moonstone,

Nerva

Trajan

which reflected everything that happened behind Domitian's back. By now the emperor had withdrawn from virtually all human contact, ensconced behind the walls of his heavily fortified palace, haunted by premonitions of his imminent death.

Nevertheless, a group of conspirators that included several palace officials, both recently appointed Praetorian prefects—one of whom was Norbanus, the former governor of Lower Germany—and probably the empress as well, hit upon the happy device of approaching Domitian with evidence of a plot against his life. A freedman named Stephanus, the steward of the emperor's niece, Domitilla, was outfitted with a dagger hidden in a woolen bandage wrapped around his arm; he wore the bandage for several days before the assassination attempt to prevent Domitian from suspecting foul play. On September 18, 96, the fifteenth year of Domitian's troubled reign, Stephanus was ushered into the emperor's bedroom to present a petition outlining the details of the spurious conspiracy. While the emperor scanned the document, Stephanus pulled out his knife and stabbed Domitian in the groin. The two men struggled, Domitian attempting alternately to claw out Stephanus' eyes and pry the knife from his assailant's fingers, until several other conspirators arrived and finished both of them with their swords.

Shortly before Domitian died, he dreamt that he saw himself with a golden hump growing out of his back; later, someone interpreted this vision as a prophecy of better times to come for the empire after Domitian was gone.

As previously arranged, the Senate named the elderly nobleman Marcus Coccius Nerva emperor; to placate the army, which was enraged at the murder of its benefactor, Nerva adopted the popular commander of the legions of Upper Germany, Marcus Ulpius Traianus—Trajan—as his successor. In January 98, after a blissfully uneventful reign of less than two years, Nerva died, and Trajan succeeded to the powers of Augustus.

The Revealer

The Island of Patmos, 96–100 C.E.

> After this I saw another angel coming down from
> heaven.
> He had great authority, and the earth was illuminated
> by his splendor. With a mighty voice he shouted:
>
> "Fallen! Fallen is Babylon the Great!
> She has become a home for demons
> and a haunt for every evil spirit. . . ."
>
> —THE BOOK OF REVELATION

L ate in the first century, toward the end of Domitian's reign
or the beginning of Nerva's brief time on the throne, a
Jewish Christian prophet who called himself John—recently exiled to
the tiny island of Patmos, in the Aegean Sea, for his refusal to worship
the emperor—fell into an ecstatic trance while worshipping his God.
"I heard behind me," wrote John afterward, "a loud voice like a
trumpet, which said, 'Write on a scroll what you see and send it to
the seven churches. . . .'"

I turned around to see the voice that was speaking to me. And when I
turned I saw seven golden lampstands, and among the lampstands was
someone "like a son of man," dressed in a robe reaching down to his
feet and with a golden sash around his chest. His head and hair were
white like wool, as white as snow, and his eyes were like blazing fire.
His feet were like bronze glowing in a furnace, and his voice was like

the sound of rushing waters. In his right hand he held seven stars, and out of his mouth came a sharp double-edged sword. His face was like the sun shining in all its brilliance.

This messenger was, of course, the resurrected Jesus, though the visual and aural symbolism employed by John was derived largely from the Jewish prophetic tradition, particularly from the books of Daniel and Ezekiel; the seven golden lampstands, for instance, obviously were a reference to the menorah. In his vision, John was entrusted by Jesus with a message for a group of seven churches in Asia Minor, all within a hundred miles of Ephesus. In those days, when the gospel of Christianity was spread by itinerant preachers and missionaries, or apostles, these seven communities may have been part of a single circuit, and they certainly were all personally familiar to John. By this time, there were perhaps eighty thousand Christians in Anatolia, many having made their way to that region during or after the disastrous revolt in Judea three decades earlier.

While the messages this celestial vision imparted to John included praise for the steadfastness of each church, there were also stern admonitions to return to the faithfulness and fervor of the first generation of Christians. For by this time, the Christian churches in the Roman Empire were beset by a multitude of problems. Some members of the flock, charged John, had grown weary of waiting for the Second Coming of Christ, and had lost the enthusiasm that had accompanied their initial conversion. Others were being misled by self-appointed prophets, though in an age when there was not yet any established orthodox Christian doctrine, furious controversies about the divine authority of any particular preacher or prophet must have been endemic. It was during this time that Christian gnosticism, for instance, emerged as a separate intellectual force, picking up strands of dualist thought from the Essenes and apocalyptic Jewish sects such as the community at Wadi Qumran, among others.

The Christian churches also had to contend with rival Hellenistic saviors, like the numerous charlatans who professed to be either the original Nero himself—whose death had been witnessed by only a handful of people—or the reincarnation of that mystically minded emperor. A more serious threat stemmed from the quasi-mythical itinerant sages such as Apollonius of Tyana, whom the Christians contemptuously dismissed as nothing but a second-rate magician. Allegedly the offspring of the god Apollo and a human mother, Apol-

lonius had withdrawn from the world in his youth to seek a solution
to the problem of human suffering. (Obviously he was not the first
person in these pages to do this sort of thing.) Strengthened by years
of silent meditation and communion with heaven, his reflections in-
terrupted only by the steady procession of sick or lame pilgrims who
came to be healed by contact with his spiritual power, Apollonius at
last experienced a revelation of the unity and permanence of life, of
the links between humanity and the Divine. He then journeyed to
India, where he studied for several months with ascetic Buddhist
monks, who confirmed his perception that "true life consists in ceas-
ing to have any affection even for life itself, and in bearing the judg-
ment of death in oneself so that one might not trust in oneself."
Thereupon Apollonius returned to Asia Minor to preach his own
gospel of love, compassion, and abandonment of self, stopping at
Ephesus, where he denounced the notorious pagan cult of the goddess
Diana; at Smyrna, where he castigated the residents for their supine
submission to the edicts of the decadent Roman government; and
then across the Aegean to Athens, where he condemned the blood-
thirsty ritual of their gladiatorial games. Imprisoned by Domitian for
sedition (probably, like John, for a refusal to worship the emperor as
a god), Apollonius was released shortly before the accession of Nerva,
and died soon thereafter. But rumor had it that no one had seen him
die; and someone remembered that he had once said, "Conceal your
life, and if you cannot do that conceal your death."

Domitian's persecution of dissidents had also taken its toll on the
churches to whom John revealed his vision; indeed, one of John's
primary purposes in addressing them was to strengthen their resolve
to resist Roman pressure and refuse to renounce their faith. In John's
vision, Rome—known by the code name of Babylon, after the de-
stroyer of the first Temple—was a great beast, to whom Satan, de-
picted as a dragon, awarded his throne and his power. "Men wor-
shipped the dragon," John wrote, "for he had given his authority to
the beast, and they worshipped the beast, saying, 'Who is like the
beast, and who can fight against it?' " The beast had, however, re-
cently received a mortal wound—an oblique reference to the civil
wars, or the death of Nero—which had somehow been healed. Never-
theless, as John explained, this apparently invincible behemoth

> was allowed to make war on the saints and to conquer them. And
> authority was given it over every tribe and people and tongue and

nation, and all who dwell on earth will worship it, every one whose name has not been written before the foundation of the world in the book of life of the Lamb that was slain [i.e., Jesus]. If any one has an ear, let him hear. . . . Here is a call for the endurance and faith of the saints.

The emperor himself—probably Domitian—was depicted as a woman "arrayed in purple and scarlet, and bedecked with gold and jewels and pearls, holding in her hand a golden cup full of abominations and the impurities of her fornication [Domitian was notoriously oversexed]; and on her forehead was written a name of mystery: 'Babylon the great, mother of harlots and of earth's abominations.' And I saw the woman," continued John, "drunk with the blood of the saints and the blood of the martyrs of Jesus."

John's vituperative rhetoric notwithstanding, other Christian writers—no less pious than John the Revealer—strove to achieve an accommodation with Rome, primarily by demonstrating that Christianity was not a revolutionary sect, at least not in the conventional political sense. Hence the authors of the four Gospels (Matthew, Mark, Luke and John)—all of which appear to have been written between 60 and 100 C.E., employing anecdotal evidence and various oral and written collections of Jesus' sayings, which the authors welded with often contradictory results into narratives of his life—earnestly emphasized Jesus' indifference to political affairs. And in the aftermath of the Jewish revolt, the Gospels (particularly John, the last one written) took great pains to distinguish Jesus from the Jewish elite of his day, to criticize the Jews at every opportunity for their obstinacy and blindness, and to charge the Jewish authorities in Jerusalem—and not the Roman government, in the person of Pontius Pilate—with responsibility for the crucifixion of Jesus. In fact for these writers the destruction of Jerusalem by the Romans became, at least in retrospect, God's ultimate punishment of the Jews for killing the Messiah.

As if the Jews did not already have enough problems of their own. In the wake of the Judean revolt, with their holy city of Jerusalem a wasteland, the Jewish state simply ceased to exist, its people dispersed throughout the Mediterranean world even more than before, so that contemporary Jewish sages spoke of "our days, when Israel no longer dwells on its own soil" (though a substantial minority did continue to reside in Palestine under Roman rule). Whole towns

throughout the province had been wiped out, the economy ruined for decades. Although the upper classes had represented, on the whole, a stronghold of loyalist sentiment, they suffered far more from the Roman reaction than any other segment of Jewish society. Shortly after his accession, Vespasian expropriated all the land in Judea, declaring it his own personal property, and then sold much of it to Gentiles or Samaritans, reducing its former Jewish owners to the status of tenant farmers or sharecroppers.

And the Temple was gone forever. Its passing represented a catastrophe of the first magnitude, for it meant that the Jewish religion could no longer be practiced in the form that had sustained it for centuries. No other center of communal, ritual worship existed for the Jews, no other altars to offer sacrifices to their God. For that unfortunate generation of Jews, the grief and bewilderment must have been almost impossible to bear. "Blessed is he who was not born," mourned the author of the Book of Baruch:

> Or he, who having been born, has died.
> But as for us who live, woe unto us.
> Because we see the afflictions of Zion,
> And what has befallen Jerusalem. . . .
>
> Do thou, O sun, withhold the light of thy rays.
> And do thou, O moon, extinguish the multitude of thy
> light;
> For why should light rise again
> Where the light of Zion is darkened?

Vespasian rubbed salt in the wound by issuing an edict that henceforth the annual tax for the upkeep of the Temple would be collected and used to support the Temple of Jupiter Capitoline in Rome. This sort of vindictiveness did nothing to discourage the hatred of the empire that still prevailed in certain Jewish circles, and definitely helped discredit those members of the Jewish elite who persisted in seeking an accommodation with Rome.

Without a Temple, there could be no High Priest, and the Sadducees too lost their preeminent role. Theoretically, the Sanhedrin still existed as a high court to enforce religious laws, though with diminished authority. The priesthood, too, survived but without any power or privileged status. By the end of the first century, leadership of the

Jewish communities in the Diaspora had already passed to the Pharisees and rabbis who now served the people as the teachers, interpreters, and guardians of the Law. In their hands, the Torah was transformed into the primary instrument of practical guidance and spiritual idealism that was sufficiently durable to sustain the faith of Jews for centuries.

The Pharisees' task was facilitated by the establishment of a new center of Jewish studies at Yavneh (Jamnia), along the Mediterranean coast. Founded by Rabbi Johanan ben Zakkai, who had fled Jerusalem during the siege and, like Josephus, managed to ingratiate himself with the Roman high command, the Yavneh academy preserved the scholarly traditions of Judaism, and its own Council eventually assumed most of the authority and duties of the Sanhedrin.

Although the synagogues subsequently took over certain communal functions of the Temple, as some parts of the liturgy were lifted directly from the Temple service, the most important ritual of worship—the sacrificial offering to God—could not be reproduced elsewhere. Judaism was thus constrained to discover a substitute, and fortunately one lay ready at hand in the reaffirmation and elevation of the importance of ethical conduct as a means of salvation. The point was well made by the Rabbi Johanan himself in a conversation with a student who stood staring disconsolately at the ruins of the Temple, crying, "Woe unto us, that this, the place where the iniquities of Israel were atoned for, is laid waste!" "My son," replied Rabbi Johanan, "do not be grieved. We have another atonement as effective as this—acts of loving kindness. For it is said, 'I desire mercy and not sacrifice.'"

At the same time, however, the extraordinary crisis created by the demise of the Jewish state, and the accompanying persecutions inflicted by Rome, induced Judaism to close its ranks in order to ensure its survival, to insist upon a central orthodoxy and cast out the fringe groups that had thrived and caused so much dissension in the first half of the century—not to mention the havoc they had wreaked during the siege of Jerusalem. And one of the first factions to be ousted from the fold was the community of Jewish Christians. In the wake of the destruction of Jerusalem, the Gentile wing of the Christian movement, the churches founded by Paul and his colleagues, emerged as the dominant party within Christianity; the Jewish Christians (who had *not* all fled to Pella before or during the siege) had been irrevocably damaged by their association with the failed revolt, their

congregations scattered throughout the Diaspora with their non-Christian Jewish colleagues. Now, around the year 85, they were thrown out of the synagogues as well, by Gamaliel II, the successor to Johanan ben Zakkai at Yavneh.

From his island prison, John the Revealer fully reciprocated the Jews' hostility. "Behold," he quoted Jesus in his vision, "I will make those of the synagogue of Satan who say that they are Jews and are not, but lie—behold, I will make them come and bow down before your feet, and learn that I have loved you." For John, the Jewish Christians were the true heirs of the Judaic tradition, the chosen few who would inherit "the new Jerusalem," the holy city that would soon be "coming down out of heaven from God, prepared as a bride adorned for her husband." (The old Jerusalem, John charged, had been turned into Sodom by the blasphemy of the Jews who had crucified Jesus.)

And clearly, in the revelation imparted to John, the Second Coming and the final judgment would not be long delayed. God would unleash the four horsemen of the apocalypse—the fourth of whom rode a pale horse, and his name was Death—and seven angels, whose seven trumpets would destroy a third of mankind and darken a third of the heavens; and there would be a final cataclysmic war in heaven, in which the Lamb and the Christian martyrs would vanquish the beast and the dragon, whereupon seven bowls (or cups) full of plagues would be poured out upon the earth, very much like the plagues that struck Egypt in the days of Moses, punishing humanity for its faithlessness. All this appalling destruction would be followed by the creation of a new heaven and a new earth, by the resurrection of the dead, and the Second Coming of the Christ. It was an awful prospect to which John looked forward with trembling anticipation: "The Spirit and the Bride say, 'Come.' And let him who hears say, 'Come.' And let him who is thirsty come, let him who desires take the water of life without price. . . . He who testifies to these things says, 'Yes, I am coming soon.'

"Amen. Come, Lord Jesus!"

XXXII

The Envoy

China, India, and Asia Minor,
97–100 C.E.

> Da Qin lies west of the sea [i.e., the Black Sea and the
> Mediterranean]. It is many thousands of *li* in extent, has
> more than four hundred cities, and scores of small vassal
> states. The walls of cities are built of stone. . . . The
> people wear their hair cut short, and they wear
> embroidered clothes. They ride in chariots. . . . Their
> Kings do not rule permanently; they always appoint
> worthy men as Kings; if there are ill-omened portents, or
> the seasons are disordered, the King is deposed and
> another set up. . . .
>
> —REPORT OF A CHINESE EMISSARY OF THE CUSTOMS IN THE
> ROMAN PROVINCE OF SYRIA

In China, the year 69 had been notable for the absence of war
anywhere within the empire.

Four years later, the emperor Mingdi dispatched forces to the
Western Regions (modern Turkestan) to reestablish Chinese control
over the trade routes between China, India, and Parthia. One of the
military officials who wangled an appointment to accompany this
expedition was Ban Chao, brother of two of the most famous scholars
in Chinese history; sick and tired of working as a librarian and a minor
bureaucrat in Luoyang, Ban Chao had volunteered for the mission
with alacrity.

Accompanied initially by only thirty-six soldiers, Ban Chao employed a remarkably adroit combination of diplomacy and intimidation to persuade the tiny but recalcitrant states along the southern Silk Road to submit to Chinese hegemony. When he was recalled to Luoyang in the year 76, however, the natives revolted; dispatched once more to Central Asia four years later, this time with several hundred troops under his command, Ban Chao succeeded through constant warfare in bringing the entire Tarim Basin under Chinese control.

Trouble then erupted to the south in the year 90, when Kadphises II, the ruler of the Kushan Empire in northwestern India, refused to accept the position of vassal to the Chinese emperor. By the last decade of the first century, India had become a crucial link in both the overland trade from Asia Minor and Parthia, and the maritime commerce between Egypt and southern Asia. During Claudius' reign, a Greek sailor had discovered how to use the monsoon winds to sail directly from the Red Sea to India, where westerners were greeted by a bewildering land of "great mountains and all kinds of wild beasts—leopards, tigers, elephants, enormous serpents, hyenas, and baboons of many sorts—and many populous nations, as far as the Ganges." And though the journey was still painfully slow and difficult (sailors had to hug the coast, navigating at night by the stars), this sea route held out the promise that by circumventing Parthia completely, the stranglehold of extortionate Parthian middlemen over the southern Silk Road might someday be broken.

Certainly there were already considerable contacts between India and Asia Minor in the cultural sphere, for one or more Christian missionaries—possibly though not necessarily St. Thomas, one of the original disciples, who allegedly reached southern India in the sixth decade of the century and was martyred near Madras—appear to have established at least a single community of The Way along the northwestern frontier of India, and perhaps another in the southern reaches of the subcontinent.

At any rate, Kadphises sent an army to teach Ban Chao a lesson, but by the time his troops struggled over the formidable Tashkurghan Pass, about fourteen thousand feet high, they were so exhausted that Ban Chao tore them to shreds, whereupon Kadphises was forced to pay tribute to the emperor in Luoyang.

In the year 97, Ban Chao—who had meanwhile been appointed Protector General for his victory over the Kushans—reached the

shores of the Caspian Sea. His advance marked the greatest westward thrust of Chinese power in history; never again would a Chinese army stand so close to the borders of Europe. To discover what lay beyond, in the mysterious land of Da Qin (the Roman Empire, or more specifically the province of Syria) and perhaps find a way around Parthia, Ban Chao dispatched an emissary, a lieutenant named Gan Ying, who made his way to the Black Sea but was prevented from traveling all the way to Syria by the Parthians. Determined to maintain their commercial monopoly, Parthian merchants tried to frighten Gan Ying with tales of sea crossings that took two years; "If the Han ambassador is willing to forget his family and his home," they told him, "he can embark."

But Gan Ying turned back, full of fabulous tales of Da Qin, where "corn and food are always cheap, so that the country is very wealthy," where ordinary citizens could petition the king for justice, and even the deposed kings accepted their fate with good grace, showing no resentment at all. It seemed, in short, a model empire.

Several years later, Ban Chao requested permission to return to Luoyang. He died a month after reaching the capital. Within fifty years, his work had been destroyed; preoccupied by internal difficulties, the Chinese government quickly lost control over the oases of the Tarim Basin. Although the Silk Road was maintained sporadically by intermediaries for nearly another century, by the early third century the chain had been snapped completely, and Chinese links to the West were severed for a thousand years. Not until the Mongol Empire restored order and security in the late thirteenth century did any regular, significant overland contact resume between Europe and the Orient.

Epilogue

The Three Kingdoms
Judea, China, and Rome to 476 C.E.

I n the fourth decade of the second century, during the reign of the emperor Hadrian, the land of Judea once again erupted in revolt. Appalled and infuriated by an imperial regulation banning circumcision as an unwholesome and alien practice, by a prohibition against teaching the Torah, and by Hadrian's blasphemous decision to erect a Roman colony named Aelia Capitolina—named after Hadrian's clan, the Aelii, and dedicated to Capitoline Jupiter, complete with a Temple of Zeus—upon the ruins of their holy city of Jerusalem, an army of Jews under the leadership of Simeon bar Kosiba, a distant descendant of the Maccabees, rose in rebellion in the year 132. Despite the fact that on this occasion the Jewish insurgents enjoyed far more unity (including the support of Rabbi Akiba ben Joseph, the leading Pharisee and scholar of the age) and a more effective organization than their counterparts three generations earlier, the revolt lasted only three years. After heavy losses on both sides, the uprising collapsed in August 135, perhaps on the anniversary of the very day when Titus had demolished the Temple almost seven decades before. Roman troops defeated the last remnants of Simeon's army at the fortress of Bethar by the Dead Sea; Simeon himself was slain, and the survivors sold as slaves.

As punishment, the Roman government forbade Jews from en-

tering Aelia Capitolina except on a single Day of Mourning every year. The Jewish population of Judea appears to have declined precipitously, and the center of Jewish settlement in the holy land was transferred to Galilee. And still more retribution followed, marked by heavy taxation of Jews and the execution by the Romans of the Ten Martyrs (including Rabbi Akiba) whose deaths are still commemorated on the Day of Atonement, Yom Kippur.

In the aftermath of the Second Revolt, Jewish expectations of political deliverance by a Messiah became a distant and fading hope.

Although the Later Han dynasty continued to rule China into the third century c.e., the debilitating effects of factionalism and intrigue at Luoyang—along with a succession of child emperors and the usurpation of power by eunuchs within the imperial court—weakened control of the empire at its very center. In the latter half of the second century, a wave of agrarian discontent and peasant uprisings, culminating in the rebellion in the year 184 of the Yellow Turbans (who commanded three hundred thousand troops), accelerated the disintegration of the regime; the rise of independent regional warlords in the following decade provided the final blow to the dynasty. Following the death of the last Han emperor, Xiandi, in 220, the Chinese Empire was split into three separate kingdoms. China would not be reunited for nearly four centuries.

Under the capable military leadership of Trajan—the first provincial citizen ever to become emperor—the Roman Empire reached the height of its power. After strengthening the army and raising the number of imperial legions to thirty, Trajan embarked upon an aggressive campaign of conquest, annexing the kingdom of Dacia and conquering a substantial portion of Parthia; by the end of the year 115, Roman troops were camped on the edge of the Persian Gulf for the first and last time. But a series of rebellions behind the lines, followed by Trajan's death the next year, forced his successor, Hadrian, to pull back to the frontier of the Euphrates.

In 165, the peace of the Empire was shattered when a wave of Germanic tribes crossed the Alps and invaded Italy and the Balkans. Although the emperor Marcus Aurelius managed to regain control of most of the lost territories, the limits of imperial authority had clearly been reached. During the rest of the second century and most of the third, the empire was plagued by continuing invasions of Germans

(Goths) from central Europe, by the rising power of the Persians in the East, and by recurring unrest within the imperial army, as individual legions once again adopted the disruptive habit of putting forth their own candidates for emperor.

Meanwhile, the religion of Christianity had spread throughout much of the empire despite repeated official persecutions, though at the start of the third century it was still centered primarily in the lower- and middle-class urban populations. Shortly after his accession to the throne in 312, however, the emperor Constantine announced his conversion to Christianity for both political and personal reasons, thereby transforming it into the ruling, universal religion of the empire. Constantine hoped that Christianity would unite the empire and forestall the disintegration that was eating away inexorably at the state; but it did not.

Worn out by the seemingly interminable cycle of civil wars, by the mounting hostility between army and civilians, by the ever-widening gulf between social classes, by inflation and the oppressive burden of taxation upon the middle class, by the inability of the legions to defend the frontiers against persistent pressure from the Huns and other barbarian marauders, by the enmity between the western and eastern halves of the empire, and by the diversion of the most talented individuals from the state to the Christian church, the Roman Empire collapsed. In the year 476, the last emperor of Rome was deposed by the ruler of the Visigoths. The eastern half of the empire, which possessed a much more unified society and enjoyed far more defensible borders, survived for nearly a thousand years more, until the Ottoman Turks finally conquered its capital of Constantinople in the year 1453.

Source Notes

The first citation of a published source always includes an abbreviated title; subsequent citations employ only the author's last name, unless I have used more than one book by that author.

PROLOGUE

PAGE

3. "He who has never seen . . .": Grant, *Jews*, p. 72.
8. "it was a glorious thing . . .": Josephus, *Bellum Judaicum* (Jewish War), I, 33, 2.
10. "more worthy of observation . . .": Josephus, *Antiquitates Judaicum* (Jewish Antiquities), XVII, 6, 3.
 "undergo death, and all sorts . . .": Josephus, *BJ*, I, 33, 3.
12. "I know the Jews . . .": ibid., I, 33, 6.

PART ONE: THE EMPIRES

18. "Rome is supported . . .": quoted in Africa, *Rome*, p. 12.
21. "There is nothing that was . . .": Lewis, *Principate*, p. 11.
22. "Your possession is equal . . .": ibid., p. 33.
25. "I could not bear the way . . .": Suetonius, *Augustus*, 62.
 "left untried no . . .": Velleius Paterculus, *Roman History*, II, 100, 2.
31. "Is it really you . . .": ibid., II, 104, 2.
32. "There was not one of us . . .": ibid., II, 114, 1.
 "He often admonished . . .": ibid.
 "Truly the army . . .": Tacitus, *Annals*, I, 17–18.

33. "soldiers ate what they could . . .": Grant, *Army,* p. xxiii.
35. "a country that is thankless . . .": Tacitus, *Germania,* 2, 1.
36. "Ye Heavens . . .": Velleius, II, 106.
38. "And if you ever . . .": Suetonius, *Augustus,* 65, 2.
41. "You alone are rulers . . .": Lewis, p. 35.
 "Through war to wealth . . .": quoted in Africa, p. 19.
42. "We are your flocks . . .": Dio Cassius, *Roman History,* 56, 16, 1.
 "A considerable detachment . . .": Velleius, II, 110.
 "unless precautions . . .": ibid., II, 111, 1.
44. "They were thoroughly familiar . . .": Dio, 55, 30, 2.
 "the most bitterly fought . . .": Suetonius, *Tiberius,* 16.
45. "Ah, never to have . . .": Suetonius, *Augustus,* 65, 2.
46. "All these objects . . .": Dio, 56, 14, 1.
51. "How is it that you sought . . .": Luke 2:49.
55. "plotting to interfere . . .": Pan Ku, *Wang Mang,* p. 72 fn.
 "She has not . . .": ibid.
 "As the Emperor . . .": ibid., p. 88.
57. "they wore . . .": Ch'ü, *Han Social Structure,* p. 110.
62. "The institutions of our . . .": Loewe, *Crisis,* p. 272.
63. "When there was something . . .": Pan Ku, *Wang Mang,* p. 77.
64. "The court should act . . .": ibid., p. 83.
 "He wears poor clothing . . .": ibid., p. 99.
 "Day and night . . .": ibid., p. 91.
65. "Seeking ancient institutions . . .": ibid., p. 135.
66. "Wang Mang poisoned . . .": ibid., p. 161.
67. "Your Sacred Thoughts . . .": ibid., p. 163.
 "This is a symbol . . .": ibid., p. 174.
 "I, unvirtuous one . . .": ibid., p. 178.
69. "Gods of Quirinius' city . . .": Ovid, *Tristia,* 1.3.
 "I will be . . .": ibid.
75. "Men eat to vomit . . .": Baldson, *Life,* p. 42.
76. "Golden, truly . . .": Ovid, *Ars,* 2.277–78.
 "I have lost everything . . .": Ovid, *Tristia,* 4.16.49–52.
80. "exterminated almost . . .": Velleius, II, 119.
81. "Quinctilius Varus . . .": Suetonius, *Augustus,* 23.
82. "It struck him . . .": Dio, 56, 24.
84. "There was a total . . .": ibid., 56, 29, 2.
85. "Poor Rome . . .": Suetonius, *Tiberius,* 21.
 "Have I played . . .": Suetonius, *Augustus,* 99.
 "Goodbye, Livia . . .": ibid., 99, 2.
 "Forty young men . . .": ibid.
88. "We all understand . . .": Dio, 56, 35.
 "At the time . . .": ibid., 56, 43.

93. "Fathers and sons . . .": Pan Ku, *History,* III, p. 286.
97. "he did not consider . . .": ibid., p. 327.
98. "Because of my . . .": ibid., p. 380.
100. "This is because . . .": ibid., p. 425.
101. "every time he broke . . .": Tacitus, *Annals,* I, 24.
102. "You will never be . . .": ibid., I, 17.
103. "a State which could . . .": ibid., I, 10.
 "Oh, let him . . .": Suetonius, *Tiberius,* 24.
 "a miserable and . . .": ibid.
 "may be good enough . . .": ibid.
 "holding a wolf . . .": ibid., 25.
104. "Why have you come . . .": Tacitus, *Annals,* I, 26.
 "Men's minds, once . . .": ibid., I, 27.
105. "It rained so hard . . .": ibid., I, 29.
 "There was universal . . .": ibid., I, 32.
106. "End this . . .": ibid., I, 35.
107. "In these last days . . .": ibid., I, 42–43.
108. "This was unlike . . .": ibid., I, 48.
 "This is no cure . . .": ibid., I, 49.
109. "There is nothing to fear . . .": ibid., I, 59.
110. "Now the anchors . . .": ibid., II, 23.
 "There have been . . .": ibid., II, 25.
111. "that a right-minded . . .": Suetonius, *Tiberius,* 29.
112. "if you ever feel . . .": ibid., 67, 3.
 "quite unperturbed . . .": ibid., 28.
 "A good shepherd . . .": ibid., 32.
113. "Let them hate me . . .": ibid., 59, 7.
116. "a dried-up ham . . .": Davis, *A Day,* pp. 356–7.
118. "he certainly gave . . .": Dio, 57, 1.
119. "Piso was certain . . .": Tacitus, *Annals,* II, 44.
120. "It is the wickedness . . .": ibid., II, 70.
121. "No one appeared . . .": ibid., III, 18.
 "While I am alive . . .": Dio, 57, 13.
123. "the sums spent . . .": Tacitus, *Annals,* II, 52.
 "If our energetic . . .": ibid.
125. "Heaven bestowed the virtue . . .": Pan Ku, *History,* III, p. 464.
126. "a crowd of thieves . . .": ibid., p. 436.
127. "Wherever an army . . .": ibid., pp. 443–4.
128. "When an army wishes . . .": ibid., p. 444.
 "a great wind . . .": ibid., p. 445.
129. "Since thou . . .": ibid., p. 458.
130. "You rebellious peasant, . . .": ibid., p. 463.

"Heaven bestowed . . .": ibid., p. 464.

"How can I face . . .": Pan Ku, *Wang Mang,* p. 94.

"dragon who had flown . . .": Pan Ku, *History,* III, p. 473.

132. "better to spend . . .": Tacitus, *Annals,* III, 37.

133. "I know that I may be . . .": ibid., IV, 8.

135. "any officials who can . . .": ibid., III, 54.

136. "gave peace and the blessing . . .": quoted in Grant, *Twelve,* p. 97.

137. "We cannot spare . . .": Suetonius, *Tiberius,* 28.

144. "They guard against . . .": Josephus, *BJ,* II, 8, 2.

"their doctrine is this . . .": ibid., II, 8, 11.

145. "There shall gather . . .": quoted in Farmer, *Maccabees,* pp. 163–4.

"The officers . . .": ibid.

147. "He that has . . .": Luke 3:11.

"O generation . . .": Luke 3:7–8.

"A voice . . .": Luke 3:4–6, 9.

148. "You are my beloved . . .": Luke 3:22.

149. "a monster . . .": Suetonius, *Claudius,* 3, 2.

150. "a bigger fool . . .": ibid.

"I am sorry . . .": ibid., 4, 6.

"I'll be damned . . .": ibid., 4, 8.

151. "In brief . . .": Scramuzza, *Claudius,* p. 40.

153. "You have long ago . . .": Tacitus, *Annals,* IV, 40.

"His arrogance . . .": ibid., V, 1.

155. "for it seemed that no day . . .": ibid., IV, 70.

156. "people behaving secretively . . .": ibid., IV, 69.

163. "like a swarm . . .": Bielenstein, *Restoration,* p. 113.

166. "It is I who am . . .": *Gospel of Thomas* (77), in Robinson, *Nag Hammadi,* p. 135.

"When the unclean spirit . . .": Luke 11:24–26.

167. "They that are well . . .": Luke 5:31–32.

168. "The spirit of the Lord . . .": Luke 4:18–19.

"The time is fulfilled . . .": Mark 1:15.

170. "there he [Jesus] could do . . .": Mark 6:5.

"Do you believe . . .": Matthew 9:28–29.

"Go; be it done . . .": Matthew 8:13.

"So his fame . . .": Matthew 4:24–25.

171. "Woe unto you . . .": Luke 6:24–25.

"You have heard . . .": Matthew 5:38–45, 48.

172. "sell what you have . . .": Mark 10:21–23.

173. "Where your treasure is . . .": Matthew 6:19–21.

"He who loves . . .": Matthew 10:37.

"Let the dead . . .": Luke 9:59–60.

"Do not be anxious . . .": Matthew 6:25.

174. "What man among you . . .": Matthew 7:9–11.

"Ask, and it will be . . .": Matthew 7:7–8; Luke 12:24–31.

175. "Are you he . . .": Luke 7:19–22.
 "I myself shall . . .": Thomas (114), in Robinson.
176. "Go nowhere . . .": Matthew 10:5–36, *passim*.
 "Everyone who . . .": ibid.
178. "an army without . . .": Bruce, *New Testament,* p. 185.
 "foxes have holes . . .": Luke 9:58.
179. "The Son of man . . .": Luke 9:22.
 "If any man . . .": Mark 8:34–35.
180. "Truly, I say . . .": Mark 9:1.
 "If any one . . .": Luke 14:25.
 "Do you think . . .": Luke 13:2–3.
181. "Do you not see . . .": Mark 7:18–22.
 "You leave the . . .": Mark 7:6–8.
 "Woe to you . . .": Luke 11:52.
 "It is like children . . .": Matthew 11:16–19.
182. "Woe to you, Chorazin . . .": Luke 10:13–15.
 "I tell you . . .": Luke 15:10.
187. "And what are . . .": quoted in Africa, p. 40.
 "Down come the . . .": quoted in Grant, *Twelve,* p. 103.
188. "There grew up . . .": ibid., p. 96.
 "My lords . . .": Suetonius, *Tiberius,* 67.
193. "I must be on my way . . .": Luke 13:33–34.
194. "My house shall be . . .": Luke 19:46.
195. "Tell us by what . . .": Luke 20:2–8.
 "Is it right . . .": Luke 20:22–25.
196. "In the resurrection . . .": Matthew 22:30.
 "Beware of the teachers . . .": Luke 20:46–47.
 "I tell you . . .": Luke 21:3–4.
 "As for what you see here . . .": Luke 21:6–7.
197. "The master has this . . .": Luke 22:11.
198. "How I have longed . . .": Luke 22:15–16.
 "Prophet . . .": Luke 22:64.
199. "Are you the . . .": Luke 22:67–70.
200. "If you let this man . . .": John 19:12.
 "Are you the king . . .": John 18:33–38.
201. "Let the Messiah . . .": Mark 15:29–32.
 "At midday . . .": Mark 15:33–37.

PART THREE: REBELLION

205. "He is not thirsty . . .": Suetonius, *Tiberius,* 59, 5.
207. "blocked their projected route . . .": Josephus, *AJ,* XVIII, 4, 1.
208. "I am nursing . . .": Suetonius, *Gaius,* 11.
 "abandoning the . . .": Tacitus, *Annals,* VI, 47.
 "If Tiberius . . .": ibid., VI, 48.

211. "To the Tiber . . .": Suetonius, *Tiberius*, 75.
213. "Simon son of John . . .": John 21:15.
214. "The God of Abraham . . .": Acts 3:13–23, *passim*.
215. "We gave you . . .": Acts 5:28.
 "Men of Israel . . .": Acts 5:35–39.
216. "You are just . . .": Acts 7:51–52.
 "The Most High . . .": Acts 7:48.
217. "Look! I see . . .": Acts 7:56.
220. "I adjure you . . .": Baldson, *Life*, pp. 318–19.
221. "The races are on . . .": quoted in ibid., p. 320.
223. "If Tiberius really . . .": Dio, 59, 16.
229. "to perfect the statue . . .": Philo, *Embassy to Gaius*, 246.
 "with a menacing . . .": ibid., 350.
 "Are you the . . .": ibid., 353.
 "They seem to me . . .": ibid., 367.
234. "change the people . . .": Hickey, *Sons*, p. 57.
241. "a stupid old idiot . . .": Suetonius, *Claudius*, 15, 3.
243. "I do not wish to be . . .": quoted in Scramuzza, p. 145 (from Claudius'
 Letter to the Alexandrians).
 "this oldest Italian art . . .": Tacitus, *Annals*, XI, 15.
244. "disturbances . . . at the instigation of . . .": Suetonius, *Claudius*,
 25, 3.
252. "loosely clasped . . .": quoted in Peddie, *Invasion*, p. 148.
255. "Saul, Saul . . .": Acts 26:14.
 "to open their eyes . . .": Acts 26:18.
256. "All who rely . . .": Galatians 3:10.
258. "spy out . . .": Galatians 2:4.
 "What they were makes no . . .": Galatians 2:6.
259. "You are a Jew . . .": Galatians 2:14–21, *passim*.
261. "the most delightful . . .": Josephus, *AJ*, XIX, 7, 5.
 "the silver, illumined . . .": ibid., XIX, 8, 2.
264. "pray for the welfare . . ." and "this people . . .": quoted in Alon, *The
 Jews*, p. 23 fn.
265. "Here there cannot be . . .": Colossians 3:11–15.
266. "Put on then . . .": ibid.
 "If it had been . . .": Acts 18:12–17.
267. "If I speak . . .": I Corinthians 13:1–2.
268. "We exhort you . . .": I Thessalonians 4:10–11, 5:1–2.
 "You are severed . . .": Galatians 5:2–8.
269. "It is nothing but . . .": quoted in Strem, *Life*, pp. 20–21.
 "it is difficult to use . . .": ibid., p. 32.
272. "Hear what Claudius . . .": quoted in Grant, *Twelve*, p. 145.
273. "a rigorous, almost . . .": Tacitus, *Annals*, XII, 6.
275. "any child born to . . .": Suetonius, *Nero*, 6.

276. "You must live . . .": quoted in Grant, *World,* p. 196.
 "how much more human . . .": ibid.
278. "from out of all . . .": quoted in Grant, *Twelve,* p. 154.
279. "How I wish . . .": Suetonius, *Nero,* 10.
 "He would lie on . . .": ibid., 20.
280. "chariot racing . . .": Tacitus, *Annals,* XIV, 14.
281. "I must not . . .": Grant, *Twelve,* p. 154.
289. "hung up naked . . .": Dio, 62, 7.
292. *'I* am doing . . .": Tacitus, *Annals,* XIV, 50.
293. "The festivals were . . .": Josephus, *AJ,* XX, 8, 10.
294. "Who shall separate . . .": Romans 8:35–39.
295. "Paul! You are raving! . . .": Acts 26:24.
 "The ship was caught . . .": Acts 27:15–20.
296. "quite openly . . .": Acts 28:30.
 "Each of the bands . . .": quoted in Grant, *Jews,* p. 165.
297. "True gentlemen . . .": Suetonius, *Nero,* 30.
 "He was convinced . . .": ibid., 29.
298. "The entertainment . . .": Tacitus, *Annals,* XV, 37.
300. "Good, now I . . .": Suetonius, *Nero,* 31.
 "The Palace is . . .": ibid., 39, 2.
305. "not to see them . . .": quoted in Wolpert, *New History,*
 p. 51.
308. "held in honor . . .": Twitchett, *China,* p. 821.
312. "war, if it be . . .": Josephus, *BJ,* II, 16, 4.
314. "Hereupon Cestius . . .": ibid., II, 18, 9.
315. "Many of the most eminent . . .": ibid., II, 20, 1.
317. "to give the signals . . .": ibid., II, 20, 7.
 "despaired of the success . . .": ibid., III, 6, 3.
323. "would soften . . .": Suetonius, *Nero,* 43.
 "How ugly and vulgar . . .": ibid., 49, 2.
 "What a loss . . .": ibid., 49, 1.
324. "I select . . .": Suetonius, *Galba,* 16.
326. "that fag . . .": quoted in Grant, *Twelve,* p. 191.
 "To polish off . . .": ibid.
328. "was not as flabby . . .": Tacitus, *Histories,* I, 22.
 "Otho was appalled . . .": ibid., I, 27.
 "Why? What harm . . .": Dio, 53, 7.
332. "While a sacrifice . . .": Suetonius, *Vitellius,* 13.
 "If I had not . . .": quoted in Grant, *Twelve,* p. 199.
334. "Though tired out . . .": Dio, 54, 12–13.
337. "plaiting their hair . . .": Josephus, *BJ,* IV, 9, 10.
339. "Truly the very view . . .": ibid., VI, 1, 1.
340. "they would do all possible damage . . .": ibid., V,
 11, 2.

343. "Not its great antiquity . . .": ibid., VI, 10, 1.
 "There is nothing but . . .": ibid., VII, 8, 3.
344. "Let our wives die . . .": ibid., VII, 8, 6.

PART FOUR: THE AFTERMATH

352. "I must always ensure . . .": Suetonius, *Vespasian,* 18.
353. "Dear me . . .": ibid., 23, 4.
 "either my sons . . .": ibid., 25.
 "you are my . . .": Suetonius, *Titus,* 9, 2.
 "as if the mountains . . .": Dio, 66, 22–23.
358. "When we were clear . . .": Pliny the Younger.
359. "his life was being . . .": Suetonius, *Titus,* 10.
362. "Those emperors . . .": Dio, 67, 2.
366. "I heard behind me . . .": Revelation 1:10–16.
368. "true life consists of . . .": Campbell, *Apollonius,* p. 80.
 "Men worshipped . . .": Revelation 13:4.
 "was allowed to . . .": Revelation 13:7–10, *passim.*
369. "arrayed in purple . . .": Revelation 17:4–6.
371. "Woe unto us, . . .": quoted in Alon, *The Jews,* p. 50.
372. "Behold, I will make . . .": Revelation, 3:9.
 "The Spirit and the Bride . . .": Revelation 22:17–21, *passim.*
374. "great mountains and . . .": Lewis, *Principate,* p. 70.
375. "If the Han ambassador . . .": Fitzgerald, *China,* p. 197.

Bibliography

Readers who wish to study the ancient literary sources in English should find the following translations most helpful.

Dio Cassius. *Roman History.* 9 vols. Transl. by Ernest Cary. Cambridge: Harvard University Press, 1955.

Josephus, Flavius. *The Complete Works.* Transl. by William Whiston (1737). Philadelphia: John E. Potter & Co., 1870.

———. *The Jewish War.* Transl. by G. A. Williamson. New York: Dorset Press, 1970.

Pan Ku. *History of the Former Han Dynasty.* 3 vols. Transl. by Homer Dubs. Baltimore: Waverly Press, 1955.

———. *Wang Mang.* Ed. and transl. by Clyde Bailey Sargent. Westport, Connecticut: Hyperion Press, 1947.

Philo Judeas. *The Embassy to Gaius.* Transl. by F. H. Colson. Cambridge: Harvard University Press, 1955.

———. *The Essential Philo.* Ed. by Nahum Glatzer. New York: Schocken Books, 1971.

Philostratus, Flavius. *The Life of Apollonius of Tyana.* Transl. by F. C. Conybeare. London: William Heinemann Ltd., 1912; Transl. by C. P. Jones, New York: Penguin Books, 1970.

Strabo. *The Geography.* 8 vols. Transl. by H. L. Jones. Cambridge: Harvard University Press, 1960.

Suetonius (Gaius Suetonius Tranquillus). *The Twelve Caesars.* Transl. by Michael Graves. Penguin Books, 1973.

Tacitus, Publius Cornelius. *Agricola and the Germania.* Transl. by Harold Mattingly. Penguin Books, 1987.

———. *Annals.* Transl. by Michael Grant. Penguin Books, 1977.

——. *Histories.* Transl. by Kenneth Wellesley. Penguin Books, 1986.
Velleius Paterculus. *Compendium of Roman History.* Transl. by Frederick W. Shipley. London: William Heinemann, 1924.
——. *The Tiberian Narrative.* Ed. by A. J. Woodman. Cambridge: Cambridge University Press, 1977.

For quotations from the New Testament, I employed (where appropriate) the King James Version, the Oxford Annotated Bible (Revised Standard Version), and the New International Version.

Amid a wide range of secondary material on the first century, the works of Michael Grant on Rome and the Jews; Paul Petit on the Roman Empire; J. B. Campbell on the Roman Army; J. P. V. D. Baldson on the details of everyday life in Rome; Michele Pirazzoli-t'Serstevens, Michael Loewe, and Hans Bielenstein on Wang Mang and the Han Dynasty; John Peddie on the Claudian invasion of Britain; and Sara Mack on Ovid proved exceptionally enlightening. The following is a more complete guide to the studies I found most instructive and helpful.

Africa, Thomas W. *Rome of the Caesars.* New York: John Wiley & Sons, Inc., 1965.
Alon, Gedaliah. *The Jews in Their Land in the Talmudic Age.* Cambridge: Harvard University Press, 1989.
Baldson, J. P. V. D. *The Emperor Gaius (Caligula).* Oxford: Clarendon Press, 1934.
——. *Life and Leisure in Ancient Rome.* New York: McGraw-Hill, 1969.
Benario, Herbert W. *An Introduction to Tacitus.* Athens: University of Georgia Press, 1975.
Bentwich, Norman. *Philo-Judeas of Alexandria.* Philadelphia: Jewish Publication Society of America, 1910.
Bielenstein, Hans. *The Restoration of the Han Dynasty.* Vol. II, Stockholm: The Museum of Far Eastern Antiquities, 1959.
Boardman, John, Jasper Griffin, and Oswyn Murray, eds. *The Roman World.* Oxford: Oxford University Press, 1988.
Bornkamm, Gunther. *Paul.* New York: Harper & Row, 1971.
Bradford, Ernle. *Paul the Traveller.* New York: Macmillan Publishing Company, 1974.
Branigan, Keith. *Roman Britain.* London: Reader's Digest Assoc. Ltd., 1980.
Bruce, F. F. *New Testament History.* Garden City: Doubleday, 1971.
Buchan, John. *Augustus.* London: Hodder and Stoughton, 1937.
Buttinger, Joseph. *The Smaller Dragon: A Political History of Vietnam.* New York: Praeger, 1958.
Cairns, Earle E. *Christianity Through the Centuries.* Grand Rapids, Michigan: Zondervan, 1954.

Campbell, F. W. Groves. *Apollonius of Tyana.* Chicago: Argonaut Inc., 1968.

Campbell, J. B. *The Emperor and the Roman Army, 31 B.C.–A.D. 235.* Oxford: Clarendon Press, 1984.

Charles-Picard, Gilbert. *Augustus and Nero: The Secret of Empire.* London: Phoenix House, 1966.

Chisolm, Kitty and John Ferguson, eds. *Rome: The Augustan Age.* Oxford: Oxford University Press, 1981.

Ch'ü T'ung-tsu. *Han Social Structure.* Seattle: University of Washington Press, 1972.

Cohen, Shaye J. D. *From the Maccabees to the Mishnah.* Philadelphia: The Westminster Press, 1987.

Colish, Marcia L. *The Stoic Tradition from Antiquity to the Early Middle Ages.* Vol. I. Leiden, The Netherlands: E. J. Brill, 1985.

Collins, John J. *Between Athens and Jerusalem.* New York: Crossroad, 1983.

Conybeare, Rev. W. J., and Rev. J. S. Howson. *The Life and Epistles of St. Paul.* Grand Rapids: W. B. Eerdmans, 1949.

Cullmann, Oscar. *Peter: Disciple—Apostle—Martyr.* Philadelphia: Westminster Press, 1953.

D'Arms, John H. *Romans on the Bay of Naples.* Cambridge: Harvard University Press, 1970.

Davis, William Stearns. *A Day in Old Rome.* Boston: Allyn and Bacon, 1925.

Drinkwater, J. F. *Roman Gaul.* Ithaca: Cornell University Press, 1983.

Durant, G. M. *Britain: Rome's Most Northerly Province.* New York: St. Martin's Press, 1969.

Farmer, Edward L., et al., eds. *Comparative History of Civilizations in Asia.* Vol. I. Boulder, Colorado: Westview Press, 1986.

Farmer, William R. *Maccabees, Zealots, and Josephus.* New York: Columbia University Press, 1956.

———, ed. *New Synoptic Studies: The Cambridge Gospel Conference and Beyond.* Macon, Georgia: Mercer University Press, 1983.

Finkelstein, Louis. *The Pharisees.* Philadelphia: Jewish Publication Society of America, 1962.

Fitzgerald, C. P. *China: A Short Cultural History.* New York: Praeger Publishers, 1961.

Fox, Robin Lane. *Pagans and Christians.* New York: Knopf, 1987.

Fredriksen, Paula. *From Jesus to Christ.* New Haven: Yale University Press, 1988.

Frere, Sheppard. *Britannia.* London: Routledge & Kegan Paul, 1987.

Garzetti, Albino. *From Tiberius to the Antonines.* London: Methuen & Company, Ltd., 1974.

Gernet, Jacques. *A History of Chinese Civilization.* Cambridge: Cambridge University Press, 1982.

Goodenough, Erwin R. *An Introduction to Philo Judeas.* Oxford: Basil Blackwell, 1962.

Grant, Michael. *The Army of the Caesars.* New York: Charles Scribner's Sons, 1974.

———. *Herod the Great.* London: Weidenfeld & Nicolson, 1971.

————. *History of Rome.* New York: Charles Scribner's Sons, 1978.

————. *The Jews in the Roman World.* New York: Charles Scribner's Sons, 1973.

————. *The Twelve Caesars.* New York: Charles Scribner's Sons, 1975.

————. *The World of Rome.* Cleveland: The World Publishing Company, 1960.

Griffin, Miriam T. *Nero: The End of a Dynasty.* New Haven: Yale University Press, 1985.

————. *Seneca: A Philosopher in Politics.* Oxford: Clarendon Press, 1976.

Herm, Gerhard. *The Celts.* New York: St. Martin's Press, 1975.

Hickey, Gerald Cannon. *Sons of the Mountains: Ethnohistory of the Vietnamese Central Highlands to 1954.* New Haven: Yale University Press, 1982.

Hoehner, Harold W. *Herod Antipas.* Cambridge: Cambridge University Press, 1979.

Johnson, Paul. *A History of the Jews.* New York: Harper & Row, 1987.

Jones, A. H. M. *Augustus.* New York: W. W. Norton & Co., 1970.

Keller, Werner. *Diaspora: The Post-Biblical History of the Jews.* New York: Harcourt, Brace & World, 1966.

Latourette, Kenneth Scott. *The Chinese: Their History and Culture.* New York: The Macmillan Company, 1964.

Levick, Barbara. *Tiberius the Politician.* London: Thames and Hudson, 1976.

Lewis, Naphtali, ed. *The Roman Principate: 27 B.C.–285 A.D.* Toronto: A. M. Hakkert Ltd., 1974.

Loewe, Michael. *Crisis and Conflict in Han China.* London: George Allen & Unwin, Ltd., 1974.

————. *Everyday Life in Early Imperial China.* London: B. T. Batsford, Ltd., 1968.

————, ed. *Records of Han Administration.* Vol. I. Cambridge: Cambridge University Press, 1967.

Mack, Sara. *Ovid.* New Haven: Yale University Press, 1988.

MacKendrick, Paul. *The Dacian Stones Speak.* Chapel Hill: University of North Carolina Press, 1975.

Maranon, Gregorio. *Tiberius: A Study in Resentment.* London: Hollis & Carter, 1956.

Mays, James L., ed. *Harper's Bible Commentary.* San Francisco: Harper & Row, 1988.

Mendell, Clarence W. *Tacitus: The Man and His Work.* New Haven: Yale University Press, 1957.

Millar, Fergus, and Erich Segal, eds. *Caesar Augustus: Seven Aspects.* Oxford: Clarendon Press, 1984.

Muggeridge, Malcolm, and Alec Vidler. *Paul, Envoy Extraordinary.* New York: Harper & Row, 1972.

Myerowitz, Molly. *Ovid's Games of Love.* Detroit: Wayne State University Press, 1985.

Otis, Brooks. *Ovid As an Epic Poet.* Cambridge: Cambridge University Press, 1970.

Peddie, John. *Invasion.* Gloucester: Alan Sutton Publishing, 1987.

Pelikan, Jaroslav. *Jesus Through the Centuries.* New Haven: Yale University Press, 1985.

Perowne, Stuart. *The Caesars' Wives.* London: Hodder and Stoughton, 1974.

Petit, Paul. *Pax Romana.* Berkeley: University of California Press, 1976.

Piggott, Stuart. *The Druids.* New York: Praeger Publishers, 1975.

Pirazzoli-t'Serstevens, Michele. *The Han Civilization of China.* Oxford: Phaidon Press Ltd., 1982.

Rackham, Richard B. *The Acts of the Apostles.* London: Methuen & Co., Ltd., 1947.

Rand, Edward K. *Ovid and His Influence.* New York: Cooper Square Publishers, 1963.

Reinhold, Meyer, ed. *The Golden Age of Augustus.* Toronto: Samuel Stevens, 1978.

Robinson, James M., ed. *The Nag Hammadi Library.* San Francisco: Harper & Row, 1988.

Salway, Peter. *Roman Britain.* Oxford: Clarendon Press, 1981.

Scramuzza, Vincent M. *The Emperor Claudius.* Cambridge: Harvard University Press, 1940.

Scullard, H. H. *From the Gracchi to Nero.* London: Methuen & Co., Ltd., 1959.

———. *Roman Britain: Outpost of the Empire.* London: Thames and Hudson, 1979.

Seager, Robin. *Tiberius.* Berkeley: University of California Press, 1972.

Shulvass, Moses A. *The History of the Jewish People,* Vol. I. Chicago: Regnery Gateway, 1982.

Smith, Vincent A. *The Early History of India.* London: Oxford University Press, 1924.

Spence, Lewis. *Boadicea: Warrior Queen of the Britons.* London: Robert Hale Ltd., 1937.

Stauffer, Ethelbert. *Christ and the Caesars.* Philadelphia: Westminster Press, 1955.

Stipcevic, Aleksandar. *The Illyrians: History and Culture.* Park Ridge, New Jersey: Noyes Press, 1977.

Strem, George G. *The Life and Teaching of Lucius Annaeus Seneca.* New York: Vantage Press, 1981.

Syme, Ronald. *The Augustan Aristocracy.* Oxford: Clarendon Press, 1986.

———. *History in Ovid.* Oxford: Clarendon Press, 1978.

Taylor, Buck. *Saint Paul: A Study of the Development of His Thought.* New York: Charles Scribner's Sons, 1969.

Thomas, Charles. *Celtic Britain.* London: Thames and Hudson, 1986.

Todd, Malcolm. *Roman Britain.* Atlantic Highlands, New Jersey: Humanities Press Inc., 1981.

Twitchett, Denis, and Michael Loewe, eds. *The Cambridge History of China.* Vol. I: *The Ch'in and Han Empires.* Cambridge: Cambridge University Press, 1986.

Wacher, John. *Roman Britain.* London: J. M. Dent & Sons, Ltd., 1978.

Wang, Zhongshu. *Han Civilization.* New Haven: Yale University Press, 1982.

Wellesley, Kenneth. *The Long Year: A.D. 69.* Boulder: Westview Press, 1976.

Wells, C. M. *The German Policy of Augustus.* London: Oxford University Press, 1972.

————. *The Roman Empire.* Stanford: Stanford University Press, 1984.

Wilkes, J. J. *History of the Provinces of the Roman Empire: Dalmatia.* Cambridge: Harvard University Press, 1969.

Wilkinson, L. P. *Ovid Recalled.* Cambridge: Cambridge University Press, 1955.

Williamson, G. A. *The World of Josephus.* Boston: Little Brown & Co., 1964.

Wilson, William Riley. *The Execution of Jesus.* New York: Charles Scribner's Sons, 1970.

Wolpert, Stanley. *A New History of India.* New York: Oxford University Press, 1982.

Ying-shih Yu. *Trade and Expansion in Han China.* Berkeley: University of California Press, 1967.

Index